botany
FOR THE
artist

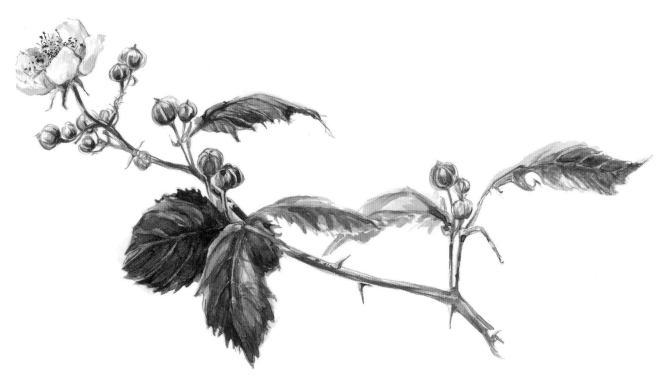

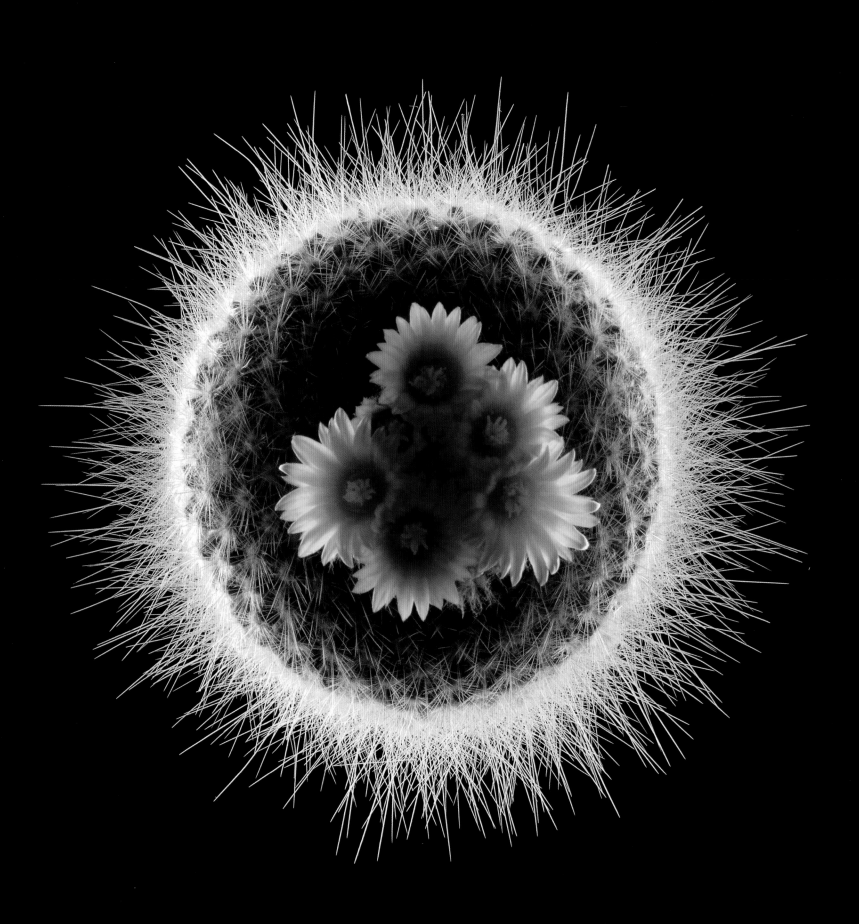

botany

FOR THE

artist

SARAH SIMBLET

Photography **Sam Scott–Hunter**
Botanical Advisor **Stephen Harris**

FEATURING PLANTS FROM THE UNIVERSITY OF OXFORD BOTANIC GARDEN
AND OXFORD UNIVERSITY HERBARIA

LONDON, NEW YORK,
MUNICH, MELBOURNE, DELHI

Senior Editor | Project Art Editor
Angela Wilkes | Silke Spingies

Editor | Advisor
Susannah Steel | Dr. Stephen Harris

US Editor | US Consultant
Chuck Wills | Jill Hamilton

Photographer | Jacket Designer
Sam Scott-Hunter | Silke Spingies

Production Editor | Picture Researcher
Luca Frassinetti | Sarah Smithies

Managing Editor | Production Controller
Julie Oughton | Sarah Hewitt

Associate Publisher | Managing Art Editor
Liz Wheeler | Louise Dick

Publisher | Art Director
Jonathan Metcalf | Bryn Walls

Bramble
(*Rubus* sp.)

First American Edition, 2010

Published in the United States by DK Publishing,
345 Hudson Street, New York, New York 10014

14 10 9 8 7 6 5 4 3

014-AD359-Feb/2010

Published in Great Britain by Dorling Kindersley Limited

A catalog record for this book is available from the Library of Congress.

ISBN: 978-0-7566-5250-0

DK books are available at special discounts when purchased in bulk for
sales promotions, premiums, fund-raising, or educational use.
For details, contact: DK Publishing Special Markets, 345 Hudson Street,
New York, New York 10014 or SpecialSales@dk.com.

Color reproduction by Media Development & Printing Ltd., UK
Printed and bound in China

Discover more at
www.dk.com

Contents

The art of botany 8

Images from the past 10
Drawn from life 12
The printed truth 14
Private passions 16
Expanding worlds 18
Personal drawing books 20
Voyages of discovery 22
Zen composition 24
Meditations 26

Drawing plants 28

Working with plants 30
Materials 32
Mark making 34
Mixing colors 35
Preparatory drawings 36
Creating a drawing 38
Sources of inspiration 40
Masterclass: Illuminated
 Letter, Nikolaus
 Von Jacquin 42

Diversity 44

Introduction 46
Plant classification 48
Algae 50
Fungi 52
Lichens 56
Mosses and liverworts 58
Ferns and horsetails 60
Conifers 62
Flowering plants 64
Monocots 66
Eudicots 68
Masterclass: Great piece
 of turf, Albrech Dürer 70

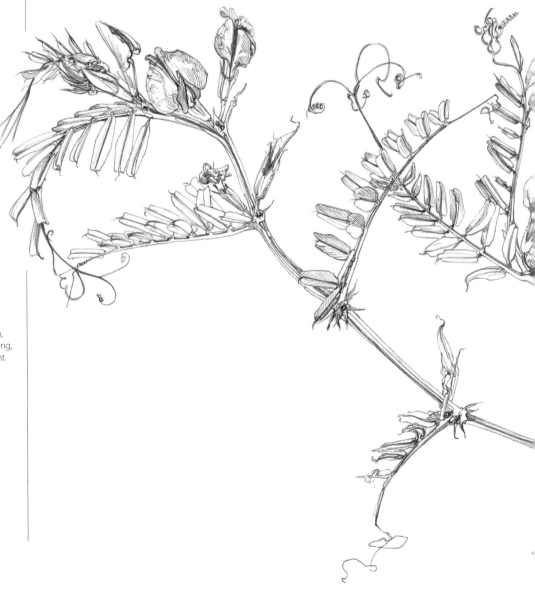

Roots 72

Introduction 74
How roots work 76
Spreading roots 78
No need for soil 80
Drawing class:
 Hawthorn 82
Masterclass: Étude
 de Botanique,
 Girolamo Pini 84

Stems 86

Introduction 88
Strong stems 90
Stem buds 92
Study: Wild stems 94
Drawing class: Pine tree 96
Bark 98
Study: Trees in the
 landscape 100
Masterclass:
 Bird and flowers,
 Kanō Yukinobu 102
Drawing class:
 Composition 104
Study: Folded fritillary 106
Runners 108
Climbers 110
Masterclass: Passiflora
 caerulea, John Miller 112
Wetland plants 114
Underground storage 116
Drawing class:
 Kohlrabi 118
Modified stems 120
Skin surfaces 122
Masterclass: Blackberries,
 Leonardo da Vinci 124

Leaves 126

Introduction 128
Simple leaves 130
Compound leaves 134
Leaf veins 136
Leaf arrangements 138
Study: Pine needles 140
Drawing class: Leaves in
 perspective 142
Masterclass: Spray of olive,
 John Ruskin 144
Pitchers 146
Heterophylly 148
Bracts 150
Masterclass:
 Arum Dioscoridis,
 Ferdinand Bauer 154
Study: Fern crosiers 156
Drawing class: Autumn
 leaves 158

Flowers 160

Introduction 162
Anatomy of a flower 164
Inside a flower 166
Pollination 168
Study: Cross sections 170
Masterclass:
 Geranium phaeum,
 Arthur Harry Church 172
Study: Opening buds 174
Symmetry in flowers 176
Drawing class:
 Aristolochia 178
Flower forms 180
Study: Tulips 184
Branching 186
Cymes 188
Racemes 190
Study: Wild flowers 192
Flower heads 194
Study: Hippeastrum 196
Spikes, catkins, and
 spathes 198
Capitula 200
Capitula variations 202
Drawing class:
 Windflower 204
Masterclass: Spear Lily,
 Mali Moir 206

Fruit, cones, and seeds 208

Introduction 210
Dispersal 212
Capsules 214
Drawing class: Conkers 216
Pods 218
Study: Herbarium fruits 220
Masterclass: Bowl of
 broad beans,
 Giovanna Garzoni 222
Achenes 224
Study: Banksias 226
Small dry fruits 228
Winged fruits 230
Masterclass: Yellow-
 throated warbler, pine
 warbler, and red maple,
 Mark Catesby 232
Fleshy fruits 234
Drawing class:
 Watermelon 236
Fruit diversity 238
Masterclass: Pineapple
 with cockroaches,
 Maria Sibylla Merian 240
Study: Cones 242
Drawing class:
 Pine cone 244
Germination 246

Glossary 248
Index 252
Acknowledgments 256

Common vetch
(*Vicia sativa*)

Foreword

This book was inspired by my love of gardening, a desire to know more about the structures, forms, and lives of plants, and an opportunity to spend a whole year exploring wild landscapes and the fabulous collections of the University of Oxford Botanic Garden and Oxford University Herbaria. These collections generously gave or lent me hundreds of pieces of plants to draw or have photographed for this book. *Botany for the Artist* features around 550 species, chosen to represent almost every kind of plant and habitat on Earth. Gorgeous, unfamiliar exotics are celebrated alongside more common plants, to show the beauty and wonder of the bird-of-paradise flower and the pavement milk thistle, tropical forest fruits and the orchard apple, giant pine cones, and tufts of city moss. Fungi, and some species of algae, are not scientifically classified as plants, but are featured here because they are fabulous to draw and fascinating in themselves.

Drawing is a powerful tool for both our insight and our imagination. It is a direct and universal language, as old as humankind, from which the written word developed. We all engage with drawing every day. Myriad images surround us in advertising and packaging, and we enjoy the patterns and designs we choose for our clothes and homes. In making drawings we can doodle and jot down ideas, sketch quick maps, and share a sense of humor. Drawing enables us to express our attitudes and emotions freely, and above all, to look at and learn to see the world that surrounds us. If you spend just one hour drawing a plant, you will understand it far better than if you spent the same hour only looking at it. There is something in the physical act of drawing, the coordination of the hand and eye, and the translation of sensory experience into marks and lines that reveals an entirely new way of seeing. There is a significant difference between looking and seeing. Artists know this, but it is something we can all experience if we draw. And time spent drawing is a revelation, regardless of the results. Drawing is about so much more than just making pictures that sometimes the finished image is irrelevant. It can be thrown away without losing what was experienced and learned. I firmly believe that everyone can learn how to draw—if they want to. The first steps are not difficult, and results will soon inspire you with the confidence to carry on. Books of advice, classes, and looking at the works of other artists will help you greatly, but you can also learn how to draw simply by doing it. I think sometimes that the hand and eye can learn from experience and lead to inner confidence. The first step is to simply have a go.

I always draw from real plants—never photographs—because plants are three dimensional and were once alive, even if they are no longer. They are physically present, and can move, change, and challenge the person drawing them. An artist's relationship with their subject is always innately expressed in their work, so it is usually possible to tell if they worked from life or photographs. A subject drawn from imagination can be just as present as a real one, because it, too, is never flat or static. A camera is great for making quick visual notes, creating an *aide-mémoire*, and a photograph can also be an exquisite work of art. Throughout this book, Sam Scott-Hunter's photographs reveal subtle insights that could not be captured in drawing. They also magnify many details so we can look very closely into them. I have drawn most plants life-size, for comparison, and also to convey the excitement of giant-sized objects. This diversity is just one characteristic of the vast kingdom of plants that surrounds us all, and it is always there, just outside our door, waiting to be explored.

Sarah Simblet

Sarah Simblet

Bulbous buttercups
These buttercups grew between two roadside curbstones and their roots were full of ants, so I put them in an old ceramic basin to draw them on my desk. Each flower bud quickly opened and turned to face the window on my left, and I had to keep rotating the basin to bring some of the blooms back to face me. All this is a part of the pleasure of working with living things.
Bulbous buttercup (*Ranunculus bulbosus*)

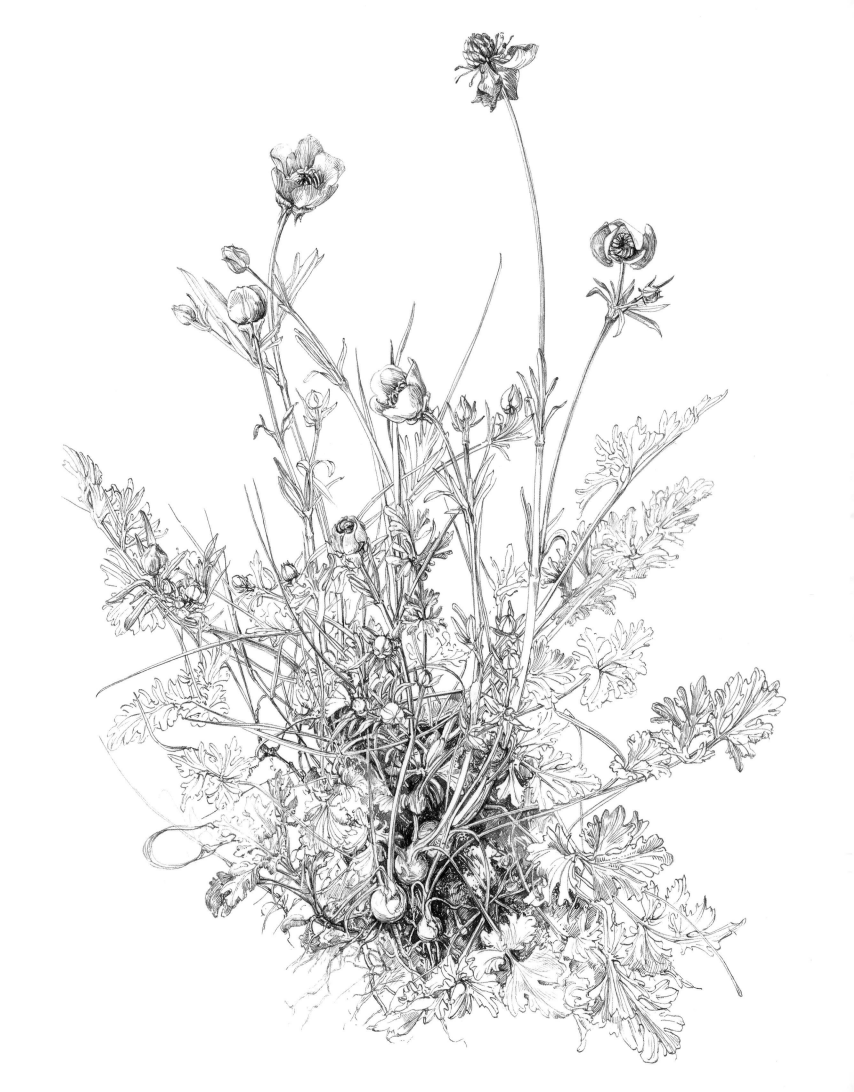

The art of botany

Ancient Egyptians painted wheat in tombs to provide food for their dead, the Romans displayed the opulence of plants in mosaics overflowing with flowers and fruits, and for centuries illustrators have kept records of plants in precious books. This chapter presents just a few of the millions of images of plants that have been made in the pursuit of knowledge, meditation, power, and sheer delight in their beauty.

Images from the past

The oldest images of plants are not the work of human hands. They are fossils, imprints left by leaves and other vegetable matter trapped and compressed for millennia between layers of sedimentary rock. Plants began to evolve in the oceans as green algae more than 540 million years ago. Larger organisms more easily recognizable as plants first appear among fossils dating back about 440 million years. A fossilized leaf like the one shown below is not only beautiful, it provides us with a glimpse of the vastly distant past. Its size and shape explain the climate in which it grew and help us to picture the landscape and environment of the prehistoric earth.

The earliest surviving manuscript illustrations of plants were painted in Egypt in the 5th century CE. They appear on a fragment of papyrus discovered in 1904 by J. de M. Johnson, while he was working in Antinoe, Egypt. One side of the sheet depicts what looks like a heavy melon, scuttling on roots above a fragment of ancient Greek text. This is described as a comfrey plant (right). On the reverse is another species, thought to be mullein. What is most striking about the plant shown here—besides its lively character—is that in reality, comfrey is tall and slender, with thin and hairy branched stems, broad, oval, pale green leaves, and small pink or white tubular flowers. It looks nothing like a melon. The artist worked without once referring to a real comfrey plant and this was common practice in early botanical books. The text was all-important, and pictures, if used, could remind the reader that plants are usually green and have roots. Early books on plants, known as herbals, were copied by hand often many times over several centuries and, in extreme cases, a copied illustration could be accidentally turned upside down. Roots in the latest version might now wave in the air and bear fruit, while leaves languish more dimly underground. Illustrations would not be seen as truly important for nearly another 1,000 years after the Johnson Papyrus.

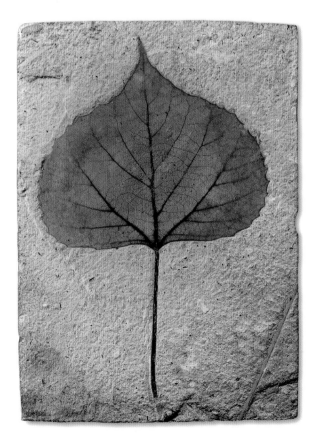

Fossilized *Populus latior* leaf
This 23-million-year-old fossilized leaf fell from a flowering tree called *Populus latior*, which resembles the modern Canada Poplar. Every detail is perfectly preserved, from its net-like veins branched above the stalk, to its delicately scalloped border sweeping around each side and up to the tip.
Fossilized leaf of Populus latior, leaf 4¼in (11cm), Natural History Museum, London, UK

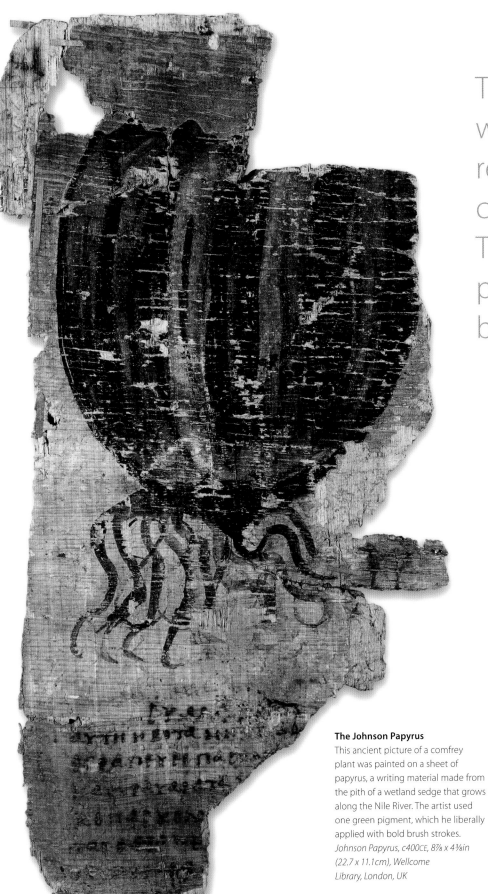

The artist worked without once referring to a comfrey plant. This was common practice in early botanical books.

The Johnson Papyrus
This ancient picture of a comfrey plant was painted on a sheet of papyrus, a writing material made from the pith of a wetland sedge that grows along the Nile River. The artist used one green pigment, which he liberally applied with bold brush strokes.
Johnson Papyrus, c400CE, 8⅞ x 4⅜in (22.7 x 11.1cm), Wellcome Library, London, UK

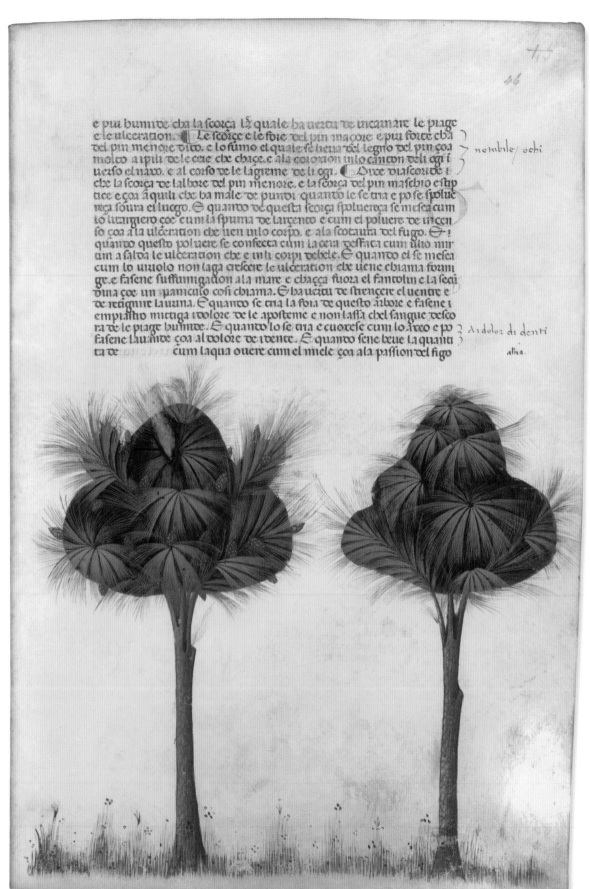

The Carrara Herbal
Subtle brush strokes of gouache (watercolour mixed with chalk) are here blended into a sheet of vellum (prepared calfskin). The dark under-shape of foliage was painted first, an inspired generalization of a tree, over which details observed from life are finely laid.
Plate 40, c1390–1404, 35 x 24cm (13⅝ x 9⅜in), British Library, London, UK

Drawn from life

For centuries, botany has been closely linked to medicine, because plants provide the raw materials for many lotions and drugs. For example, aspirin, one of the most widely used drugs in the world, was originally derived from the bark of a willow tree, after the bark had been known for centuries to have anti-inflammatory properties. Herbals describing curative plants enabled knowledge to pass from one generation to the next, although many of the earliest books would have been of little use as field guides. The Johnson Papyrus (see p.11) shows how far illustrations could deviate, delightfully, from the text, and many plants described in classical scholarship are not found beyond the Mediterranean. Around the end of the 14th century, artists began to make new, fresh, and direct observations from life. Especially fine examples are seen among the pages of the Carrara Herbal.

Written in vernacular Italian for the last Duke of Padua, the Carrara Herbal is a translation of the work of a 9th-century Arab physician called Serapion the Younger, and it is celebrated for the beauty and realism of its paintings. The unnamed artist did not copy the works of others but instead looked at nature. In painting these two pine trees (left), wafting their soft fronds over a meadow of flowers, we see the artist expressing his own knowledge of plants through what he sees with his own eyes and this was revolutionary.

Like the painter of the Carrara Herbal, the Italian fine artist Antonio Pisanello (c.1395–1455), working in the very early years of the Renaissance, was ahead of his contemporaries in so far as he also drew directly from nature. His work marks an important transition between the Medieval practice of copying traditional designs from pattern books (although he also used these), and the Renaissance—the rebirth of the classical practice of looking directly at life. Pisanello was a fresco and portrait painter, and pre-eminent carver of commemorative medals, but today he is best known for his beautiful drawings, especially of hunting animals, costumes, and birds. He also drew plants, and here (right), is his silver-point study of a flag iris, a branch of fig leaves, a single veined leaf, and possibly some vinca flowers and a sprig of mallow.

> In the Early Renaissance, artists returned to looking directly at nature.

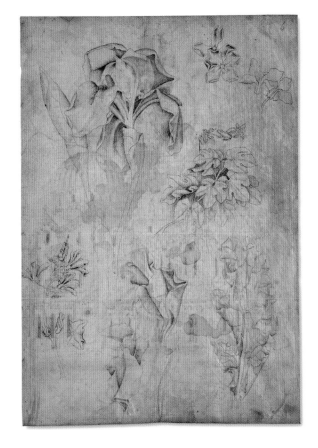

Plant study
These plants may be studies for a larger work. The artist drew them with a fine silver rod (the predecessor of pencil) on a sheet of prepared paper, with the living plants in front of him. Each of the drawings has a sculptural quality, as if carved in stone.
Etudes d'iris, d'autres fleurs et de feuillages, Antonio Pisanello, 7 x 10¼in (18.4 x 26.1cm), Musée Bonnat, Bayonne, France

Kuchenschell. Hackekraut.

OTHO BRVNNFELSIVS.

CONSTITVERAMVS ab ipso statim operis nostri initio, quicquid esset huiuscemodi herbarum incognitarum, et de quarum nomenclaturis dubitaremus, ad libri calcem appendere, & eas tantum sumere describendas, quae fuissent plane uulgatissimae, adeoq; & officinis in usu: uerum longe secus accidit, & rei ipsius periculum nos edocuit, interdum seruiendum esse scenae και καιρῶ λατρεύειν, quod dicitur. Nam cum formarum deliniatores & sculptores, uehementer nos remorarentur, ne interim ociose agerent & prela, coacti sumus, quamlibet proxime obuiam arripere. Statuimus igitur nudas herbas, quarum tantum nomina germanica nobis cognita sunt, praeterea nihil. Nam latina neq; ab medicis, neq; ab herbarijs rimari ualuimus (tantum abest, ut ex Dioscoride, uel aliquo ueterum hanc quiuerimus demonstrare) magis adeo ut locum supplerent, & occasionem praeberent doctioribus de ijs deliberandi, q;

t 3

Pulsatilla with text

Weiditz's naturalistic drawings were made on paper and transferred in reverse to blocks of wood, so that they could be carved, inked, and printed. Here, a pulsatilla and its text are subtly integrated, the uppermost petal of the left-hand flower curling to fit underneath the lettering at the top of the page.
Herbarium Vivae Eicones, Otto Brunfels, 1532, woodcut on paper, 7½ x 12½in (19 x 31.5cm), Natural History Museum, London, UK

The printed truth

Botanical drawing was established as a powerful and influencial presence in printed books.

The revolution in printed botanical illustration began in High Renaissance Germany with two books, published in close succession, that both depict true likenesses of plants. The first of these, *Herbarum Vivae Eicones* (Living Portraits of Plants), appeared in 1530. Written by Otto Brunfels, it was illustrated by Hans Weiditz, a former pupil of the renowned painter and engraver Albrecht Dürer. A few years later, in 1542, Leonard Fuchs published his *De Historia Stirpium Commentarii Insignes* (Notable Commentaries on the History of Plants), with illustrations by Albrecht Meyer.

Brunfels, a botanist, theologian, and doctor, published several books on theology and plants in collaboration with the printer Johannes Schott. He was among the first to write an account of local German flora, using the earlier writings of classical scholars as the basis of his work. The text of his *Herbarum* was not ground-breaking, but Weiditz' illustrations were; the scientifically accurate drawings are what make this book important. Weiditz worked from living specimens to produce 260 portraits of plants, complete with their natural imperfections, such as a wilted leaf, snapped stem, or small marks of disease. His interpretations capture clearly the character of each plant, showing them as individuals—just as all plants are when looked at in life.

The text written by Fuchs differed from that of Brunfels in being a piece of original research. Like many scientists of his time, Fuchs regarded personal artistic freedom as a threat to truth and accuracy. After commissioning Meyer to produce the illustrations, he gave his artist a tight brief, not allowing him to use tone, and insisting that he collate information from several specimens of each plant. In contrast to the work of Weiditz, the result was that Meyer created perfect concepts of species, rather than individual portraits.

With the publications of Brunfels and Fuchs, accurate botanical drawing was established as a powerful and influential tool. A good drawing can stand in place of a living plant because it captures likeness and explains habit and detail. Drawings present facts more directly than text because they are instantly read and they can show the reader exactly where to look and what to see.

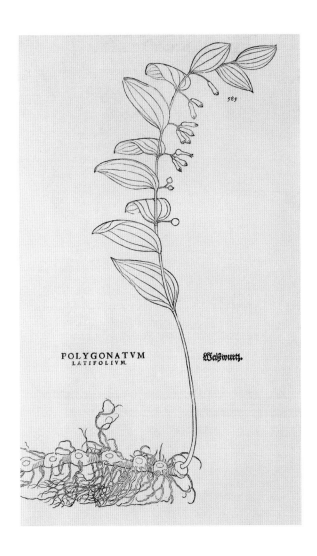

POLYGONATVM
LATIFOLIVM. Weißwurtz.

Solomon's seal
This woodblock print of Solomon's seal is one of Meyer's 500 drawings for Fuchs. Created from the study of several plants, clear, smoothly carved lines describe structure without tone. Meyer shortened and gently curved the plant to fit the page.
Drawing of Solomon's seal, Albrecht Meyer, 1542, Natural History Museum, London, UK

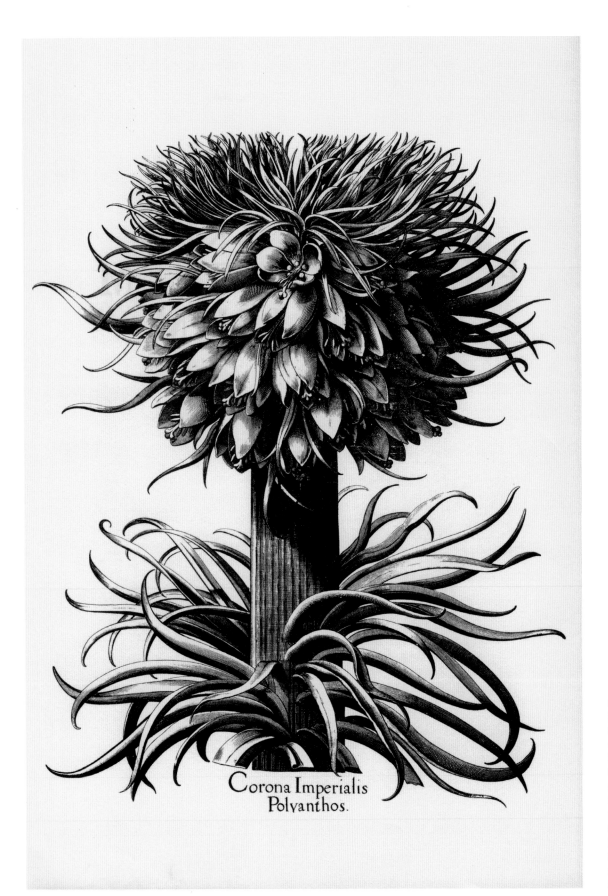

Corona Imperialis
Polyanthos.

Crown imperial

Strong illumination deepens the shadows and sculptural forms of this menacing plant, a native of Turkey, introduced to Vienna in the 1570s. Copperplate engraving, the technique used, allows larger images to be made and finer lines to be cut than in woodblock printing, where numerous small blocks are assembled to create larger works.

Crown imperial, 1613, copper engraving, Royal Horticultural Society, Lindley Library, UK

Private passions

By the 17th century, the scope for botanical art was expanding as improved navigation and wider exploration of the globe brought thousands of newly discovered plants pouring back into Europe. Exotic botanical specimens were avidly cultivated and collected, and horticulture became a widespread enthusiasm. Botanical gardens were created to document the cultivated and collected plants and to serve as living herbals. Some wealthy plant connoisseurs established their own private botanical collections, at least in part to show off their status and their impeccable taste. To immortalize their gardens, such collectors commissioned gorgeous books of botanical art, known as florilegia, which were produced as large format and expensive limited editions. Unlike the herbals, florilegia usually illustrate miscellanies of species enjoyed primarily for their beauty and rarity, not their medicinal usefulness.

The largest and most influential florilegium of its day was Basilius Besler's *Hortus Eystettensis* (The Garden at Eichstätt), published in 1613. This features more than 1,000 life-size drawings, reproduced as copperplate engravings. The book documents the German garden of the Prince Bishop of Eichstätt, who sent boxes of cut plants to Nuremberg to be drawn by a team of artists. Besler himself managed the project but none of the artists has been credited. The crown imperial shown here (left) as an example of the work is an especially bombastic individual—and glorious for that. Its heavy head of flowers and flailing, tentacle-like leaves trumpet their own sense of

> To immortalize their gardens, collectors commissioned gorgeous books of botanical art, known as florilegia…

importance. But unbeknown to botanical scientists at the time, such a massive distortion in growth was in fact due to viral infection.

The phenomenon of "tulip mania," which swept through Holland in the 1620s and continued for about a decade, was another rich source of opportunity for botanical artists. This was a time when tulips became the focus of a breeding craze, as growers experimented with hybridizing. New color variations—again, the result of viral infection—sometimes occurred. At the height of the mania, tulips with rare color mutations could be sold for enormous prices. A single bulb of the striped specimen illustrated here (left) may have been worth many times the annual salary of the skilled but little-known craftsman who painted it.

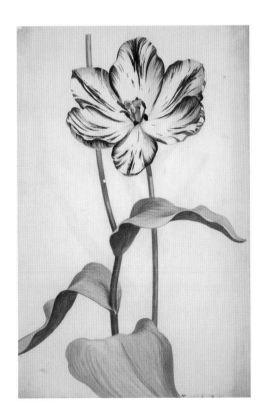

Tulip fever
This painting of a fragile striped tulip captures a fleeting moment of beauty before the petals collapse. Its tall stem has been cut and arranged so that the tulip's foliage can be appreciated too.
Tulipa cultivar, Vincent Laurensz van der Vinne, watercolor, 10½ x 16¼in (27 x 41.5cm), Natural History Museum, London, UK

Expanding worlds

In 1665, one of the most inspiring publications in the history of science made its appearance. This book, called *Micrographia*, was the work of the brilliant scientist Robert Hooke (1635–1703), and contained 38 copperplate engravings made from Hooke's own drawings of objects seen through his microscope. Hooke was a member of the Royal Society in London, alongside the architect and scientist Sir Christopher Wren. In 1661, Wren had presented his own microscopical drawings of insects to King Charles II, who was delighted and asked for more. When Wren did not respond, the Royal Society asked Hooke to step in and create a book of drawings, both for the king and for scientific research. Hooke, an accomplished draftsman, drew things he found most exciting to enlarge—corn violet and thyme seeds, ice crystals, handwriting, cheese mold, the tip of a pin, a flea, and the eyes of a fly. *Micrographia* also illustrates Hooke's most famous, and unexpected, discovery—plant cells. His drawing of a slice of cork showing cell structure uses a startling pictorial device. The black circle puts our eye directly to his microscope lens, as if to say—this is the truth, see this new world for yourself.

New discoveries also inspired Hooke's near contemporary, Alexander Marshall (c.1620–1682), to produce his unique botanical portraits, but his work was not a scientific exercise, or even meant for publication. Marshall, an eminent horticulturalist and collector, painted his own florilegium for sheer pleasure, a single book filled with plants picked from his and his friends' gardens, and arranged into seasons. Marshall's friends included the most renowned gardeners of his day, John Evelyn and John Tradescant among others, so he had access to the rarest and newly introduced species. (This was the era in which English gardening came into being. The first British botanical garden had opened at Oxford in 1621.) Marshall freely painted animals among his flowers, at different scales and dotted all over the pages. For example, a cyclamen leaf combined with a lobster, and some grapes share space with a monkey, a heron, a macaw, a hazel nut, and a toad. The whole book brims with artistic abandon.

> In his *Micrographia*, Hooke drew things he found most exciting to enlarge.

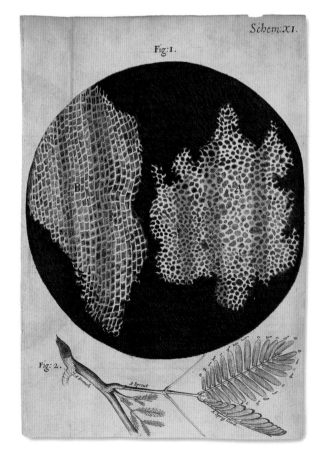

Cork cells
Here cork cells are shown in vertical and horizontal section, with a sprig of the plant lying beneath the viewing circle of the microscope. The copperplate engraving was made by cutting grooves into a copper plate, which were then filled with ink to produce a print on damp paper. *Micrographia, Robert Hooke, 1665, engraving on paper, 9½ x 11¾in (24 x 30cm), Natural History Museum, London, UK*

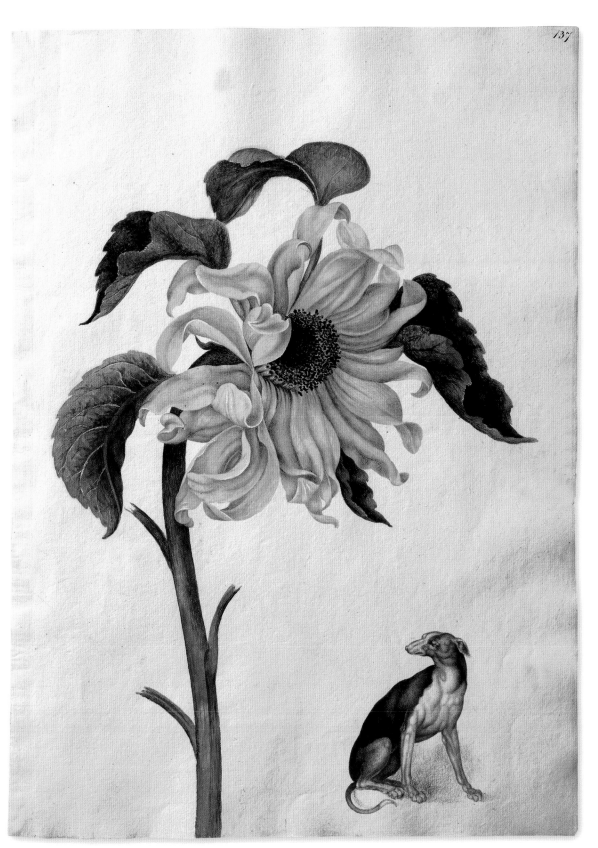

The bold sunflower

This sunflower, imported from America, was seen as a wonder for its size and movement as its head follows the sun's path during the day. Marshall's gentle pet greyhound looks a little unnerved by it. Both plant and dog are painted with relatively small dry strokes and stipples of gouache on paper.

Common sunflower and greyhound, Alexander Marshal, 1682, watercolor, 18 x 13in (45.6 x 33.3cm), The Royal Collection, UK

Gentian flowers
Ehret's gentian flowers are most striking for their gem-like brilliant blue, which is enhanced by the contrasting warm hue of the pink paper that surrounds them and glows through the highlights of the petals. The simple linear rendering of the leaves and stems has been done in ink with a quill pen. The artist's first pencil marks can be seen beside the lowest flower.
Gentiana acaulis (Stemless gentian), Georg Dionysus Ehret, c.mid-1700s, pencil, ink, and watercolor on paper, 8 x 7¼in (20.5 x 18.5cm), Natural History Museum, London, UK

Personal drawing books

Ehret's drawings are personal notes, freshly made studies, direct records of the appearance and nature of plants.

The 18th century is called the Golden Age of botanical painting, and Georg Dionysius Ehret (1708–1770) is often praised as the greatest botanical artist of the time. Born in Heidelberg, Germany, he was the son of a gardener who taught him much about art and nature. As a young man, Ehret traveled around Europe, largely on foot, observing plants and developing his artistic skills. In Holland, he became acquainted with the Swedish naturalist Carl Linnaeus, who devised the first standardized system for naming and classifying plants and animals—the basis for modern taxonomy. Through his collaborations with Linnaeus and others, Ehret provided illustrations for a number of significant horticultural publications. His reputation for scientific accuracy gained him many commissions from wealthy patrons, particularly in England, where he eventually settled.

Here two of Ehret's colored sketches from his notebooks give an insight into his methods of working. These drawings are personal notes, freshly made studies, direct records of the appearance and nature of fascinating and very beautiful plants. They are not complex or formal botanical plates, made to explain every single detail of each plant and to fit the page of a publication. Personal touches and informal qualities in drawings like these, together with incidental marks made by pollen stains and splashed paint, help us to feel present at the moment of making, looking over the artist's shoulder.

Aloe vera
Ehret drew this succulent plant from northern Africa in pencil, adding light washes of pink and blue watercolor then successively darker washes. Nearly dry strokes laid on after the washes have dried emulate the bloom of the plant's skin. The handwritten notes refer to three different species of aloe. Around each fleshy leaf, small sharp spines change color from neutral gray pencil into shades of red, purple, and blue.
Sketch 249 from the Ehret Collection of Sketches by Georg Dionysius Ehret, c.mid-1700s, pencil, ink, and watercolor on paper, 14 x 22in (35.5 x 56cm), Natural History Museum, London, UK

Voyages of discovery

A turning point in the history of botany, and botanical illustration, was the voyage of the HMS *Endeavour*, between 1768 and 1771. Under the command of Lieutenant James Cook, in the service of King George III, the ship was commissioned to circumnavigate the globe, observe the transit of Venus on Tahiti, and search for Terra Australis Incognita, a vast southern continent thought to counterbalance the landmass of the north. Among those sailing with Cook was botanist Joseph Banks, who was wealthy enough to pay for a party of nine to accompany him, including another botanist, Daniel Solander, and artists Sydney Parkinson and Alexander Buchan.

The voyage lasted three years. Banks and Solander hunted and studied almost every day. They caught marine creatures, and shot and skinned birds and land animals. Their haul of botanical specimens was enormous, and Banks eventually described over 1,000 new species and at least 100 new genera. The botanists pressed and dried plants in sheaves of paper, and boxed up fruits and seeds. And they gave everything to Parkinson to draw. In a tiny cramped cabin, working late into the night under a flickering oil lamp, Parkinson produced a huge number of immensely important scientific drawings and paintings of new species, including the beautiful Tahitian gardenia illustrated here (right).

Endeavour's journey stimulated scientific interest in global plant diversity.

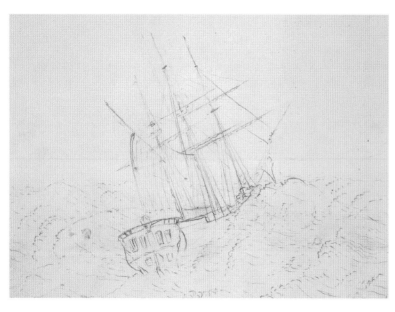

Diary sketch
The *Endeavour* was a 106ft (33m) long coal ship, built in Whitby, in northeast England. While on board, Sydney Parkinson used pencil and paper to capture in his diary the drama of the voyage.
The Endeavour at sea, Sydney Parkinson, 1768–1771, pencil, British Library, London, UK

Newly gathered specimens did not stay fresh for long in the searing tropical heat and Parkinson had to work swiftly to make an accurate record. Later, the paintings were completed using the dried collections for reference. At times Parkinson was overwhelmed, if not by volumes of work, then by insects. Banks wrote in Tahiti, "a mosquito net covers chairs, painter, and drawings, but even that is not sufficient... flies eat the painter's colours off the paper as fast as they can be laid on." Both Parkinson and Buchan among many others died before the vessel returned home. *Endeavour's* journey stimulated British scientific interest in global plant diversity. It provided Banks with the influence to lobby for resources to improve the developing botanical gardens at Kew, near London, and to send trained plant collectors around the world. Some of the very best botanical illustrations ever produced can be attributed to Banks' pioneering spirit.

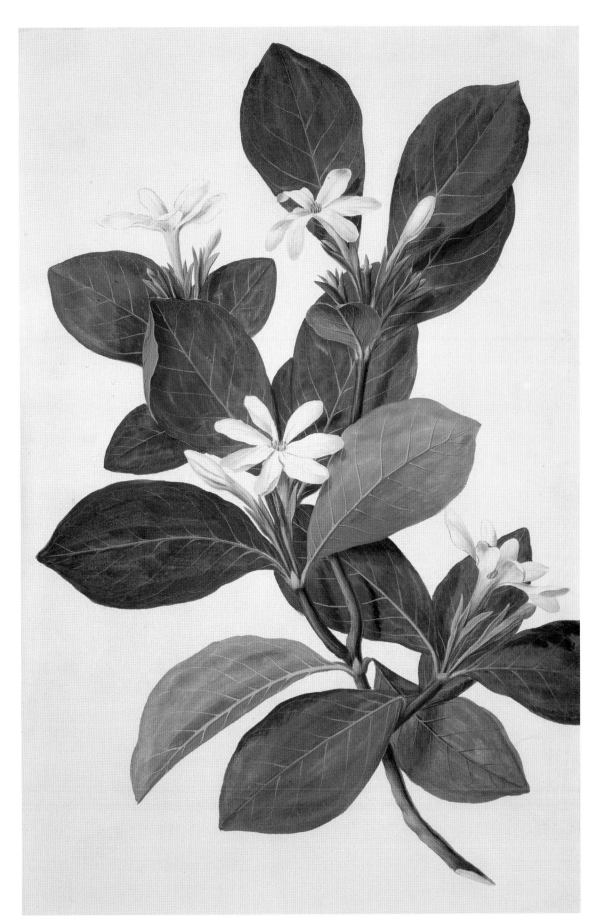

Tahitian gardenia
Parkinson made precise pencil drawings of each plant while it was still fresh, and painted one leaf, one flower, or one fruit to provide a key to living colors and textures. The paintings could then be completed from dried material. In this Tahitian gardenia, the pale green veins were brushed on to the leaves after the darker colors had dried.
Gardenia taitensis, Sydney Parkinson, 1768–1771, watercolor, Natural History Museum, London

Zen composition

The dramatic irises shown below, painted across a gilded folding screen, are an elegant example of the strong asymmetry typical of many masterpieces of Japanese art and design. They were painted in 1702 by Ogata Korin (c.1657–1716), and represent a scene from *The Tales of Ise*, a collection of ancient Japanese courtly poems and stories, thought to date from around the 9th century. In one of the tales the central character rests beside a bridge in the famous iris marshes of Mikawa province, to reflect on his longing for lost loves and the beauty of nature. Korin came from a family of Kyoto silk merchants who provided exquisite fabrics for the wives of feudal lords. He was a leading artist of the Rinpa school of arts and crafts that developed in Kyoto. His work is especially characterized by bold and stylized but evocative brush strokes, with which he captured the essence of every plant he painted. Intuitively, he created rhythms with differing intensities of repeated shapes and marks.

Visual harmonies are best created intuitively, without self-consciousness.

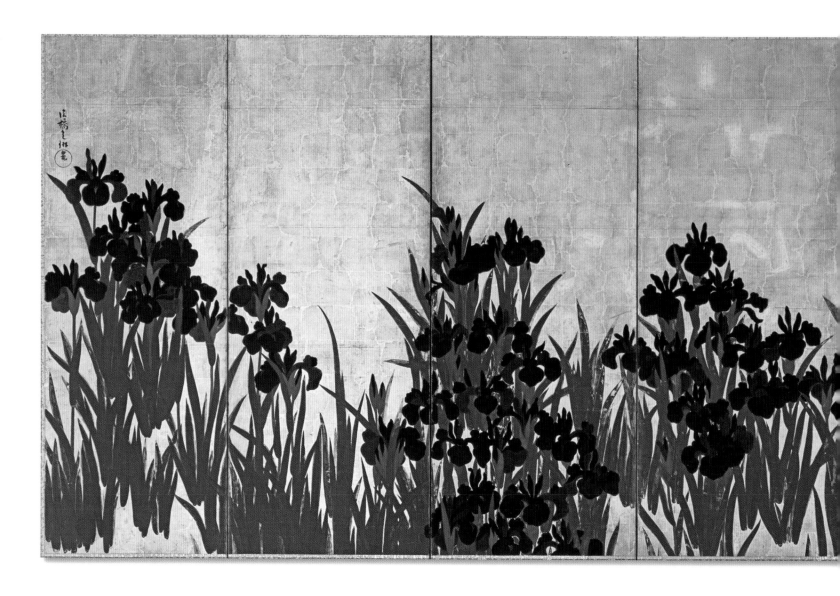

Sometimes, beguilingly seductive works of art can be made almost inadvertently. In 1936, Dr. Dillon Weston, a British plant pathologist, who suffered from insomnia, began to spend his wakeful nights producing glass models of enlarged microscopic fungi. Working with a Bunsen burner, a pair of pliers, and fine rods of Czech glass, he created sculptures of organisms that cause disease or mold in crops such as wheat, potatoes, soft fruits, and bread. Weston used his models for practical purposes—to show farmers what their problems were and how best to treat them—but they are also beautiful art forms. In this model of downy mildew (right) quivering droplets of pearl-like glass are held with the same composure, harmony, and asymmetrical balance found in traditional Japanese brush painting. This is no coincidence, visual harmonies are often created intuitively, when focus is given to the meaning and intention of the work, without being self-conscious of composition. This is the essence of zen: a visual practice of balance and harmonious expression.

**Downy mildew
(*Bremia lactucae*)**
This downy mildew, modeled in glass, is 400 times life-size. What look like clusters of tiny oyster pearls are the fruiting bodies of the fungus, while the silvery threads beneath are its hyphae, a microscopic network of tubes that convey water and nutrients.
Glass model of Bremia lactucae, Dr. William Dillon, 1930s, glass, 9⅝in (25cm), Whipple Museum, Cambridge, UK

Irises
Without under-drawing, Korin laid paint directly over prepared surfaces of gold or silver leaf. His irises were painted with a broad soft bamboo and natural hair brush and a limited palette. He used one green for all of the leaves, and four purple hues for the flowers.
Irises (folding screen), Ogata Korin c1705, color on gold foil over paper, 59⅜ x 133½in (51 x 338.8cm), Nezu Art Museum, Tokyo, Japan

Meditations

Artists working in widely differing styles, cultures, and centuries, have used fragile plants and flowers as a visual metaphor for the temporality of human life. The piece of gilded calligraphy (below), made on a real tobacco leaf, is an Islamic prayer, a *basmalah*, from the Quran. It reads *bismi Ilahi r-raHmani r-raHim*, which means "In the name of God, the most merciful, most compassionate." The art of writing prayers on gilded leaves dates mostly from 19th-century Ottoman Turkey. Tough leaves were chosen, and perfect specimens were pressed between sheets of absorbent paper and smooth glass, left outside in the shade to dry, then transferred to wire meshes to complete drying. Leaf surfaces were picked away from the veins with a needle-like tool and a thin coat of gum arabic was applied to stabilize each leaf. Finally, the prayer was brushed into place through a paper stencil. The extreme delicacy of these labor-intensive pieces of craftmanship was seen to parallel human impermanence.

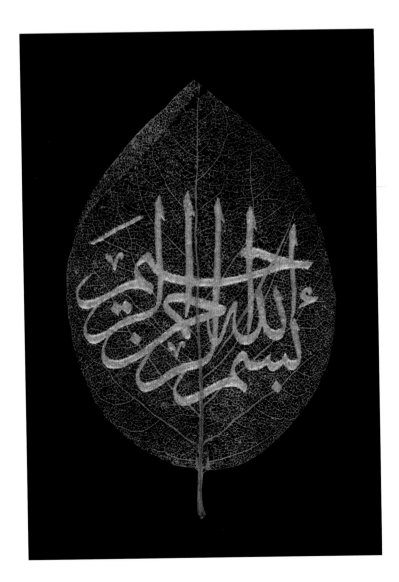

For centuries, artists have used fragile plants and flowers as a visual metaphor for the temporality of human life.

Prayer leaf
Little is known of the artists who made gilded prayer leaves, but most worked in the western Anatolian city of Bursa. The petiole and midrib of the leaf is always important in the composition. All scripts fit harmoniously within their leaf shape. Here, downward strokes complement the verticality of the central midrib, while loops in the calligraphy echo the looped and net-like arrangement of the leaf's tertiary veins.
Gilded calligraphic composition on a tobacco leaf with the Basmalah, 19th century, gold on tobacco leaf, 5⅝ x 4½in (14.3 x 11.5cm), Nasser D. Khalili Collection of Arts of the Islamic World

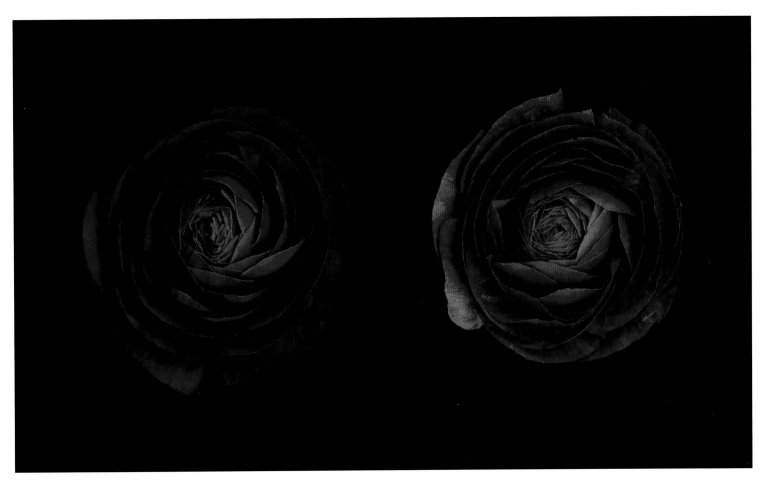

Digital image of two ranunculi
Many of Furneaux's recent digital-works are time-based, meaning that they can be watched like short films on a monitor or projected onto a gallery wall. These mesmeric images can slowly pulse, dissolve, or drift into pieces.
Ranunculi, Sera Furneaux, 27 December 2006 at 2.38am, 6½ x 4in (16.5 x 10cm)

The quietly poetic works of contemporary artist Sera Furneaux also reflect upon the impermanence of life as it is seen in, and can be represented by, cut flowers. She created the digital images of a ranunculus (above) using a scanner and computer. Furneaux chooses her blooms with care, observing each one closely over a period of hours or days, as it opens or closes, wilts, and falls apart, moving constantly and almost imperceptibly. She captures the changing forms and failing strengths of a flower on the glass plate of her scanner. Working at night, in absolute darkness, she is one step removed from her image-making process as she is not composing through a camera lens. Instead, she anticipates each image and waits for it to be revealed by the scanner, before she begins work on her computer. Sera is one of an increasing number of contemporary artists working with plants, whose images help to deepen our own vision and understanding of the presence and complexity of the natural world, and our fragile but exciting place within it.

Drawing plants

Drawing opens our eyes to the world that surrounds us. It excites our imaginations and enables us to see and understand things more clearly. This chapter offers some practical advice on how to work with living plants indoors, ranges of art materials to choose from, the importance of mark making, and the value of searching out local resources such as herbaria and botanic gardens.

Working with plants

Plants are sensitive and responsive when you bring them indoors to draw. Potted plants turn their leaves and blooms toward the light of your window, and cut flowers sometimes follow sunspots across the wall. Toadstools tilt their caps upward if laid on their sides. Spring bulbs and buds respond to sudden heat and grow. Dry fruits continue drying, then pop and throw their seeds at you, while ants, earwigs, and other delightful insects can run riot on the desk. That is fine, so long as they don't wriggle between stored sheets of drawings, where their ill-placed demise can devastate a precious piece of work. This is all part of the pleasure of working with plants. They demand that we be patient and take care of them, and constantly remind us that they are very much alive.

Airtight humidity is the key to keeping cut plants fresh. Circulating air makes them wilt. When collecting a specimen in warm weather, put it straight into a clear plastic bag. Inflate this like a balloon, and tie the top very tightly so the bag cannot deflate. This makes a humid, protective tent, and a rigid container that can be packed beneath others without being crushed. You can make small tents from tie-top freezer bags. Plants keep firm and fresh in these, without being cooled, for hours or even days, especially if you add a few drops of water. Alternatively, use airtight plastic boxes with wet paper towels laid flat in the bottom to provide humidity. Vases are useless for storing cut plants—they allow them to crush together and dry out.

Coolness and shade delay plant growth and flowers opening. Darkness will make a flower close. A fridge is good for storing alpine and dormant winter plants, but is far too cold for late spring and summer flowers and foliage, which will turn brown or collapse in the cold. Plants left in low light for too long when actively growing will distort, so it is best to keep rooted specimens outdoors when not working with them. Masking tape makes a good insect barrier if erected like a miniature fence, sticky side facing inward, all around the rim of any pot containing soil.

Subjects to watch
Winter tree buds make a fascinating subject to watch. Placed in a vase of water in a warm room they soon burst open and grow. They can also be kept dormant in the fridge.
Oak buds (*Quercus* sp.)

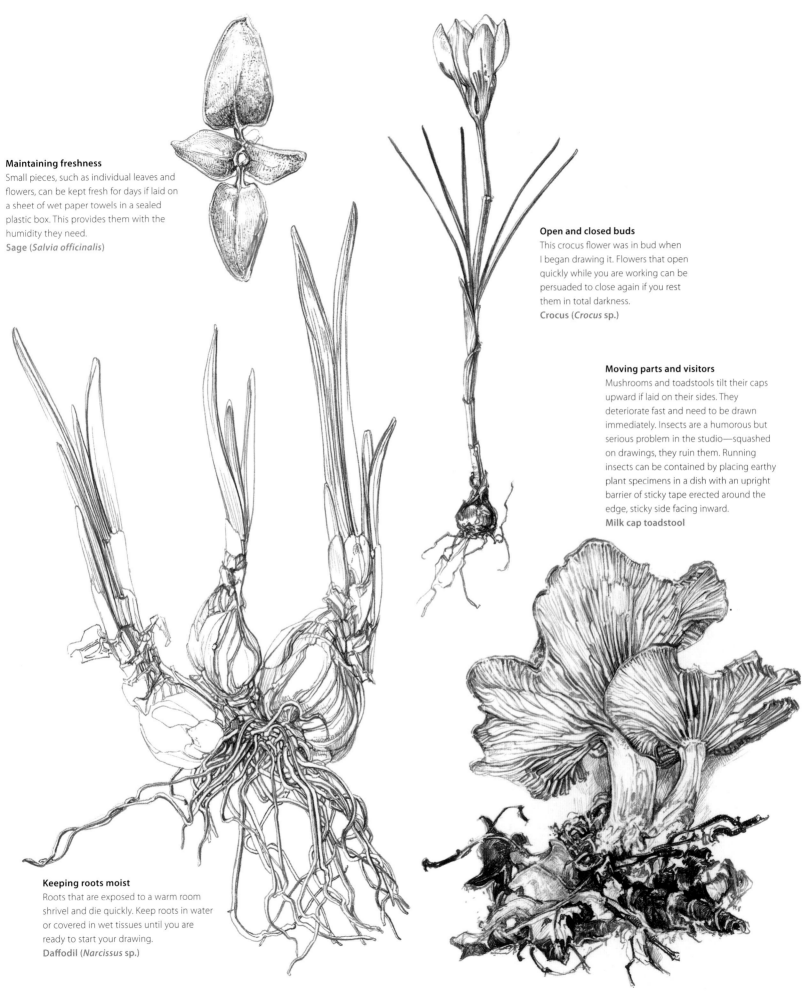

Maintaining freshness
Small pieces, such as individual leaves and flowers, can be kept fresh for days if laid on a sheet of wet paper towels in a sealed plastic box. This provides them with the humidity they need.
Sage (*Salvia officinalis*)

Open and closed buds
This crocus flower was in bud when I began drawing it. Flowers that open quickly while you are working can be persuaded to close again if you rest them in total darkness.
Crocus (*Crocus* sp.)

Moving parts and visitors
Mushrooms and toadstools tilt their caps upward if laid on their sides. They deteriorate fast and need to be drawn immediately. Insects are a humorous but serious problem in the studio—squashed on drawings, they ruin them. Running insects can be contained by placing earthy plant specimens in a dish with an upright barrier of sticky tape erected around the edge, sticky side facing inward.
Milk cap toadstool

Keeping roots moist
Roots that are exposed to a warm room shrivel and die quickly. Keep roots in water or covered in wet tissues until you are ready to start your drawing.
Daffodil (*Narcissus* sp.)

Materials

A drawing board and paper can be carried everywhere in search of exciting new plants—use them in the landscape, a botanical garden, art gallery, or museum. Drawing boards are expensive in art shops, so it is best to make your own. Calculate a range of dimensions and have several boards cut at once in a wood yard. Smooth plywood, thick enough not to flex, is ideal. Avoid grainy wood that will jolt drawn lines and indent paper. It is also useful to own a portfolio. A high-quality portfolio will last a lifetime; cheap ones can fall apart in days. I make my own using two boards of thick card

or thin plywood, hinged securely, with four internal flaps to hold paper in place, and ribbon ties to keep it closed. I make portfolios in a range of sizes to fit different work. Good light is important when drawing, to see your subject and the tonality of your work. At home, an anglepoise lamp is very useful for accentuating shadows and form. When drawing outside, sit in the shade, so you are not blinded by the white of your paper and avoid facing the sun. Looking into the sun is not just uncomfortable, it stops you from seeing tones properly and results in flattened work.

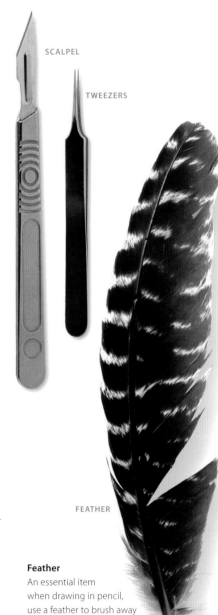

Arches Aquarelle 300GM2 (Rough)
Top quality hot-pressed (smooth) watercolor paper. It is made of 100% cotton and sold in sheets, blocks, and rolls. Use with any media.

Fabriano Artistico 300GM2 HP (Traditional white)
Tough, white textured paper that can take abrasive use of any medium. HP means hot-pressed. Fabriano produce a range of different weights.

370GSM Lambeth Drawing Cartridge
Heavy, hot-pressed (smooth) paper that is acid-free, so will last. Sold in flat sheets, it can be rubbed without crumpling or tearing.

Saunders Waterford 300GM2 (NOT)
Mid-quality textured watercolor paper. "NOT" means not hot-pressed and so it is rough textured.

Fabriano Accademia
An affordable standard medium range multipurpose cartridge. Use with any media from pencil to paint.

Paper
Papers differ in thickness (weight), size, texture, color, absorbency, pH, and cost. They may be hand-, mold-, or machine-made in sheets, blocks, or rolls. Cheap wood-pulp papers are acidic, turning brown and brittle. Cotton papers are high quality and acid-free, resisting deterioration. Use cheap paper for rough ideas and quality paper for work to last.

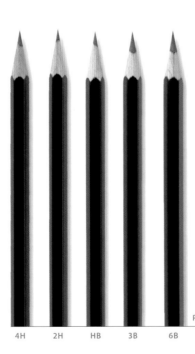

PENCILS

PENCIL SHARPENER

4H 2H HB 3B 6B

WHITE PLASTIC ERASER

Scalpel
Keep pencils sharp if making detailed work. A scalpel cuts a better point than a pencil sharpener, and is needed to dissect flowers. When dissecting flowers, change scalpel blades regularly. Blunt blades tear petals.

Tweezers
Use a pair of fine-tipped metal tweezers to hold specimens when cutting. Such tweezers are available from medical instrument suppliers.

Pencils and sharpener
HB pencil rubs out cleanly and completely from beneath watercolor and ink. Perfect for an under-drawing that is to be removed. I use HB for everything. Softer pencils (2 to 6B) make richer, thicker, darker marks, good for expressive drawing but do not erase well. Pencil sharpeners are safer to travel with than scalpels.

Eraser
Some white plastic erasers will erase diluted ink substantially, and cleanly, without staining or tearing paper. Cutting the eraser into triangular pieces gives plenty of clean edges for refining detail.

SCALPEL

TWEEZERS

FEATHER

Feather
An essential item when drawing in pencil, use a feather to brush away eraser particles without smudging your work.

All artists have their own favorite materials, and pots full of brushes, pencils, and pens can offer a feast of possibilities for every subject and mood. If you are unsure of what to buy, begin with a few things that you find interesting. Buy one of each, try them at home, and return for more of what proves best. I do this when searching for good pen nibs. A range of materials are illustrated here, but I only use some of the items to draw with. One HB pencil suits my needs, but lots of artists use three pencils: a hard, a medium, and a soft. Three pencils will give you the

maximum range of tones that are possible, for example, 4H, HB, and 6B. You don't need to buy every grade. Take pleasure in assembling your own kit and modify tools if necessary, so they fit perfectly in your hand. For example, I like a short-handled pen, and so I cut and file the ones that I buy from the shop. I keep my materials in a small box so they are stable in transit and on any work surface. When the box is opened it creates a safe place in which to stand jars of water and ink, whether outside, in a field, or in a museum.

Pen

You can distinguish a drawing pen nib from other types, because it is pointed like a fine fountain pen, but without the little ball of metal on the back of the tip. Avoid needle-sharp mapping pens that scratch and kick, and broad calligraphy nibs, because neither of these are made for drawing. Nibs and handles are sold separately and nibs wear out so need replacing from time to time.

Ink

Chinese ink is carbon-based and can be erased if weakly diluted. Check how light-fast a brand is by making test marks on paper and leaving them on a windowsill for a month, half covered and half exposed to the light. I use two dilutions of ink, one very pale and the other a mid-gray, which in three or so layers appears black. Always keep a tissue nearby to blot the nib and spills.

DIP PEN

JAR FOR DILUTED INK

CHINESE CALLIGRAPHY INK

Watercolors

Red, yellow, and blue are the three primary colors from which all others can be mixed. Transparent yellow, permanent rose, and ultramarine blue (green shade) are the best primaries to use as a beginner (see p.35).

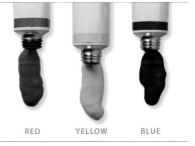

RED YELLOW BLUE

Brushes

Brushes vary hugely in size, shape, purpose, cost, and durability, as do the materials they are made from. Synthetic brushes are firmer, cheaper, and longer lasting than natural brushes, which are softer, hold more pigment, and make finer points.

1. Artetje Nost

This brush is synthetic and so relatively firm, makes a fine point, and holds plenty of pigment. I used this brush for this book.

2. Pointed Traditional Writer

This long sable-hair brush holds large amounts of ink for long lines and points well for detailed work.

3. Small Japanese Brush

Made with sable hair, this brush has a soft drawing tip and small ink-holding capacity good for linear work.

4. Larger Japanese Brush

Made with natural hair, this brush has a broad wash capacity and can achieve a very wide range of marks.

5. Squirrel–Hair Sword Liner

This natural-haired brush has maximum ink-holding capacity and an extremely fine and flexible point.

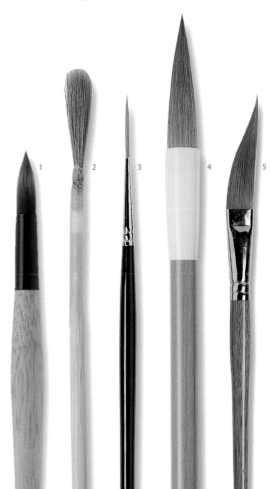

Mark making

Lines and marks are the basis of all drawing, and they can be given different lengths, thicknesses, tones, textures, speeds, and directions, to actively describe shapes, forms, movements, and emotions. Lines and marks have sensory qualities. For example they can be jagged or soft, loud or quiet, direct or hesitant. Like actors on stage, they can physically perform the actions and meaning of what they describe and so bring a subject alive.

Look at the drawings of great artists and study the lines and marks they have made in isolation; think about how they work in the picture and why.

When making your own drawings, you can learn a lot by covering a sheet of paper with as many different lines and marks as you can make with one pencil. Keep changing the pressure, speed, and direction of your hand, and try to use the pencil to enact different sensory experiences. Then, write words beneath your marks to describe them. For example, agitated, sharp, crackling, or blurred. Assigning written language to drawn language will quickly show you how we can use drawing to communicate. If you focus on drawing the expressive character of every subject you draw, as much as its structure and shape, it will become real on the page in front of you.

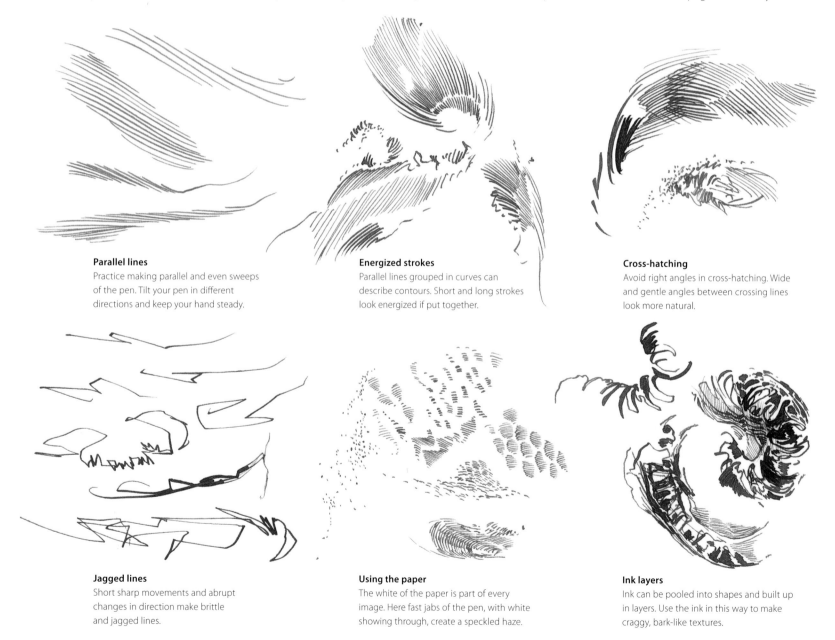

Parallel lines
Practice making parallel and even sweeps of the pen. Tilt your pen in different directions and keep your hand steady.

Energized strokes
Parallel lines grouped in curves can describe contours. Short and long strokes look energized if put together.

Cross-hatching
Avoid right angles in cross-hatching. Wide and gentle angles between crossing lines look more natural.

Jagged lines
Short sharp movements and abrupt changes in direction make brittle and jagged lines.

Using the paper
The white of the paper is part of every image. Here fast jabs of the pen, with white showing through, create a speckled haze.

Ink layers
Ink can be pooled into shapes and built up in layers. Use the ink in this way to make craggy, bark-like textures.

Mixing colors

Red, yellow, and blue are the primary colors. From these, all others can be made. I recommend you use transparent yellow, permanent rose, and ultramarine blue (green shade). These colors are clear (not gritty), and transparent and luminous, which are key qualities in watercolor. When mixed, these colors give the broadest range of secondary colors: greens, oranges, and violets, and tertiary colors: grays, browns, and blacks. It is important for a beginner to start simply, and to learn to mix their own colors, which is a pleasure and not a difficult task. Try mixing two primary colors to create a secondary color: mix red and yellow to create orange,

yellow and blue to create green, and blue and red to create violet. Next mix each of the secondary colors with its complementary color, which is its opposite on the color wheel (see below), to create tertiary colors. By altering the amounts of secondary color and complementary color that you use, you can create a range of tertiary colors as shown below. When mixing colors, a large white ceramic plate makes a good palette. Use two pots of water, one to clean brushes, the other to dilute paint. Use an old brush to mix colors, and your best brush to apply them. Never stand brushes in water, always keep them clean, and dry all brushes flat.

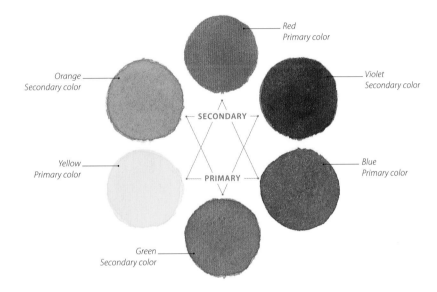

Red
Primary color

Orange
Secondary color

Violet
Secondary color

SECONDARY

Yellow
Primary color

Blue
Primary color

PRIMARY

Green
Secondary color

The color wheel
This wheel shows how the three primary and three secondary colors relate to one another. Each secondary color sits between the two primary colors it is mixed from. Opposite each secondary color is its complementary color—the primary color that it does not contain.

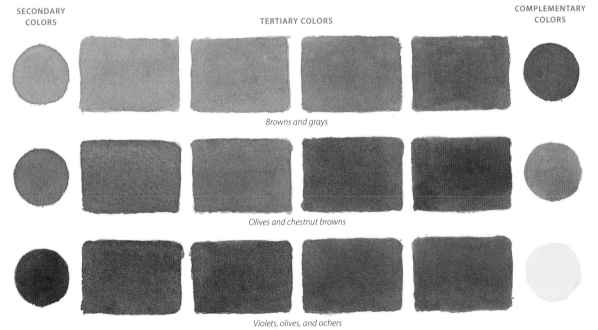

SECONDARY
COLORS

TERTIARY COLORS

COMPLEMENTARY
COLORS

Browns and grays

Olives and chestnut browns

Tertiaries
Tertiaries all contain differing proportions of the three primary colors—red, yellow, and blue. Tertiaries are usually created by adding small amounts of a complementary color to a secondary color. Gradations are best made slowly, by mixing together tiny amounts of paint to create gentle changes in hue.

Violets, olives, and ochers

Preparatory drawings

Preparatory drawings can be made in many ways and for many different purposes. When planning books, I sketch my first ideas in colored felt-tip pens on rough paper, using thick, fast marks to represent the sizes, shapes, and positions of drawings, photographs, and blocks of text. Next, when making a botanical plate, I use a pencil to draw each plant roughly onto photocopy paper. Then I cut out the drawings and place them onto another plain sheet of paper, on which I have drawn a rectangle to represent the plate. By moving the cut-out pencil drawings inside the rectangle I can see how everything will fit together on the plate, before beginning a final work. Here, investigative drawings are shown—the kind of preparatory work that I make in notebooks when I am traveling or trying out ideas. These drawings combine thoughts about volume, form, and view, with observations of character and detail. Drawing the same thing over and over again helps me to see it more clearly, understand it, and memorize its most important characteristics.

A sketchbook is a wonderful thing to keep in your bag at all times, and its presence will actively encourage you to draw. As it fills with drawings it becomes an invaluable personal reference book and a journal. Our own drawings hold vivid memories for us, of events, time, and places. I drew these rosehips and honeysuckle flowers while staying in an old wooden house in Bergen, Norway, during a terrific summer storm.

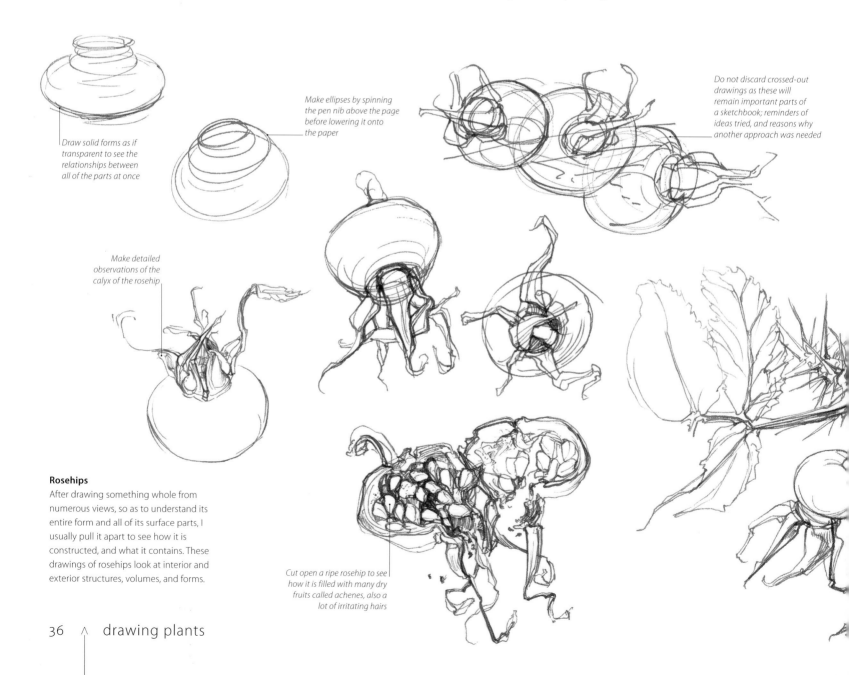

Draw solid forms as if transparent to see the relationships between all of the parts at once

Make ellipses by spinning the pen nib above the page before lowering it onto the paper

Do not discard crossed-out drawings as these will remain important parts of a sketchbook; reminders of ideas tried, and reasons why another approach was needed

Make detailed observations of the calyx of the rosehip

Rosehips
After drawing something whole from numerous views, so as to understand its entire form and all of its surface parts, I usually pull it apart to see how it is constructed, and what it contains. These drawings of rosehips look at interior and exterior structures, volumes, and forms.

Cut open a ripe rosehip to see how it is filled with many dry fruits called achenes, also a lot of irritating hairs

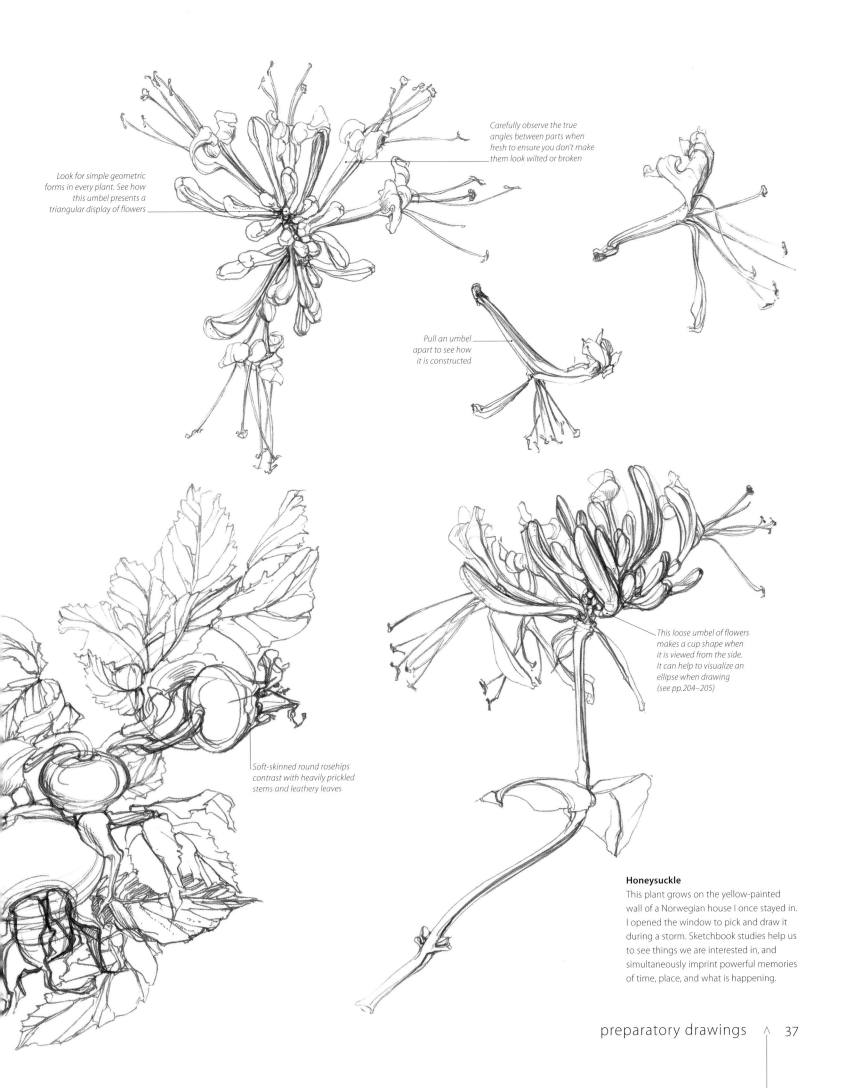

Look for simple geometric forms in every plant. See how this umbel presents a triangular display of flowers

Carefully observe the true angles between parts when fresh to ensure you don't make them look wilted or broken

Pull an umbel apart to see how it is constructed

This loose umbel of flowers makes a cup shape when it is viewed from the side. It can help to visualize an ellipse when drawing (see pp.204–205)

Soft-skinned round rosehips contrast with heavily prickled stems and leathery leaves

Honeysuckle

This plant grows on the yellow-painted wall of a Norwegian house I once stayed in. I opened the window to pick and draw it during a storm. Sketchbook studies help us to see things we are interested in, and simultaneously imprint powerful memories of time, place, and what is happening.

preparatory drawings ∧ 37

Creating a drawing

These five mahogany fruits (*Swietenia macrophylla*) show how I use pen and ink to draw plants. First I use a sharp HB pencil to lightly sketch the whole subject on my paper, looking for simple geometric forms to help me find and correct perspectives. Here, I visualized a sphere within a cone. Then I refine each individual shape and make precise connections between all of the parts, still using my pencil. Next I dilute a small amount of Chinese ink with tap water to make a very pale shade of gray, and dip a clean, metal drawing pen into the diluted ink. I then stroke the loaded nib swiftly across a tissue, to draw off excess liquid, and ensure the marks I make are relatively dry and fine. My first ink lines are made to confirm the precise structure of the subject, and when dry, I erase all of the pencil marks that are beneath them. This ensures that gray pencil tones do not interfere with the developing image.

I then mix a dark gray dilution of ink in a second glass. Diluted Chinese ink can be erased slightly or completely if rubbed with a hard white plastic eraser. Erasing ink is an important part of my process and creates depths of texture and sheens of light. Neat ink is jet black, a tone never seen in the shadows of plants, so too strong for my drawings of them. Instead, I use ranges of gray with rare touches of near black. I test newly mixed ink tones on scrap paper, leave them to dry, and adjust them if necessary before starting to draw with them. Different lengths, speeds, pressures, and directions of mark (see p.34) can be used to create a variety of textures. I seek to understand the core structure and posture of a plant, and express its individual character with marks that emulate its surfaces. Every drawing is built in layers working across the whole image so it remains unified, and the darkest tones are always drawn last.

First ink lines are smooth, minimal, and pale enough to be faded with an eraser. They define structures, connections, and boundaries

Ink pooled into small, rounded shapes suggests the corky texture of the mesocarp (the middle layer of the fruit)

First ink lines

2 When happy with the structure of the under-drawing, I replace it with pale ink outlines and completely erase all pencil marks. This stage can look flat and diagrammatic but it will soon be brought to life.

Pencil under-drawing

1 I hold my pencil loosely in my fingertips and allow it to move freely over the paper, searching for shapes and volumes. Under-drawing is kept pale so it erases cleanly.

Tones and textures

3 I build tones and textures in layers, working over the entire image at once, never from one end to the other. As soon as possible I establish the greatest contrasts between rough and smooth, light and dark.

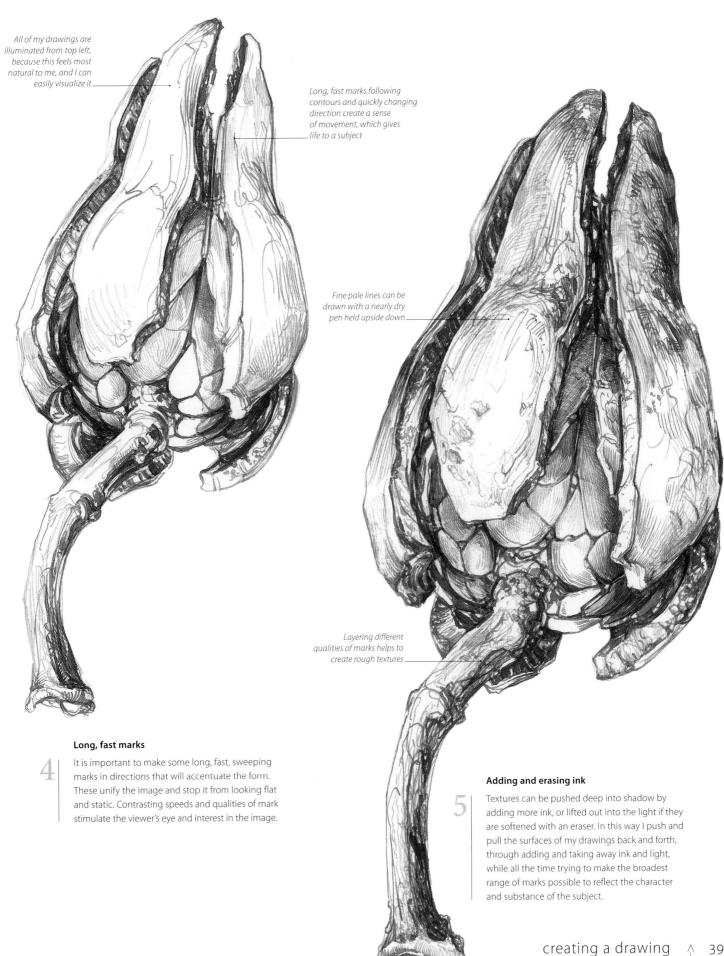

All of my drawings are illuminated from top left, because this feels most natural to me, and I can easily visualize it

Long, fast marks following contours and quickly changing direction create a sense of movement, which gives life to a subject

Fine pale lines can be drawn with a nearly dry pen held upside down

Layering different qualities of marks helps to create rough textures

Long, fast marks

4 It is important to make some long, fast, sweeping marks in directions that will accentuate the form. These unify the image and stop it from looking flat and static. Contrasting speeds and qualities of mark stimulate the viewer's eye and interest in the image.

Adding and erasing ink

5 Textures can be pushed deep into shadow by adding more ink, or lifted out into the light if they are softened with an eraser. In this way I push and pull the surfaces of my drawings back and forth, through adding and taking away ink and light, while all the time trying to make the broadest range of marks possible to reflect the character and substance of the subject.

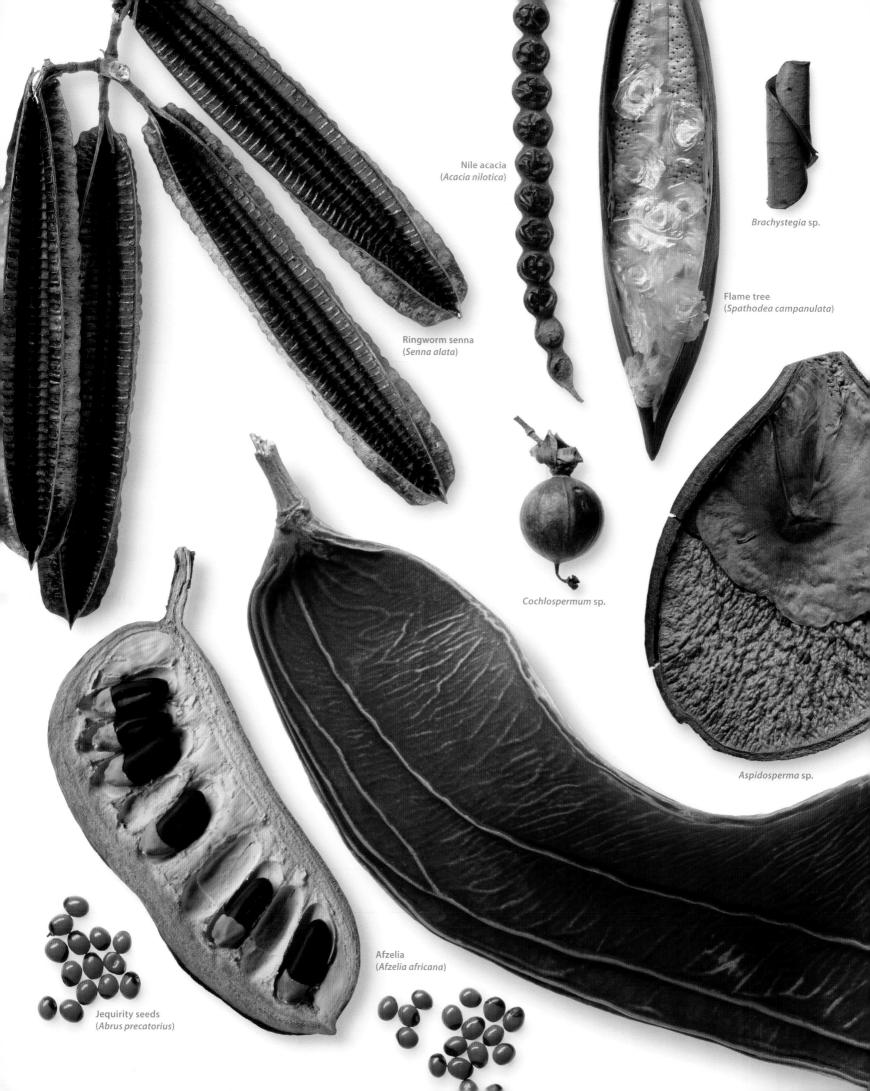

Nile acacia
(*Acacia nilotica*)

Brachystegia sp.

Ringworm senna
(*Senna alata*)

Flame tree
(*Spathodea campanulata*)

Cochlospermum sp.

Aspidosperma sp.

Afzelia
(*Afzelia africana*)

Jequirity seeds
(*Abrus precatorius*)

Sources of inspiration

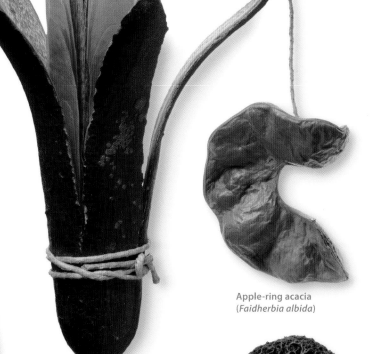

Many people with a passion for plants will know where to find the best botanic and private gardens, horticultural shows, and specialist nurseries—all are immensely rich resources from which to draw. Few people, however, know where to find their local herbarium. Herbaria are treasure troves for the artist, or indeed for anyone with a love of plants, natural forms, and history. They are collections of preserved plants, usually assembled over hundreds of years, together with books and works of art. Herbaria are used for scientific and artistic study and can be found associated with many universities and natural history museums. These fruits belong to Oxford University Herbaria, which are open by appointment to everyone and are full of inspiration for designers, writers, photographers, and artists.

Apple-ring acacia
(*Faidherbia albida*)

Cedro espino
(*Pachira quinata*)

Sapele
(*Entandrophragma* sp.)

Tallow tree
(*Detarium senegalense*)

Devil's claw
(*Harpagophytum procumbens*)

Drift seed from Seychelles

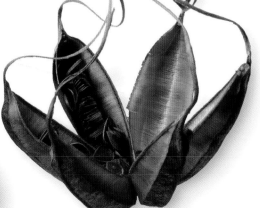

Dutchman's pipe
(*Aristolochia ringens*)

Gilbertiodendron splendidum

MASTERCLASS

Illustrated letter
Nikolaus von Jacquin

Nikolaus von Jacquin (1727–1817) was a Dutch scientist who dedicated his life to the discovery and understanding of plants. He trained in medicine, chemistry, and botany and, in his own distinct and perhaps self-taught style, painted numerous fine plant portraits. His sharp eye and ability to draw simply the essential shapes and details of plants proved invaluable as he explored the West Indies and South America discovering flora—especially when, as often happened on botanical expeditions, many of his collected plants were devoured by ants during the long sea journey back to Europe.

This illustrated letter, dated October 5, 1792, shows the detailed workings of a mind brimming with ideas. The sense of von Jacquin's need to show and tell is overpowering, even if we cannot read a word of his writing. This sheet is part of a letter von Jacquin sent to Jonas Dryander, a fellow botanist then living in London. Sumptuously painted details of bulbs and flowering plants jostle with simpler drawings of the same species and blocks of underscored text. Von Jacquin used pencil to outline every shape. He looked carefully and drew what he saw, although he found shading with pencil difficult and clearly did not know how to make a bulb look round. He was more successful when he applied color, and a great strength of this work is that he kept his painting simple.

All the elements on the paper flow and shuffle together, competing for space, and charging the modest sheet with great energy and delight. This letter shows the power of drawing as a direct tool for seeing and thinking, for questioning, recording, and exchanging ideas. It also shows how much can be achieved with elementary skills, a confidence in your ability, and an enjoyment of drawing no matter what your level of skill. There is something reminiscent of Leonardo da Vinci's notebooks here (see pp.124–125), the same kind of hectic precision has been unleashed. The sheet of paper was then carefully folded, addressed, and put in the post.

Closer look

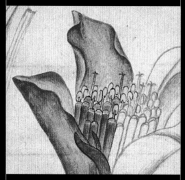

Lily in bloom
This harlequin-like drawing of a lily flower shows how just a partial use of color can convey all the information that is needed. The division between pencil and paint makes clear the relationship between form and vibrancy.

Bringing details to life
These tiny yellow flowers are outlined simply so their details can be seen and counted. They are also touched by a staining flow of ink that reveals the address written on the other side: 3, Soho Square, London.

Illustrated letter
1792, pencil and ink on paper, Botany Library at the Natural History Museum, London, UK

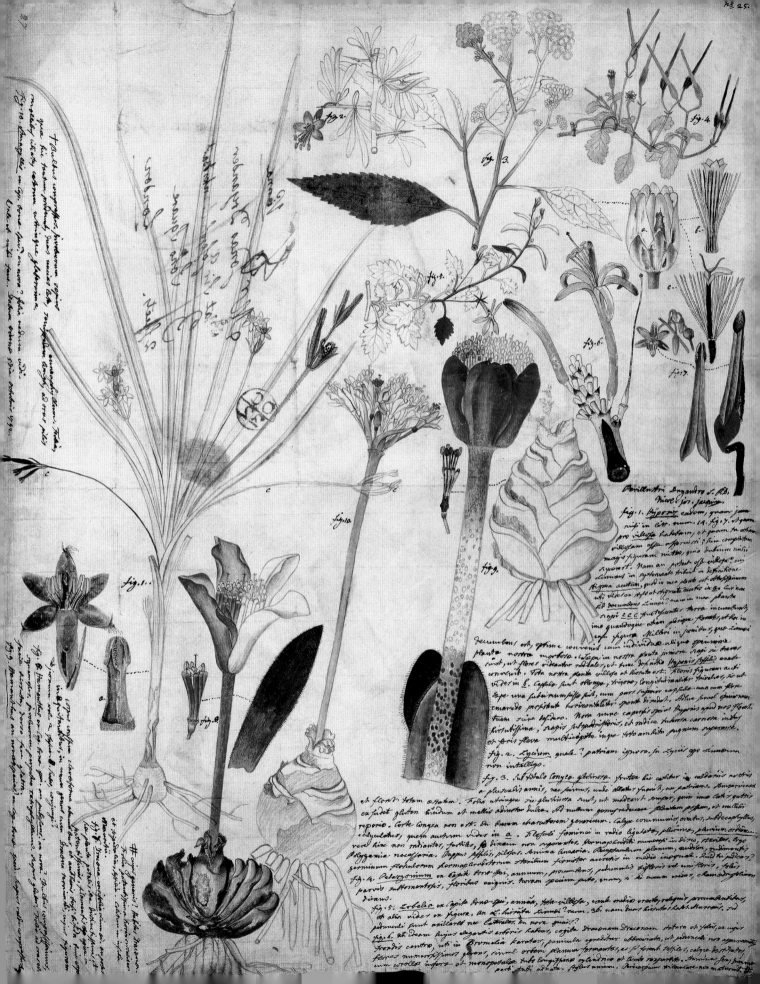

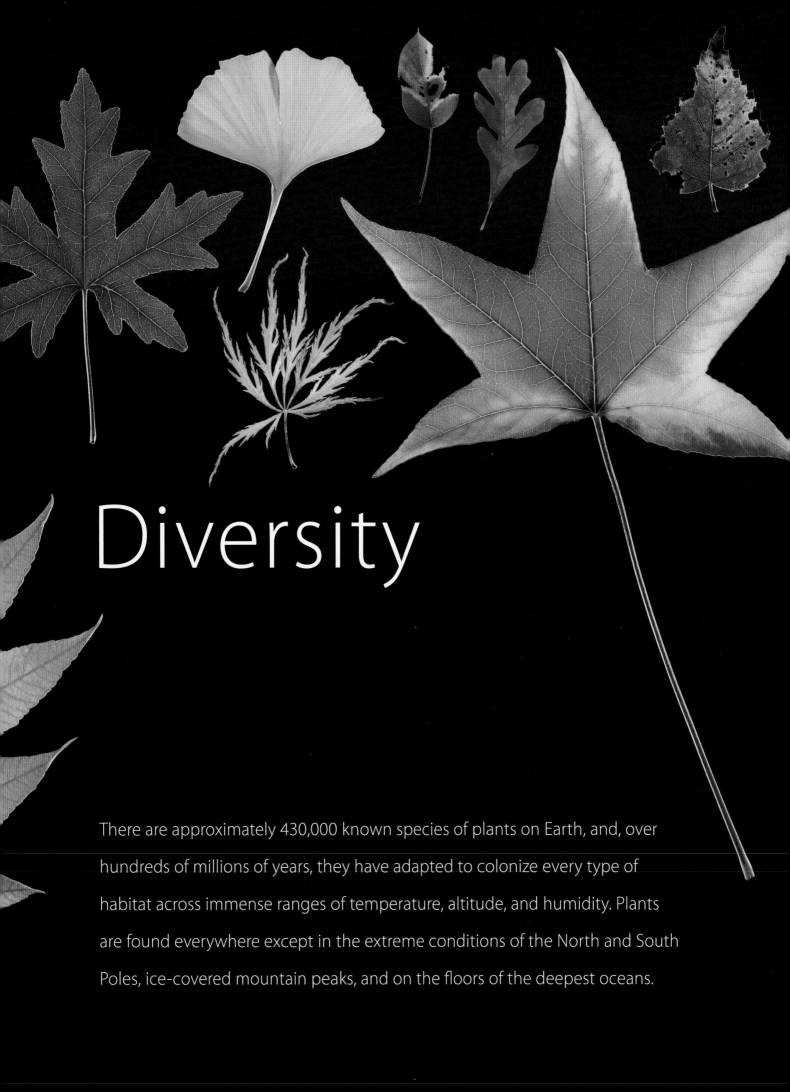

Diversity

There are approximately 430,000 known species of plants on Earth, and, over hundreds of millions of years, they have adapted to colonize every type of habitat across immense ranges of temperature, altitude, and humidity. Plants are found everywhere except in the extreme conditions of the North and South Poles, ice-covered mountain peaks, and on the floors of the deepest oceans.

Introduction

Unlike animals, plants cannot escape from environmental difficulties, such as winter ice, flooding, sea salt, and hungry insects. They have to make a stand or perish, so over millions of years every species has evolved ways of coping with its local conditions. Some plants contain chemical repellents to deter animals. Others have developed prickles or thorns, acid-tipped or unsavory coats of hair, or fire-retardant bark.

Plants change shape, size, and character, depending on where they live. In the harsh conditions of the Arctic, or at high altitudes, most plants are very small and have tiny, tough leaves. They cling close to the ground and only grow in summer, when temperatures rise. In the tropics, the opposite is true. Because of the constant warmth and humidity, plants grow all the year round, so they are usually large. Some water lilies, for example, roll out coracle-like leaves large enough to support the weight of a child as they optimize their share of available sunlight.

Prehistoric plants originated in the sea, where red and green algae are thought to have evolved from bacteria that could photosynthesize. Later, some green algae made the move to land, becoming the forebears of liverworts and mosses. Millions of years later, giant horsetails and ferns became the dominant plants on Earth, then gymnosperms, such as gingkos and conifers, took over. These were followed, about 125 million years ago, by flowering plants, which are now the largest and most dominant group of all. This chapter looks at the astonishing diversity of plant life, explaining when different plants evolved and how they are classified.

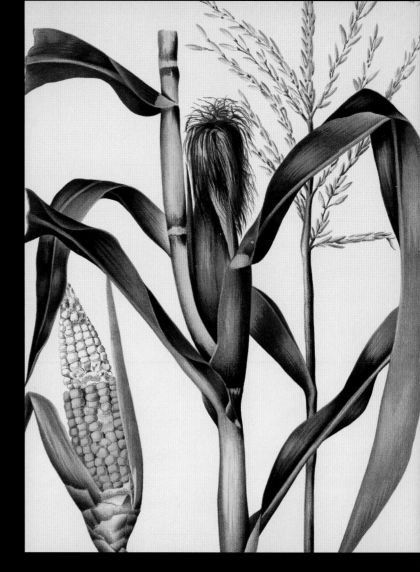

1	2	3
4	5	6

1 Corncobs are the fruits of cultivated corn, a type of grass. Each kernel of corn is a tiny individual fruit called a caryopsis.
Felix Martinez, 1877–1883
Corn (*Zea mays*)

2 Female cedar cones disintegrate into papery layers when ripe and disperse their seeds on the wind. This ripe cone is green with algae growing on its surface.
Atlas cedar (*Cedrus atlantica*)

3 In this fern leaf, delicately divided leaflets branch out from the main veins.
Soft tree fern (*Dicksonia antarctica*)

4 Capsules full of spores are held on delicate stems above this moss. The tiny cap at the tip of each capsule falls away to release the spores.
Funaria hygrometrica

5 Filmy red algae grow in deep water, where there is not much light. They absorb nutrients from the sea water.
Sea beech (*Delesseria sanguinea*)

6 The upper, petal-like bracts of this plant are bright blue, to attract pollinators toward the tiny flowers in their center.
Eryngium (*Eryngium* sp.)

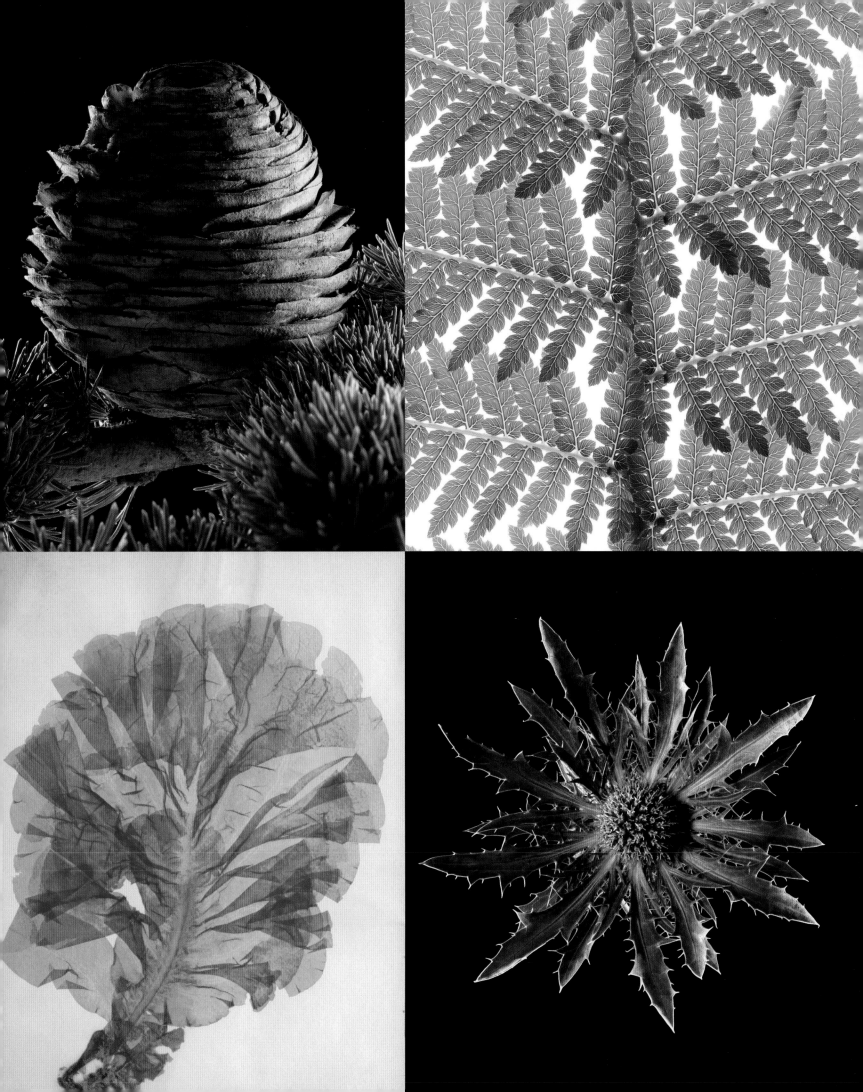

Plant classification

Since ancient times, people have sought to name and categorize plants. However, as the sheer diversity of the plant kingdom began to emerge with the explorations and discoveries of the Renaissance period, botanists struggled with increasingly long names that were designed to be both unique and descriptive. Much needed brevity came with the naming system of Carl Linnaeus, first published in 1753, which made consistent use of two-word names in its classification of 5,900 species based on flower parts. The simplified family tree (right) is used today and illustrates the relationship between different types of plant. Plants are divided into divisions (for example, gymnosperms) and classes (for example, monocotyledons), then families—similar to human dynasties—according to the structure of their flowers, fruits, and other parts. Families might consist of clearly related plants, such as the orchid family (*Orchidaceae*), or may include apparently diverse plants, as is the case with the rose family (*Rosaceae*), which includes, for example, alchemilla, pyracantha, and hawthorn, as well as roses.

Within each family there are genera (singular: genus) made up of related species, such as oaks (genus *Quercus*) or lilies (genus *Lilium*). All genera in a family share common characteristics that reveal how they are related. Genera differ because they diverged generations back in time. Each genus may contain one or many species, the smallest general unit of classification. Every plant has a double Latin name, known as a Latin binomial: the first part of the name signifies the genus and the second part the species. *Lilium candidum*, for example, is the Latin name of one lily in particular: the Madonna lily. Plant names are Latinized so that they can be understood internationally and avoid the confusion caused by multiple common names. They also show the relationships between plants.

Numerous features are used to classify plants, such as the forms of leaves, stems, flowers, and fruits in ever greater detail. Combinations of features enable botanists to place plants in families. A plant that has simple, alternate leaves, is wind-pollinated, and has cupules beneath its fruits, for example, is likely to be in the oak family (*Fagaceae*). Botanists then run down lists of generic features, followed by species features, before arriving at the identity of the individual plant. Physical characteristics have been the basis for classification since Renaissance times but, in the past thirty years, DNA evidence has cast a new light on many relationships between plants, and some classifications are now being revised.

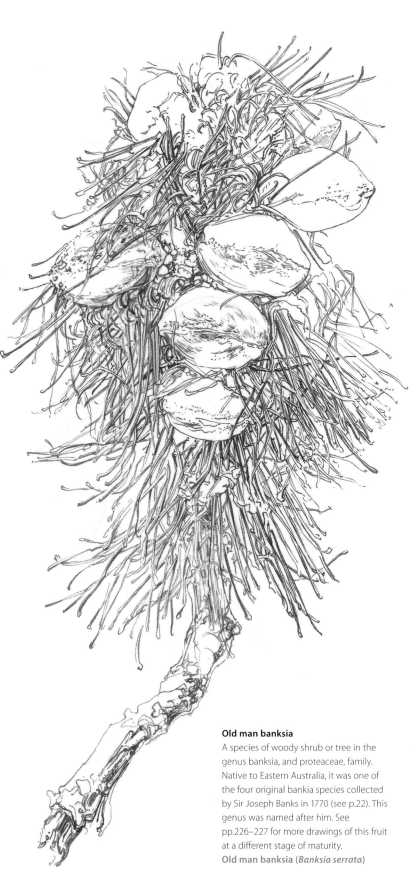

Old man banksia
A species of woody shrub or tree in the genus banksia, and proteaceae, family. Native to Eastern Australia, it was one of the four original bankia species collected by Sir Joseph Banks in 1770 (see p.22). This genus was named after him. See pp.226–227 for more drawings of this fruit at a different stage of maturity.
Old man banksia (*Banksia serrata*)

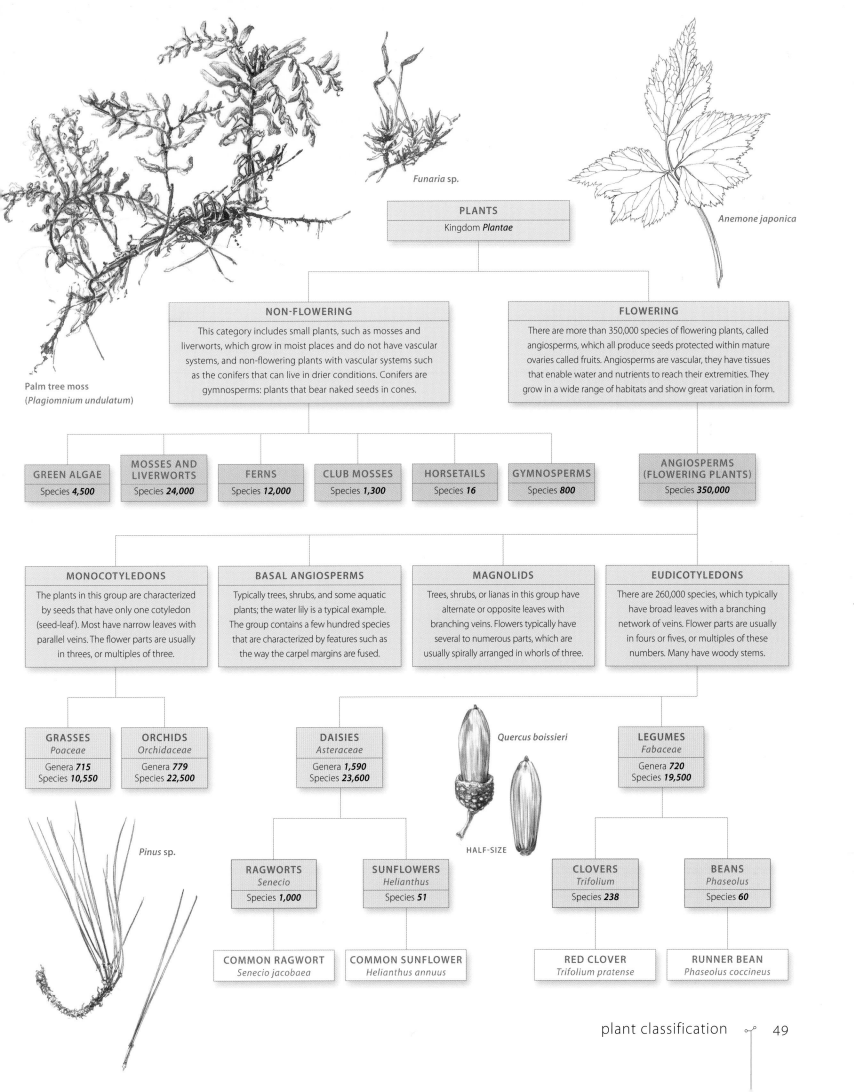

Funaria sp.

Anemone japonica

Palm tree moss
(*Plagiomnium undulatum*)

PLANTS

Kingdom *Plantae*

NON-FLOWERING

This category includes small plants, such as mosses and liverworts, which grow in moist places and do not have vascular systems, and non-flowering plants with vascular systems such as the conifers that can live in drier conditions. Conifers are gymnosperms: plants that bear naked seeds in cones.

FLOWERING

There are more than 350,000 species of flowering plants, called angiosperms, which all produce seeds protected within mature ovaries called fruits. Angiosperms are vascular, they have tissues that enable water and nutrients to reach their extremities. They grow in a wide range of habitats and show great variation in form.

GREEN ALGAE

Species **4,500**

MOSSES AND LIVERWORTS

Species **24,000**

FERNS

Species **12,000**

CLUB MOSSES

Species **1,300**

HORSETAILS

Species **16**

GYMNOSPERMS

Species **800**

ANGIOSPERMS (FLOWERING PLANTS)

Species **350,000**

MONOCOTYLEDONS

The plants in this group are characterized by seeds that have only one cotyledon (seed-leaf). Most have narrow leaves with parallel veins. The flower parts are usually in threes, or multiples of three.

BASAL ANGIOSPERMS

Typically trees, shrubs, and some aquatic plants; the water lily is a typical example. The group contains a few hundred species that are characterized by features such as the way the carpel margins are fused.

MAGNOLIDS

Trees, shrubs, or lianas in this group have alternate or opposite leaves with branching veins. Flowers typically have several to numerous parts, which are usually spirally arranged in whorls of three.

EUDICOTYLEDONS

There are 260,000 species, which typically have broad leaves with a branching network of veins. Flower parts are usually in fours or fives, or multiples of these numbers. Many have woody stems.

GRASSES
Poaceae

Genera **715**
Species **10,550**

ORCHIDS
Orchidaceae

Genera **779**
Species **22,500**

DAISIES
Asteraceae

Genera **1,590**
Species **23,600**

Quercus boissieri

HALF-SIZE

LEGUMES
Fabaceae

Genera **720**
Species **19,500**

Pinus sp.

RAGWORTS
Senecio

Species **1,000**

SUNFLOWERS
Helianthus

Species **51**

CLOVERS
Trifolium

Species **238**

BEANS
Phaseolus

Species **60**

COMMON RAGWORT
Senecio jacobaea

COMMON SUNFLOWER
Helianthus annuus

RED CLOVER
Trifolium pratense

RUNNER BEAN
Phaseolus coccineus

Algae

Algae are a large group of plant-like organisms that live in water, or close to it. They have no roots, stems, or leaves, and no flowers or seeds. Water and nutrients move freely through their thin membranes and they multiply by shedding spores.

Algae visible to the naked eye are traditionally arranged into three groups by color: brown, red, and green. They all make their own food using sunlight (photosynthesize), and green algae are definitely plants. However current research suggests that brown algae are more closely related to animals than to plants. Red algae are a distinctive and attractive group, not only because of their coloration caused by a particular class of red pigments, but because they have a special type of starch food reserve. The pond-dwelling euglena is another species traditionally called algae, it is green with a light-sensitive spot, like an "eye," and moves using a whip at the end of its body.

Algae thrive in all kinds of places. Microscopic single-celled colonies make slippery green blooms on wet park benches and form slime in fish tanks, while multi-celled species spread a hair-like skin over stagnant water. Seaweeds are algae and are economically important. Brown seaweeds are used to make gelling agents in processed foods, and some types of seaweed are delicious to eat. Yet others are important sources of fertilizers.

There are few more stressful environments for an organism to live than on a rocky coast. Algae are battered relentlessly by waves at high tide, then exposed to drying wind and sun when the tide recedes. Bladderwrack (far right) is particularly tough and resilient. It uses a root-like attachment, called a holdfast, to grip onto rocks and hold it firmly in place. Clear zones of algae run in bands along seashores, rising from beneath the shallow waters to the low tide line. Different species of algae live in each zone and have adapted to different degrees of stress. In the sea, algae also grow in specific zones, depending on the levels of light. Green algae grow in bright, shallow water, whereas red algae thrive further out, where the water is deeper and darker.

Flattened fronds
All species of wrack have flattened (thallate), rubbery fronds, and these can develop bubble-like bladders full of air, to make them buoyant in the water.
Wrack (*Fucus* sp.)

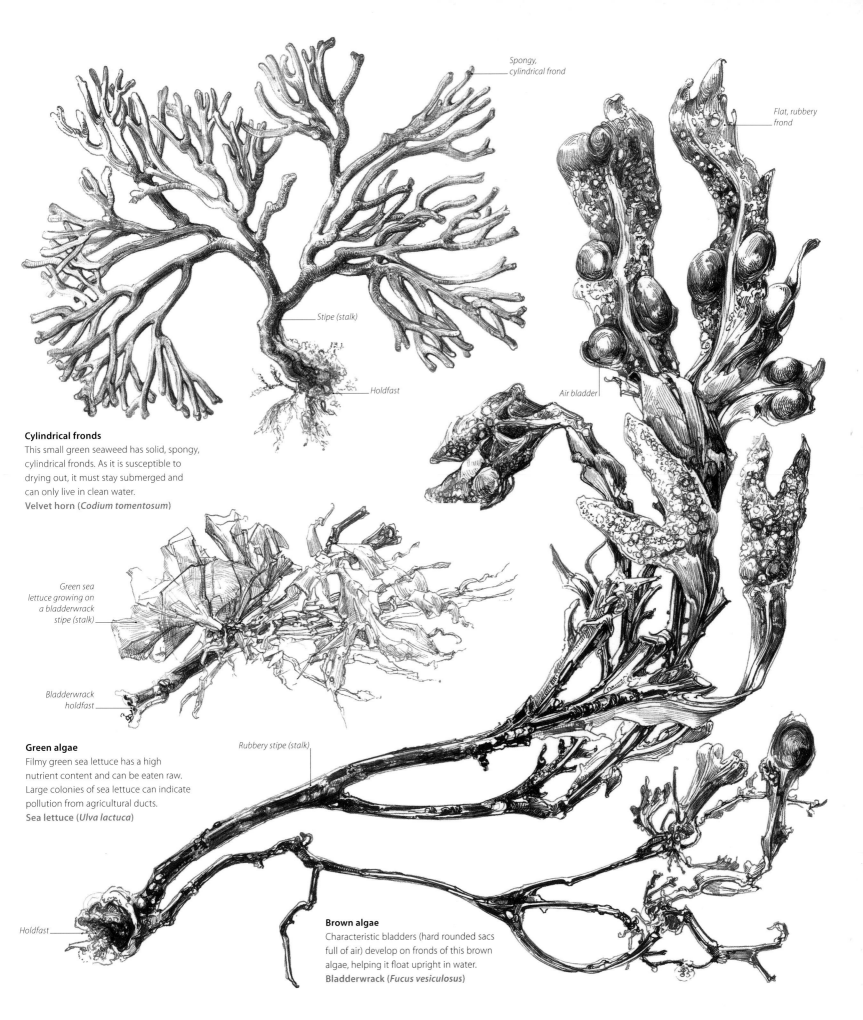

Spongy,
cylindrical frond

Flat, rubbery
frond

Stipe (stalk)

Holdfast

Air bladder

Cylindrical fronds
This small green seaweed has solid, spongy,
cylindrical fronds. As it is susceptible to
drying out, it must stay submerged and
can only live in clean water.
Velvet horn (*Codium tomentosum*)

Green sea
lettuce growing on
a bladderwrack
stipe (stalk)

Bladderwrack
holdfast

Green algae
Filmy green sea lettuce has a high
nutrient content and can be eaten raw.
Large colonies of sea lettuce can indicate
pollution from agricultural ducts.
Sea lettuce (*Ulva lactuca*)

Rubbery stipe (stalk)

Holdfast

Brown algae
Characteristic bladders (hard rounded sacs
full of air) develop on fronds of this brown
algae, helping it float upright in water.
Bladderwrack (*Fucus vesiculosus*)

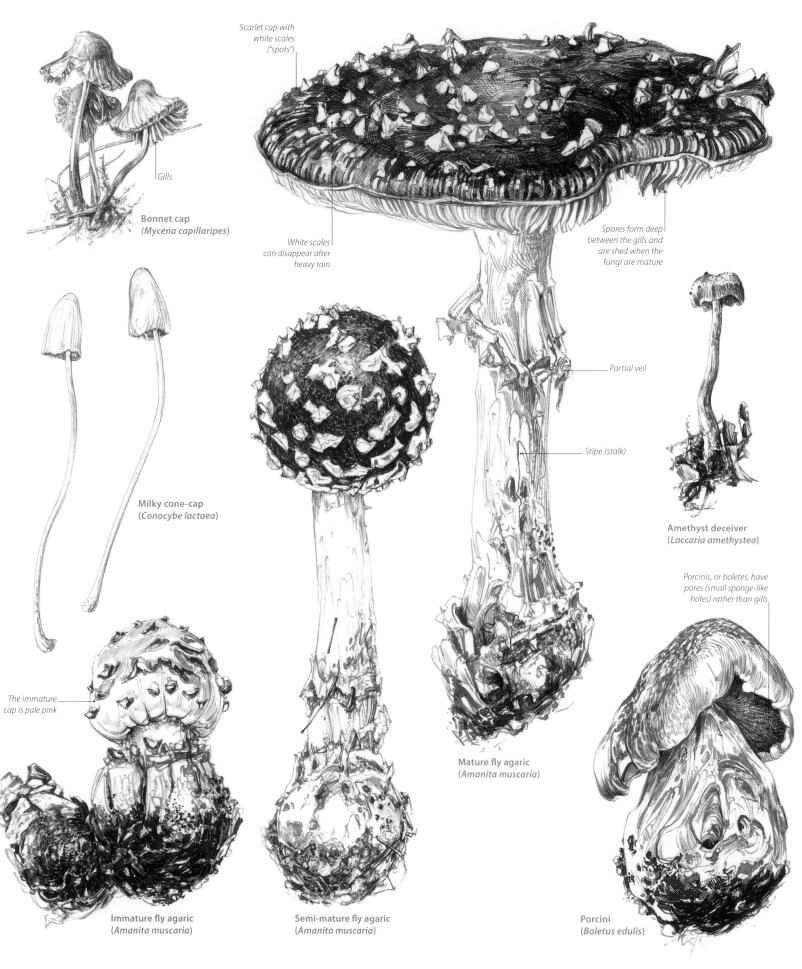

Gills

Bonnet cap
(*Mycena capillaripes*)

Scarlet cap with
white scales
("spots")

White scales
can disappear after
heavy rain

Spores form deep
between the gills and
are shed when the
fungi are mature

Partial veil

Stipe (stalk)

Amethyst deceiver
(*Laccaria amethystea*)

Milky cone-cap
(*Conocybe lactaea*)

Porcinis, or boletes, have
pores (small sponge-like
holes) rather than gills

The immature
cap is pale pink

Mature fly agaric
(*Amanita muscaria*)

Immature fly agaric
(*Amanita muscaria*)

Semi-mature fly agaric
(*Amanita muscaria*)

Porcini
(*Boletus edulis*)

Fungi

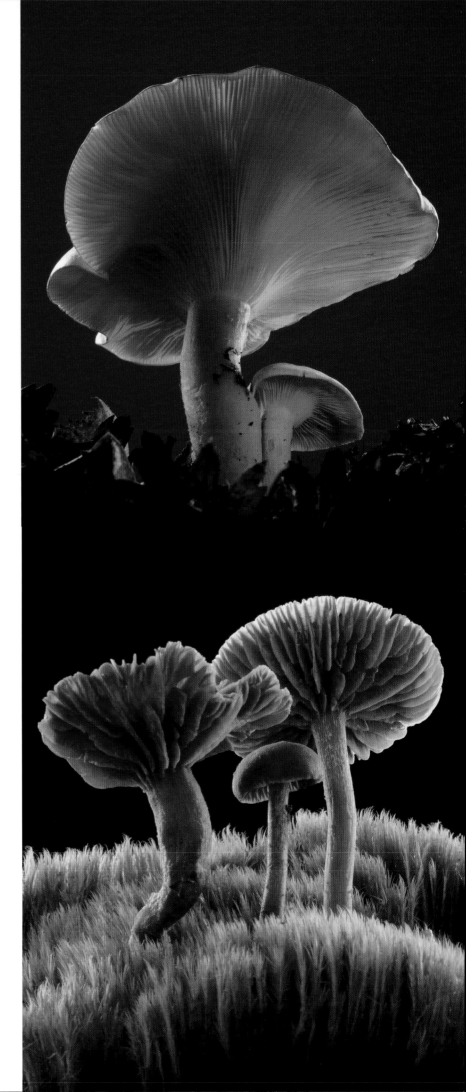

More than 70,000 species of fungi have now been described, although it is thought that up to 1.5 million species may exist. Fungi do not photosynthesize (make their own food, using sunlight) and, like some algae, are more closely related to animals than plants. Fungi are found everywhere that things grow, including inside our own bodies. Some of them live by breaking down dead organic matter. These recyclers play a vital role in maintaining healthy ecosystems. Familiar fungi used everyday include yeasts, molds in food, and medicines such as penicillin. Other fungi are destructive parasites that have been responsible for terrible famines, such as the Irish potato famine in the late 1840s. Destructive fungi include the blights, black spots, and rusts, on our garden plants.

In the fall, woods come alive with colorful toadstools. These are the spore-producing reproductive bodies of underground networks, known as hyphae, that absorb food. Hyphae are in the earth for most of the year, and if dug up they look like long, white filaments. They have symbiotic relationships with many trees and shrubs, which they supply with minerals in exchange for photosynthates (products of photosynthesis). A mature oak tree can die if the earth directly beneath its canopy is plowed and the fungal network that supports it is destroyed.

Fungi are remarkable plumbers. Their cell walls contain a tough protein called chitin, which makes them waterproof and prevents them from drying out. This is the same protein that is found in the skeletons of insects. It also strengthens hyphae so that they can channel water at eight times atmospheric pressure. This tremendous force, the highest water pressure known in the biological world, drives the hyphae through the soil. Fruiting bodies—the fungi we see—form underground in a folded position over a few days, then are pumped full of water and suddenly balloon up from the earth (see the fly agaric left).

Woodland fungi
The five species of British woodland fungi (left) show some of the dramatic forms these organisms can take, while the fly agaric (left) illustrates the variety within one species as it matures. All fungi grow from networks of hyphae and produce spores. They are particularly fascinating to draw, but handle them with care; fly agaric, for example, is poisonous.

Funnel cap (*Clitocybe* sp.)
The delicate vertical gills of this fungus (top right) run from the margin of its cap down into a neat rim around its stalk. All gilled fungi have spore-producing cells deep between their gills. Spores fall into the breeze to be dispersed.

Amethyst deceiver (*Laccaria amethystea*)
With its thick gills and bluish-violet coloring, the amethyst deceiver (right) is easily identified in fall growing in moist, shady, woodland soil and leaf litter.

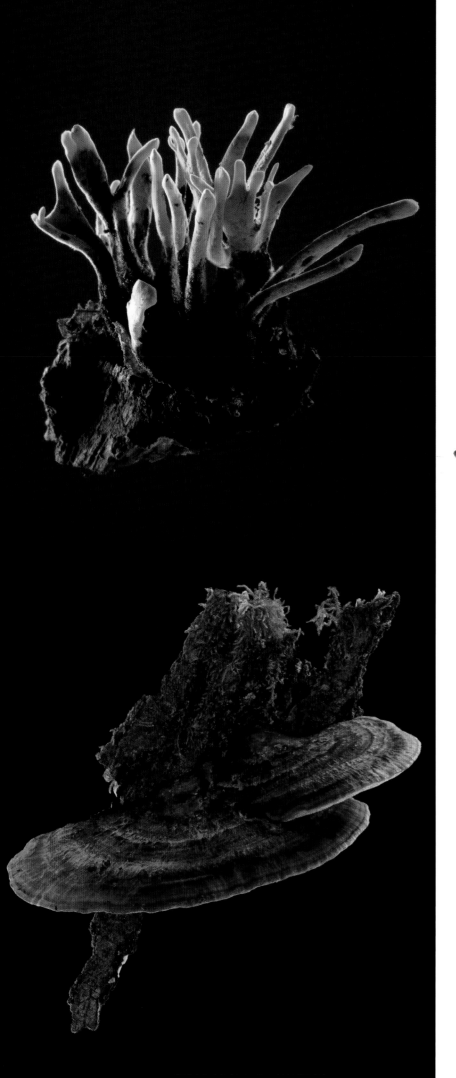

Xylaria fungi

These fungi usually grow at ground level on rotten wood. Dead man's fingers (right) have firm white flesh inside and shed copious black spores.

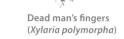

Dead man's fingers
(*Xylaria polymorpha*)

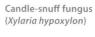

Candle-snuff fungus
(*Xylaria hypoxylon*)

Candle-snuff fungus (*Xylaria hypoxylon*)

This common fungus (top left) grows on dead tree stumps and logs. Its flat, black fruiting bodies have antler-like, powdery tips. It is said to have luminous hyphae.

Blushing bracket (*Daedaleopis confragosa*)

The flat, semicircular fruiting bodies of this bracket fungus (left) grow on logs and branches, especially those of birch, and willow. Spores are shed from small pores on the underside.

Elf cup (*Sarcoscypha autstriaca*)

The fertile inner surface of this jelly-like and cup shaped fungus is smooth and bright red when young. The outer infertile surface is paler in color and covered in tiny hairs. Elf cups are often found on decaying wood in very damp environments.

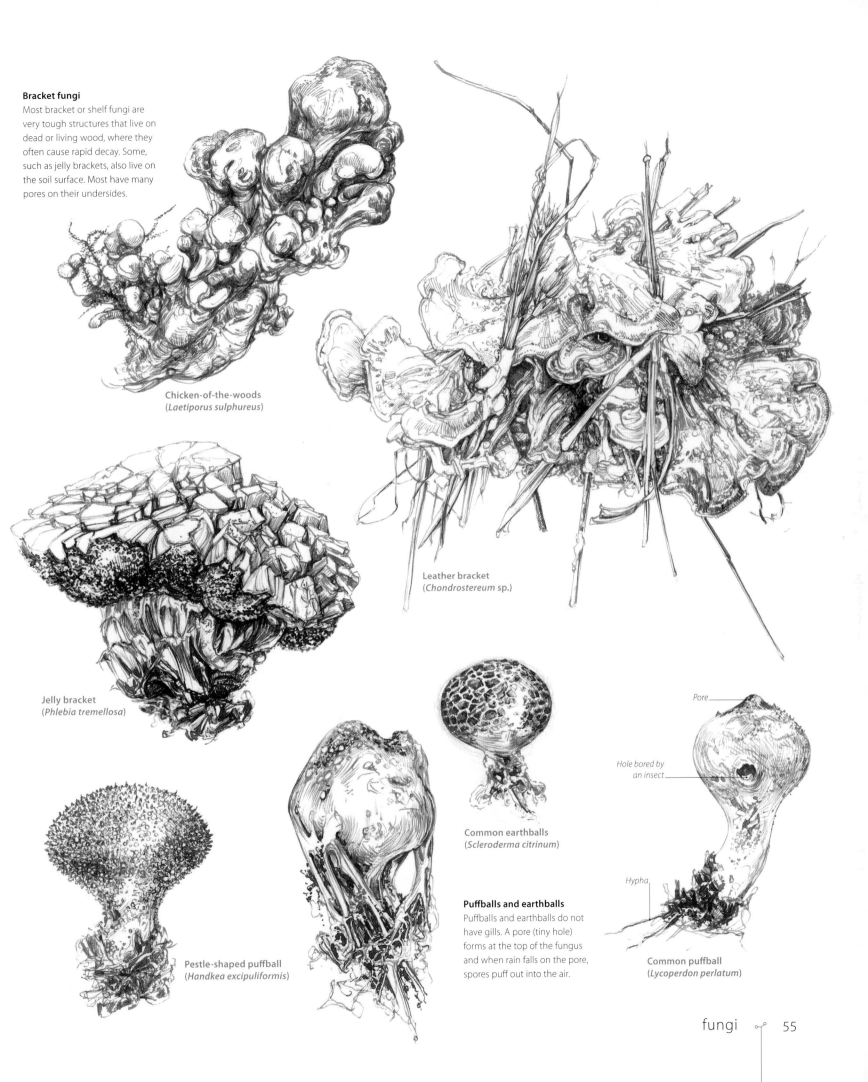

Bracket fungi
Most bracket or shelf fungi are very tough structures that live on dead or living wood, where they often cause rapid decay. Some, such as jelly brackets, also live on the soil surface. Most have many pores on their undersides.

Chicken-of-the-woods
(*Laetiporus sulphureus*)

Leather bracket
(*Chondrostereum* sp.)

Jelly bracket
(*Phlebia tremellosa*)

Pestle-shaped puffball
(*Handkea excipuliformis*)

Common earthballs
(*Scleroderma citrinum*)

Puffballs and earthballs
Puffballs and earthballs do not have gills. A pore (tiny hole) forms at the top of the fungus and when rain falls on the pore, spores puff out into the air.

Pore

Hole bored by
an insect

Hypha

Common puffball
(*Lycoperdon perlatum*)

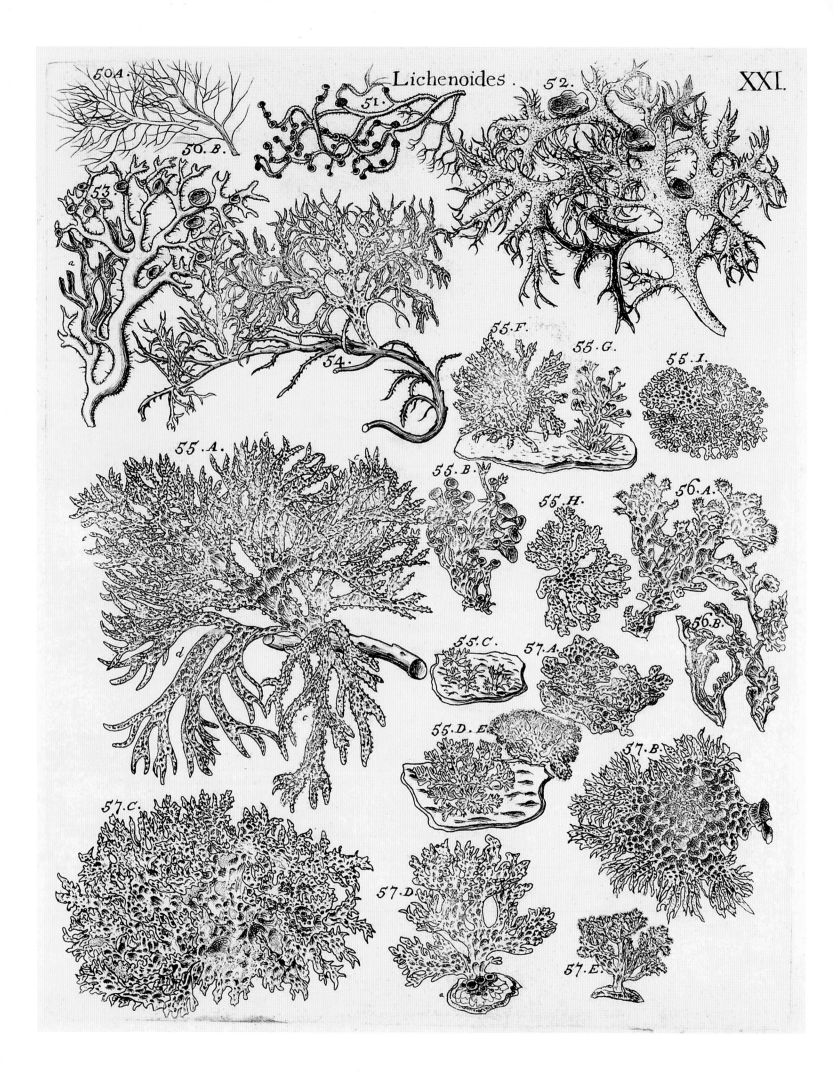

Lichens

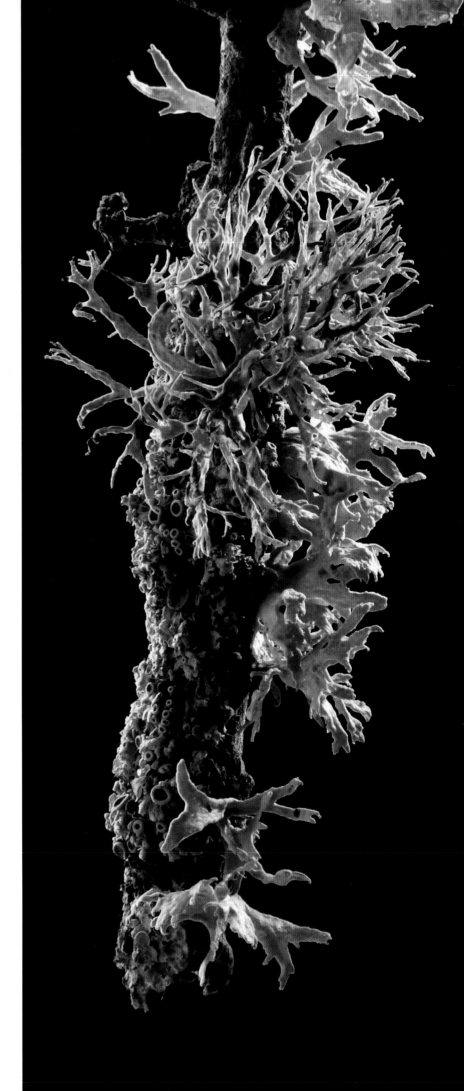

Lichens are peculiar. They are made up of two types of organism—a green or blue-green alga and a fungus—that join together in a mutually beneficial relationship: the alga lives among the fungus's hyphae (network of underground filaments) and together they create a lichen. The fungus draws minerals from decaying organic matter, while the alga photosynthesizes to produce food (sugars) from sunlight. Many of the algae and fungi that form lichens can also live independently from each other, but when they do so they take on very different forms.

There are three main groups of lichen: fruticose, foliose, and crustose, which are recognized by how they grow (their habit). Fruticose lichens look a little like shrubs and are sometimes forked and antler-like (see top right and top left). They dominate the arctic tundra because they contain chemicals that act like anti-freeze and can survive the extreme cold. Despite these unappetizing chemicals, they are a major food source for reindeer. Foliose lichens are often found on wet stones, wood, and painted metal gates. They are slightly raised and leafy at the edges, and have distinctive, upward-facing cups (see bottom left in both the photograph and the illustration). Crustose lichens are perhaps what we generally think of as lichen. They grow flush on gravestones, walls, and roof tiles, where they create circular or fan-shaped patterns in an enormous range of colors, from creamy blue-grays through lemon yellow and ocher to deep red.

Lichens regenerate from a combination of algae and fungi spores. They grow extremely slowly, and can live for hundreds of years. There are reports of specimens in museum collections that, when accidentally dampened, have started growing again after 30 years of dormancy. Some lichens are highly sensitive to pollution, so are used by scientists to monitor environmental change.

Historia Muscorum
The fruticose and foliose lichens (left) were drawn by the scientist Johann Jakob Dillenius (1687–1747), for *Historia Muscorum*—the most important book on lichens, mosses, and algae until the start of the 19th century.
Johann Jakob Dillenius, 1741

Encrusted branch
Graceful sprays of antler-like fruticose lichen appear to wave and curl around a dead branch of an apple tree (right), while egg-yellow and aquamarine craters of foliose lichen encrust the lower left-hand side of the branch.

Mosses and liverworts

Mosses and liverworts are small, green, moisture-loving, prehistoric plants that evolved from green algae to become the first plants to grow on land. They do not produce flowers, fruits, or seeds. There are around 15,000 known species of moss, and they grow in temperate, cool tropical, moist forest, alpine, and arctic habitats. Most mosses thrive in very wet conditions, but some, more unusually, have adapted to drier places, such as along the tops of walls or on roofs, where they can lie desiccated and dormant for long periods, waiting for rainfall.

There are about 9,000 species of liverwort, which take two forms: leafy liverworts look like moss, while the more distinctive thalloid liverworts (see below) have flattened, ribbon-like or liver-shaped, branching green lobes that lie flat against the surfaces they grow on. Liverworts will thrive along the undisturbed, damp side of a shaded wall, a downpipe, or a bridge, and are a familiar sight growing on the soil around neglected pot plants. If you lift mosses or liverworts, you will see that neither of them has true roots, but root-like fibers, called rhizoids, which anchor them in place. They do not have true stems or leaves either. Their leaf-like structures and lobes have no waterproof cuticle (tough, outer layer) to prevent them from drying out in the sun, and both mosses and liverworts are non-vascular, which means that they have no internal network of veins to transport liquid and food, but absorb them instead through their outer membranes. Both mosses and liverworts reproduce by means of spores, released from stalked structures that grow upward from the plants (see below and right). All these characteristics mean that mosses and liverworts remain low-growing and compact, and most of them will only survive in damp places.

Thalloid liverwort (*Marchantia polymorpha*)
Umbrella-like reproductive structures, called archegoniophores, rise above the horizontal green lobes of a thalloid liverwort (below). These tiny umbrellas are green when immature and gradually darken, through shades of orange, to purple as they mature.

Mosses
Although mosses (right), like liverworts, do not have true roots, stems, and leaves, they do have upright stalks with green filament growths that look uncannily like leaves. These mosses, collected from diverse regions, are pressed and belong to a herbarium. Some are over 200 years old.

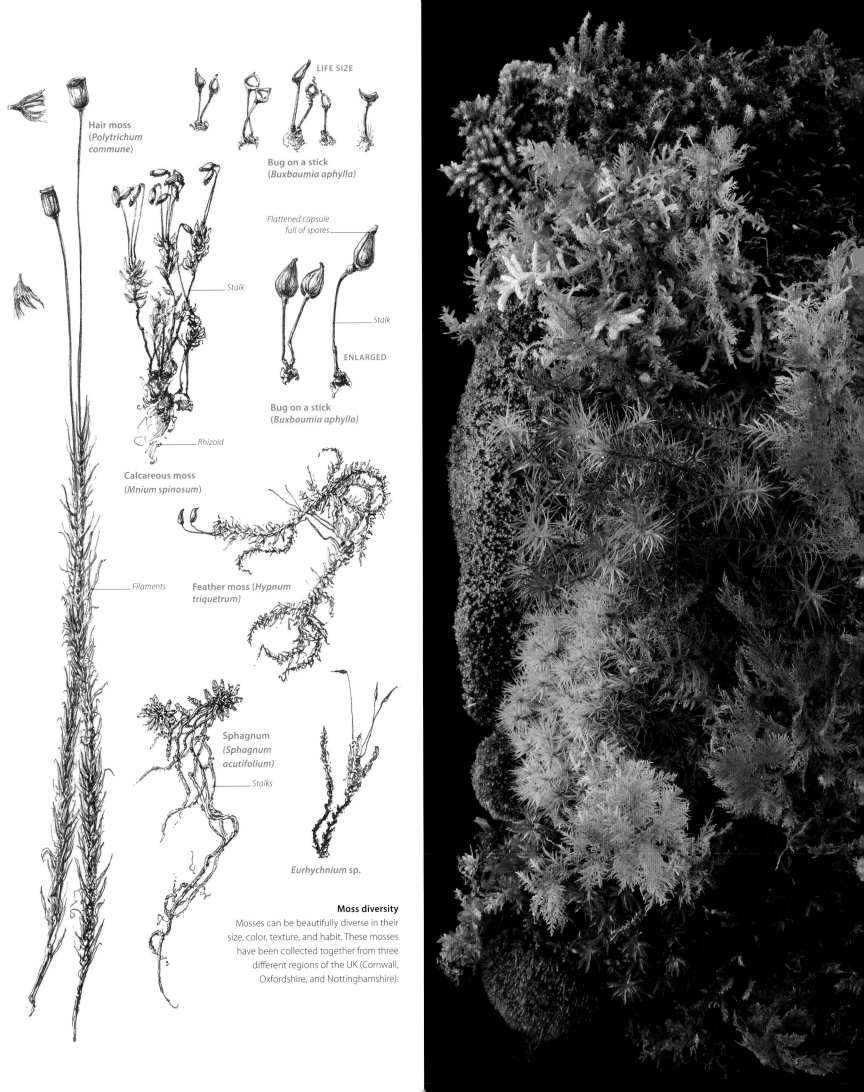

Hair moss
(*Polytrichum commune*)

LIFE SIZE

Bug on a stick
(*Buxbaumia aphylla*)

Stalk

Flattened capsule
full of spores

Stalk

ENLARGED

Bug on a stick
(*Buxbaumia aphylla*)

Calcareous moss
(*Mnium spinosum*)

Rhizoid

Filaments

Feather moss (*Hypnum triquetrum*)

Sphagnum
(*Sphagnum acutifolium*)

Stalks

Eurhychnium sp.

Moss diversity
Mosses can be beautifully diverse in their
size, color, texture, and habit. These mosses
have been collected together from three
different regions of the UK (Cornwall,
Oxfordshire, and Nottinghamshire).

Ferns and horsetails

Ferns and horsetails are distinguished from mosses, liverworts, and algae by having vascular systems. These networks of vessels draw water and minerals from the soil and carry them, together with sugars made during photosynthesis, throughout the plants, enabling them to grow tall, have bigger leaves, and gain greater access to light. All vascular plants contain a strengthening material called lignin, which makes it possible for them to grow upright and remain standing. Lignin appears in fossilized plants dating from around 400 million years ago, and its evolution has been linked to increased oxygen levels at that time. It enabled plants such as ferns and horsetails to rise above the ground and take their characteristic forms.

Like horsetails, ferns are primitive land plants that helped to shape the first green canopies on Earth. There are about 23,000 species of fern, varying in size from spleenwort (center right) to huge tree ferns that grow up to 65½ ft (20 m) tall in Australia and New Zealand. Most ferns (apart from tree ferns) have spreading underground stems, called rhizomes, which produce conical clumps of divided leaves, called fronds. Ferns reproduce using spores released from small sacs, called sporangia, that are arranged on the backs of fronds and take different shapes and forms. Ferns, unlike mosses and liverworts, are able to control water loss through their beautiful leaves, and grow in moist shade and are prolific in tropical forests.

There are about 16 species of horsetail which, like ferns, have creeping underground rhizomes. Horsetails spread quickly and are vigorous when taking over new ground. Their spring shoots look like daggers, but as they lengthen and mature, photosynthetic branches open out like umbrella spokes, then soften into more brush-like forms. The horsetails we see today are the miniature descendants of prehistoric species that, over 300 million years ago, could grow up to 30 ft (10 m) in diameter. The hardened remains of these massive ancestors are the main source of the fossil fuels we burn. All horsetails contain a high level of the mineral silica, which makes them rough to the touch.

Sori
On the underside of this fern leaf you can see paired rows of coppery red sori, which contain bag-like sporangia. These bags split open when mature and release dust-like reproductive spores.
Wood fern (*Dryopteris* sp.)

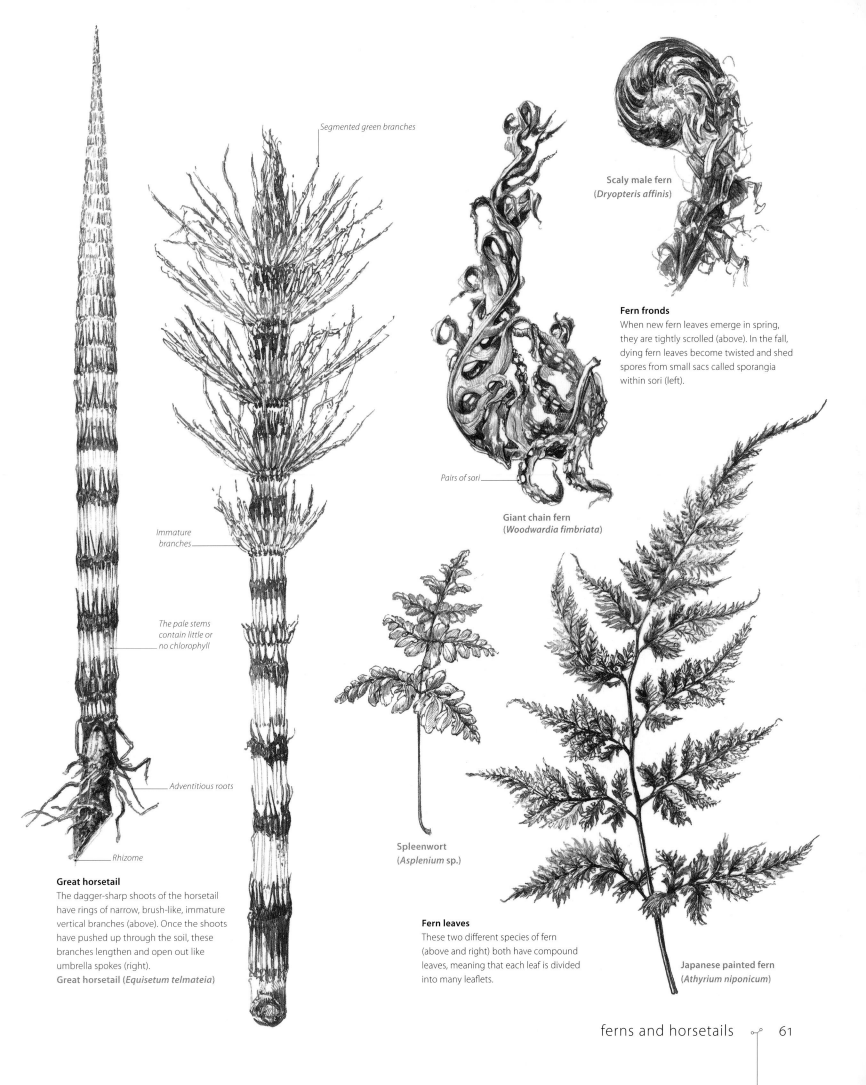

Segmented green branches

Scaly male fern
(*Dryopteris affinis*)

Fern fronds
When new fern leaves emerge in spring, they are tightly scrolled (above). In the fall, dying fern leaves become twisted and shed spores from small sacs called sporangia within sori (left).

Immature branches

The pale stems contain little or no chlorophyll

Pairs of sori

Giant chain fern
(*Woodwardia fimbriata*)

Adventitious roots

Rhizome

Great horsetail
The dagger-sharp shoots of the horsetail have rings of narrow, brush-like, immature vertical branches (above). Once the shoots have pushed up through the soil, these branches lengthen and open out like umbrella spokes (right).
Great horsetail (*Equisetum telmateia*)

Spleenwort
(*Asplenium* sp.)

Fern leaves
These two different species of fern (above and right) both have compound leaves, meaning that each leaf is divided into many leaflets.

Japanese painted fern
(*Athyrium niponicum*)

ferns and horsetails 61

Conifers

Larch
A fast-growing, deciduous conifer, the larch has small, rounded cones with reflexed scales. When the scales open, they release seeds, which are carried away on the wind.
European larch (*Larix decidua*)

Each seed has a papery wing

Next year's leaf buds

To colonize more diverse habitats, plants needed to evolve new methods of reproduction that did not depend on water, and they began to produce seeds. Botanists arrange seed-producing plants into two distinct groups: gymnosperms, which are non-flowering plants with naked (not enclosed) seeds; and angiosperms, flowering plants, whose seeds are enclosed in ovaries. The largest group of gymnosperms alive today are conifers, of which there are around 600 species, including pine and fir trees, junipers, and yews. Conifers reproduce using cones, and most cones are familiar to us as the scaly wooden containers we find under fir and pine trees. The red and blue "berries" of yews and junipers are also cones, but they are small, colorful, and fleshy. Wind carries pollen between all types of male and female cone, so that exposed ovules held inside the female cones are fertilized. Some mature female woody cones, such as the larch, open their scales to shed their ripe seeds (left). Other woody cones disintegrate into papery layers, like those you find on the ground beneath a cedar tree (right).

Some of the oldest and tallest plants on earth are conifers. One living specimen of bristlecone pine (*Pinus longaeva*) is thought to be around 4,800 years old, and the tallest recorded Californian redwood (*Sequoia sempervirens*) is 367 ft (112 m) tall. All conifers have shallow, fibrous roots that enable them to colonize steep mountain slopes, although these shallow roots also make them vulnerable to falling in high winds if they are growing alone. A conifer's narrow leaves or needles minimize water loss and are full of resin, which acts like anti-freeze. These attributes mean that conifers can grow at higher altitudes than flowering trees, whose soft, tender shoots perish in icy conditions. Conifers make up the so-called coniferous zones—bands of pine and fir trees around the higher slopes of tree-clad mountains. They also dominate some of the coldest and most inhospitable habitats on Earth, such as the vast evergreen belt of trees crossing northern Canada, the United States, Norway, Sweden, Finland, and Siberia below the Arctic Circle. This band of trees, called the taiga or boreal forest, is the biggest terrestrial ecosystem.

About 200 million years ago, gymnosperms were the dominant plants on Earth. Ancient gymnosperms that have survived extinction are cycads (palm-like plants), ginkgo trees, and gnetophytes, most of which are trees or woody climbers. The oddest of these is the welwitschia, a plant with a long, strangely twisted pair of strap-like leaves that grows in the Namib desert.

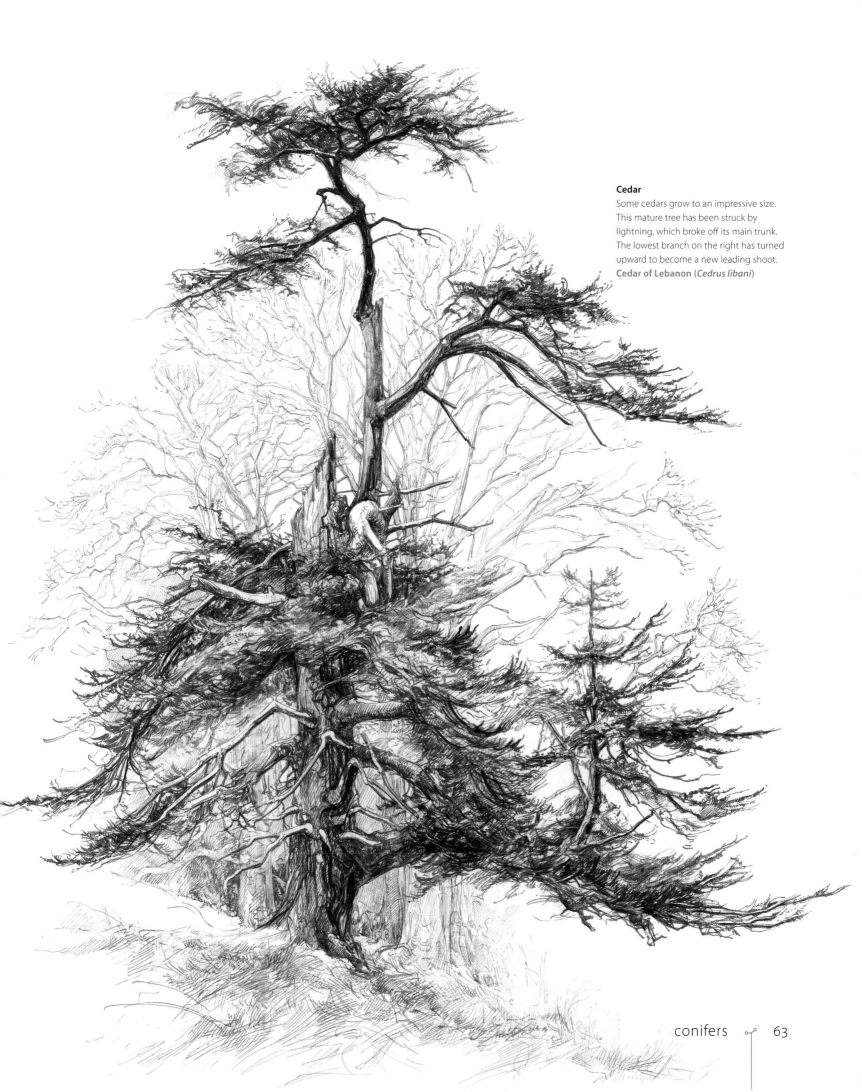

Cedar
Some cedars grow to an impressive size. This mature tree has been struck by lightning, which broke off its main trunk. The lowest branch on the right has turned upward to become a new leading shoot.
Cedar of Lebanon (*Cedrus libani*)

Flowering plants

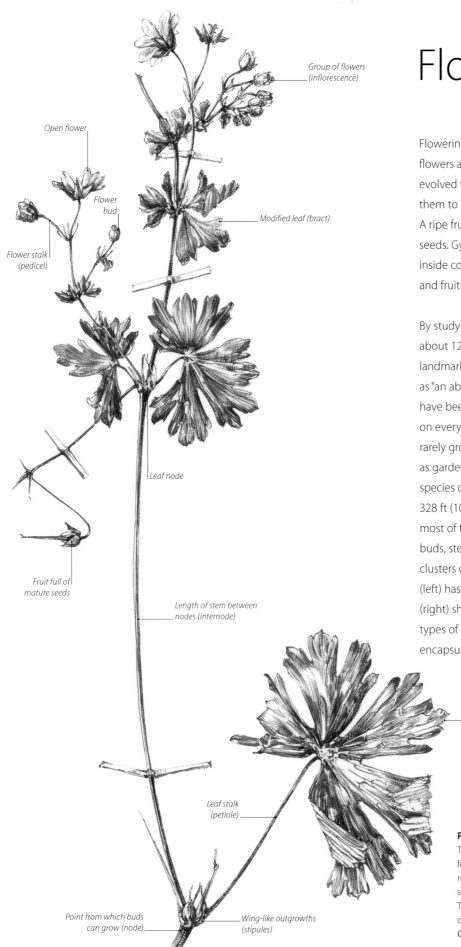

Group of flowers (inflorescence)

Open flower

Flower bud

Modified leaf (bract)

Flower stalk (pedicel)

Leaf node

Fruit full of mature seeds

Length of stem between nodes (internode)

Leaf

Leaf stalk (petiole)

Point from which buds can grow (node)

Wing-like outgrowths (stipules)

Flowering plants, called angiosperms, are the only plants that produce true flowers and fruits. The fascinating shapes, colors, and scents of flowers evolved to attract insects and other animals, which pollinate them, enabling them to produce fruits. Some flowers are pollinated by the wind.
A ripe fruit is essentially a mature ovary—a vessel enclosing one or more seeds. Gymnosperms, such as conifers, also produce seeds, but they form inside cones not fruits, and are "naked"—not enclosed by ovaries. Flowers and fruits are the two defining features of a flowering plant.

By studying fossils, scientists have learned that flowering plants evolved about 125 million years ago. Their relatively sudden appearance marked a landmark in evolution, and was described by the naturalist Charles Darwin as "an abominable mystery". Today over 350,000 species of flowering plant have been identified and arranged into about 350 families. They are found on every continent and in all but the most extreme environments—they rarely grow under the sea, for example. We tend to think of flowering plants as garden flowers or wildflowers, but they also include all grasses, and many species of broad-leaved tree. They range in size from $1/16$ in (2 mm) to over 328 ft (100 m) tall, but despite their huge variety in appearance and size, most of them share the same basic features. Flowering plants have roots, buds, stems, and leaves, bracts (modified leaves), individual flowers or clusters of flowers (inflorescences), and different kinds of fruit. The geranium (left) has all the features of a typical flowering plant, while the engraving (right) shows a fictional flowering plant. In the illustration, many different types of root, leaf, flower, and fruit are all attached to a generic stem to encapsulate the essence and diversity of flowering plants.

Parts of a flowering plant
This geranium stem shows all the key features of a flowering plant, except for its roots. The fruits are dry and pointed and spring open to disperse (scatter) their seed. The geranium was pressed and mounted on a herbarium sheet in 1896.
Geranium (*Geranium pyrenaicum*)

Conceptual flowering plant

This engraving, based on a drawing by Johann von Goethe (1749–1832), is a beautiful example of a teaching aid popular in the 19th century. It depicts an imaginary plant that incorporates the characteristics of many diverse flowering plants, with various kinds of stamen, leaves, stems, bulbs, tubers, and even leaf galls.

Pierre Jean François Turpin, 1837

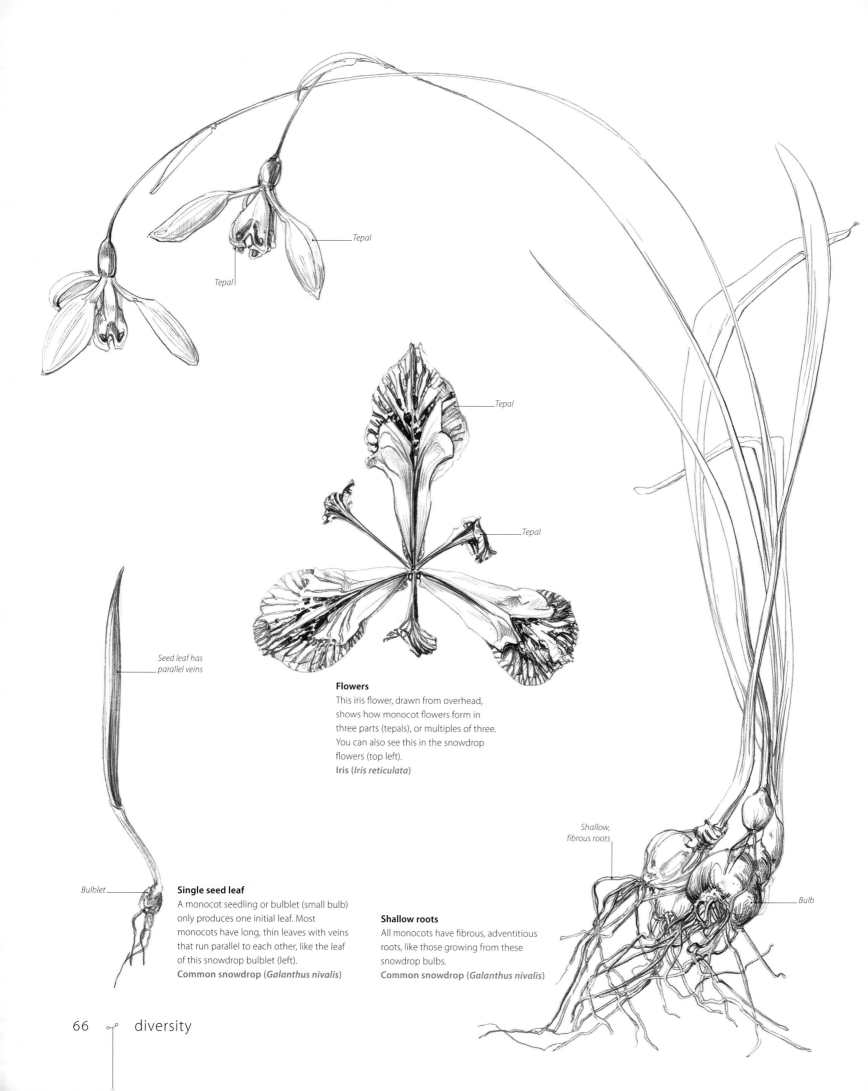

Tepal

Tepal

Tepal

Tepal

Tepal

Flowers
This iris flower, drawn from overhead,
shows how monocot flowers form in
three parts (tepals), or multiples of three.
You can also see this in the snowdrop
flowers (top left).
Iris (*Iris reticulata*)

*Seed leaf has
parallel veins*

Bulblet

Single seed leaf
A monocot seedling or bulblet (small bulb)
only produces one initial leaf. Most
monocots have long, thin leaves with veins
that run parallel to each other, like the leaf
of this snowdrop bulblet (left).
Common snowdrop (*Galanthus nivalis*)

Shallow roots
All monocots have fibrous, adventitious
roots, like those growing from these
snowdrop bulbs.
Common snowdrop (*Galanthus nivalis*)

*Shallow,
fibrous roots*

Bulb

Monocots

Monocots are flowering plants whose seedlings only have one seed leaf (cotyledon). There are about 70,000 monocots, which include two of the largest plant families in the world—orchids and grasses—as well as lilies, flowering bulbs, palms, bananas, and dates. Grasses form a vital part of the food chain and just four species of grass—rice, wheat, corn, and sugar cane—provide humans with 80 percent of their calorie intake.

Monocots have several characteristics in common. They nearly all have long, thin leaves with veins that run parallel to each other—it is very rare for them to have rounded leaves with branching veins. A monocot does not have separate whorls of petals and sepals, arranged one inside the other (see p.164), but a single whorl of petal-like structures, called tepals. The floral parts of a monocot are arranged in groups or multiples of three, as seen in the iris and snowdrops (left). The delicate male and female parts of grass flowers hang out of the flowers so that they can be pollinated by the wind. It is fascinating to look at them under a hand lens, and you will also see how their floral parts are arranged in multiples of three.

Most monocots are herbaceous, which means that they die back down into the ground at the end of each growing season. Some, however, such as bamboo and palms, have tough stems that persist from year to year. Palms, often called palm trees, are not really trees at all. Their trunks are single stems without branches, containing tubular vessels that carry sap up and down between the roots and leaves of the plant, like the vessels in all stems. No monocots produce tap roots: they all have dense, shallow, fibrous roots.

Grasses
Grasses are the most common monocots. Their tiny, wind-pollinated flowers are clustered together into flowerheads called spikelets. The arched, ocher-colored grass seen here is rice, while the purple spikelet is Siberian melic, an ornamental grass cultivated from a cold climate forest-edge species. The blue grass shown is two-rowed barley, an edible crop.
Rice (*Oryza sativa*)
Siberian melic (*Melica altissima* "Atropurpurea")
Two-rowed barley (*Hordeum distichon*)

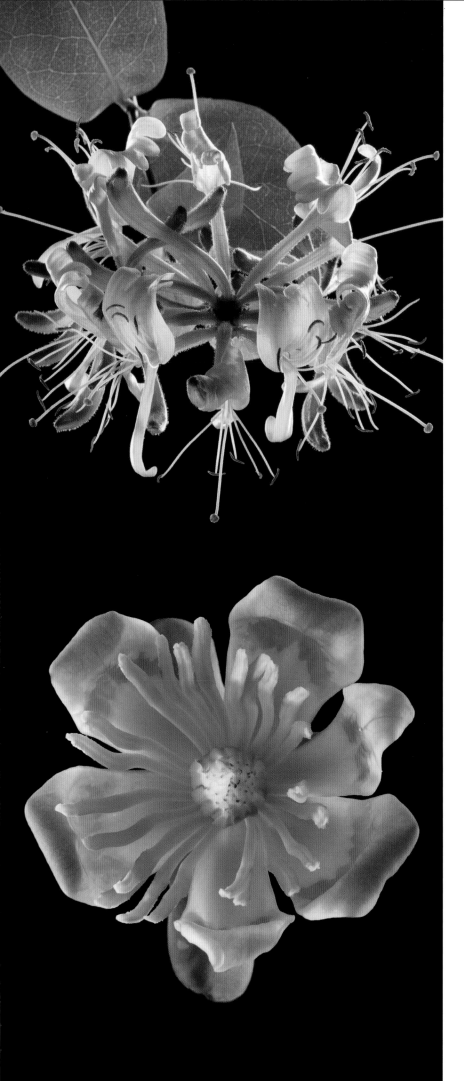

Eudicots

Traditionally, botanists have called plants with two seed leaves dicotyledons (dicots). The distinction between monocotyledons and dicotyledons was first made by the British naturalist John Ray at the end of the 17th century. Recent developments in DNA sequencing, however, have proved that dicots are really a collection of different groups. The largest group, which constitutes the vast majority of flowering plants, has been renamed eudicots, meaning "true dicots," while the other dicots have been placed in smaller groups. There are about 260,000 species of eudicot, which include the daisy, pea, and rose families, as well as most broad-leaved trees. Many species have woody stems.

A typical eudicot has broad leaves with a branching network of veins and the floral parts, such as petals and sepals, arranged in groups or multiples of five, as seen in the hellebore and sweet almond (right). The petals (or tepals) of a eudicot may be completely separate from each other, as in the hellebore, or fused together to form a tubular flower, as in honeysuckle (left). The "flowers" in the vast daisy family are not individual flowers at all, but flowerheads packed full of many tiny tubular flowers that are similar in many ways to the individual flowers of a honeysuckle.

The tulip tree (bottom left) is a member of a group called magnolids—prehistoric survivors of some of the first flowering plants to evolve on Earth. Nutmeg and avocadoes are also magnolids. Like eudicots, they have broad leaves with branching veins, but their floral parts are often arranged in multiples of three rather than multiples of five.

Wild honeysuckle (*Lonicera periclymenum*)
The petals of a honeysuckle (top left) are fused together to form fragrant, tubular flowers. These are arranged in a flowerhead called an umbel (see p.194).

Tulip tree (*Liriodendron tulipifera*)
This prehistoric flower grows on a huge broad-leaved deciduous tree. Its floral parts are arranged in multiples of three. Here we see many thickened stamens opening out from a fleshy core.

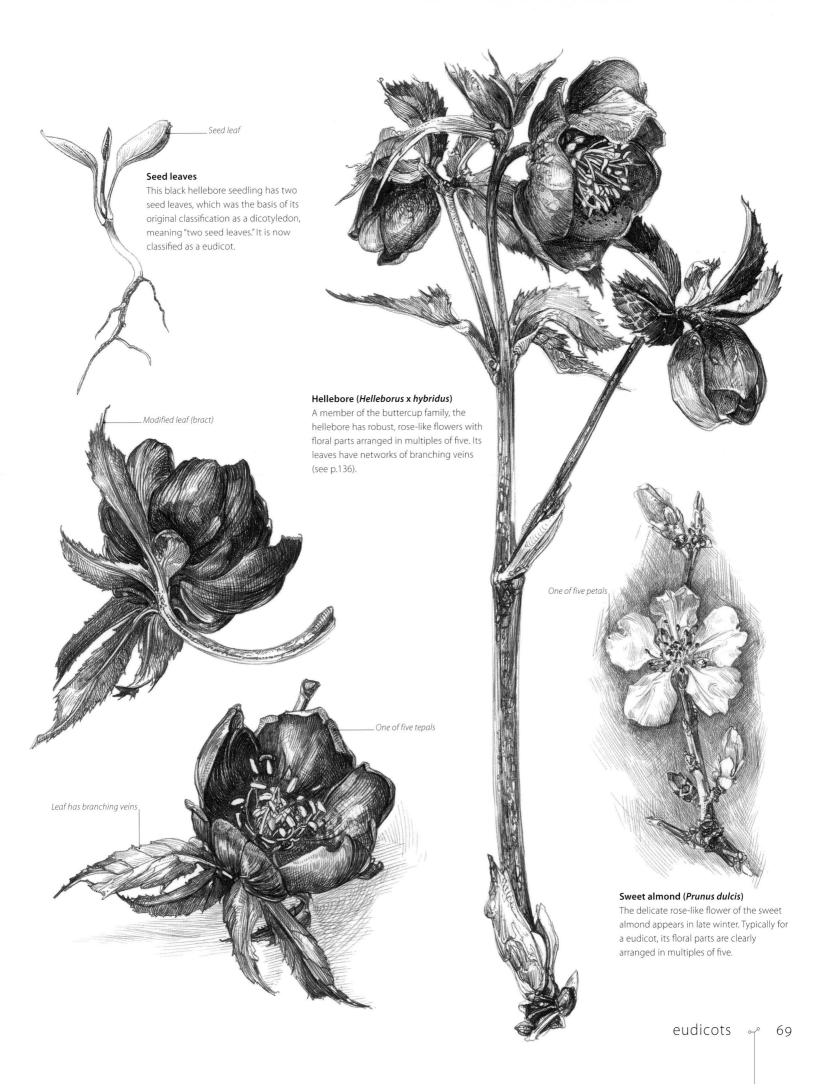

Seed leaf

Seed leaves
This black hellebore seedling has two seed leaves, which was the basis of its original classification as a dicotyledon, meaning "two seed leaves." It is now classified as a eudicot.

Modified leaf (bract)

Hellebore (*Helleborus* x *hybridus*)
A member of the buttercup family, the hellebore has robust, rose-like flowers with floral parts arranged in multiples of five. Its leaves have networks of branching veins (see p.136).

One of five petals

One of five tepals

Leaf has branching veins

Sweet almond (*Prunus dulcis*)
The delicate rose-like flower of the sweet almond appears in late winter. Typically for a eudicot, its floral parts are clearly arranged in multiples of five.

Great piece of turf
Albrecht Dürer

With this portrait of teeming vegetation, painted in 1503, Albrecht Dürer (1471–1528) invented a new subject for the artist: nature itself, free from the bonds of symbolic meaning and ponderous metaphor that were so prevalent in the art of his time. *Great Piece of Turf* is a masterpiece in realism, an uncultivated slice of summer meadow cut from a field near where Dürer lived in Franconia, southern Germany. It is celebrated today as one of the first European studies of biodiversity: numerous species are depicted together as they grow naturally in their habitat. From a perspective reminiscent of childhood hours spent hiding low in long grass, Dürer shows us small plants mutually entangled, competing for light, space, and water. We look up through spent dandelion heads leaning on milky tubular stalks, flowering grasses, and leathery rosettes of plantain leaves—all common plants that animals graze on, and that we sit on and crush underfoot. These are weeds, yet Dürer shows us how beautiful and important they are. With this painting he tells us that the more closely we look at small, ordinary things, the greater and more extraordinary they will become, that there are entire worlds to be discovered in small places and we needn't go far to reach them. This timeless painting expresses the patience required to truly see, and the rich rewards of looking closely. It inspires us with its revelation that for artists there is always the potential to create great art from things as commonplace as a spadeful of meadow.

Dürer, one of the great Northern Renaissance artists, worked before pencils were invented, when brushes were made of animal hair tied into feathers, pigments were often home-made, and paper was scarce. He probably drew with a metal stylus on vellum, a prepared calf skin, brushed with a pale wash of paint (called a ground) to give the surface a texture that a stylus could make a mark on. He then used watercolor and body color (gouache) in combinations of dry strokes and washes to achieve sharp details over soft tones. Several drawing classes in this book demonstrate this technique.

Great Piece of Turf— study of weeds
1503, watercolor and bodycolor on vellum, 16 x 12½in (40 x 31cm), Graphische Sammlung Albertina, Vienna, Austria

Closer look

Translucent washes
These grass flowers were painted with thin washes of watercolor. Some are softly focussed while others appear sharper giving an impression of depth.

Visual connections
Flecks of red-brown appear beneath each yellow dandelion flower. These make a visual connection with red hues in the soil to give the picture unity.

Reddened shadows
Dürer used blue-greens mixed with white to paint these grass leaves, and yellow-greens to paint the daisy leaves behind. All of the shadows are deepened by adding red.

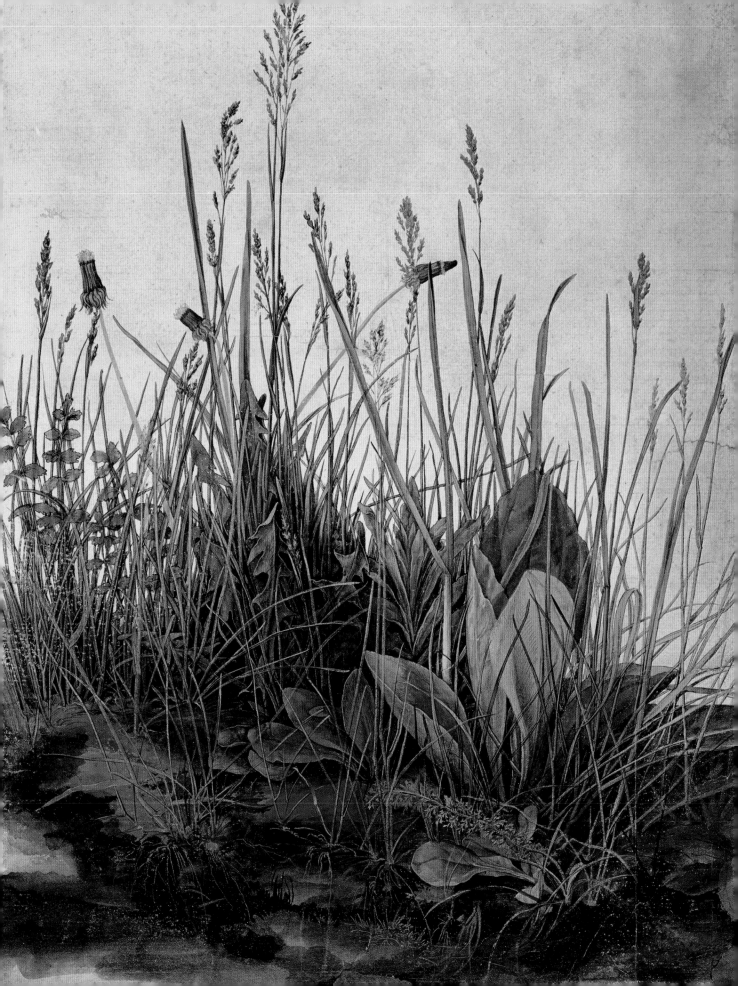

Roots

Roots hold plants in place and help them find water and essential minerals.

The roots of a plant can be invisibly fine, or so thick and strong that they can split

open rocks and destroy masonry as they burrow through the soil and into cracks.

Most root systems develop as vast, delicate networks beneath the soil, but not all

roots grow in the ground. Some float like lace in water, while others hang in the

air, or grip and climb, smothering any surface that does not move.

Introduction

The roots of a plant anchor it in its environment. They enable it to absorb minerals and water, and are always searching for new resources. The first tiny, fragile root that emerges from a seed is called the radicle. As it thickens and branches it becomes a primary root, which might thicken further into a tap root with side branches, or die away to be replaced by a hair-like mass of fibrous roots. Tap roots grow straight down to become immovable anchors; desert-dwelling African acacias use their deep tap roots to reach water up to 100 ft (30 m) below ground. Fibrous roots, on the other hand, such as those of all gymnosperms (see p.62) and grasses, spread out just beneath the surface of the soil to create tough mats. Some plants develop a combination of tap and fibrous roots.

Root systems mature in many forms. The roots of some marshland and salt lake trees push up like bumps above the surface of the water to enable them to breathe. The notorious strangler fig, which germinates high in the branches of tropical trees, lowers its roots through the air to the ground, lacing them so thickly around its supporting tree that it kills it, then stands free on the hollow, latticed trunk created by its roots. Many roots swell to become fleshy food reserves. Others, if broken or cut away, sprout buds to create new plants. Bulbs can even contract or relax some of their roots to raise or lower themselves in the soil in response to seasonal change or misplaced planting.

1 Carrots are tapered tap roots full of nutrients. Wild species can be purple or white, while cultivated crops are orange and can grow up to 8 in (20 cm) long.
Carrot (*Daucus carota*)

2 Hellebores have adventitious roots, which branch out repeatedly at the base of the plant's stem to make a fibrous root system.
Ferdinand Lucas Bauer, 1830
Hellebore (*Helleborus orientalis*)

3 Many tropical forest orchids grow high up in trees, or on rocks. Their long aerial roots can absorb water and minerals from the humid atmosphere.
Orchid (*Vanda* sp.)

4 Bald cypress trees along the Mississippi River Valley are renowned for their "knees"—cone-shaped root extensions, called pneumatophores, which enable them to breathe above the water.
Bald cypress (*Taxodium distichum*)

5 Beets are shallow, swollen roots full of stored sugars. They grow to about 2 in (5 cm) wide. Rings of vascular tissue vessels are visible in this beet slice.
Beet (*Beta vulgaris*)

6 Low-lying and coastal mangroves are supported by vigorous prop roots that look like forked limbs pushed into the earth.
Red mangrove (*Rhizophora mangle*)

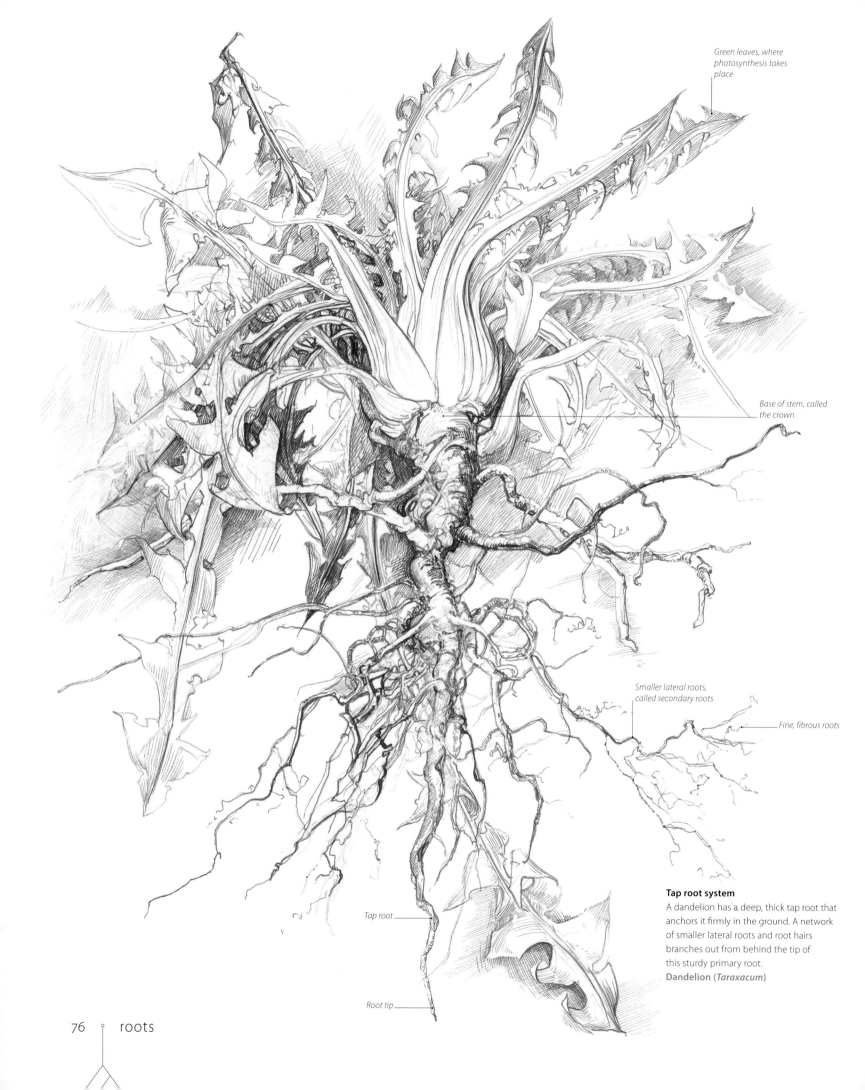

Green leaves, where photosynthesis takes place

Base of stem, called the crown

Smaller lateral roots, called secondary roots

Fine, fibrous roots

Tap root system
A dandelion has a deep, thick tap root that anchors it firmly in the ground. A network of smaller lateral roots and root hairs branches out from behind the tip of this sturdy primary root.
Dandelion (*Taraxacum*)

Tap root

Root tip

How roots work

Plants make their own food supply from sunlight, using their leaves and a process known as photosynthesis (see p.127). Plants rely on their roots to search for and absorb water and dissolved minerals, which are then drawn up into their leaves so that photosynthesis can take place. Only one percent of the water gathered by a plant's roots is used for growth; the remaining 99 percent goes into photosynthesis, during which it is lost to the atmosphere. The water that is continually lost has to be replenished, so when a plant is growing, its roots have to constantly extend their search to find and supply massive quantities of water.

Roots are therefore highly active systems. A root grows from its tip, which is covered with a tough, lubricated cap that is pushed forward through the soil. When the outer surface of the cap wears away from abrasion with the soil, it is speedily replaced. The root cap also detects the pull of gravity and aims the root tip downward. Just behind the root cap, cells divide and then elongate to drive the cap forward (top right). Behind the root tip, fine root hairs—often only one cell wide—grow out into the soil to gather supplies. This vital activity all takes place within ¼ in (5 mm) of the root tip.

Masses of tiny root hairs, which can be seen on the magnified mustard seedling (bottom right), grow behind the tips of all roots. They absorb water and dissolved minerals, but they live for only a few days. When they die off, the area of the root on which they grew is reinforced to transport the water and minerals taken up by new hairs growing further down the extending root. As nutrients are drawn up from roots into leaves, food reserves made by photosynthesis move down to feed every part of the plant, including the roots.

Elongated cells

Root cap

Growing tip

Root tip
This magnified image (above) shows a longitudinal section of a root tip, the root cap, and the cells that divide and elongate to force the root tip down through the soil.
Broad bean (*Vicia faba*)

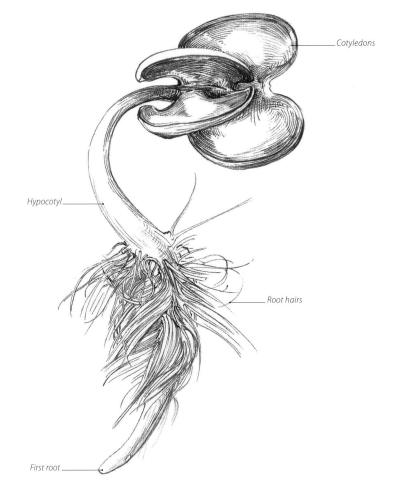

Cotyledons

Hypocotyl

Root hairs

Germinated seed
The first root (radicle) of this mustard seed (magnified) displays a thick cuff of microscopic white root hairs, which grip the soil and suck in moisture and minerals. The seedling is actually ³⁄₈ in (8 mm) long.
Mustard (*Sinapis*)

First root

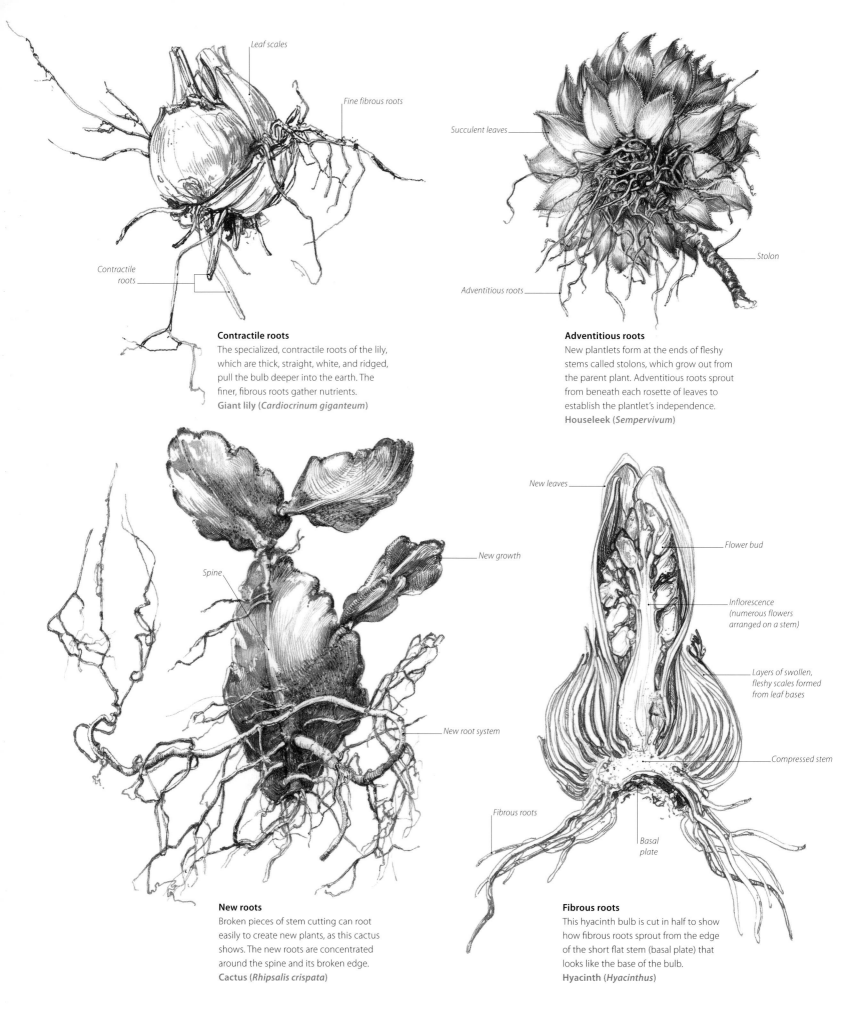

Contractile roots

The specialized, contractile roots of the lily, which are thick, straight, white, and ridged, pull the bulb deeper into the earth. The finer, fibrous roots gather nutrients.
Giant lily (*Cardiocrinum giganteum*)

Leaf scales

Fine fibrous roots

Contractile roots

Adventitious roots

New plantlets form at the ends of fleshy stems called stolons, which grow out from the parent plant. Adventitious roots sprout from beneath each rosette of leaves to establish the plantlet's independence.
Houseleek (*Sempervivum*)

Succulent leaves

Stolon

Adventitious roots

New roots

Broken pieces of stem cutting can root easily to create new plants, as this cactus shows. The new roots are concentrated around the spine and its broken edge.
Cactus (*Rhipsalis crispata*)

Spine

New growth

New root system

Fibrous roots

This hyacinth bulb is cut in half to show how fibrous roots sprout from the edge of the short flat stem (basal plate) that looks like the base of the bulb.
Hyacinth (*Hyacinthus*)

New leaves

Flower bud

Inflorescence (numerous flowers arranged on a stem)

Layers of swollen, fleshy scales formed from leaf bases

Compressed stem

Fibrous roots

Basal plate

Spreading roots

Plants cannot get up and move if conditions are unfavorable, or stand aside to make way for their young, but are fixed to one place by their roots. They can, however, maneuver or spread themselves into new places by growing rooted stems out to the side and toward better resources. Houseleeks, for example, produce daughter plants at the ends of long, fleshy stems. These settle on the ground a short distance from the parent plant and fibrous roots soon emerge to establish the plantlets' independence. Cheese plants (*Monstera* sp.), which are native to southern Mexico, germinate on the forest floor and climb trees to reach the light. Aerial roots (see right) sprout from inside each cheese plant's stems to grip the host tree firmly for support, and collect water and minerals from the outside of the bark and leaf litter.

Bulbs, corms, and some plants with tap roots, such as dandelions, are able to pull themselves deeper into the soil using specialized roots, known as contractile roots. These roots literally grip the soil and contract in response to seasonal change, or if the bulb is dislodged by a foraging animal. The base of the dormant giant lily bulb (top left) shows its contractile roots, which are thick, white, and straight, with banded surfaces. When bulbs grow they sprout dense, fibrous roots from around the rim of their flattened stems, as seen in the cross-section of a hyacinth bulb (bottom left). Fibrous roots can also emerge from between the leaf scales of a bulb, as in the giant lily bulb. Roots that grow from leaves and stems are called adventitious roots.

Some plant cells can reprogram themselves to produce any type of new tissue that they need. This is how tiny fragments of broken stem or root will sometimes grow into new plants. The stem cutting of the cactus (bottom far left), for example, has sprouted roots along its spine and from the wound of its broken edge.

Forest vine
Aerial roots sprouting from the stem of this tropical forest vine grip the painted wall of a glasshouse to enable the vine to climb. Some of this plant's aerial roots also hang free in the air. Old leaves that have fallen away from the green stem have left pale bands, called leaf scars.
Cheese plant (*Monstera* sp.)

No need for soil

The bare winter canopies of temperate deciduous trees sometimes reveal heavy balls of deep-green mistletoe, a partially parasitic plant that pushes its roots under the bark of its host tree to extract all the essential minerals and water it needs. These parasitic roots are known as haustoria.

Other plant species, called epiphytes (from the Greek words *epi*, meaning "upon," and *phyton*, meaning "plant"), also perch in the branches of trees. Like mistletoe, they use their hosts for support, but they do not take root on, or feed from them. Instead, their aerial roots hang freely and absorb moisture from the air and dissolved minerals in water droplets that drip down. Many tropical orchids growing in rain forests are epiphytic and their roots, held like silver-green strands in the air, are light and spongy to the touch. These aerial orchid roots are surrounded by a thick, soft tissue called velamen, which absorbs water from the atmosphere and traps dissolved minerals washed down from decaying plants above. Aerial roots can also turn green and photosynthesize: these are known as photosynthetic, or assimilatory, roots. This is why the popular moth orchids (*Phalaenopsis* species) are sold in clear plastic pots; their growth is weak if their roots are in dark containers.

Not all photosynthetic roots are found hanging from trees. The roots of the water chestnut (right), for example, float in moving water. Unlike many plants that grow in soil, huge aquatic plants can have relatively small root systems. The submerged roots are usually finely divided to maximize their surface contact with the water and so that the water can flow through them, rather than pulling the plant downstream. Aquatic root systems like this are very efficient because nutrients in the water continually flow toward and through them. They also prove that plants do not actually need soil to survive; just water and the nutrients contained in it.

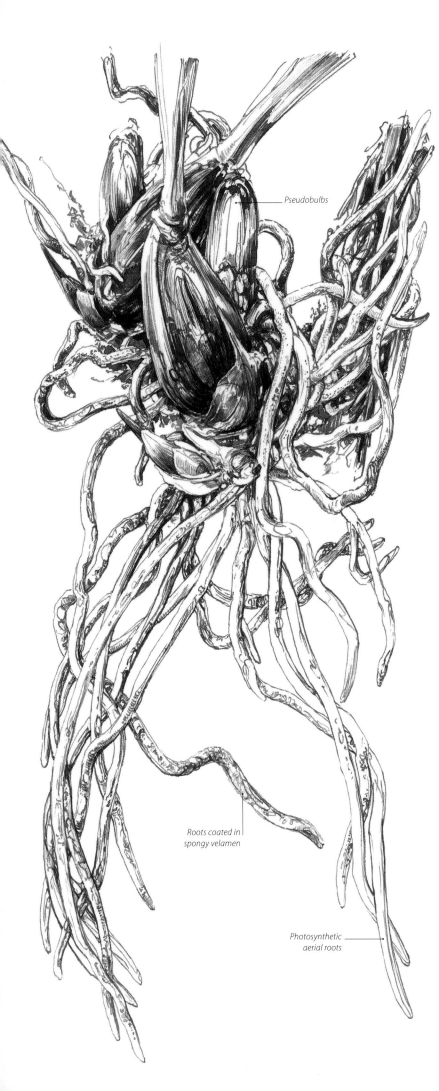

Pseudobulbs

Roots coated in spongy velamen

Photosynthetic aerial roots

Aerial roots
The roots of this orchid contain bright green chlorophyll, so they can photosynthesize. The water needed for this process is trapped by the coating of spongy velamen. Clumps of swollen pseudobulbs (short-lived organs derived from the stem of the plant) may store the sugars that are a product of the photosynthesizing roots.
Spider orchid (*Brassia verrucosa*)

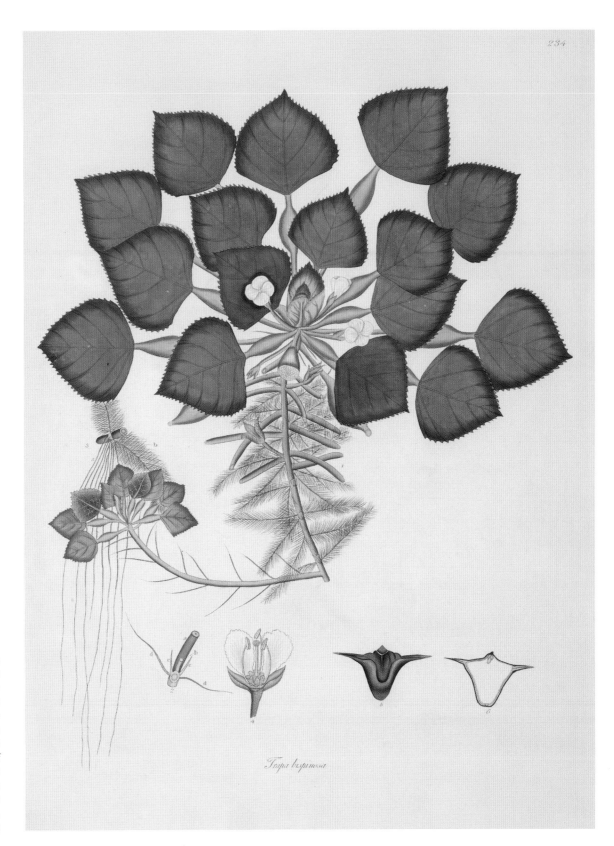

Aquatic roots
This hand-colored engraving shows the feather-like roots produced by a water chestnut. The whole plant is held buoyant by its swollen, round leaf stalks, which are full of air. The engraving is one of many drawings of indigenous Indian plants published in William Roxburgh's *Plants of the Coast of Coromandel*. Roxburgh (1751–1815) trained a team of local artists to draw thousands of plants that he collected for his Calcutta Botanical Garden.
Water chestnut (*Trapa natans*)

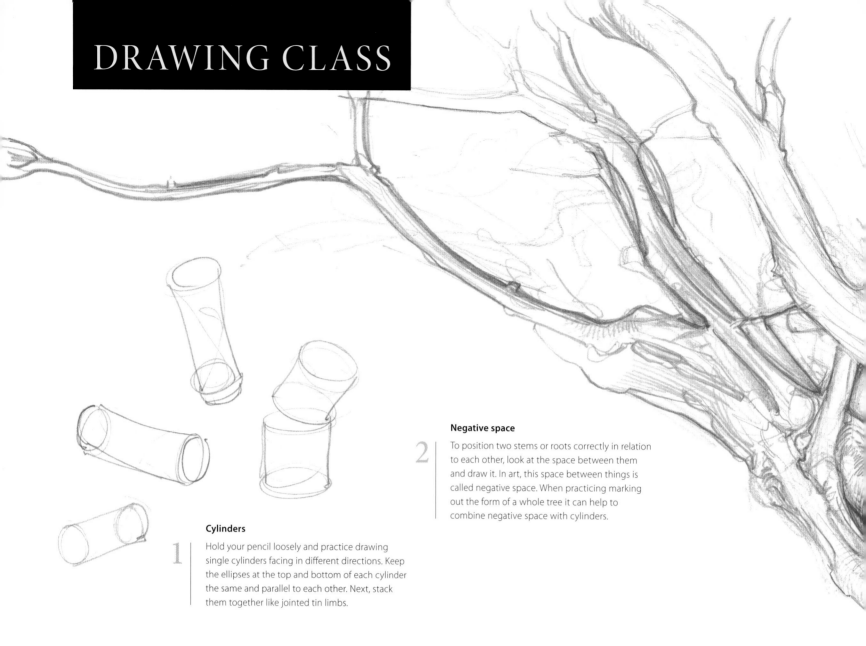

Negative space

2 | To position two stems or roots correctly in relation to each other, look at the space between them and draw it. In art, this space between things is called negative space. When practicing marking out the form of a whole tree it can help to combine negative space with cylinders.

Cylinders

1 | Hold your pencil loosely and practice drawing single cylinders facing in different directions. Keep the ellipses at the top and bottom of each cylinder the same and parallel to each other. Next, stack them together like jointed tin limbs.

Hawthorn

The branched surface roots of old trees look like powerful tentacles reaching across the earth to grip onto it. Beneath the ground more roots branch profusely and can be imagined mirroring the massive expanse of branches in the air. The roots and stems of most plants differ distinctly, but in trees we see these woody structures flowing seamlessly into each other, with no marked divisions between.

Rough drawings are important for thinking, making decisions, sharpening your focus, and warming up. Exercise drawings are different: they are about learning how to see, training your perceptions and manual skills. Exercise drawings, as seen here, are valuable for what they reveal, and may involve making marks and shapes not used in your finished drawings. Roots and stems are essentially cylinders, which lean, twist, and burrow in different

directions. It can be hard to step back and see this when faced with the overwhelming complexity of a whole plant, so it helps to practice drawing cylinders on purpose, to investigate where surfaces actually are, and when and how they change direction.

Hold your pencil loosely about 2in (5cm) back from its point. This will help you to draw more freely.

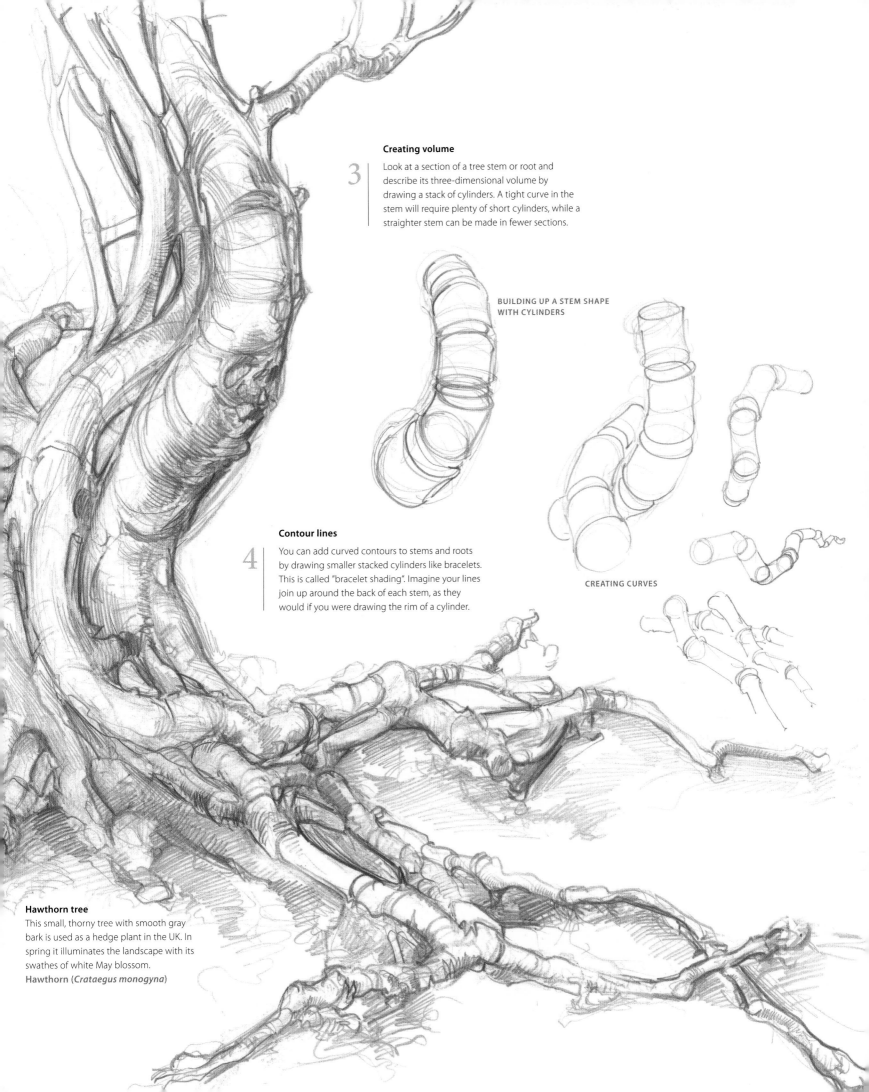

Creating volume

3 Look at a section of a tree stem or root and describe its three-dimensional volume by drawing a stack of cylinders. A tight curve in the stem will require plenty of short cylinders, while a straighter stem can be made in fewer sections.

BUILDING UP A STEM SHAPE WITH CYLINDERS

Contour lines

4 You can add curved contours to stems and roots by drawing smaller stacked cylinders like bracelets. This is called "bracelet shading". Imagine your lines join up around the back of each stem, as they would if you were drawing the rim of a cylinder.

CREATING CURVES

Hawthorn tree

This small, thorny tree with smooth gray bark is used as a hedge plant in the UK. In spring it illuminates the landscape with its swathes of white May blossom.

Hawthorn (*Crataegus monogyna*)

Étude de botanique
Girolamo Pini

Little is known about the obscure Italian artist Girolamo Pini, who painted this study of rooted plants in Florence, around 1614, using oil on canvas. It is one of a pair, and these two extant paintings are his only known works. Oil painting originated in Afghanistan around the 7th century and did not become popular in Europe until the 15th century, but by the height of the Italian Renaissance it had virtually replaced tempera on gesso, which had been used up until then. Tempera, a mixture of egg yolk and pigment applied to plaster covering a board, is celebrated for its bright color and luminosity. Oil paint is less luminous, but can achieve greater depths of tone and is more true to life. Here, for example, the almost black greens of Pini's leaves, the shiny, brittle wings of the red ladybug (center), and the waxy presence of the lily, tulip, and crocus tepals are all characteristic of oil painting. Compare this image with other master works in this book and you will immediately see the differences between oil- and water-based paint.

Oil paintings are built up in layers or glazes, following the principle of fat over lean. This means that the deepest layers of paint contain the least oil in relation to pigment. They dry quickly but are relatively brittle, whereas the final layers of paint contain the most oil. These dry slowly and are more flexible, ensuring that the finished surface of the painting does not crack. Pigments are traditionally bound in linseed, poppy seed, or walnut oil and are applied with stiffer brushes than those used in watercolor.

Pini has achieved an eerie illumination in this gorgeous display, as if he was working with a candle or a lamp shining upward from beneath. Plants are seen floating against an earth-colored wall, with a theatrical under-lighting that catches the brightness of the flowers and the whiteness of their wriggling roots. The study was probably made over several spring and summer months and features entire plants. It may have been roughly planned in charcoal or chalk on the prepared canvas, or improvised as more plants came into flower. All of the plants are named on the paper scroll that is painted, as if pinned to the work, in the bottom left corner.

Closer look

Dark hues
The deep and sumptuous black hues of this iris flower confirm the use of oil paint (such darkness is harder to achieve with egg tempera). The thin glazes of oil paint over a white primed canvas (see left) make the background look luminous.

Crocus bulb roots
The bulb of this spring crocus is rendered in dark undertones and pale surface brush marks. Its roots seem to wriggle in ivory whites over pale gray shadows that give them depth and a lively substance.

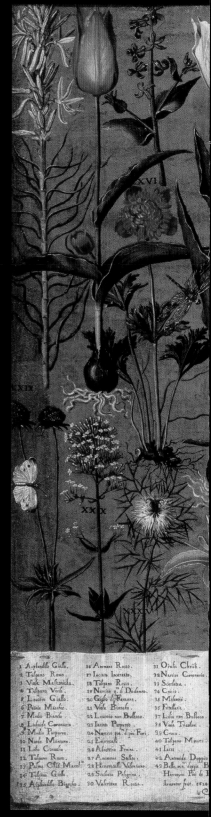

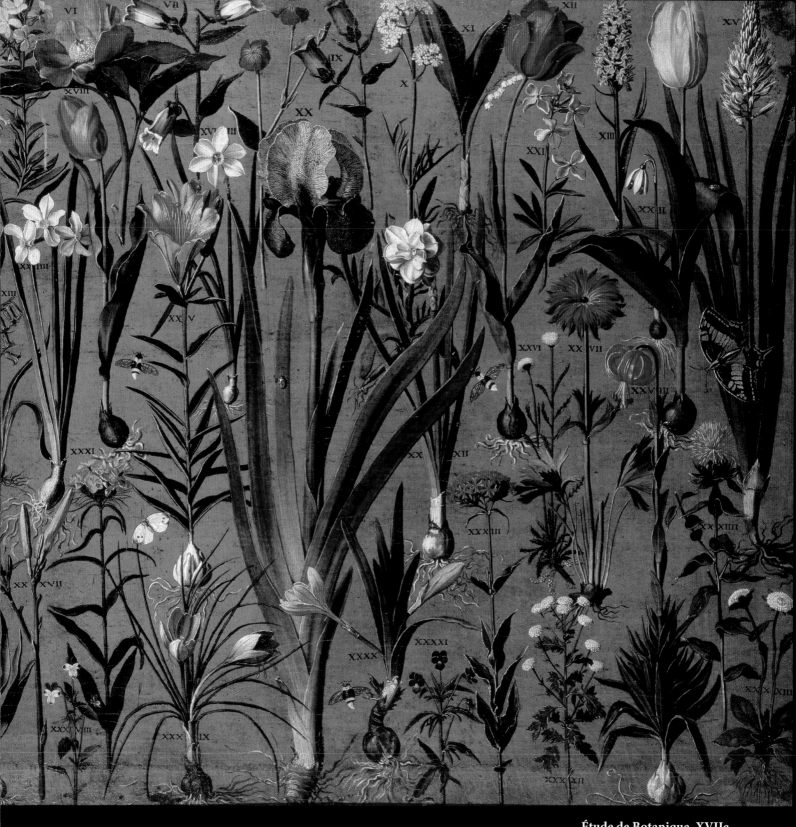

Étude de Botanique, XVIIe
1614, oil on cloth, 36 x 47in (92 x 120cm),
Musée des Arts Décoratifs, Paris, France

Stems

Stems form the structural shape of every plant, and enable us to recognize different species. They also contain vital plumbing; bundles of tiny tubes, which carry nourishing sap up and down to reach every cell of the plant. Stems can be singular or branched, short and squat or immensely tall and slender, and they can live for only a few short weeks or survive for thousands of years. The vast trunks of trees are stems, and when en masse as a woodland or forest they can dramatically shape our experience of the landscape.

ntroduction

When you think of stems, you might picture a range of structures from delicate leaf and flower stalks to the branches and trunks of trees. Some plant stems are strong, live for a long time, and achieve enormous height and girth, while others are fragile and may snap easily and shrivel in the warmth of your hands. Trees, for example, are so strong they may support the weight of a neighboring tree leaning against them, while most delicate aquatic plant stems rely on water to hold their shape. Stems also enable plants to tilt and orientate themselves so they can scramble and grow taller, moving in search of more space and light. They carry buds all the year round, for future new growth.

Plant stems are not all green or brown: some, such as young lime tree shoots (see p.93) and rhubarb, are bright red, while *Eryngium* has steely blue stems. If you look closely at different stems, you will see that they can be rounded, oval, or square, and have horizontal ridges, vertical flutes, or scalloped surfaces. Some are coated in hairs or bristles, or have spines and thorns to protect them. Modified stems are also fascinating: a stem bud, for example, can develop into a clinging tendril or a fierce thorn.

Apart from their immense range in scale and appearance, all stems also provide a plant's plumbing. Inside every stem, bundles of tubes called xylem carry water and minerals up from the roots to the leaves, while other tubes, called phloem, distribute sugars generated by the leaves to the rest of the plant as food.

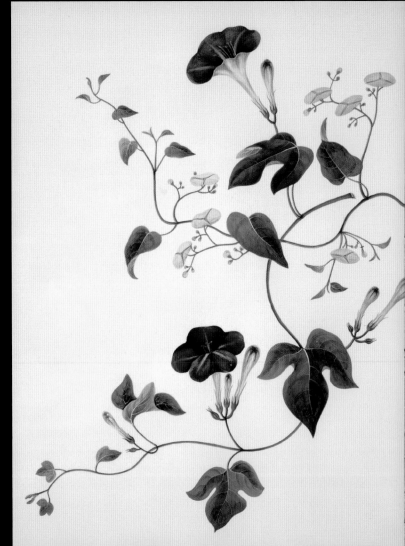

1	2	3
4	5	6

1 The long stems of this delicate vine scramble over other plants to reach light. The fragile flowers last for only one day.
Artist unknown, early 19th century
Morning glory (*Merremia umbellata*)

2 Bamboos are grasses with immensely strong, hollow, segmented stems. In Asia, giant bamboo stems are used in construction.
Ornamental bamboo (*Phyllostachys viridi-glaucescens*)

3 This conifer can grow to 100 ft (30 m) tall, depending on the growing conditions. Its elephantine lower branches can support unimaginable weight.
European black pine (*Pinus nigra*)

4 The swollen green stems of cacti take on the food production of the plants' leaves, which are modified into defensive spines.
Royen's tree cactus (*Pilosocereus royenii*)

5 The herbaceous green stems and buds of this Iceland poppy are covered in stiff, red hairs. The stems have twisted as the growing plant reaches for light.
Iceland poppy (*Papaver nudicaule*)

6 This cross section through the trunk of a laburnum tree shows circular bands of growth rings and the bark. Each growth ring represents one year of growth, so this tree is at least 16 years old.
Laburnum (*Laburnum* sp.)

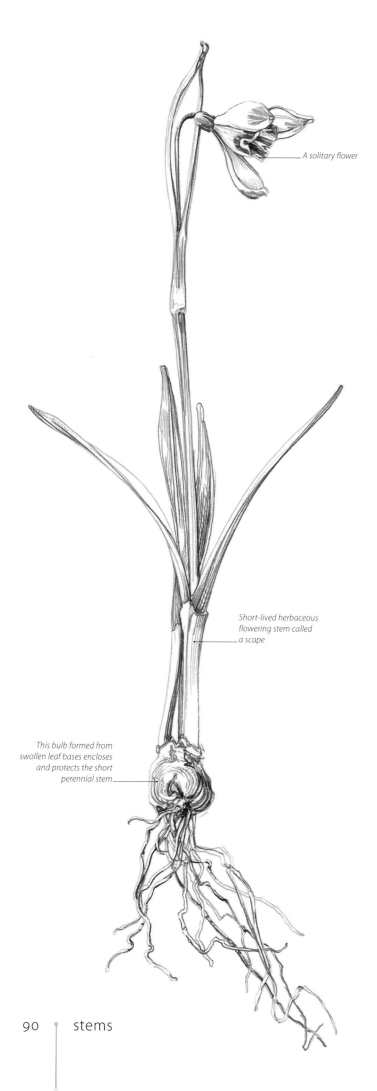

A solitary flower

Short-lived herbaceous flowering stem called a scape

This bulb formed from swollen leaf bases encloses and protects the short perennial stem

Strong stems

Strong stems stand unsupported. They literally hold themselves upright without needing water to float in, or a structure to wrap themselves around and climb over. Strong stems can be woody and live for hundreds of years, such as trees, or they can be herbaceous and live for just a few weeks, such as flowering bulbs. The strength of a stem can indicate a plant's ability to withstand being pushed and pulled by the wind, compressed under its own weight, or manually twisted and crushed.

The structural character of a plant, called its habit, is determined by the strength, growth pattern, and life cycle of its stems. Herbaceous plants have stems that die right back to the ground at the end of their growing season. Herbaceous annuals complete their whole life cycle in one year, while herbaceous perennials, such as snowdrops (left), grow new flowering stems every year. Some large plants, such as bamboo and banana, are also herbaceous but are unusual because their stems don't die down but last from one season to the next. Perennial plants with woody stems are called shrubs and range in size from small hummocks of thyme to large, dense rhododendron bushes. A tree is also a woody perennial, but it differs from a shrub in that it usually has a single main stem, or trunk.

Snowdrop
The perennial stem of a snowdrop (left) is, surprisingly, a flattened disk at the base of its bulb. The new leaves that emerge from this stem every winter, together with a flowering stem called a scape, rise directly from the ground.
Snowdrop (_Galanthus_ sp.)

Linden tree
The linden tree (right) is a close-grained hardwood traditionally used by sculptors for intricate carvings. Linden trees often develop, and are recognized by, massively knotted clumps of stems, called "witches' brooms," which grow if many buds form.
Linden (_Tilia_ sp.)

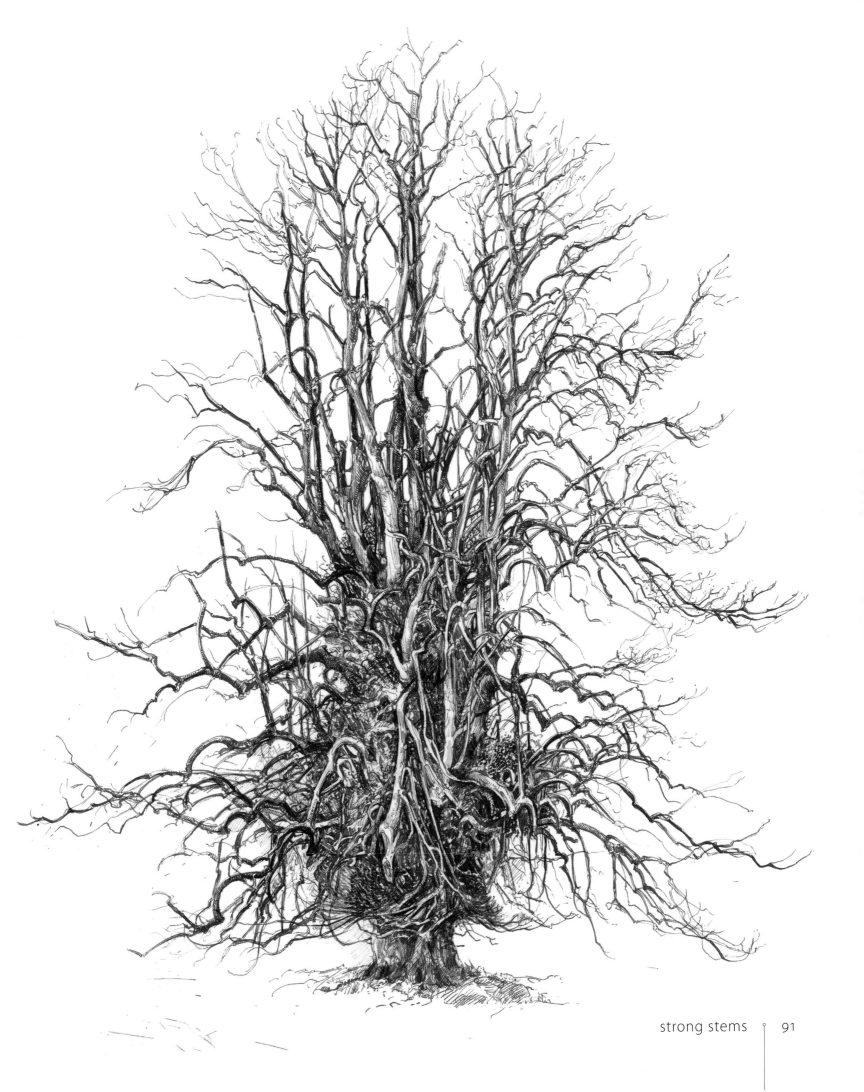

Stem buds

Buds are undeveloped shoots waiting to grow. They may produce stems with leaves or flowers, or modify into tendrils or thorns. Buds can be solitary, paired or clustered, long and slender, or short and stout, and they are present all year round tucked into the space—known as the leaf axil— where a leaf stalk and a plant stem meet. Buds can form opposite each other or on alternate sides of a stem, rising around it at intervals. The place where a bud forms is called a node, and the intervals between buds are internodes. The ways in which buds grow determine how plants will branch and be shaped.

Winter buds are sometimes covered by protective resinous or hairy scales to keep out rain, ice, and nibbling insects. Inside a bud a very short stem carries many tightly packed, immature leaves, each folded over the growing tip. Winter buds grow plump before bursting open at different times in the spring. Numerous plants, such as hazels and some magnolias, display their flowers before their leaves have developed and opened.

Every plant has a dominant bud, called the leader, at the top of its main stem. This bud grows vigorously and releases hormones to inhibit buds beneath it. The leader optimizes a plant's height and access to light. If it is cut off, its energy is diverted to the buds below, and two or more of these buds will grow with equal vigor to make the plant fork. If these new leaders are also cut away, the plant forks again. So pruning a tall, single stem on a plant encourages the other stems to grow and branch out. Natural pruning by cold wind occurs on exposed coasts and mountains where many, but not all, buds die to create dense thickets of miniaturized trees.

Dominant bud (leader)

Axillary buds

Internode (length of stem between nodes)

Vascular bundles

Axil (the angle between the stem and the bud)

Paired lateral axillary buds

Node (the swollen part of a stem where a bud grows)

Leaf scar

Dominant bud (leader)

Clustered axillary buds

Gnarled area of slowed growth from the end of the previous season

Ash branch
In winter, ash trees carry distinctive black, paired buds. These buds that line the stem are called axillary buds, and each one has a leaf scar beneath it. The dominant bud at the tip of a stem (also known as the apical bud) has no leaf scar.
European ash (*Fraxinus excelsior*)

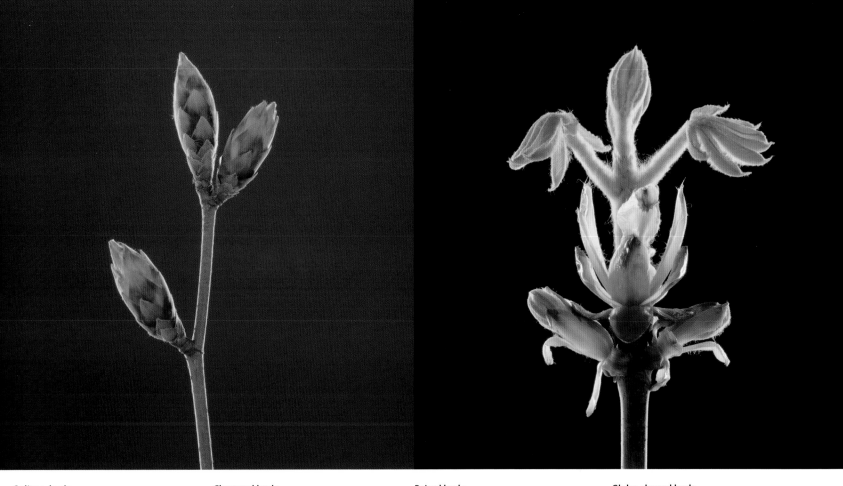

Solitary buds
Beech trees produce single, lance-shaped buds (above) on alternate sides of their stems. These winter buds have large amounts of chemical repellent to make them taste revolting to animals.
Beech (*Fagus sylvatica*)

Clustered buds
Buds are grouped in clusters on the branches of oak trees (below). These clusters of buds contain high levels of tannin. This makes them taste bitter to animals, thus protecting the buds.
Oak (*Quercus robur*)

Paired buds
The branches of a horse chestnut tree develop opposing pairs of buds (above), which are coated in a sticky resin. This protects them from frosts and possible insect damage.
Horse chestnut (*Aesculus hippocastanum*)

Globe-shaped buds
The globe-shaped buds of linden trees (below) are some of the last buds to open in spring, so have been used to investigate the connection between chemical content and the time of bud burst.
European linden (*Tilia europaea*)

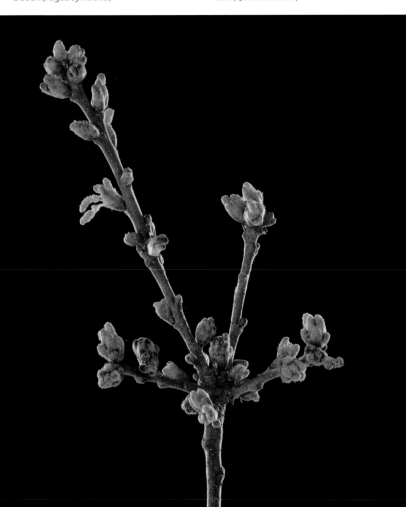

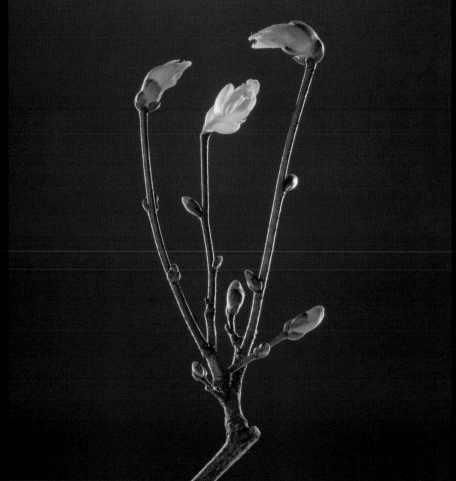

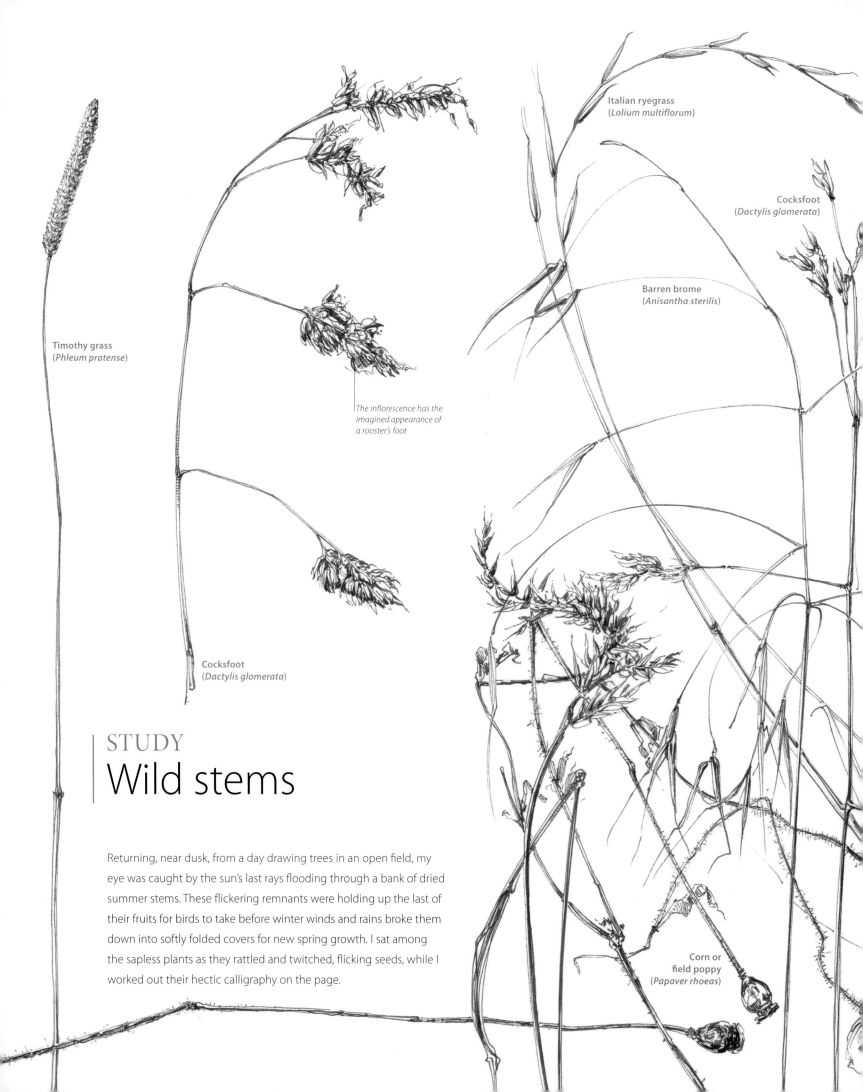

Italian ryegrass
(*Lolium multiflorum*)

Cocksfoot
(*Dactylis glomerata*)

Barren brome
(*Anisantha sterilis*)

Timothy grass
(*Phleum pratense*)

*The inflorescence has the
imagined appearance of
a rooster's foot*

Cocksfoot
(*Dactylis glomerata*)

STUDY
Wild stems

Returning, near dusk, from a day drawing trees in an open field, my
eye was caught by the sun's last rays flooding through a bank of dried
summer stems. These flickering remnants were holding up the last of
their fruits for birds to take before winter winds and rains broke them
down into softly folded covers for new spring growth. I sat among
the sapless plants as they rattled and twitched, flicking seeds, while I
worked out their hectic calligraphy on the page.

Corn or
field poppy
(*Papaver rhoeas*)

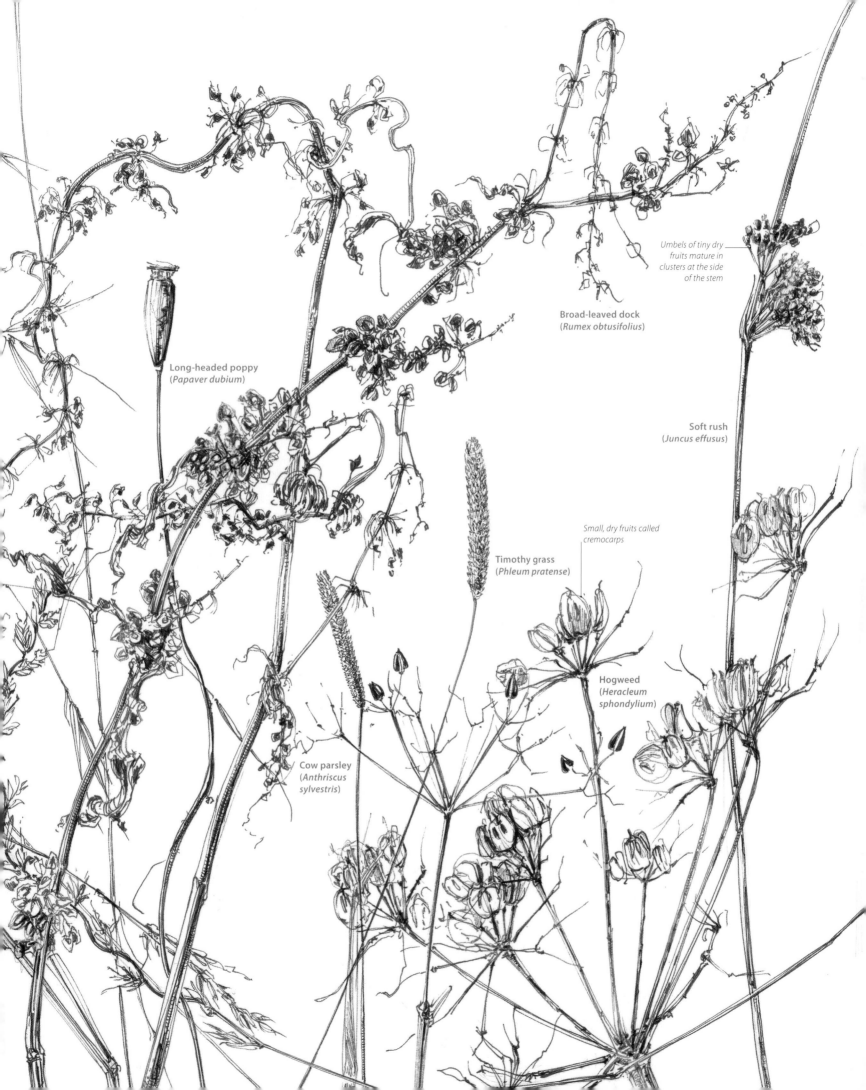

Umbels of tiny dry fruits mature in clusters at the side of the stem

Broad-leaved dock
(*Rumex obtusifolius*)

Long-headed poppy
(*Papaver dubium*)

Soft rush
(*Juncus effusus*)

Small, dry fruits called cremocarps

Timothy grass
(*Phleum pratense*)

Hogweed
(*Heracleum sphondylium*)

Cow parsley
(*Anthriscus sylvestris*)

Pine tree

I found this scruffy pine tree at the edge of a field. Its dead stems lacked foliage and storms had broken away branches, but it still stood handsomely at ease with a clear sense of balance. Solitary trees can grow uninhibitedly into the full characteristic shape of their species, while trees packed together must jostle and turn to reach light. Both conditions make exciting subjects to draw, and it is worth spending time hunting for great trees.

Tall subjects diminish in perspective (their apparent size) and focus as they rise away from us, and when we look at any subject, especially a large tree, we don't see all of it at once. Our eyes dart from one point to another, gathering less distinct information in between. When drawing, if you change the lengths and textures of your lines and the focus of your attention to combine crisp details with looser impressions, you will emulate our experience of seeing far more closely than if you finish every detail completely. Highly finished pictures can become more like photographs, and take far more time and effort to see than a rapid sketch.

We easily sense differences between bold sweeping dashes and more quietly worked areas of attention. Changes in the pressure and intensity of a line are like the changes in volume, pitch, rhythm, and speed that we experience when listening to music. Constant similarities can be mesmeric or exhausting to look at or listen to. Likewise, excessive detail in a drawing can be enjoyed, or it can leave no space for the eye to rest or the imagination to wander and no space for speculation. Drawings that have unfinished areas are often described as fresh, and this freshness refers to the sense of release we feel when we are not overloaded with visual information.

Proportions

1 Before starting to draw, ensure the orientations of your subject and paper match each other. Here I used a sharp HB pencil to swiftly and lightly mark the full height and width of the tree and the balance of its largest masses, fitting all its proportions onto a vertical sheet of paper.

Location

2 If you sit too close to a tree when drawing it, you may struggle with perspective and fitting everything onto your page. If you sit too far away, you can lose visual contact with its textures and distinguishing features. Find a distance at which you can comfortably see the whole tree and still perceive its textures.

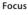

Focus

3 Think about where you want to place the emphasis and weight of your image as you compose it. Here I gave more emphasis to the lower half of the tree, partly because it carries the weight of the upper half and partly because it was closest to me, so it looked much larger, more dominant, more detailed, and could be seen in sharper focus.

Pine tree

Scots pines once covered the Scottish highlands. For centuries they were also planted as landmark trees in Britain. Groups of three or four Scots pines situated on high ground marked herding routes and farms where travelers and herds could stay.
Scots pine (*Pinus sylvestris*)

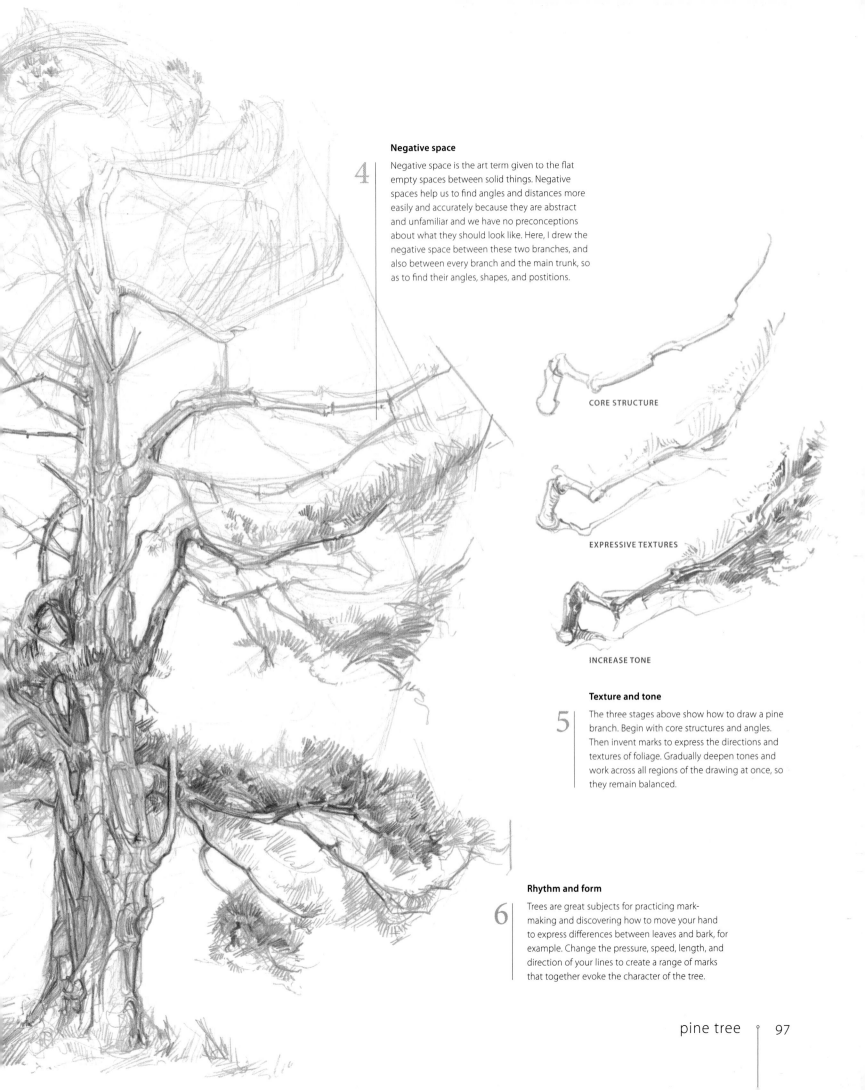

Negative space

4 Negative space is the art term given to the flat empty spaces between solid things. Negative spaces help us to find angles and distances more easily and accurately because they are abstract and unfamiliar and we have no preconceptions about what they should look like. Here, I drew the negative space between these two branches, and also between every branch and the main trunk, so as to find their angles, shapes, and postitions.

CORE STRUCTURE

EXPRESSIVE TEXTURES

INCREASE TONE

Texture and tone

5 The three stages above show how to draw a pine branch. Begin with core structures and angles. Then invent marks to express the directions and textures of foliage. Gradually deepen tones and work across all regions of the drawing at once, so they remain balanced.

Rhythm and form

6 Trees are great subjects for practicing mark-making and discovering how to move your hand to express differences between leaves and bark, for example. Change the pressure, speed, length, and direction of your lines to create a range of marks that together evoke the character of the tree.

Bark

Bark is the skin of a woody plant. Like skin, bark is complex and it breathes, absorbs, and releases moisture, protects, sheds dead layers, and changes with age. The best way to understand bark is to look at the whole vascular system of a woody plant. Two types of tissue, xylem and phloem, act like a national grid of highways and roads connecting every part of a plant from its roots to its highest leaves. They look like small, open tubes. Xylem is found inside stems, and is strengthened with a material called lignin. It provides the structural framework of the whole plant. Xylem tissues transport water and trace minerals from the soil to the leaves. Phloem is found inside the bark surrounding a woody stem and it carries nutrients, or sap, down from the leaves to other parts of the plant. Spare nutrients are stored in the roots.

Just below the bark is a layer of dividing cells called the cambium. Cells that occur inside this ring become xylem, and those outside become phloem. If you look at a cross-section of a woody stem, xylem appears in rings, each representing one year of the stem's life. Rings are clearly seen in woody plants growing in cold climates, as they grow fast in spring and slowly in the summer. Rings are harder to distinguish in woody plants that grow in the tropics, where the temperature—and plant growth—is more even.

Only the outer layers of woody stems are alive; the heartwood at the very core of the stem is dead. Woody stems also expand as they grow, so bark therefore divides laterally to accommodate this new width. Bark varies greatly in appearance, and its expansion can create deep fissures, scale-like flaking, or make the bark peel away in strips. Trees with waxy bark, such as young cherry and birch, have special breathing holes, called lenticels, that look like mouths. These let gases in through the bark so they can reach cells inside the stem.

Thick coat of bark

Stamped herbarium label

Prominent lines, called rays

Liana vine (cross-section)
(*Sabia paniculata*)

Soft, gray, corky bark

Cambium

Naturally twisted, smooth hardwood stem

Liana vine
(*Oncinotis pontyi*)

Tropical lianas
These giant, tropical, woody vines (left) drape from tall rain forest trees. In woody stems like these, prominent lines radiate from the center of the plant, showing that the plant has grown quickly. They do not have visible rings because they grow in even temperatures.
Liana vine (*Sabia paniculata*, *Oncinotis pontyi*)

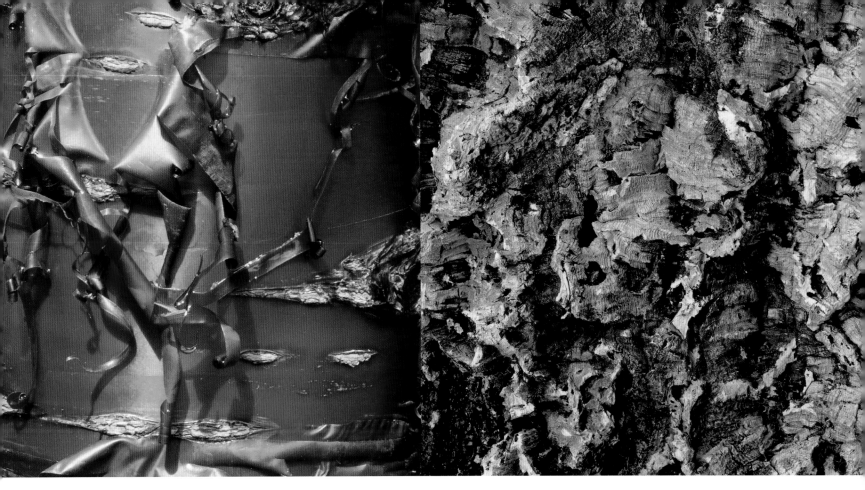

Peeling bark
Tibetan cherry bark (above) peels into horizontal papery strips. The small elliptical holes in the bark's surface are breathing holes called lenticels.
Tibetan cherry (*Prunus serrula*)

Fissured bark
The bark of the fast-growing evergreen catalina ironwood (below) stretches and cracks vertically into fine fissures to expose its reddish-brown stem beneath.
**Catalina ironwood
(*Lyonothamnus floribundus*)**

Regenerating bark
The thick, spongy bark of the cork oak (above) is a renewable resource. Once it has been harvested to be made into corks and bottle stoppers, a new layer of cork grows.
Cork oak (*Quercus suber*)

Scaly bark
Plane trees (below) have small, rounded, disk-like flakes of bark that absorb pollution and allow air to enter beneath them. They darken with age and then fall away like dead skin cells.
London plane (*Platanus* x *hispanica*)

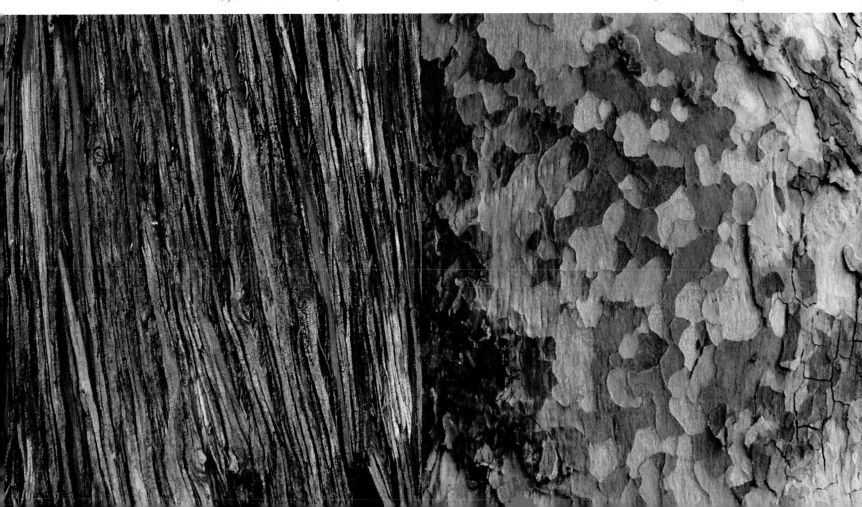

Trees in the landscape

Hours spent drawing in the open landscape are a gift. Drawing gives us time to stay still, be focused, and see the complex activities of wildlife. And as we draw, the elements and nature will surely get involved. Wind snatches all unguarded paper. Rain spits unseen on the page, and as the pen nib cuts through an invisible droplet, a tiny flood of water completely shifts the shape and meaning of the mark. Insects flick yellow stains; birds land larger ones, and as yet another stumbling ground beetle takes a wrong turn into your boot, ants lay claim to where you are seated. For one week in April, from early morning till dusk, and faced with a tide of rapidly unfurling spring

leaves, I worked swiftly to draw all the trees in this book, to capture the detail of their stems and branches before they dissolved for another summer under a fresh coat of green. While drawing the oak that is seen here (far right) and the linden tree on page 91, I witnessed most of their leaves open in just one day.

I chose this stand of cedars and oak for their beautiful contrasts in habit and shape, and drew them as I looked out from under a hawthorn at the edge of a neighboring wood. I always sit under a low-canopied tree so that I can

wedge a sturdy umbrella into the branches above my head. This provides vital shade from three problems: direct sunlight, which on white paper is blinding; small flickering shadows that interfere with composition and tone; and birds, who can destroy drawings with one simple maneuver as they pass overhead.

Light changes constantly. Mists melt into brightness. Cloud cover dulls all contrasts. Bursts of sun sharpen or bleach our view. At dawn and sunset light streams at a low angle onto the land and brings with it rich colors and deep shadows. As the sun moves through the day, branches that were dark in the morning become pale by the evening, and vice versa. This makes it important to choose one time of day and stay with that choice. This drawing took about 20 hours to complete, and the light proved best in the evening. On the first day I used an HB pencil to mark the shapes and structures, distinguishing tree species and avoiding all significant tone. On the second day I gently marked all the textural details with ink until sunset. Then for one brief hour I plunged with full commitment into drawing the greatest highlights and the deepest shadows of the composition.

Bird and flowers
Kanō Yukinobu

An old inscription on the box that holds this unsigned, unsealed hanging scroll attributes it to Kanō Yukinobu, an eminent Japanese artist living in the late 16th and early 17th centuries. This painted scroll offers a small, portable window into a winter garden. It captures a fleeting moment of a bird perching among plum blossom on a craggy branch that is interwoven with bamboo. Bird and flower painting is a traditional genre in Asian art, practiced for many centuries by different schools of artists, particularly in China and Japan. These works are characterized by a strong emphasis on the use of brush and ink, with minimal touches of color. They are made on fine paper and are usually mounted on silk.

In 10th-century China four plants were chosen to represent the four seasons and the virtues and ideals of a Confucian scholar and gentleman. These plants, called the Four Gentlemen, are the orchid, bamboo, chrysanthemum, and plum blossom. The textures and shapes of the four plants embody all of the elementary brush strokes learned by novices and practiced by masters of traditional Eastern brush painting. The four plants are standard subjects, so appear in thousands of works of ancient and contemporary art. The techniques for painting them are taught together as a complete discipline, but the plants can appear in paintings separately or in combinations. Here we see two of the Four Gentlemen.

Bamboo represents summer and embodies constancy, balance, integrity, simplicity, and a readiness to serve. Plum blossom appears in January, so represents winter, continuity, and hope. Here the asymmetrical balance of the plum branch, with its main stem to the right and forked branches to the left, expresses the Japanese love of harmony. Look at how repeated broad brush strokes create dark, spiky bamboo leaves, to contrast with the paler, wavy-edged foliage of the plum tree. Traditional Asian brush painting is associated with Zen philosophy and meditation. Precise brush strokes are laid down in harmony with the artist's breathing and the balance of his whole body. Each painting focuses on the spirit and meaning of the subject.

Closer look

Plum blossom
Finely honed technique and controlled speed give stylized works spontaneity and freshness. Here, long, thin ink strokes outline each petal. When dry, white paint was quickly added within the outlines. Small flecks of yellow lift the stamens out of the pale shadows.

Bamboo sprig
The cluster of spiky bamboo leaves was painted thickly, to create a dark, flattened, star-like pattern across the lower right of the painting. They frame the soft plum blossom and bird and counterbalance the empty sky, top left.

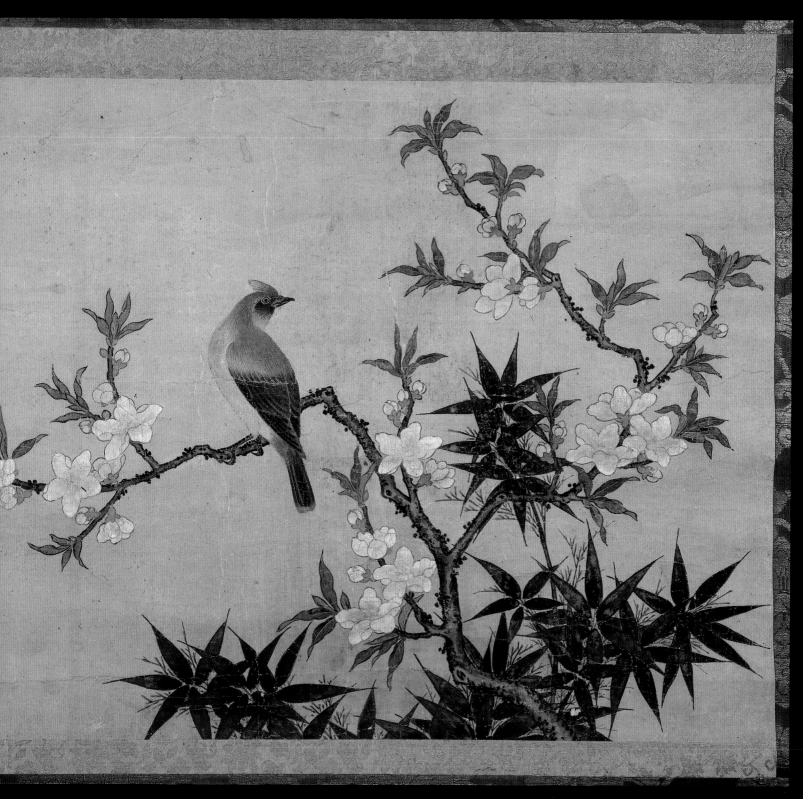

Bird and Flowers
Late 16th–early 17th century,
hanging scroll painting, 14¾ x 23½in (37.5 x 59.4cm),
British Museum, London, UK

Composition

An artist makes a composition by deliberately controlling the relationship between forms, or marks, the space or frame they occupy, and the viewer. By subtly joining these elements together, perhaps in ways the viewer is unaware of, the artist can create drama or quiet, harmony or discord, and illusions of space and form. When you start to draw, the four edges of the paper are the first four lines of your drawing and every mark you add is connected to them. It matters whether the paper is square or oblong, upright or horizontal, with a crisp or a tattered edge. These factors are part of the picture and discreetly change the meaning and impact of the image. Some aspects of pictorial composition are shown here in relation to drawing trees both in the open landscape and in an art gallery. Much can be learned by drawing other artists' works to discover what they did as the movements of your own hand follow theirs.

Framing a landscape
We can see how artists have traditionally painted trees by walking through a gallery of classical paintings. When trees are used to frame a landscape, as here, a large group is often placed on one side in the foreground so that it touches three edges of the frame. A smaller group of trees, which is half the height of the main group, is painted opposite. Smaller and paler stands of trees alternate to the left and right and recede into the distance, leading us into the bright central space.

Small sketches
These three small sketches of imaginary trees illustrate how to relate the shape and orientation of the paper to the subject. Small sketches are also useful for focusing on the essential habit and shape of a plant. These are important points to work out before embarking on a larger drawing.

Contrasts in size
Sometimes trees are made enormous in paintings so that they loom as great canopies over tiny human narratives playing out in the grass below. This sketch of a painting is a classic example of how massive contrasts in size can be used to make large elements of a picture look larger, and small elements even smaller. It is also interesting to discover which artists knew the shapes of different species, and which artists painted billowing generic impressions of trees instead.

Distance and space
Landscape painters rarely place the horizon in the middle of a picture. If they do, it can look plain and indecisive. Landscape picture height is often divided into three equal parts, with one third given to land and two thirds to sky (as here), or the other way round. If the sky occupies the greater part of the picture, a huge sculptural cloud mass may be featured in perspective. Contrasts between huge clouds and small trees or hedges and buildings amplify impressions of distance and open space.

Light effects

Strong light can be used to dramatic effect if it floods in from one side of the picture. It deepens and clarifies sculptural forms by contrasting areas of illumination and shadow. When working outdoors, these effects are best seen at dawn and dusk when the sun is low. Skies rarely appear white, and lines made to define tone can be angled to amplify the height and direction of the sun. The choice of color and texture of these lines can also evoke temperature and the speed of wind.

Connecting different elements

An image can look flat without any tone or texture in the sky around it. A dark tree against the uniform white light of the drawing paper (above left) casts the tree as a simple silhouette. When drawing outside, never face the sun. In the blinding glare you will barely be able to perceive forms, and will end up creating flat drawings like this. A few pale strokes to indicate the horizon and lighten the edge of a group of trees can quickly connect the subject to a white sky (above right).

Adapting a composition

Here, a conifer has been drawn twice on the same sized sheet of paper. In one picture (left), it stands alone and appears centerd; in the other (above), it has been drawn with a smaller tree to its left. This ties the composition to the left side of the frame, and appears to move the largest tree aside. So the apparent position of an element in a picture can be moved by adding something else. Large trees look larger if you draw some smaller specimens beside them.

Cropped composition

Here, trees fill the frame and are cropped on all sides. This barrier of trees has the effect of enclosing the viewer in a short pictorial space, with no clear way around. We are held captive as we look.

Emphasizing character

Slender stems increase the width of thick stems, and vice versa. Contrasting a craggy old trunk with a smooth young sapling amplifies the character of both. Upright and diagonal lines contrast well, too.

Studying a tree's habit

The stem growth and overall habit of a tree are greatly affected by environmental conditions such as available light, strong wind, cold temperature, competition from other plants, and the steepness of the ground. Struggling plants that have become gnarled and twisted are great subjects for artists to draw.

Thumbnail sketches of a species

It is useful to sketch and compare numerous examples of the same species. Thumbnail sketches of huge trees can immediately reveal the sweep of branches, the leans and twists of the central trunk, which direction the wind blows, and how the whole tree stands or leans toward the ground. Cover a page in oak trees, for example, to learn how to recognize and distinguish them from other trees.

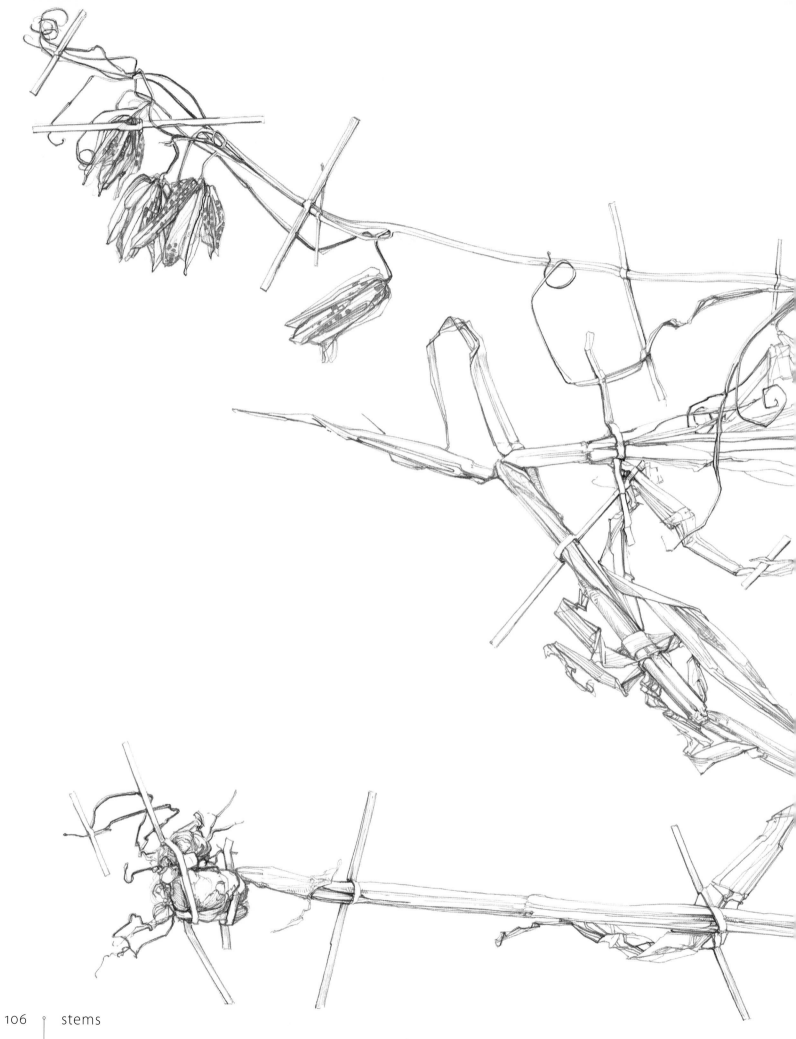

STUDY
Folded fritillary

This pale yellow fritillary (called Zhe Bei Mu locally), drawn in pen and ink, bloomed in the moist shade of a bamboo forest in Mei Chi, China, 128 years ago. A botanist pulled it from the earth and folded its stem to fit it inside a press. It now belongs to the General Herbarium of the Natural History Museum in London. I chose to draw it because I was excited by its grace and composure on the page and its likeness to a piece of text or a letter—one part of an imagined alphabet lost among the shelves of the herbarium.

Fritillary specimen
Fritillaries are spring flowering bulbs that belong to the lily family. About 100 species are native to temperate regions in the northern hemisphere. Their pendent flowers are checkered in shades of purple, yellow, green, and white. This plant was collected in 1881 and is 4 ft (1.2 m) tall.
Fritillary (*Fritillaria thunbergii*)

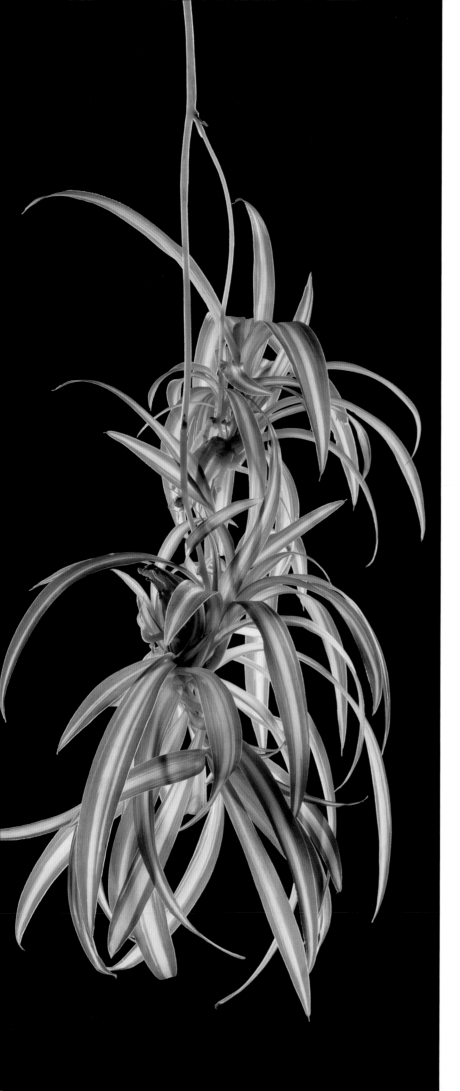

Runners

Weak-stemmed plants cannot support their own weight so they either rely on other structures for support, hang freely in the air, lie flat on the ground, or float in water. Many have hooks and tendrils to help them climb rocks or twist around other plants. Four types of relatively low-growing weak stems—runners, offsets, stolons, and suckers—enable plants to reproduce vegetatively by replicating themselves: they each develop daughter plants at their tips or along their stems, or they grow as a new plant. These new plants are all genetically identical to their parent.

A runner is a slender, elongated stem that runs along the ground from its parent plant sprouting roots and shoots from its nodes at intervals to create new plantlets. Runners grow indefinitely in all directions to colonize a surrounding area; wood sorrel (top right) is a typical example.

Offsets are lateral stems that behave like runners, but are short and thick and produce one plantlet at their tip. Offset plantlets normally break away from their parent to live independently when the offset stem withers. They are only found on plants that have rosettes of leaves, such as water lettuce and water hyacinths.

Stolons look like runners, but differ in that their long, slender stems rise obliquely through the air rather than along the ground, and develop aerial plantlets. As they gain in weight, the stolons bend down to the ground where the plantlets take root. Spider plants and strawberry plants are among many diverse species that multiply by growing stolons.

Suckers (not illustrated here) are long, lateral stems that sprout from roots beneath the ground. They grow at an angle up through the soil, emerging a short distance away from their parent. Suckering plants include roses, chrysanthemums, banana, and bamboo.

Spider plant
This popular houseplant (left) normally lives at ground level. It produces stolons (slender, branched stems), which bear small white flowers and "baby" plantlets at their tips. The plantlets root vigorously once they touch the ground.
Spider plant (*Chlorophytum comosum*)

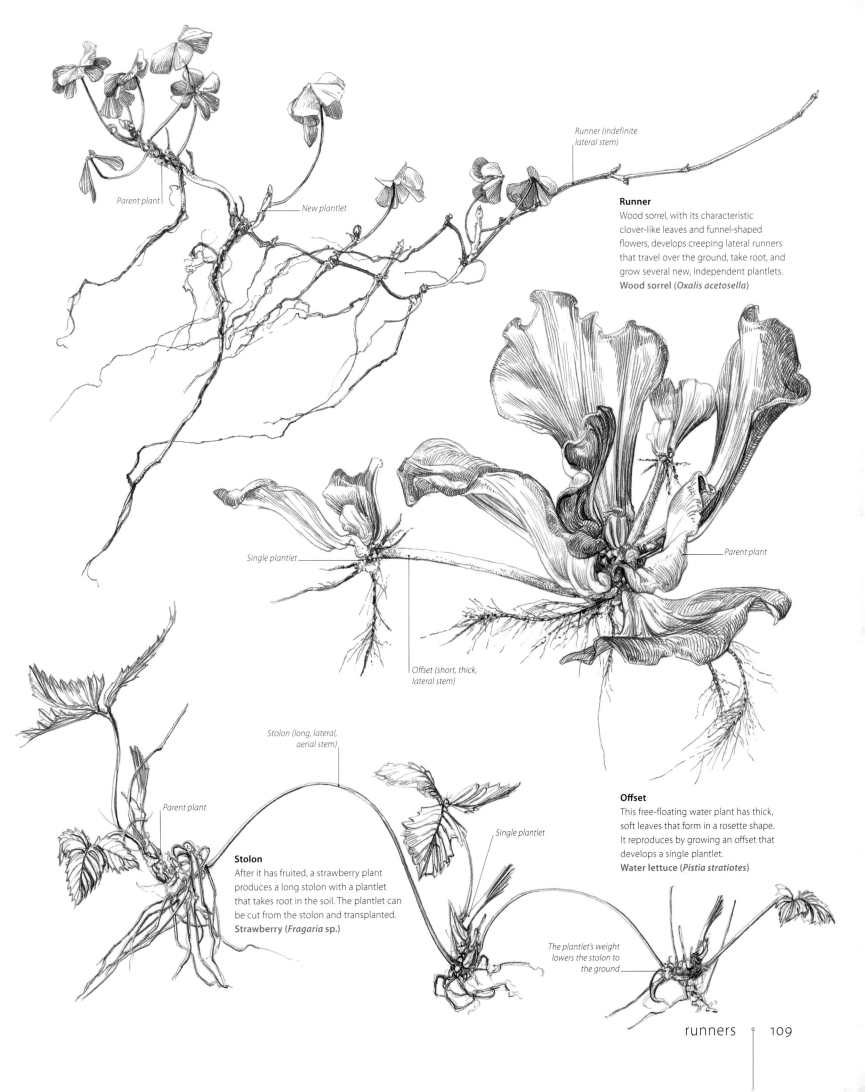

Runner (indefinite lateral stem)

Parent plant

New plantlet

Runner
Wood sorrel, with its characteristic clover-like leaves and funnel-shaped flowers, develops creeping lateral runners that travel over the ground, take root, and grow several new, independent plantlets.
Wood sorrel (*Oxalis acetosella*)

Single plantlet

Parent plant

Offset (short, thick, lateral stem)

Stolon (long, lateral, aerial stem)

Parent plant

Offset
This free-floating water plant has thick, soft leaves that form in a rosette shape. It reproduces by growing an offset that develops a single plantlet.
Water lettuce (*Pistia stratiotes*)

Stolon
After it has fruited, a strawberry plant produces a long stolon with a plantlet that takes root in the soil. The plantlet can be cut from the stolon and transplanted.
Strawberry (*Fragaria* sp.)

Single plantlet

The plantlet's weight lowers the stolon to the ground

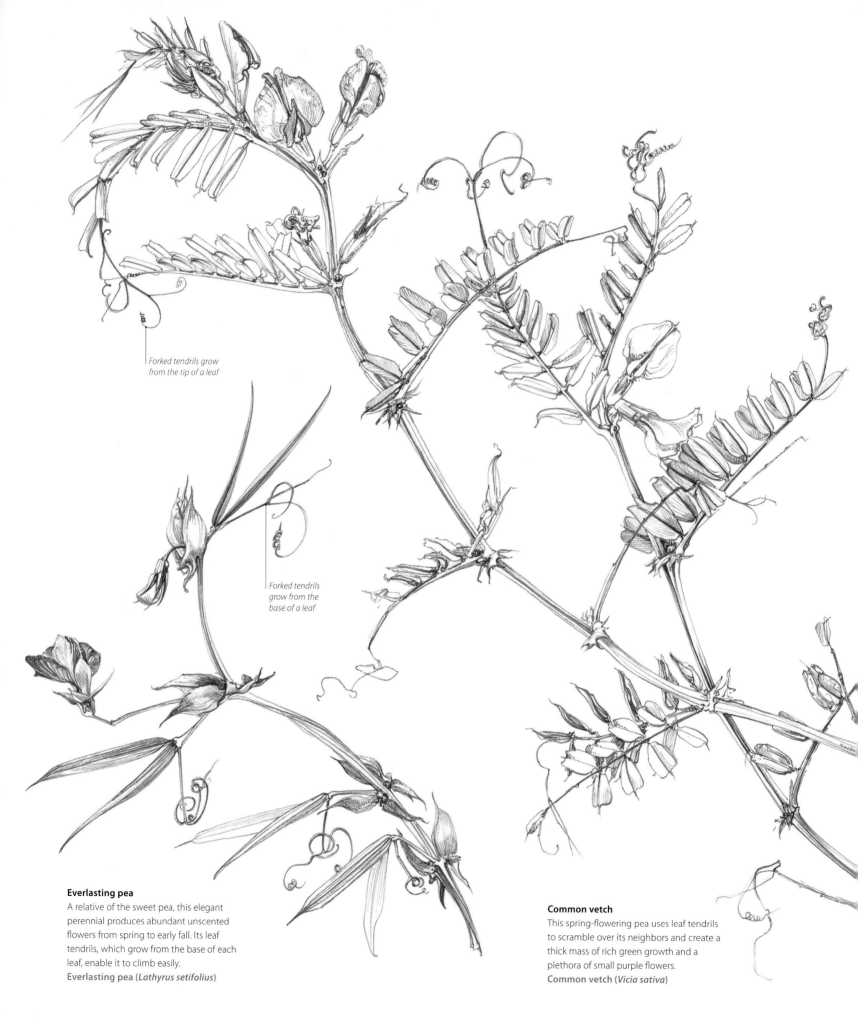

*Forked tendrils grow
from the tip of a leaf*

*Forked tendrils
grow from the
base of a leaf*

Everlasting pea
A relative of the sweet pea, this elegant
perennial produces abundant unscented
flowers from spring to early fall. Its leaf
tendrils, which grow from the base of each
leaf, enable it to climb easily.
Everlasting pea (*Lathyrus setifolius*)

Common vetch
This spring-flowering pea uses leaf tendrils
to scramble over its neighbors and create a
thick mass of rich green growth and a
plethora of small purple flowers.
Common vetch (*Vicia sativa*)

Climbers

Climbing plants produce another form of weak stems. Their thin, elongated stems wrap themselves around, clasp, or hook onto fixed structures so that they can grow upward toward the light. Root climbers, such as ivy or *Monstera* (see p.79), climb using lateral roots along their stems. Hook climbers, such as brambles and some roses, use prickles to catch onto surfaces and raise themselves aloft. Tendril climbers put out delicate feelers that wave in the air until they touch and then coil around something they find nearby. Tendrils are modified stems or leaves. Leaf tendrils develop from the tip or base of a leaf, both of which are drawn here; tendril stems can be seen on passionflowers (see overleaf).

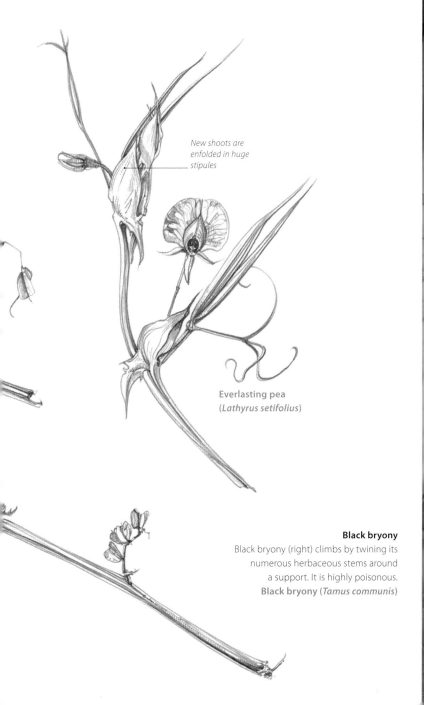

New shoots are enfolded in huge stipules

Everlasting pea
(*Lathyrus setifolius*)

Black bryony
Black bryony (right) climbs by twining its numerous herbaceous stems around a support. It is highly poisonous.
Black bryony (*Tamus communis*)

Passiflora caerulea
John Miller

John Miller (1715–c.1790) was born Johann Sebastian Müller in Nuremberg, Germany, and changed his name when he moved to London in 1744. He worked on numerous botanical publications, and today more than a thousand of his original drawings are kept in the Natural History Museum, London. This copperplate engraving of a white passionflower is hand-painted in watercolor, and is one of many luxurious illustrations that Miller drew for a book called *The Sexual System of Linnaeus*, that was published in parts between 1770 and 1799. Particular attention is given to the flower and fruit, and the inclusion of the root ensures that every aspect of this mature plant can be seen.

A printed botanical illustration is often called a plate, and most plates are made to complement the text. An accurate illustration can stand in place of a real plant, enabling botanists to see, identify, compare, and discuss a species. Such drawings are precise and invaluable documents full of information that are masterfully fitted into a relatively small space. They are not ornamental, but they can be very beautiful works of art.

I've chosen this illustration to show an example of stem tendrils. Miller has drawn the passionflower so naturally on the page that we barely notice how well he has manipulated it. He depicts the flower bud in three stages of development, and partially opened. The open flower is then viewed from the front, back, side, and in dissection, which makes eight views of the flower in total. The fruit is also shown as immature, mature, and in parts. The stem is described in section and in terms of how it branches and climbs. The leaves display all of their aspects (front, back, side), including their alternate arrangement along the stem, and their relationship to the tendrils. The severed ends of the stem and root are partly covered by a leaf to soften the notion that they have been cut, and while it is clear that this is a collection of plant parts, at a glance we see and believe in its entirety.

Passiflora caerulea
*1779, copperplate engraving,
Natural History Museum,
London, UK*

Closer look

Leaf and tendril patterns
Tendrils are modified buds that grow out of leaf axils (see p.111). The separate leaf and tendril growths are clearly visible above. Thin washes of watercolor, applied one at a time, help to bring these details alive.

Fruit and seed
Passionflower fruits are fleshy capsules (see p.215). The seeds inside are surrounded by acidic, pink, edible sacks called arils. The enlargement above shows the microscopic detail of one seed inside its aril.

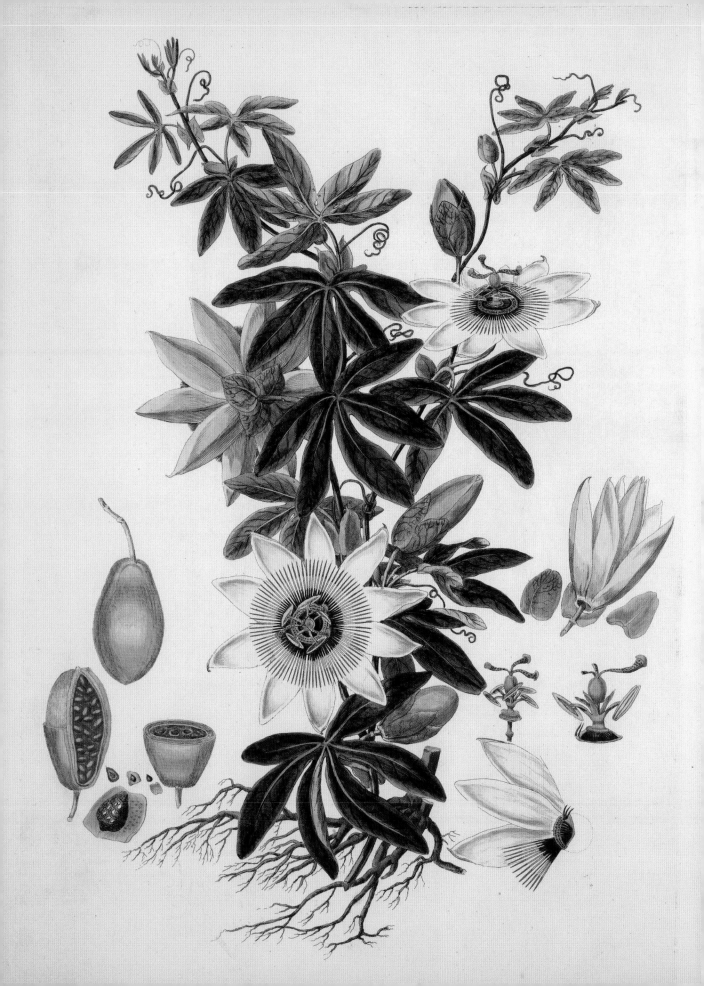

Wetland plants

Freshwater and marine wetlands are critically important environments. Mudflats, mangroves, low-lying fens, meadows, and bogs—all fed by streams and rivers—support diverse groups of wildlife and create natural flood defenses and water filtration. The stability of water levels in a wetland determines which plants will grow there. Wetlands can be permanent or seasonal: land that is flooded in winter may dry completely in the summer. The relative acidity or alkalinity of water also determines the range of plants that will grow in it, as will light levels beneath the water. Strong-stemmed wetland plants that rise out of water and stand unsupported are called emergents. The point at which water becomes too deep for flowering plants rooted in the soil to hold their heads above it is the interface between land-dwelling and submerged species. Plants that live entirely underwater, such as marine algae (far right), are known as submergents. Plants that float and hold their leaves flat on the water's surface, as water lilies do, are called floating aquatic plants.

Submergent and floating wetland plants all have weak stems and use water to support themselves. If they are lifted into the air, most of them collapse and lose their shape. The delicate plants illustrated here are all pressed and belong to a herbarium. They still seem abundantly fresh, yet the oldest of them flowered 204 years ago. Herbarium collections enable us all to see and study plants that in the wild grow out of our reach.

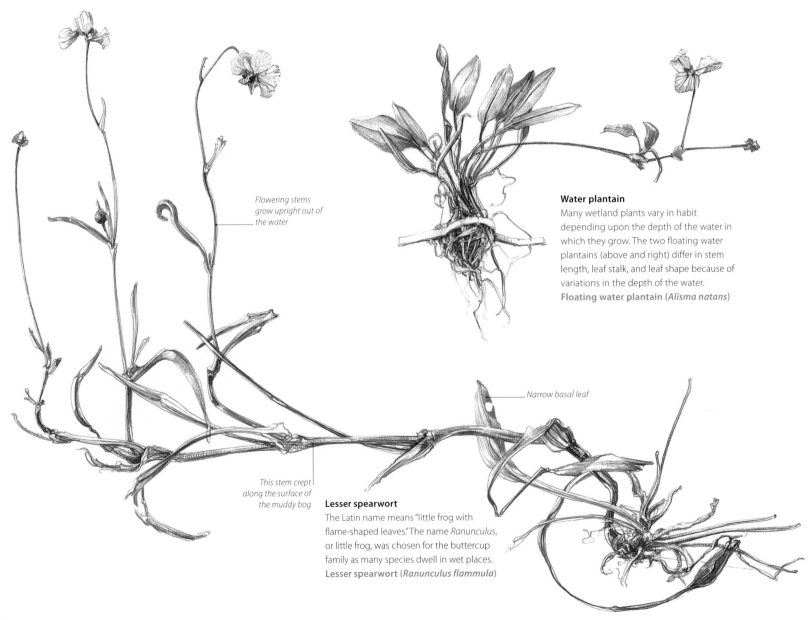

Flowering stems grow upright out of the water

Water plantain
Many wetland plants vary in habit depending upon the depth of the water in which they grow. The two floating water plantains (above and right) differ in stem length, leaf stalk, and leaf shape because of variations in the depth of the water.
Floating water plantain (*Alisma natans*)

Narrow basal leaf

This stem crept along the surface of the muddy bog

Lesser spearwort
The Latin name means "little frog with flame-shaped leaves." The name *Ranunculus*, or little frog, was chosen for the buttercup family as many species dwell in wet places.
Lesser spearwort (*Ranunculus flammula*)

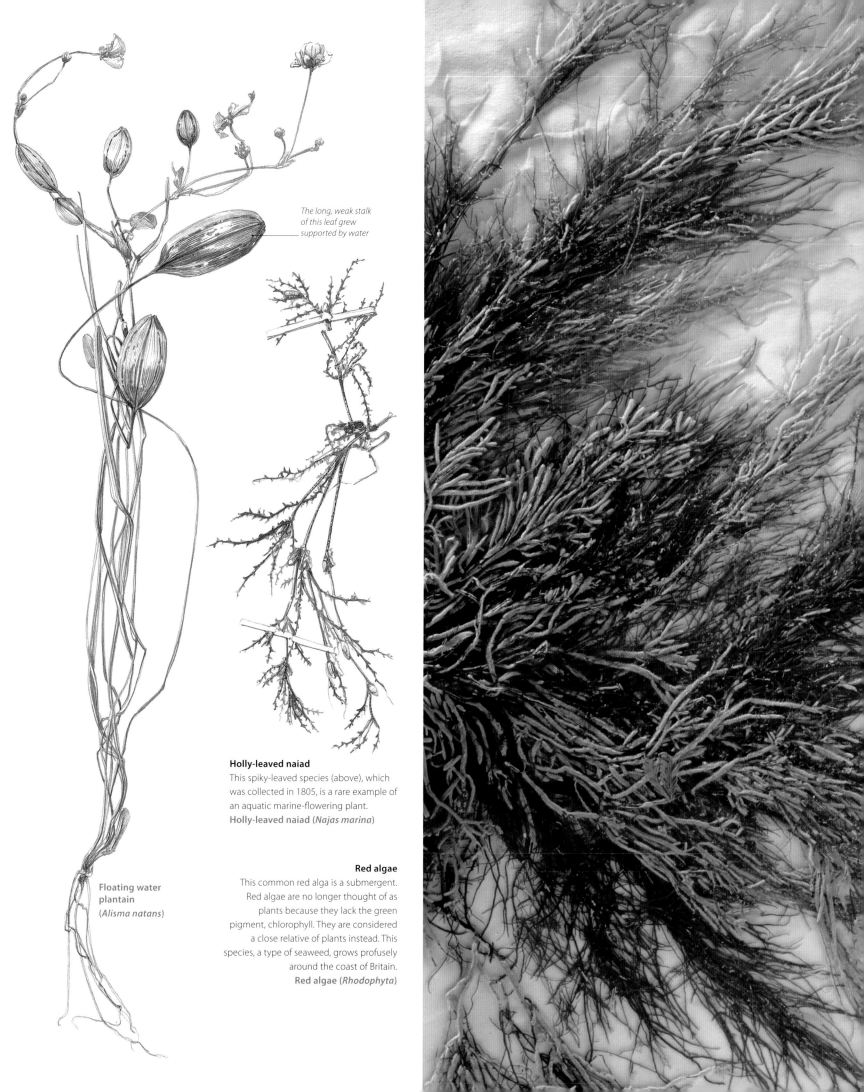

The long, weak stalk of this leaf grew supported by water

Holly-leaved naiad
This spiky-leaved species (above), which was collected in 1805, is a rare example of an aquatic marine-flowering plant.
Holly-leaved naiad (*Najas marina*)

Floating water plantain (*Alisma natans*)

Red algae
This common red alga is a submergent. Red algae are no longer thought of as plants because they lack the green pigment, chlorophyll. They are considered a close relative of plants instead. This species, a type of seaweed, grows profusely around the coast of Britain.
Red algae (*Rhodophyta*)

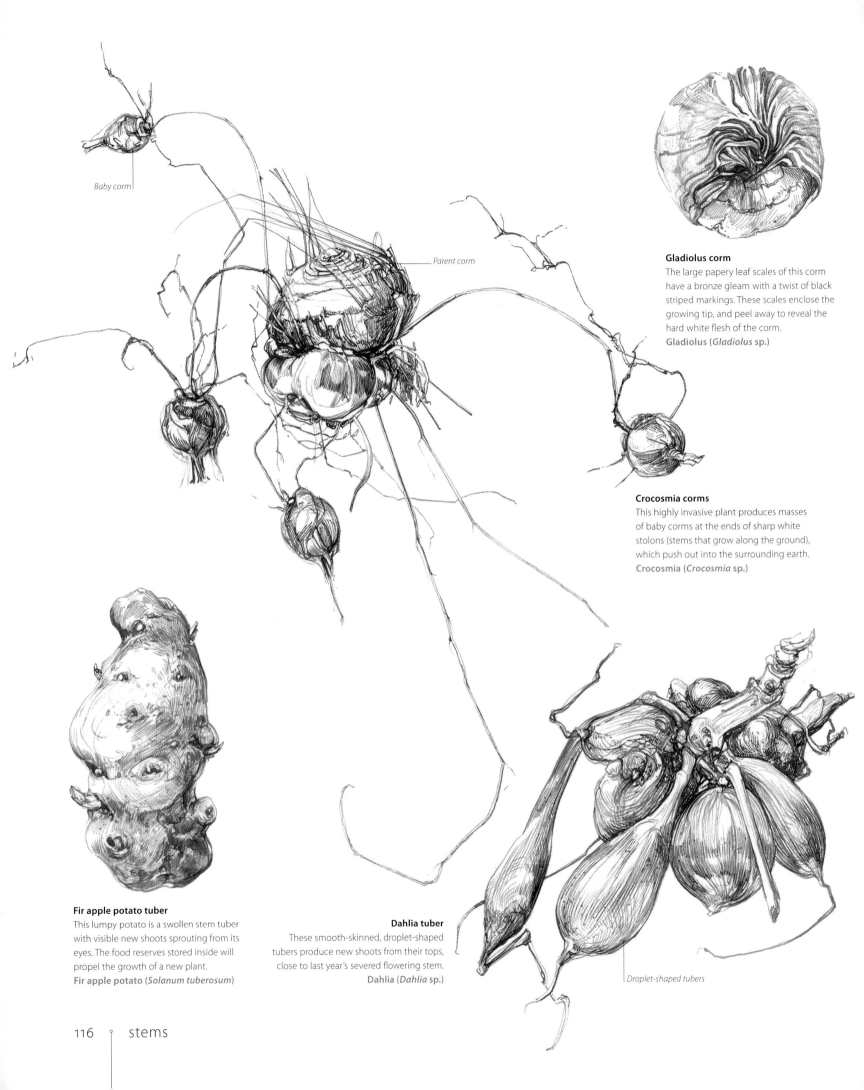

Baby corm

Parent corm

Gladiolus corm
The large papery leaf scales of this corm have a bronze gleam with a twist of black striped markings. These scales enclose the growing tip, and peel away to reveal the hard white flesh of the corm.
Gladiolus (*Gladiolus* sp.)

Crocosmia corms
This highly invasive plant produces masses of baby corms at the ends of sharp white stolons (stems that grow along the ground), which push out into the surrounding earth.
Crocosmia (*Crocosmia* sp.)

Fir apple potato tuber
This lumpy potato is a swollen stem tuber with visible new shoots sprouting from its eyes. The food reserves stored inside will propel the growth of a new plant.
Fir apple potato (*Solanum tuberosum*)

Dahlia tuber
These smooth-skinned, droplet-shaped tubers produce new shoots from their tops, close to last year's severed flowering stem.
Dahlia (*Dahlia* sp.)

Droplet-shaped tubers

Underground storage

Some herbaceous stems live permanently underground. Swollen and densely packed with food reserves, they survive cold, wet winters or hot, dry summers in a leafless, dormant state, waiting to sprout new shoots when conditions are good. Subterranean stems include bulbs, corms, tubers, and rhizomes. These all differ from roots because they have nodes from which buds grow and internodes, visible lengths of stem in between the nodes. Rhizomes, such as the iris (right), sprout roots like an insect's legs from their undersides and end in a terminal bud that dominates the next season's growth. Rhizomes usually grow horizontally just beneath or above the ground. The lily bulb (below) is a spherical mass of swollen leaf bases that enclose, protect, and feed new shoots rising from the flattened, disk-like stem at the base of the bulb. Tubers are the swollen ends of specialized underground branches, while corms are compressed, rounded, hard, vertical rhizomes covered in papery or fibrous scales.

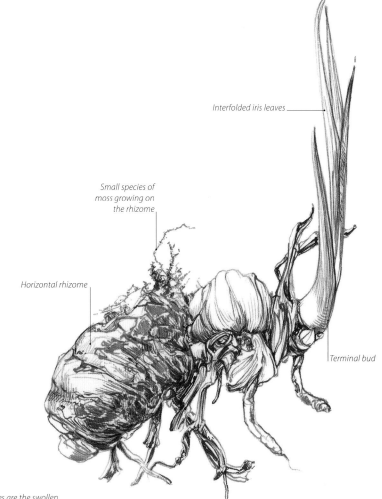

Interfolded iris leaves

Small species of moss growing on the rhizome

Horizontal rhizome

Terminal bud

Iris rhizome
This small, bug-like piece of rhizome has broken away from a larger, dense mass. After flowering rhizomes bake in the sun to ensure plentiful flowering in the following year.
Iris (*Iris* sp.)

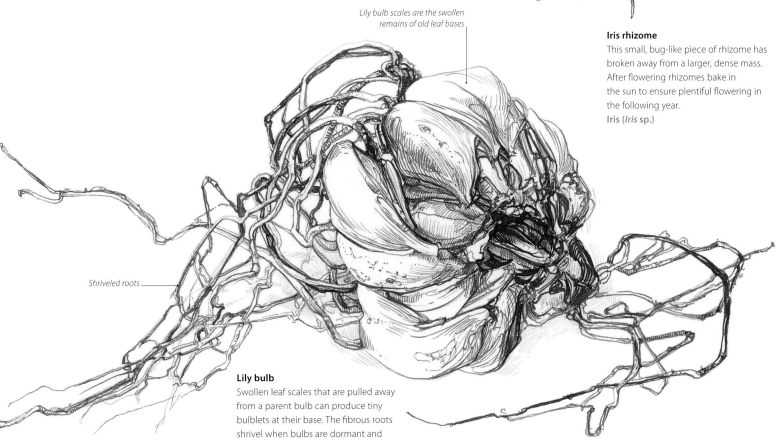

Lily bulb scales are the swollen remains of old leaf bases

Shriveled roots

Lily bulb
Swollen leaf scales that are pulled away from a parent bulb can produce tiny bulblets at their base. The fibrous roots shrivel when bulbs are dormant and regrow once active.
Lily (*Lilium* sp.)

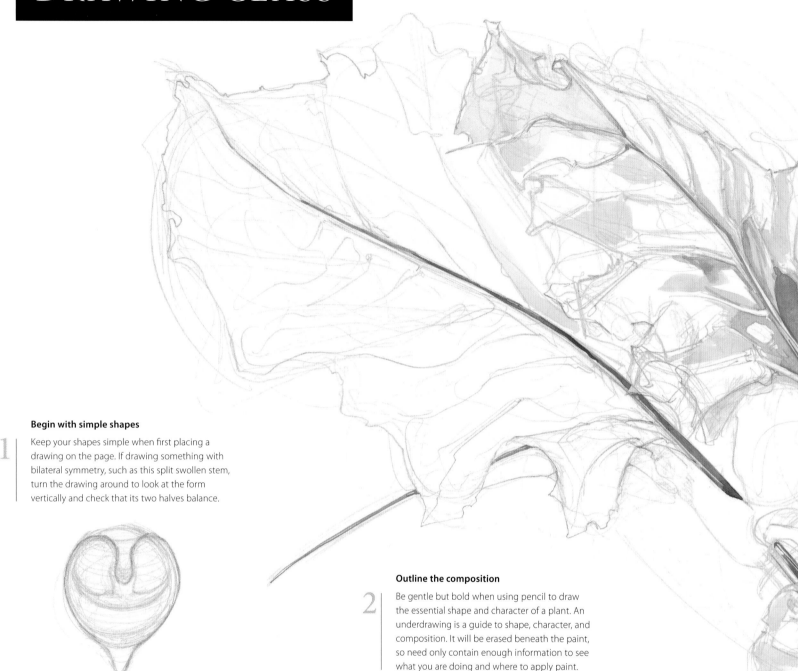

Begin with simple shapes

1 Keep your shapes simple when first placing a drawing on the page. If drawing something with bilateral symmetry, such as this split swollen stem, turn the drawing around to look at the form vertically and check that its two halves balance.

Outline the composition

2 Be gentle but bold when using pencil to draw the essential shape and character of a plant. An underdrawing is a guide to shape, character, and composition. It will be erased beneath the paint, so need only contain enough information to see what you are doing and where to apply paint.

Kohlrabi

I chose this weirdly beautiful plant as an example of a swollen stem, in which food reserves are concentrated above ground rather than in the root underground. Kohlrabi is a cultivated cabbage and probably originated as a field crop in the Mediterranean. The skin of this heavy vegetable is stained deep purple, and has a bloom on its surface like a plum. A prominent midrib rises through the center of each leaf and the plant looks more like a denizen of the sea than a cold-climate field crop.

First, I mixed a palette of tertiary colors (see above right) using transparent yellow, permanent rose, and ultramarine, and checked them against the plant. Then I followed the normal practice, when painting with watercolor, of applying pale washes first, and gradually darkened my colors until I reached the deepest hues. Once the whole image was completely dry, I added the bloom of the stem, by mixing white gouache with purple, and adding a few strokes of thin paint as swiftly as possible.

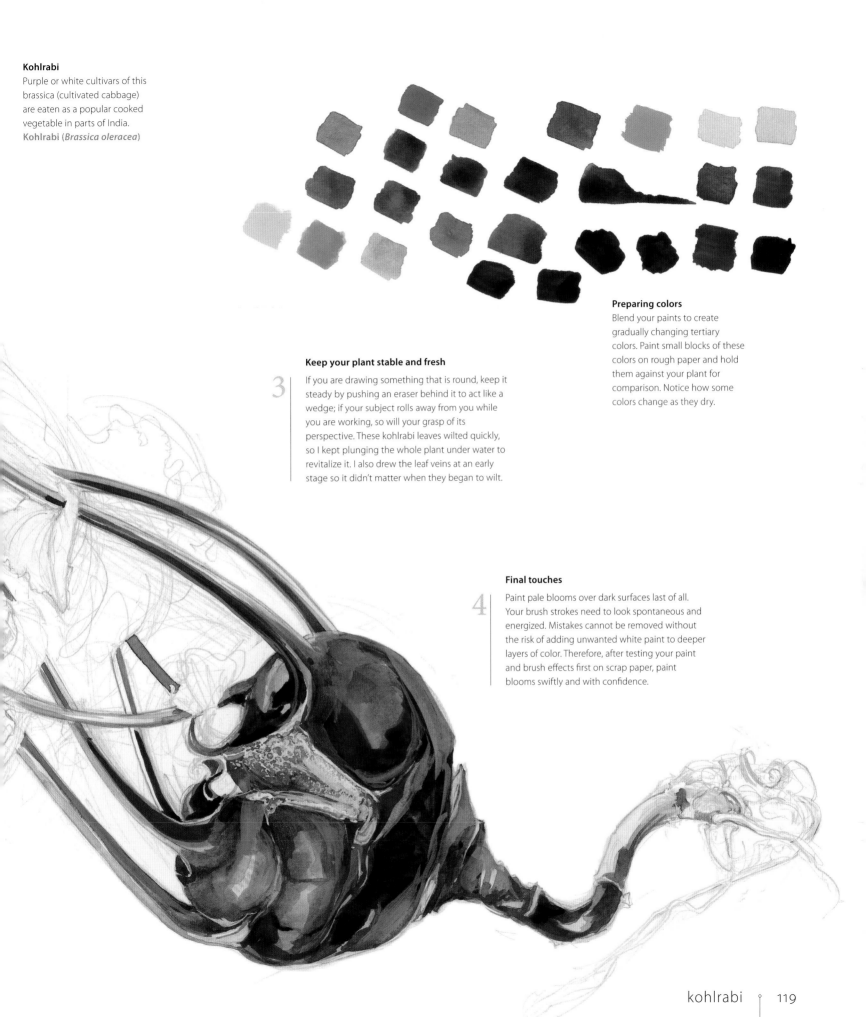

Kohlrabi

Purple or white cultivars of this brassica (cultivated cabbage) are eaten as a popular cooked vegetable in parts of India.

Kohlrabi (*Brassica oleracea*)

Preparing colors

Blend your paints to create gradually changing tertiary colors. Paint small blocks of these colors on rough paper and hold them against your plant for comparison. Notice how some colors change as they dry.

Keep your plant stable and fresh

3 If you are drawing something that is round, keep it steady by pushing an eraser behind it to act like a wedge; if your subject rolls away from you while you are working, so will your grasp of its perspective. These kohlrabi leaves wilted quickly, so I kept plunging the whole plant under water to revitalize it. I also drew the leaf veins at an early stage so it didn't matter when they began to wilt.

Final touches

4 Paint pale blooms over dark surfaces last of all. Your brush strokes need to look spontaneous and energized. Mistakes cannot be removed without the risk of adding unwanted white paint to deeper layers of color. Therefore, after testing your paint and brush effects first on scrap paper, paint blooms swiftly and with confidence.

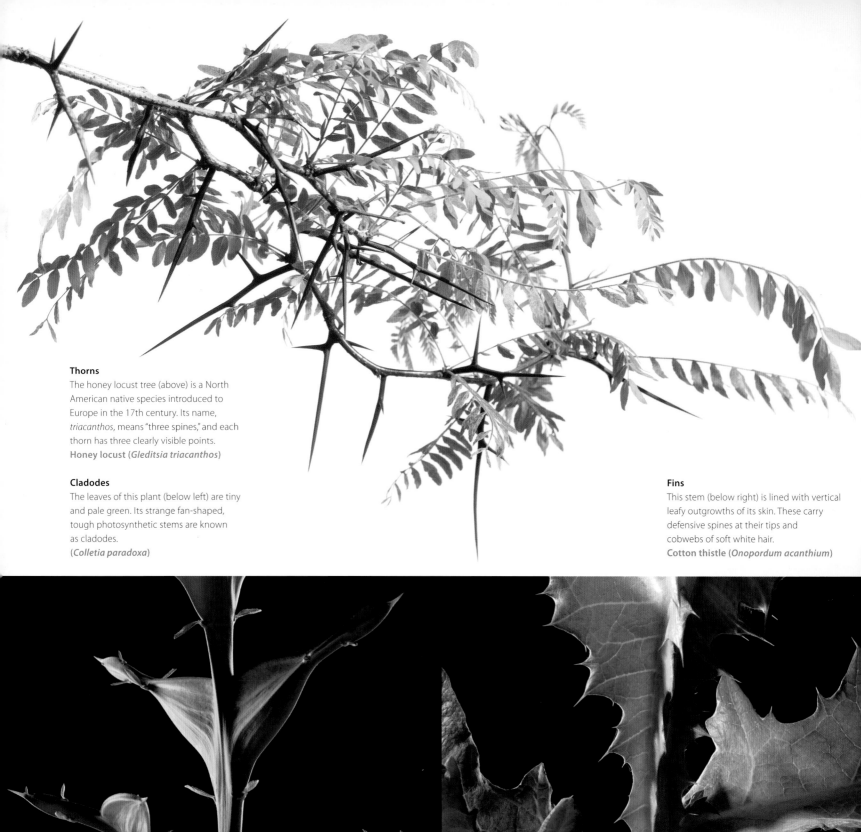

Thorns
The honey locust tree (above) is a North American native species introduced to Europe in the 17th century. Its name, *triacanthos*, means "three spines," and each thorn has three clearly visible points.
Honey locust (*Gleditsia triacanthos*)

Cladodes
The leaves of this plant (below left) are tiny and pale green. Its strange fan-shaped, tough photosynthetic stems are known as cladodes.
(***Colletia paradoxa***)

Fins
This stem (below right) is lined with vertical leafy outgrowths of its skin. These carry defensive spines at their tips and cobwebs of soft white hair.
Cotton thistle (*Onopordum acanthium*)

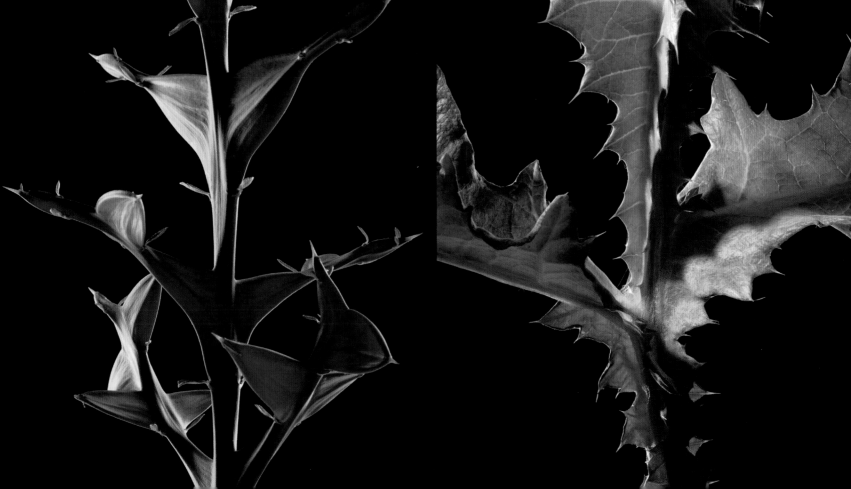

Modified stems

All thorns are modified shoots that grow directly out of the deep tissues of a plant stem. They occur at nodes, which are a plant's equivalent to joints, and in leaf axils, which are like the armpits of leaves. The thorns of a honey locust tree (left), for example, are rigid, fearsome structures, evolved to deter grazing animals. The thorns of roses and brambles are not thorns at all, but prickles, skin growths that are easily rubbed off. Some climbing tendrils (right) are modified stems, while bulbils (below) are modified buds that fall to the ground and develop into new plants. *Colletia* (bottom far left) is a desert plant that has strange, flattened, fin-like stems, called cladodes. These stems produce food in place of the plant's tiny, reduced leaves. Cladodes are distinctly, but subtly, different from the leafy skin growths found on other plants such as the cotton thistle (bottom left).

Garlic bulbils

Bulbils
Bulbils (above) are modified buds that grow into new plants. They occur in the leaf axils of many lily stems, and cluster at the top of the flowering stems of members of the onion family.
Garlic (*Allium sativum*)

Tendrils
The sensitive and coiling tendrils of passionflowers are all modified stems, which enable the plants to climb. Each tendril grows out from the main stem opposite a leaf and this can be seen clearly on pp.112–113 and pp.148–149.
Passionflower (*Passiflora* sp.)

Skin surfaces

The surface details of plants are fascinating to explore with a hand lens, as they can be covered with waxes, prickles, bristles, spines, or even sticky hairs. Like mammals, plants are often covered in hair, and a hairless plant is unusual—although the agave (below, center left) is hairless. It is also coated in wax to reduce water loss. The skin surfaces of most plants have evolved to insulate or protect them from drying out or being eaten by animals. The exceptions are those plants that themselves eat animals and therefore need a way of catching their prey. The sundew plant (below, far right) glistens with sticky hairs that trap flies so they can be digested.

The beautiful rose stems (below left) bear defensive red prickles. Prickles are skin growths that usually occur randomly along stems and on the veins of leaves, and are often hooked to help plants climb. These prickles are especially large, richly colored, and arranged around each stem in three vertical rows. Tiny bristles also grow on the stem's skin in between the prickles. Borage (below, center right) is smothered in bristles: stiff, needle-like hairs that are sharp to the touch. Bristles can also be barbed. Stachys (above right) is one of the hairiest of familiar plants. Its woolly white coat, which is pleasant to touch, insulates it against cold and water loss, and

Prickles
This species of rose has unusually ordered and upright prickles, arranged neatly in vertical rows. Short, stiff bristles are also visible along the skin of the stem.
Rose (*Rosa* sp.)

Smooth (glabrous) skin
All smooth plant skin is described as glabrous. Some, but not all, glabrous plants are also coated in wax, like this desert-dwelling agave, to limit water loss.
Agave (*Agave* sp.)

prevents ice crystals from forming on its skin. It also repels grazing animals by creating an unpleasant or choking sensation in their mouths and throats when they try to eat and swallow it. The glassy hairs of nettles (see p.191) are sharp vials full of skin-enflaming acid. Spines are adaptations or extensions of leaves. The cotton thistle (see p.120) bears spines along its leaf margins, while cacti leaves (see p.88) are reduced to piercing spines.

Trichomes (hairs)
Stachys is a native of high altitudes, and has a thick coat of white hairs to insulate it against ice and water evaporation. White hair also reflects light and deters animals.
Stachys (*Stachys byzantina*)

Glands
The sticky excretions of the sundew plant trap flies. They look like beads of water to insects, attracting them with the prospect of a drink. Long , delicate strands of upward-facing hairs cover its leaf stalks.
**Round-leaved sundew
(*Drosera rotundifolia*)**

Bristles
A thick coat of stiff, white bristles covers the stems and leaves of borage. These bristles are sharp to the touch and a repellent to animals.
Borage (*Borago officinalis*)

Blackberries
Leonardo da Vinci

The Italian Renaissance painter and inventor, Leonardo da Vinci (1452–1519), used drawing to look closely at the world that surrounded him, and to think deeply about it. He had a restless desire for knowledge and understanding and filled notebooks with observations and ideas, many of which were centuries ahead of their time. When making botanical drawings, Leonardo searched for pattern and geometric order. Here he has used red chalk on paper to study the growth patterns of a fruit-laden blackberry stem.

In this study a shoot arches through a shallow slice of pictorial space, parallel to the surface of the picture, rather than being placed in a deep perspective. Eleven fruit-bearing branches are drawn as if pressed out to the sides of the main shoot. Leonardo has discreetly opened up and flattened the plant, as if a diagram, to reveal where and how every part of it connects. Notice how few parts of the plant overlap anywhere in the drawing, so as to make its growth pattern clear.

The drawing is made in natural red chalk, called sanguine (meaning blood), which is iron oxide suspended in tight clay. Sanguine renders hard, sharp lines and soft tones, and is perfect for drawing a plant. Leonardo advised that there are four kinds of light to observe when drawing any subject: diffused light, which he described as "that of the atmosphere, within our horizon," meaning the light we experience on a cloudy day; direct light "as that of the sun or an open window"; reflected light, which he also called luster; and a fourth "which passes through semi-transparent bodies such as linen or paper." Light can also pass through thin leaves, but here, in depicting the thick, shiny leaves of a blackberry and gentle shadows, Leonardo appears to have only drawn diffused and reflected light.

Closer look

White highlights
To freshen this drawing in the late stages, Leonardo added small touches of white pigment to lift forms out of the shadows. These are featured in the detail above and upon leaves and stems around the center of the drawing.

Creating form with line
In the top left quarter of the drawing, Leonardo has quickly sketched circles to mark out his first thoughts on where to draw the leaves. Parallel tonal lines (as seen here in this detail) carve out the entire subject as if in shallow relief.

Blackberries
c.1505–1510, Red chalk, pen, and touches of white pigment on pale red prepared paper, 6 x 6⅜in (15.5 x 16cm), The Royal Collection, London, UK

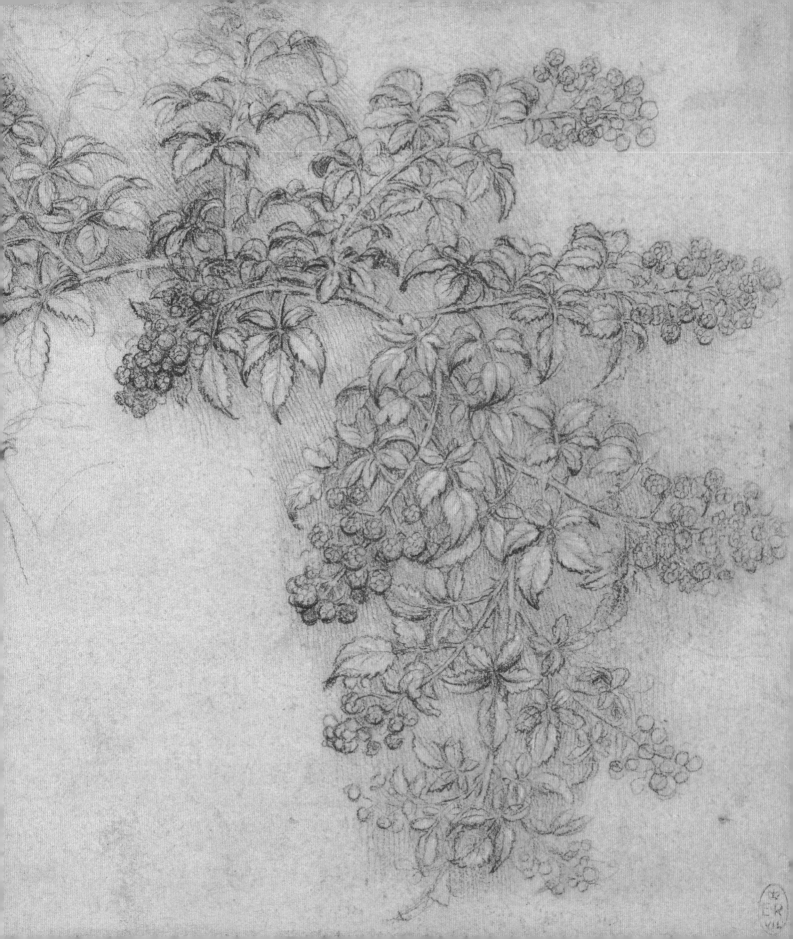

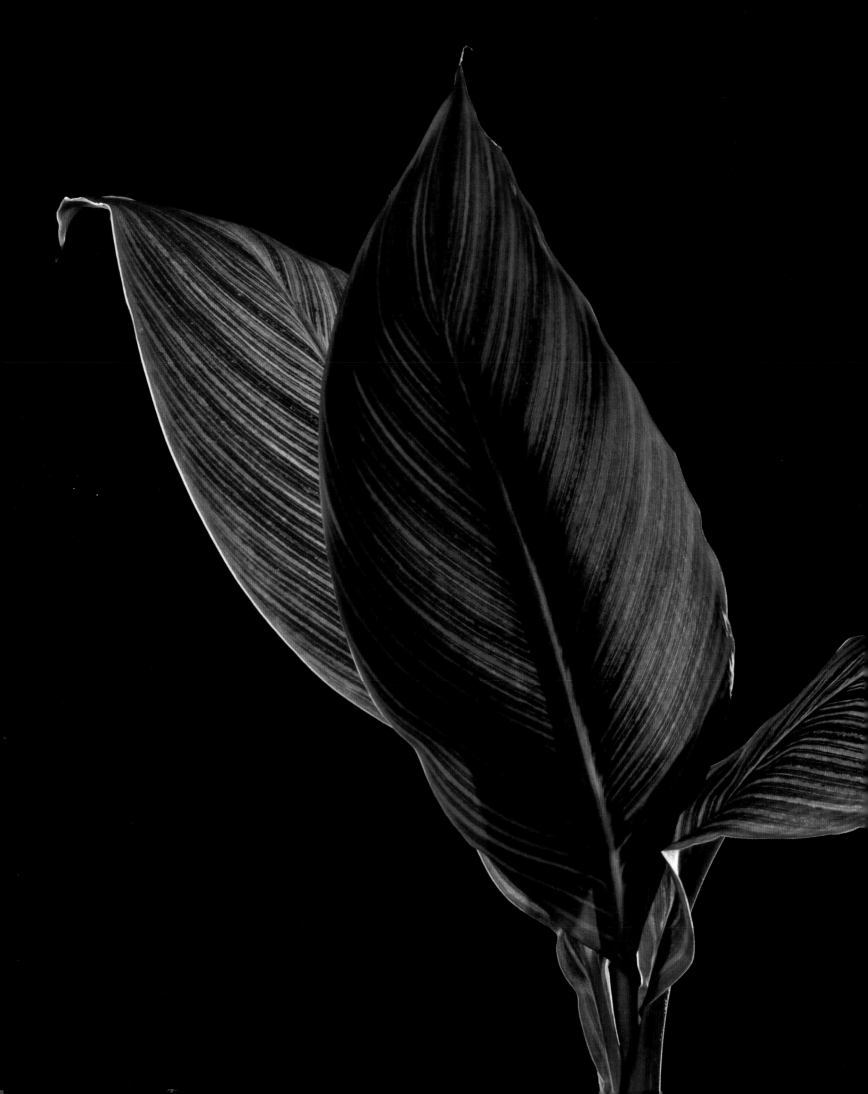

Leaves

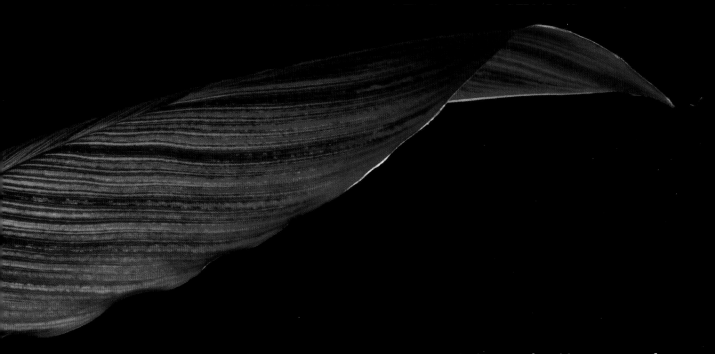

Leaves gather light. They convert energy from sunlight into food by means of a process called photosynthesis. Photo means "light" and synthesis means "putting together." Plants literally use light and a light-sensitive green pigment called chlorophyll in their leaves to transform water and carbon dioxide into sugars to feed themselves and the whole of the plant that supports them.

ntroduction

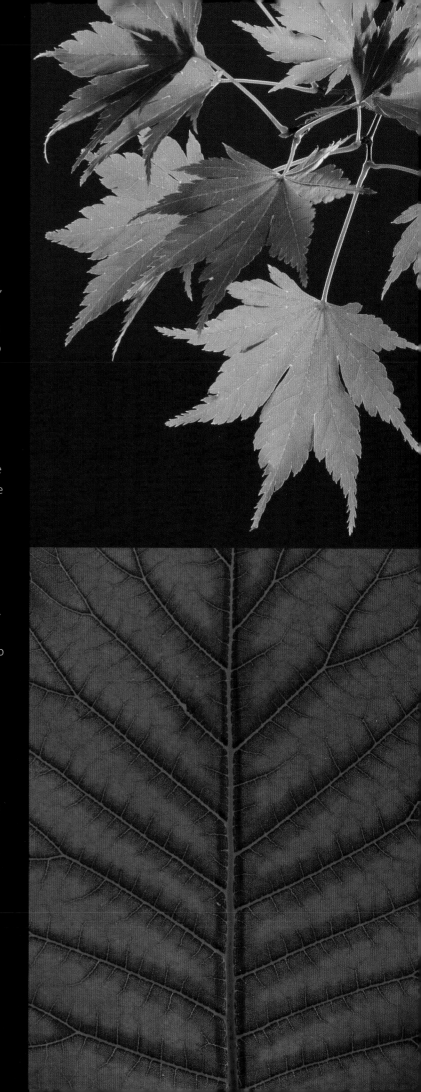

Because leaves photosynthesize, they have developed complex mechanisms to enable them to collect sunlight, transport sugars, and control water loss so that they do not dry out.

To maximize their exposure to the sun, most leaves are thin and flat. The outermost skin (the cuticle) of a leaf is waterproof to help reduce water loss, and it often contains cells that act as lenses to focus and direct incoming light. Leaves have veins that bring a constant flow of water and minerals up from the roots and transport the sugars produced during photosynthesis to every other part of the plant. The undersides of leaves also have tiny pores, called stomata, through which carbon dioxide enters and oxygen is released. Since water vapor can also be lost through stomata, they contain cells that change shape to open or close them.

All of these functions determine the basic structure of a leaf. However, there is no optimum shape or size that best suits these needs; leaves show a huge variety in color, size, and form depending on their species and growing conditions. Plants living on the floors of tropical forests, for example, need large, fleshy leaves to capture enough sunlight. The leaves of evergreen trees must be tough enough to withstand several years of sun, rain, and drying winds, so many evergreen conifers that grow in warm or cool environments have long, thin needles or short, narrow, flat, scale-like leaves. Some plants have leaves that are covered in small hairs or have a waxy surface to help prevent water loss, whereas others, such as the Venus flytrap (top right), have modified leaves to perform special functions.

1	2	3
4	5	6

1 Maple leaves spread out to optimize their access to light. Some plants also tilt and change the angles of their leaves during the day, to catch more light.
Japanese maple (Acer palmatum)

2 Some leaf stalks have outgrowths called stipules. Pairs of blush-pink stipules hang like skirts around the stem of this plant.
Amicia zygomeris

3 The modified leaf of a Venus flytrap opens wide to expose stiff, trigger-sensitive hairs on its upper surfaces. If an insect brushes against one of these hairs twice, the leaf snaps shut, trapping the insect inside.
Venus flytrap (Dionaea muscipula)

4 The veins inside leaves are connected to those inside stems, supplying water and minerals to the leaves and transporting sugars to the rest of the plant.
American smoke tree (Cotinus obovatus)

5 Pine needles, are thin leaves that can resist drying winds and cold temperatures.
Georg Dionysus Ehret, 18th century
Long-leaf pine (Pinus palustris Miller)

6 Some leaves have become protective structures called bracts. They look like petals to attract and guide insects into the real flowers within them.
Perfoliate Alexanders (Smyrnium perfoliatum)

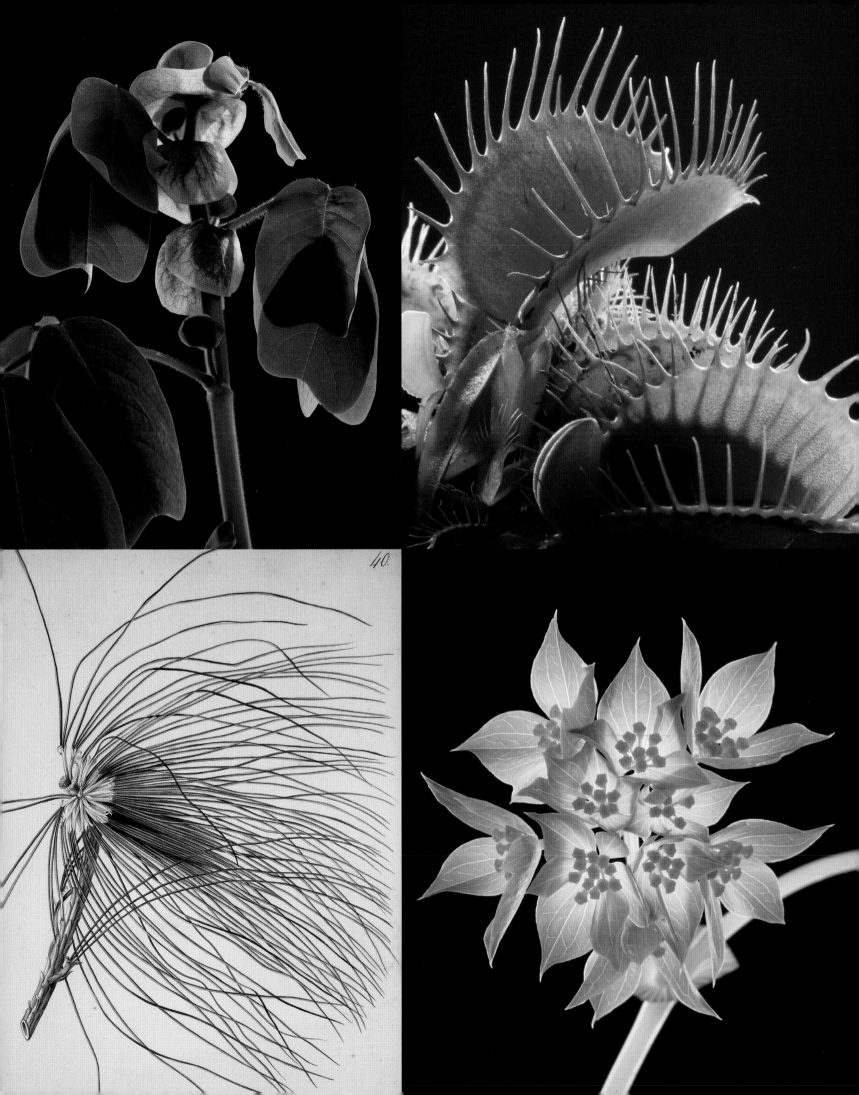

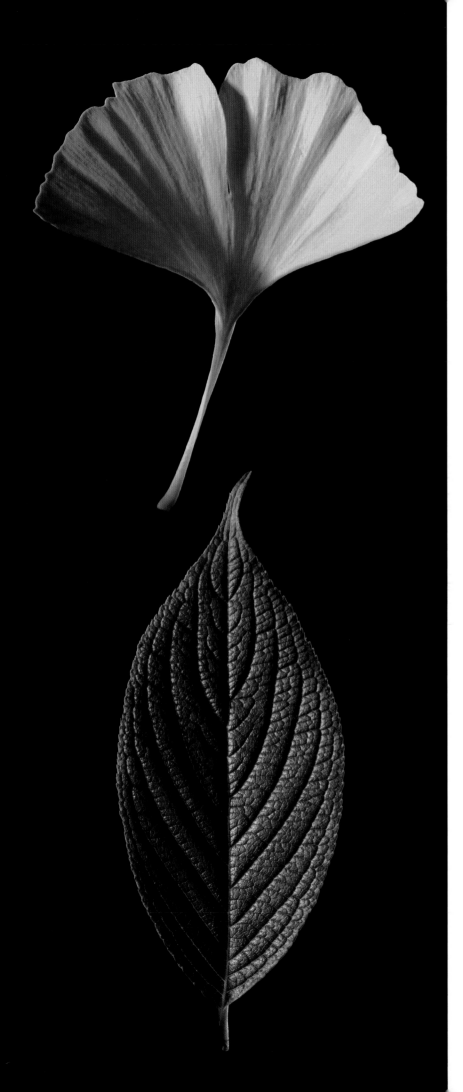

Simple leaves

Leaves, like flowers and most fruits, grow until they achieve a specific pattern and shape and then stop. Unlike a compound leaf, which is divided into several parts, a simple leaf grows in one piece.

The appearance of a leaf is determined by its shape, outer edge, base, and tip. The entire surface area of a leaf is called the blade, while its outer edge—the margin—can vary from smooth to serrated or spiny. The primary vein (if present) that runs along the center of a leaf is called the midrib, and smaller veins often branch out from it in net-like formations. The weigela leaf (below left), with its network of veins and serrated outer edge, is an example of one of the most common leaf shapes among flowering plants.

Subtle details can create significant visual differences between simple leaves. The cyclamen and water lily leaves (below right), for example, have a similar length-to-width ratio, but the locations of their widest points differ. They both have the same shaped base, but the water lily has a rounded tip and smooth margin, while the cyclamen has a pointed tip and serrated margin.

Most leaves are connected to plant stems by a stalk, called a petiole. Leaves without stalks are joined directly to the stem and are called sessile. A bud always develops in the space (called the leaf axil) between the upper side of a leaf stalk and the stem, and a leaf always grows just below a bud. This explains why, when a deciduous autumn leaf falls, it leaves a leaf scar on the stem just below the developing winter bud (see p.92).

Ginkgo leaf
The simple leaves of the ginkgo, a deciduous tree, are fan-shaped and have unusual veining (see p.137). They turn yellow in autumn. Ginkos were among the first trees to evolve, over 280 million years ago, and can tolerate high levels of pollution.
Ginkgo (*Ginkgo biloba*)

Weigela leaf
This leaf shape is one of the most common among flowering plants. Weigelas are woody, deciduous, flowering shrubs. Their pointed green leaves have a prominent midrib, net-like (reticulate) veins, and a shallow, serrated leaf edge.
Japanese weigela (*Weigela japonica*)

Simple leaf forms
The familiar simple leaves drawn here and overleaf have been chosen to show how much they differ in form and detail. Observe how the bases, margins, and tips of leaves vary in shape.

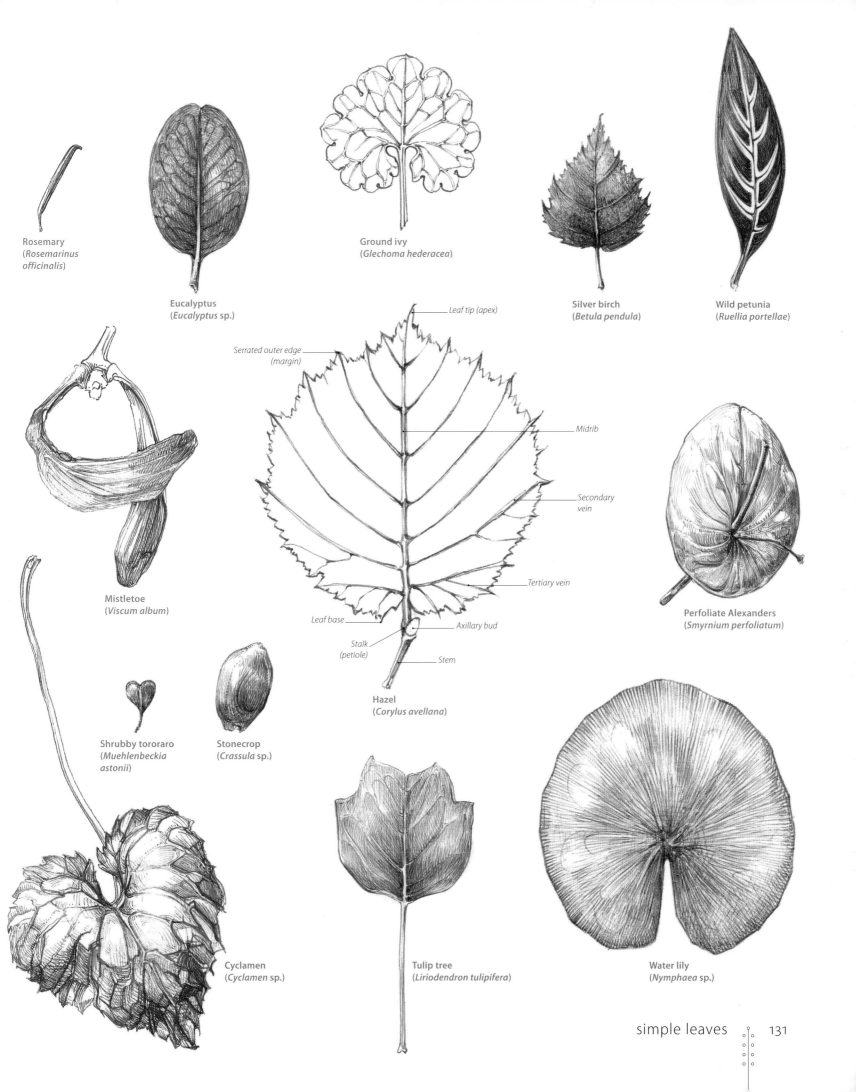

Rosemary
(*Rosemarinus officinalis*)

Eucalyptus
(*Eucalyptus* sp.)

Ground ivy
(*Glechoma hederacea*)

Silver birch
(*Betula pendula*)

Wild petunia
(*Ruellia portellae*)

Mistletoe
(*Viscum album*)

Leaf tip (apex)

Serrated outer edge
(margin)

Midrib

Secondary
vein

Tertiary vein

Leaf base

Axillary bud

Stalk
(petiole)

Stem

Hazel
(*Corylus avellana*)

Perfoliate Alexanders
(*Smyrnium perfoliatum*)

Shrubby tororaro
(*Muehlenbeckia astonii*)

Stonecrop
(*Crassula* sp.)

Cyclamen
(*Cyclamen* sp.)

Tulip tree
(*Liriodendron tulipifera*)

Water lily
(*Nymphaea* sp.)

simple leaves 131

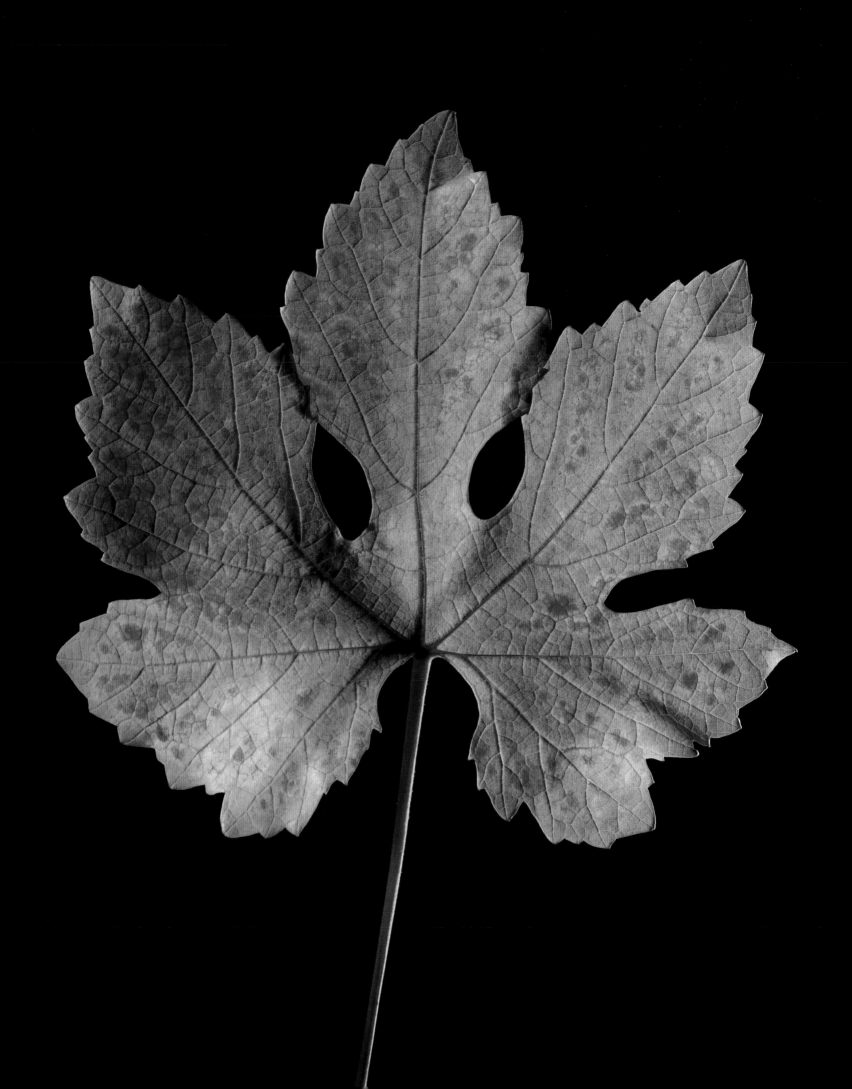

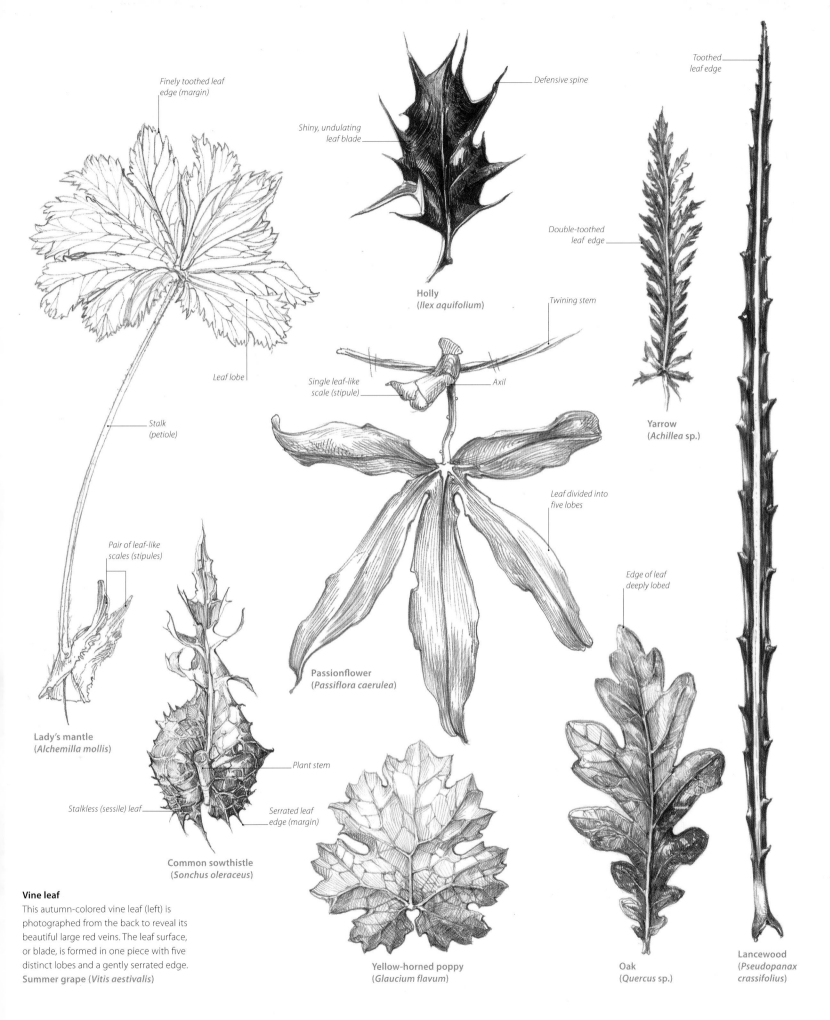

Finely toothed leaf edge (margin)

Defensive spine

Toothed leaf edge

Shiny, undulating leaf blade

Double-toothed leaf edge

Leaf lobe

Twining stem

Holly
(*Ilex aquifolium*)

Single leaf-like scale (stipule)

Axil

Yarrow
(*Achillea* sp.)

Stalk (petiole)

Leaf divided into five lobes

Pair of leaf-like scales (stipules)

Edge of leaf deeply lobed

Passionflower
(*Passiflora caerulea*)

Plant stem

Lady's mantle
(*Alchemilla mollis*)

Stalkless (sessile) leaf

Serrated leaf edge (margin)

Common sowthistle
(*Sonchus oleraceus*)

Vine leaf
This autumn-colored vine leaf (left) is photographed from the back to reveal its beautiful large red veins. The leaf surface, or blade, is formed in one piece with five distinct lobes and a gently serrated edge.
Summer grape (*Vitis aestivalis*)

Yellow-horned poppy
(*Glaucium flavum*)

Oak
(*Quercus* sp.)

Lancewood
(*Pseudopanax crassifolius*)

Compound leaves

A compound leaf is divided into separate sections, called leaflets, that look like small, individual leaves attached to the same midrib and stalk. Leaves with three parts, such as those of wood sorrel (below), are named trifoliate, while those with five or more parts, such as potentilla leaves (right), are known as palmate. More complex compound leaves can have tiny, paired leaflets, like acacia leaves, or unevenly arranged leaflets, like tomatoes. Evenly paired compound leaves may have a single leaflet at the top, as seen in indigo (bottom right), or not, as in the peanut leaf next to it.

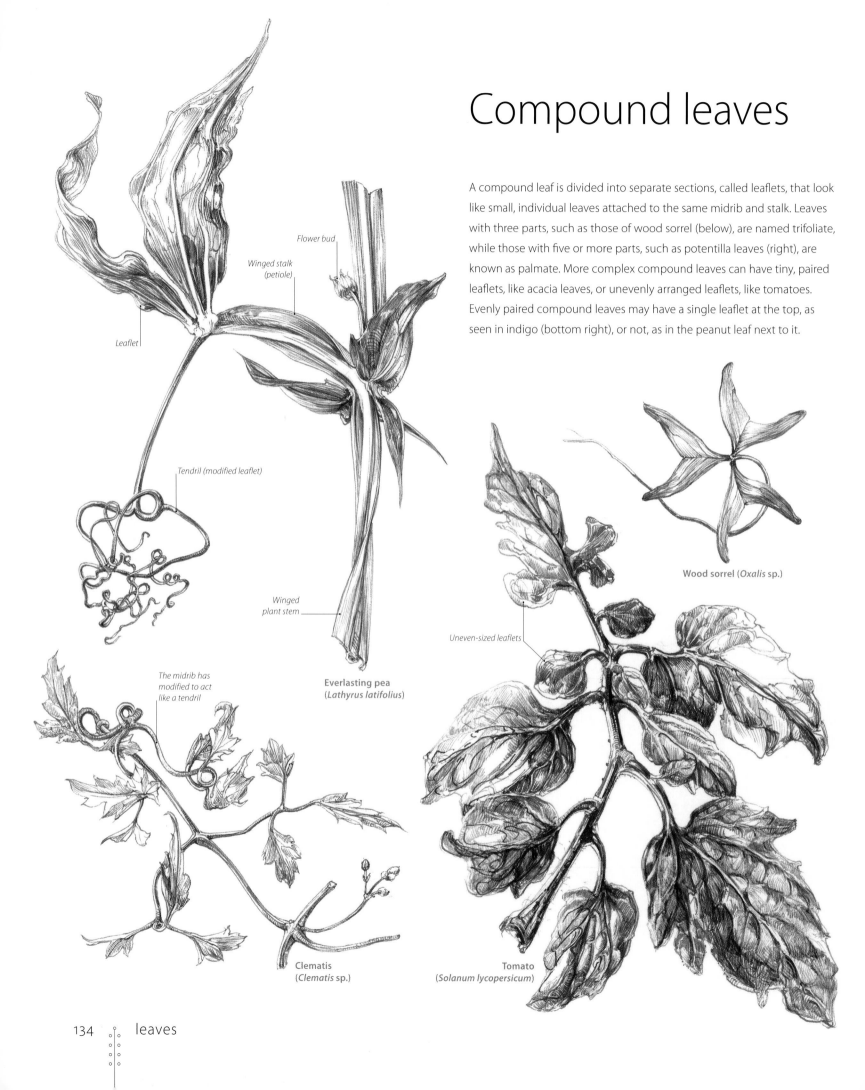

Flower bud

Winged stalk
(petiole)

Leaflet

Tendril (modified leaflet)

Winged
plant stem

Wood sorrel (*Oxalis* sp.)

Uneven-sized leaflets

The midrib has
modified to act
like a tendril

Everlasting pea
(*Lathyrus latifolius*)

Clematis
(*Clematis* sp.)

Tomato
(*Solanum lycopersicum*)

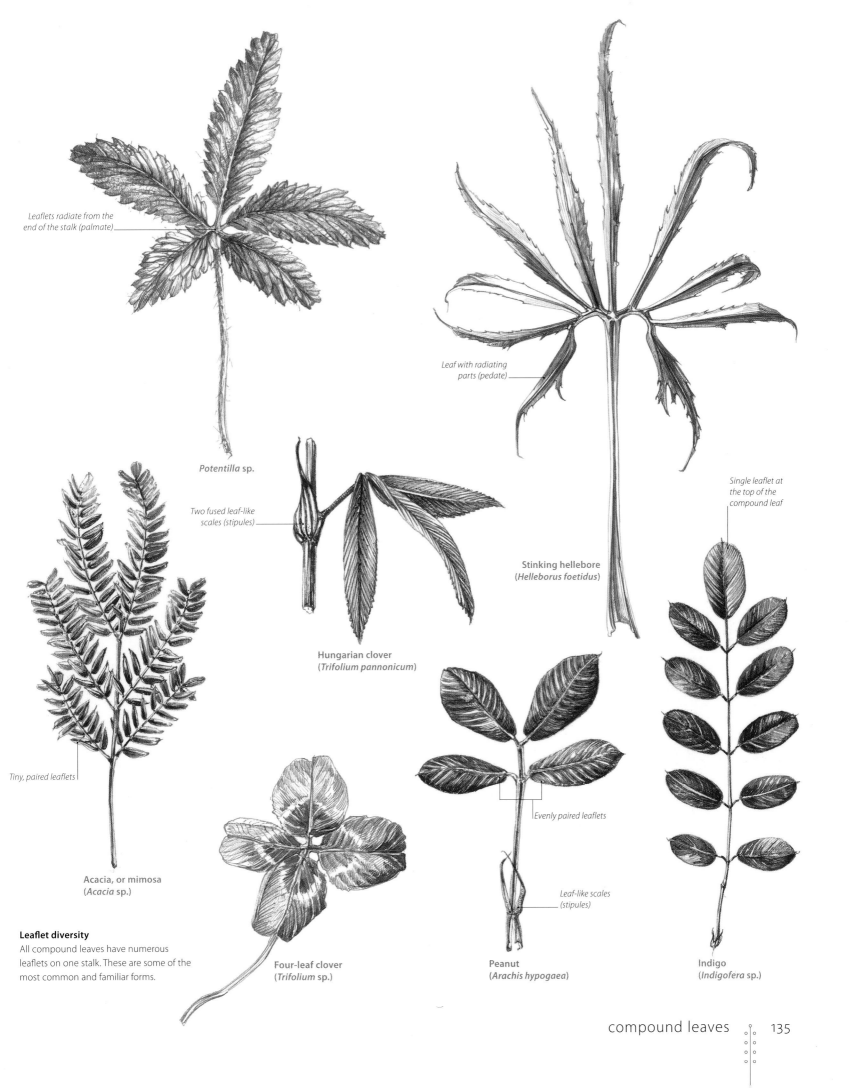

Leaflets radiate from the end of the stalk (palmate)

Potentilla sp.

Leaf with radiating parts (pedate)

Two fused leaf-like scales (stipules)

Single leaflet at the top of the compound leaf

Stinking hellebore (*Helleborus foetidus*)

Hungarian clover (*Trifolium pannonicum*)

Tiny, paired leaflets

Acacia, or mimosa (*Acacia* sp.)

Leaflet diversity
All compound leaves have numerous leaflets on one stalk. These are some of the most common and familiar forms.

Four-leaf clover (*Trifolium* sp.)

Evenly paired leaflets

Leaf-like scales (stipules)

Peanut (*Arachis hypogaea*)

Indigo (*Indigofera* sp.)

Leaf veins

The veins inside leaves are all part of the central pipework of a plant. Leaf veins are directly connected to the veins inside stems so that the leaves can be supplied with water and minerals for photosynthesis, and the sugars that they produce can be taken away to feed all the other parts of the plant. The pattern of veins inside leaves is called venation.

There are two main types of vein pattern: parallel and reticulate. Parallel veins run in straight lines parallel to each other, and are associated with monocots (see p.66), such as palms (left), grasses, lilies, tulips, and snowdrops. Reticulate veins branch repeatedly to make net-like patterns. They are typical of eudicots (see p.68) and are seen in the leaves of most flowering plants.

There are, of course, exceptions. A few monocots, such as black bryony (right, top center), have leaves with reticulate veins, and a small number of eudicots have leaves with parallel veins. The leaves of succulents have deep veins that are not visible on the surface of the leaf. Other leaves, such as ginkgo (right, bottom center), are unusual in that they have no midrib, but a fan of veins that converge at the stalk of the leaf.

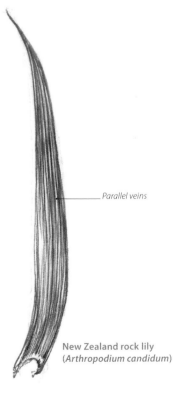

Parallel veins

Parallel veins
The veins in the leaves of monocots (see p.66) all run parallel to the primary vein, as in the New Zealand rock lily (right). All the pale, straight lines radiating from the base of the palm leaf (left) are veins running parallel to each other.
Palm (*Chamaerops humilis*)

New Zealand rock lily
(***Arthropodium candidum***)

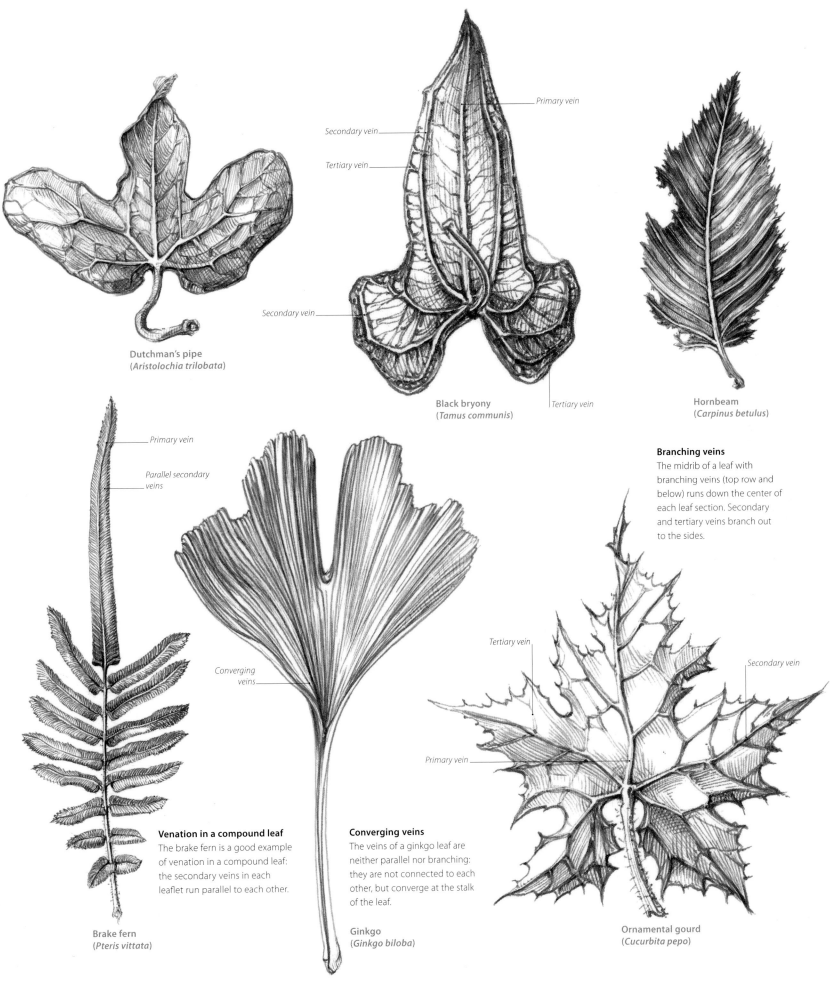

Dutchman's pipe
(*Aristolochia trilobata*)

Secondary vein

Tertiary vein

Primary vein

Secondary vein

Tertiary vein

Black bryony
(*Tamus communis*)

Hornbeam
(*Carpinus betulus*)

Primary vein

Parallel secondary veins

Converging veins

Branching veins
The midrib of a leaf with branching veins (top row and below) runs down the center of each leaf section. Secondary and tertiary veins branch out to the sides.

Tertiary vein

Secondary vein

Primary vein

Venation in a compound leaf
The brake fern is a good example of venation in a compound leaf: the secondary veins in each leaflet run parallel to each other.

Converging veins
The veins of a ginkgo leaf are neither parallel nor branching: they are not connected to each other, but converge at the stalk of the leaf.

Brake fern
(*Pteris vittata*)

Ginkgo
(*Ginkgo biloba*)

Ornamental gourd
(*Cucurbita pepo*)

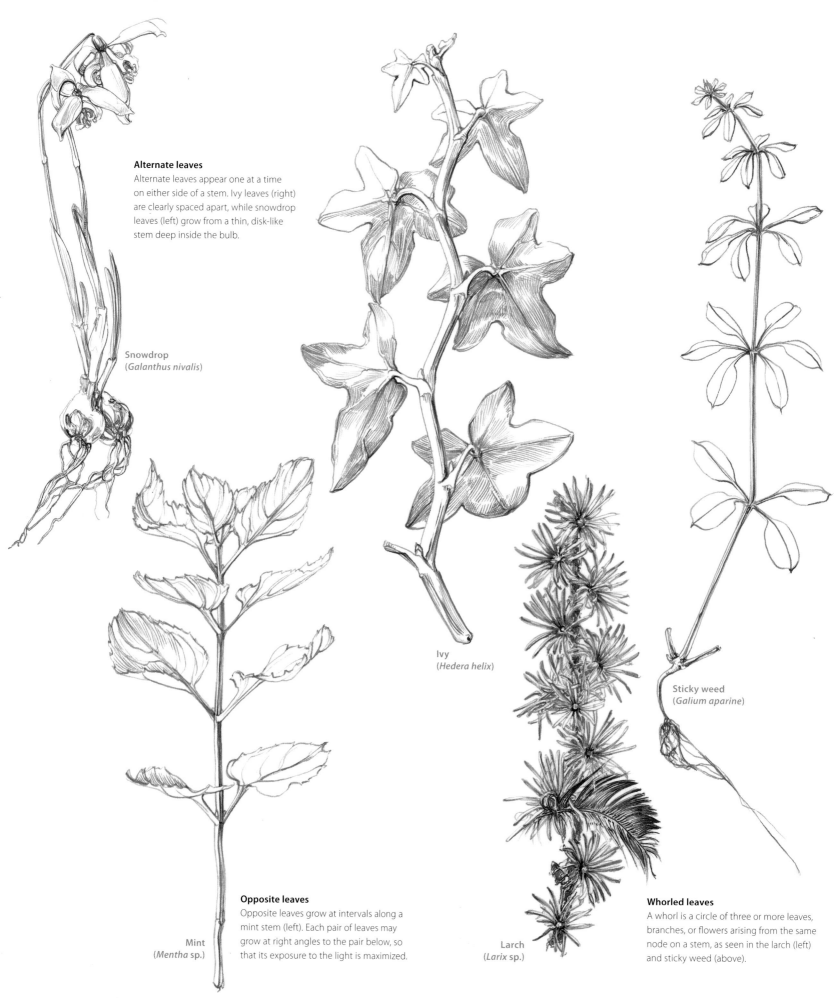

Alternate leaves
Alternate leaves appear one at a time
on either side of a stem. Ivy leaves (right)
are clearly spaced apart, while snowdrop
leaves (left) grow from a thin, disk-like
stem deep inside the bulb.

Snowdrop
(*Galanthus nivalis*)

Ivy
(*Hedera helix*)

Sticky weed
(*Galium aparine*)

Mint
(*Mentha* sp.)

Larch
(*Larix* sp.)

Opposite leaves
Opposite leaves grow at intervals along a
mint stem (left). Each pair of leaves may
grow at right angles to the pair below, so
that its exposure to the light is maximized.

Whorled leaves
A whorl is a circle of three or more leaves,
branches, or flowers arising from the same
node on a stem, as seen in the larch (left)
and sticky weed (above).

Leaf arrangements

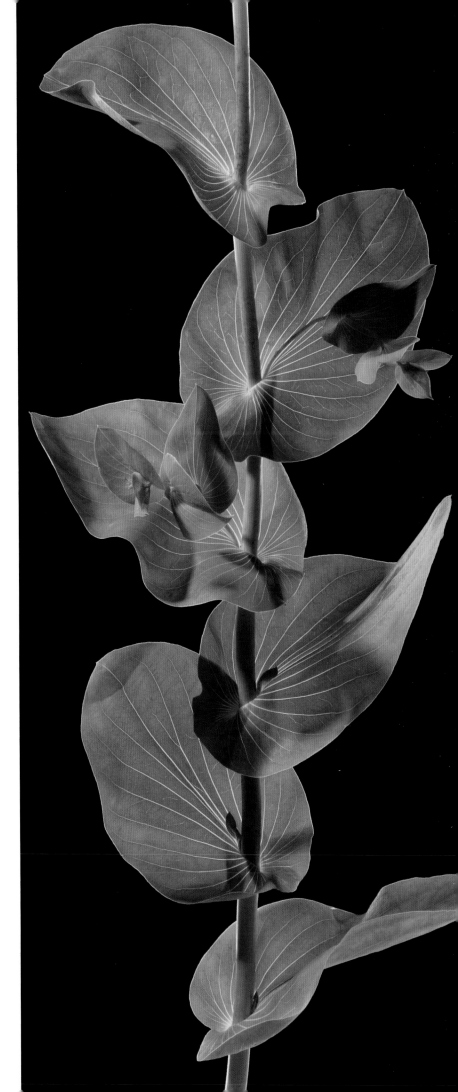

As plants need sunlight to photosynthesize, their leaves are arranged along their stems to gain the maximum amount of light and minimize leaf overlap. The way in which leaves are arranged is determined by the growth patterns of buds, which emerge at intervals to produce single, paired, or groups of three or more leaves at once. Leaves may also subtly tilt to adjust the amount of light they catch.

Leaf arrangement is one of the first things to observe if you are identifying or drawing a plant. The two most common forms are opposite and alternate. Opposite leaves are paired, one on either side of a stem, as in a mint plant (far left, bottom). Alternate leaves, the most common form of all, appear one at a time on alternate sides of the stem. Some leaves, however, grow almost vertically, or droop to reduce their exposure to light if the sun is too strong, as at the top of a mountain. Multiple leaves arranged in a circle around the same node of a stem are known as whorls, while rosettes are composed of either opposite or alternate leaves packed tightly around a very short stem. Perfoliate leaves enclose the stem of a plant.

Houseleek
(*Sempervivum tectorum*)

Rosettes
The houseleek (above), a succulent, has a rosette of fleshy leaves. Rosettes are associated with dry, sunny conditions, as their tight form reduces leaves' exposure to sunlight and minimizes water loss.

Perfoliate leaves
The alternate leaves of this plant (right) are perfoliate, meaning that they enclose the stem. Shaped like pointed shields, they decrease in size toward the top of the stem and tilt to catch the light.
Perfoliate Alexanders
(*Smyrnium perfoliatum*)

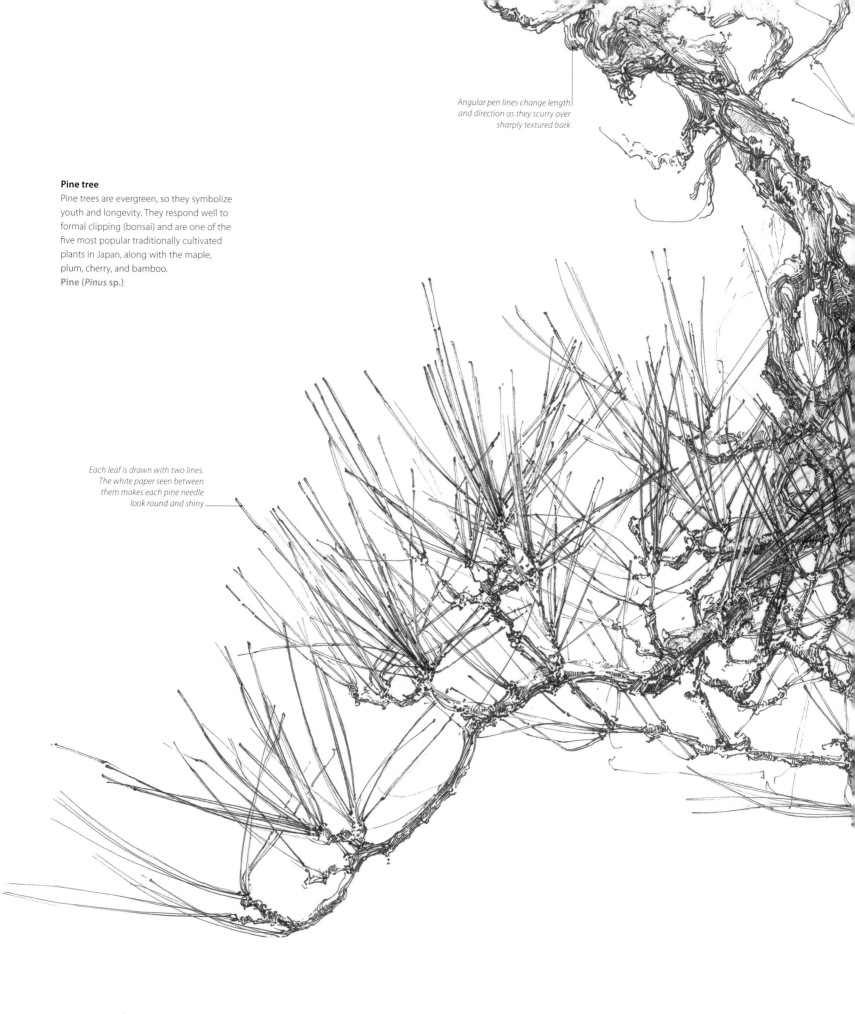

Pine tree

Pine trees are evergreen, so they symbolize youth and longevity. They respond well to formal clipping (bonsai) and are one of the five most popular traditionally cultivated plants in Japan, along with the maple, plum, cherry, and bamboo.

Pine (*Pinus* **sp.)**

Angular pen lines change length and direction as they scurry over sharply textured bark

Each leaf is drawn with two lines. The white paper seen between them makes each pine needle look round and shiny

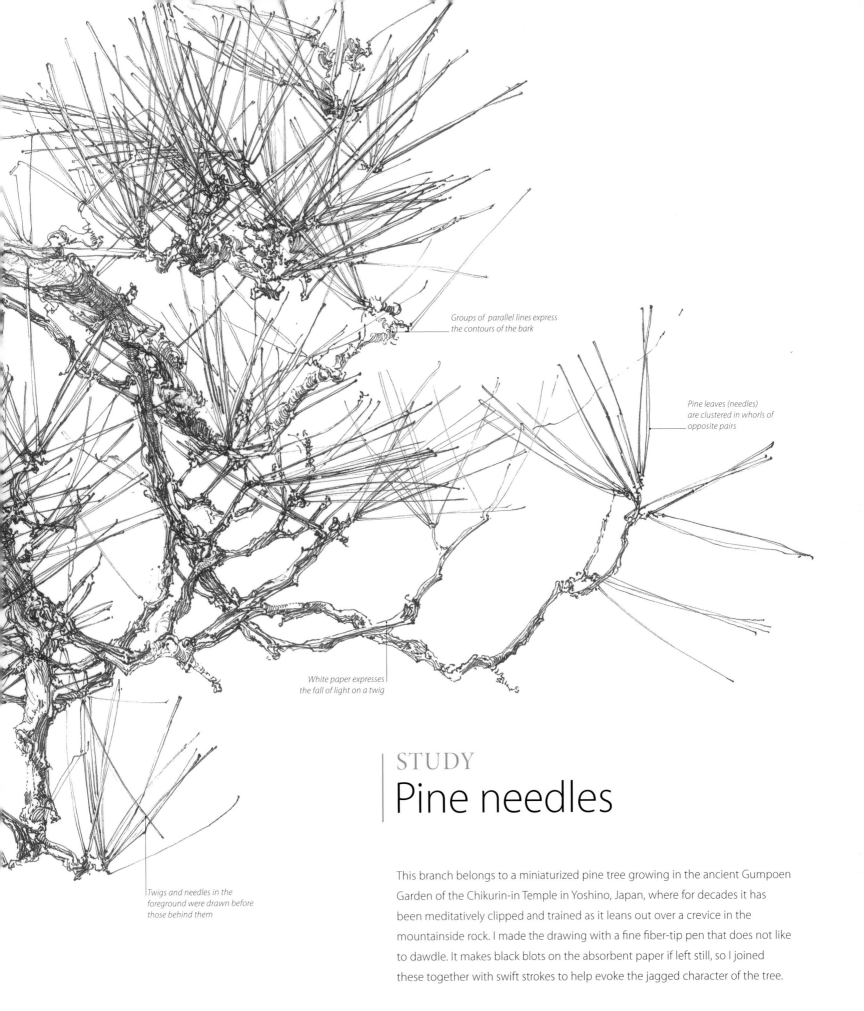

*Groups of parallel lines express
the contours of the bark*

*Pine leaves (needles)
are clustered in whorls of
opposite pairs*

*White paper expresses
the fall of light on a twig*

*Twigs and needles in the
foreground were drawn before
those behind them*

STUDY
Pine needles

This branch belongs to a miniaturized pine tree growing in the ancient Gumpoen
Garden of the Chikurin-in Temple in Yoshino, Japan, where for decades it has
been meditatively clipped and trained as it leans out over a crevice in the
mountainside rock. I made the drawing with a fine fiber-tip pen that does not like
to dawdle. It makes black blots on the absorbent paper if left still, so I joined
these together with swift strokes to help evoke the jagged character of the tree.

Leaves in perspective

Elephant's foot is a species of wild yam and a rare example of a monocot that has leaves with branching veins, rather than parallel veins. It is interesting to compare its leaves with those of black bryony (p.137), one of its relatives. Yams produce tough, heavy tubers (modified swollen stems), but this species is unusual because the tubers grow above ground. The simple leaves of this plant are clearly spaced apart, making them an ideal subject for practicing perspective—the pictorial device used to describe how things apparently change shape when they are tilted away from you.

To draw a leaf in perspective, it helps to forget that it is a leaf and that it is tilting away from you. Look at it as if it were an unfamiliar flat shape. Measure the height and width of the shape and mark these on your paper, then fit the curved outlines of the shape inside the measurements. Draw the curves you really see, however strange they may seem. The key to success with perspective is to draw what you can see, rather than what you know. Use an HB pencil for a study like this and keep the point sharpened so that your lines are precise.

STRAIGHT ON

SLIGHTLY TILTED

TILTED AT 90°

Changing perspective

These three sketches of a leaf show how it changes shape when tilted through 90 degrees. In the top drawing the leaf is seen straight on; in the middle drawing it is slightly tilted, so is the same width but looks shorter. In the bottom drawing the leaf is tilted away at about 90 degrees. It is still the same width, but now looks like a series of small shapes.

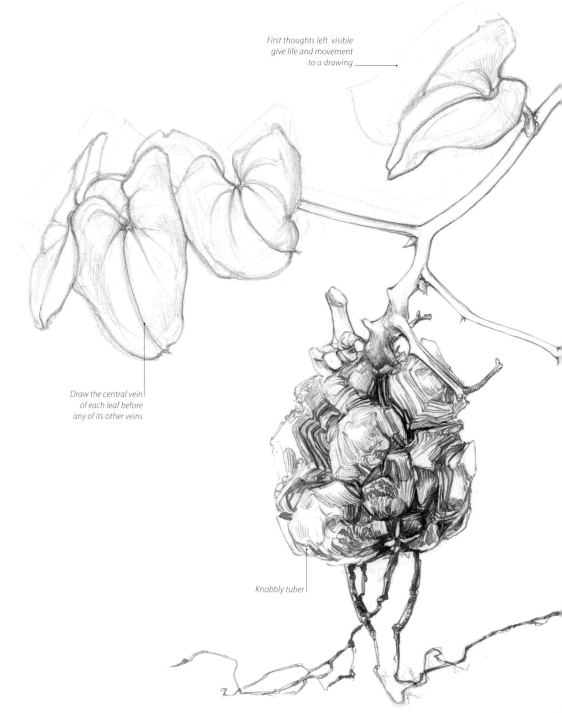

First thoughts left visible give life and movement to a drawing

Draw the central vein of each leaf before any of its other veins

Knobbly tuber

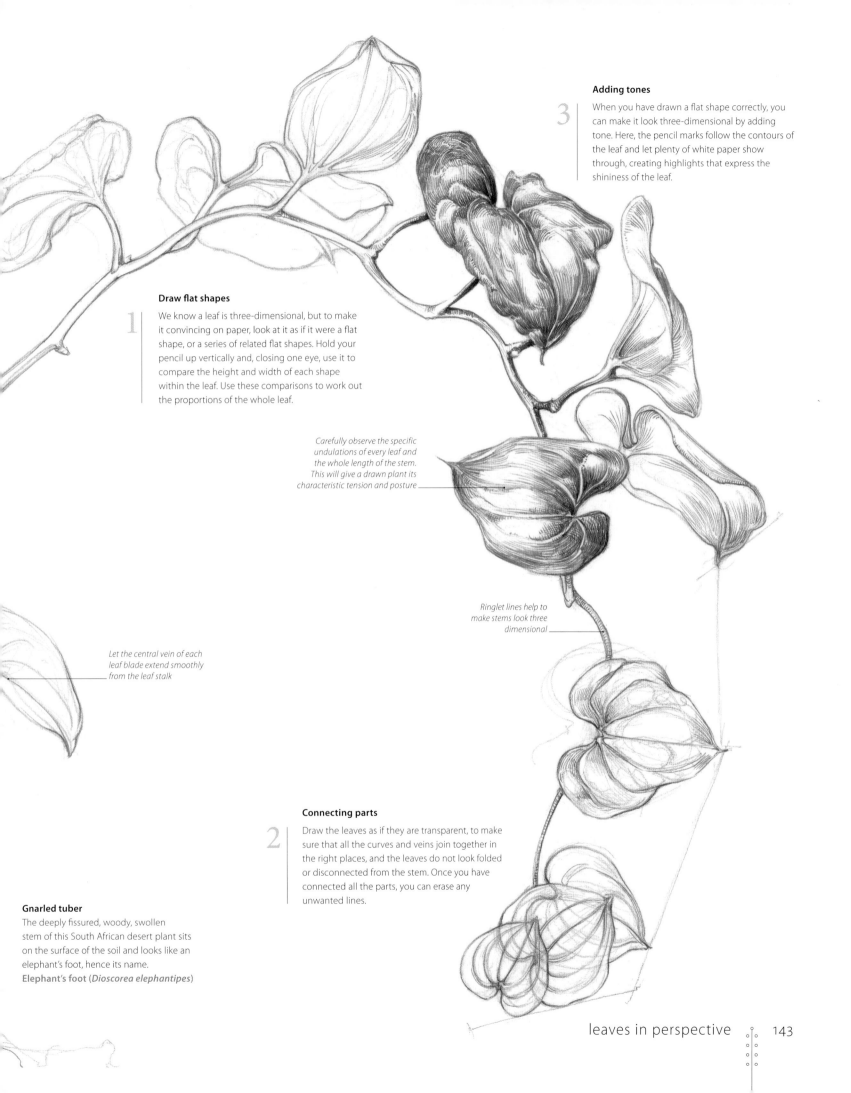

Adding tones

3 When you have drawn a flat shape correctly, you can make it look three-dimensional by adding tone. Here, the pencil marks follow the contours of the leaf and let plenty of white paper show through, creating highlights that express the shininess of the leaf.

Draw flat shapes

1 We know a leaf is three-dimensional, but to make it convincing on paper, look at it as if it were a flat shape, or a series of related flat shapes. Hold your pencil up vertically and, closing one eye, use it to compare the height and width of each shape within the leaf. Use these comparisons to work out the proportions of the whole leaf.

Carefully observe the specific undulations of every leaf and the whole length of the stem. This will give a drawn plant its characteristic tension and posture

Ringlet lines help to make stems look three dimensional

Let the central vein of each leaf blade extend smoothly from the leaf stalk

Connecting parts

2 Draw the leaves as if they are transparent, to make sure that all the curves and veins join together in the right places, and the leaves do not look folded or disconnected from the stem. Once you have connected all the parts, you can erase any unwanted lines.

Gnarled tuber
The deeply fissured, woody, swollen stem of this South African desert plant sits on the surface of the soil and looks like an elephant's foot, hence its name.
Elephant's foot (*Dioscorea elephantipes*)

Spray of olive
John Ruskin

The English artist, John Ruskin (1819–1900), was the most prominent and influential art critic in Britain in the 19th century, and one of the period's most articulate social critics. For him drawing was a fundamental activity, a direct tool for training and expanding the mind. In 1856 he wrote, "The greatest thing a human soul ever does in this world is to see something, and tell what it saw in a plain way. Hundreds of people can talk for one who can think, but thousands think for one who can see. To see clearly is poetry, prophecy, and religion, all in one" (*Modern Painters*). He believed that drawing should be at the heart of all education, and he himself taught both working men and university scholars. In 1857 Ruskin wrote a practical drawing course for beginners, *The Elements of Drawing*, that is still in print today. It is full of insightful advice, and is a key reference book for aspiring botanical artists.

Ruskin often used sprigs of leaves, such as this olive branch, as subjects for teaching drawing. Olive leaves are simple in form, with smooth edges and short stalks, and they grow alternately along slender, woody stems. Like most leaves, they grow and tilt away from each other to intercept light. An olive branch is a sign of peace (for the Chinese it is also a symbol of quiet and persistence). In mythology it is the dwelling place of the moon. Here, Ruskin evoked moonlight in the cool illumination of this olive branch by first laying a pale lilac wash of watercolor over his paper, then lightly drawing the branch with a sharpened stick of graphite. He added washes of crimson to many of the leaves, to enrich their tones. Highlights were added using white paint. Watercolor is wet and graphite is dusty; if they meet, they make mud. Part of the mastery of this drawing lies in how well Ruskin knew this, and kept the application of each layer respectfully apart.

Closer look

Drawn from life
This olive branch is illuminated strongly from the left, and tones are precisely observed. Here, each leaf appears partly lit against a darker background and partly dark against a lighter background, although the background is actually the same tone throughout.

Expressive marks
Seen closely, Ruskin's drawn marks are clearly layered, varied, swiftly made, and assured. This energy and assertiveness brings the subject alive on the page and is part of the magic of the drawing.

Spray of Olive
c.1878, watercolor and bodycolor over graphite on woven paper, 13¾ x 10¼in (35 x 26cm), Ashmolean Museum, Oxford, UK

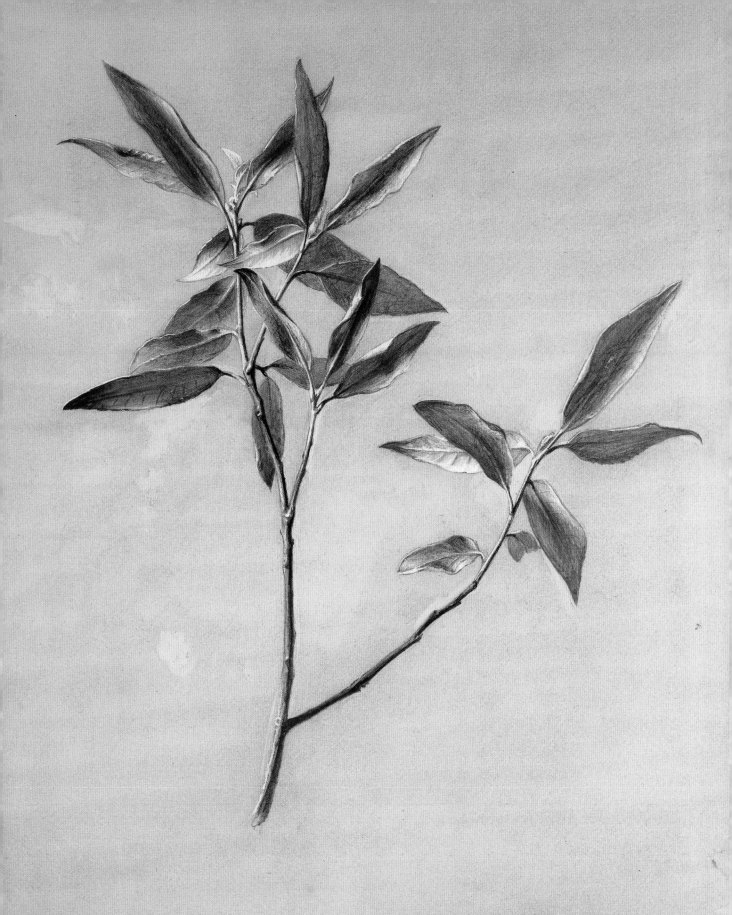

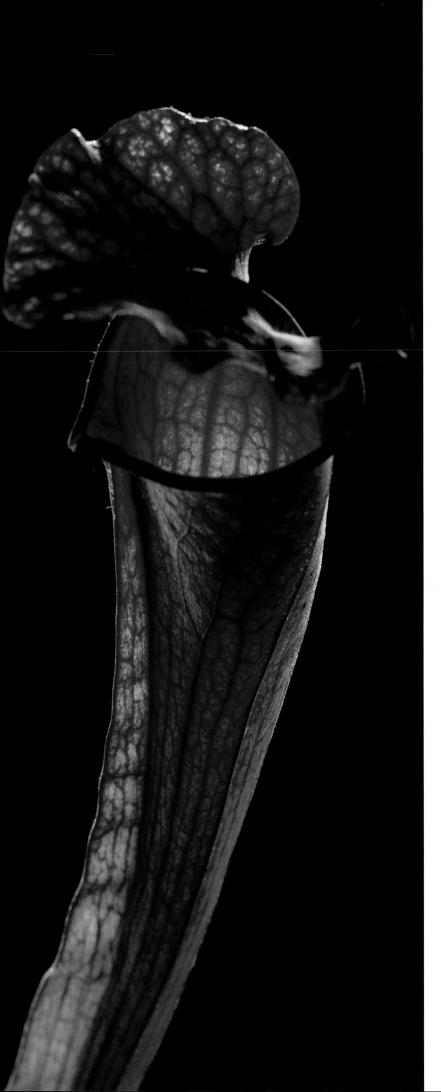

Pitchers

Carnivorous plants live in often acidic bogs, where nutrients are so scarce their roots cannot gather the essential minerals they need for growth. To overcome this problem they have gone to the extreme of evolving highly specialized leaves, which attract and ensnare insects, small mammals, or even birds. Once creatures are caught by the plant, they are slowly digested. Four species of carnivorous plant are featured in this book: the Venus flytrap (p.129), which snaps shut around an insect if touched twice; the bright red sundew plant (p.123), with its dazzling array of refreshing "drinks"—sticky droplets that look like water—held out on hairs that fatally entangle and wrap around insects if they land; and, here, two different genera of carnivorous plant—*Sarracenia* and *Nepenthes*—which have both evolved funnel-like pitchers to capture and hold their prey.

There are only eight species of the *Sarracenia* (left); it is native to both the Canadian Arctic and Florida. All of the species form rosettes of funnel-shaped leaves on the ground with each leaf covered by a hood. In spring, extraordinary flowers appear singly on tall slender stems. There are 70 species of *Nepenthes* (right), all native to the tropics. They are found in Madagascar, the Seychelles, Southeast Asia, and Queensland, Australia, where they grow in wet acidic grassland, scramble and climb up into trees, or germinate in trees and drape down through their branches in long swathes. The leaves of all *Nepenthes* have long midribs that extend beyond the blade, looking like stems, before they open out again into fleshy cups. Both *Sarracenia* and *Nepenthes* pitchers vary greatly in size, shape, and coloring, but they all have a mottled appearance, sour smell, and many are dark red or purple, to imitate the appearance and scent of carrion. They also all hold water, which soon becomes a soup of digested prey.

Sarracenia
Sarracenia pitchers are funnel shaped and grow in rosettes, standing upright on acidic bogs. The upper inside surface of each funnel is so slippery that an insect cannot grip it.
Sweet pitcher plant (*Sarracenia rubra*)

Nepenthes
Most, but not all, nepenthes pitchers hang down in the air from climbing stems. Like all carnivorous plants, they dissolve captured animals and then absorb nitrogen and phosphorus from their remains.

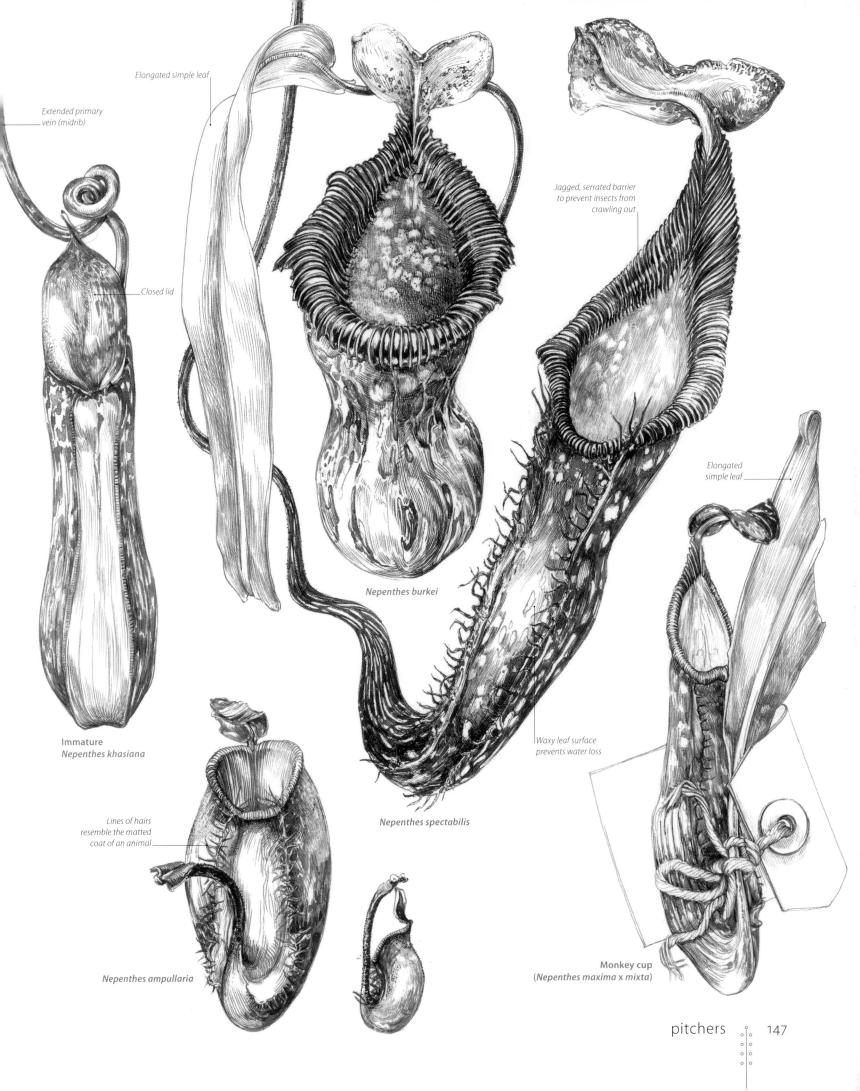

Extended primary
vein (midrib)

Elongated simple leaf

Closed lid

Immature
Nepenthes khasiana

Jagged, serrated barrier
to prevent insects from
crawling out

Nepenthes burkei

Elongated
simple leaf

Waxy leaf surface
prevents water loss

Lines of hairs
resemble the matted
coat of an animal

Nepenthes spectabilis

Nepenthes ampullaria

Monkey cup
(*Nepenthes maxima x mixta*)

Mature leaf of parent plant

One-lobed leaf

Two-lobed leaf

Three-lobed leaf

Heterophylly

Many plants produce more than one type of leaf, and this variation is called heterophylly (from the Greek *heteros,* meaning "other," and *phyllo,* meaning "leaf"). Differences in leaf form can be determined by the maturity of the plant, environmental conditions, or the position of the leaf on the stem. The water buttercup (right), for example, has two very different types of leaf. The leaves that grow above water (aerial leaves) are simple and rounded, with lobed outer edges (margins). These leaves usually rest flat on the surface of the water, where they are light enough to float, although some are held up to 2 in (5 cm) above the water. The leaves that grow underwater, on the other hand, are feathery in form. These submerged leaves have a much larger surface area for photosynthesis than the aerial leaves, but won't dry out because they grow underwater. Their fine filaments also allow water to flow through without towing the whole plant downstream. Growing these leaves is a response by the plant to its environment; if it had grown on the bank of the stream out of the water, it would only have produced rounded aerial leaves, like those at the top of its stem.

Some seedlings, such as those of linden trees, have completely different leaves from those of adult trees. This may be a form of disguise to protect the seedlings from insects. Other leaves change shape as they mature, like those of the young passionflower (left), which has three different shapes of leaf on its young stem. The mature leaf (top left), which has seven deeply cut lobes, is from the parent plant. On many plants there are also subtle differences between leaves that grow in sun and those that grow in the shade, or between the leaves at the base of each stem and those nearer the top. Variegation, a whitening of a leaf caused by an absence of the green pigment, chlorophyll, is also a form of heterophylly, since no two variegated leaves on a plant are ever exactly the same.

Passionflower plantlet
This plantlet (left) is a sucker (see p.108) growing out from the base of its parent plant's stem. The plantlet's leaves differ both from each other and from the parent plant's fully mature leaf (top left).
Passionflower (*Passiflora* sp.)

Water buttercup
(***Ranunculus aquatilis***)
Vast colonies of water buttercups, like this dried, pressed specimen (right), cover streams and ponds. The flower stalks extend upward so that the flowers can open above water. Water buttercups also grow in wet meadows, where they only produce aerial leaves.

No. 17. L. C., 8th Ed.

Ranunculus heterophyllus, Fries

Locality: *Pit west of Knowle,* in the neighbourhood
of Blackpool.

County: W. Lancashire, England. Cyb. Brit.: Co. 60.

Collected: *24th* June, 1887.

Coll. and Comm. by Charles Bailey, Manchester.

38. R. TRICHOPHYLLUS Chaix var. RADIANS (Revel). Knowle,
W. Lancs, 1887, BAILEY, as *heterophyllus.*

var. *radians* (Revel).

W.H.P. 19.12
 19

Bracts

Bracts are leaves that have modified to become attractive or protective structures on a plant, and they vary enormously. The richly colored spathe of an arum, for example, wraps itself around the plant's flower spike, helping to attract and detain flies that will pollinate it. Other large and colorful bracts look like petals to lure insects into an umbel of real flowers held at their center. The cat's whiskers plant (right), and the great masterwort and wood spurge (overleaf) all have these attractive, petal-like bracts. Bracts can also be fleshy. The small, red, outer coverings, or arils, of seeds on yew trees, for example, are also a type of fleshy bract. The striking contrast between these scarlet arils and the dark green of the yew tree needles is attractive to birds, which feed on them, so helping to disperse the seeds.

Some bracts protect developing flowers and fruits. These range from the scaly, layered cup-like bracts (involucral bracts) that surround the flowers and fruits of pot marigolds and artichoke thistles, to the leafy bracts around hazel and beech nuts and the cupules that hold acorns on oak trees (see overleaf). Pine cones are also formed from bracts. Male cones, which are small and soft compared to female cones, only have one type of bract, which opens to release pollen. Female cones have scale bracts and ovuliferous (ovule-bearing) bracts, as in the Douglas fir cone (bottom right). Scale bracts are thin and papery. The woody ovuliferous bracts, which grow directly above the scale bracts, enclose and protect developing seeds. They are closed during fertilization and remain tightly shut for six to 24 months (depending upon the species). When the seeds are mature, the ovuliferous bracts open or disintegrate to release them. Other types of bract are wing-like structures, as seen in the hornbeam (top right).

Dry, papery, wing-like bract

Nut

Hornbeam
(*Carpinus betulus*)

Ovuliferous bract

Scale bract

Douglas fir cone
(*Pseudotsuga menziesii*)

Wing-like bracts (*Carpinus betulus*)
The nuts produced by the hornbeam are surrounded by dry, wing-like bracts that help them to disperse on the wind. Linden tree fruits (overleaf) have similar bracts.
Hornbeam (*Carpinus betulus*)

Cone bracts
This female Douglas fir cone has both scale bracts and ovuliferous bracts, which remain closed to protect the developing seeds, then open once the seeds are mature.
Douglas fir (*Pseudotsuga menziesii*)

Cat's whiskers (*Tacca chantrieri*)
This shade-loving rain forest plant is native to Yunnan and Hainan in southern China. It grows from a bulb, and each thick, fleshy stem bears an umbel of flowers set against a triangular display of three purple bracts. The long whiskers are also bracts.

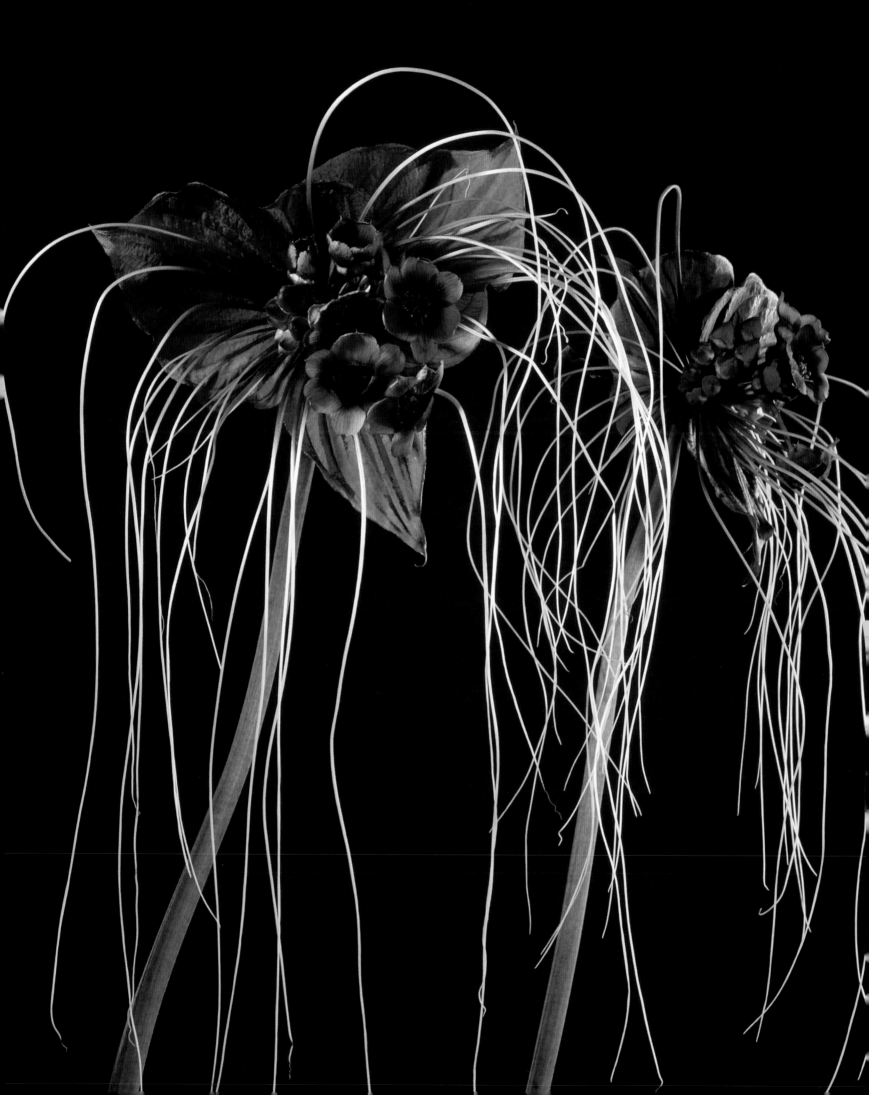

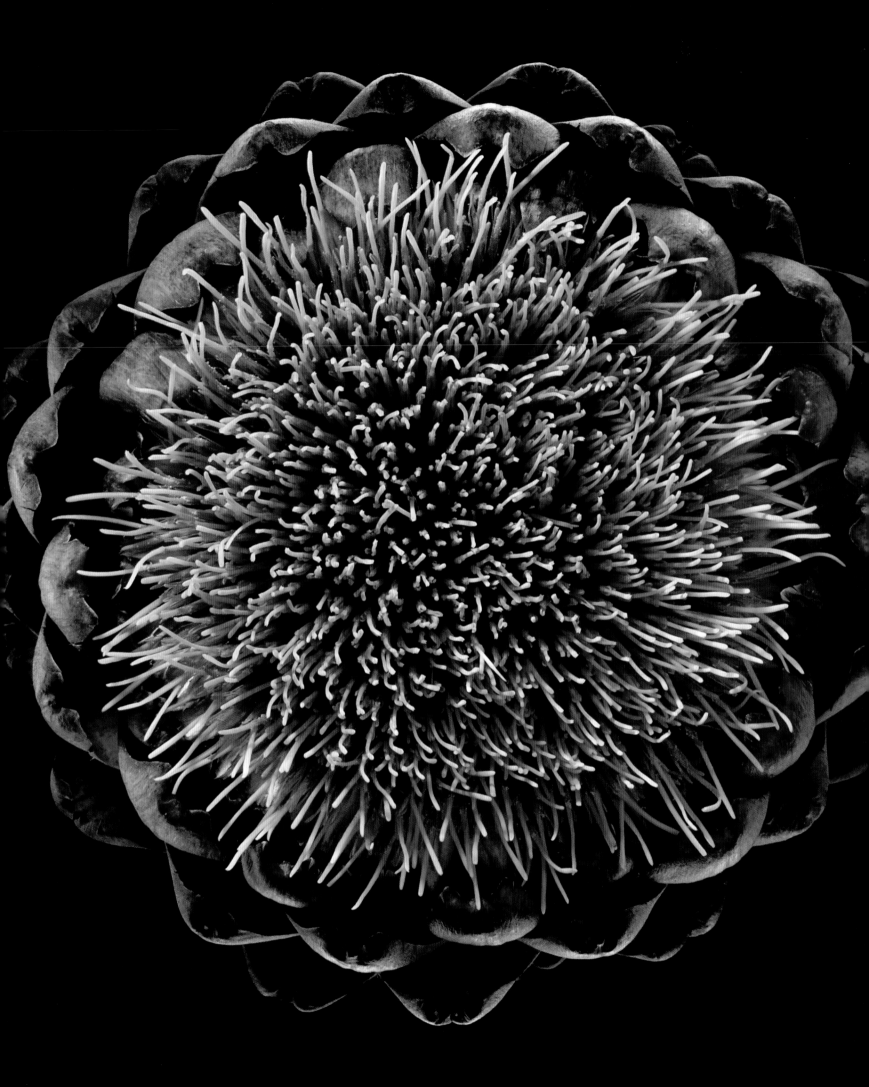

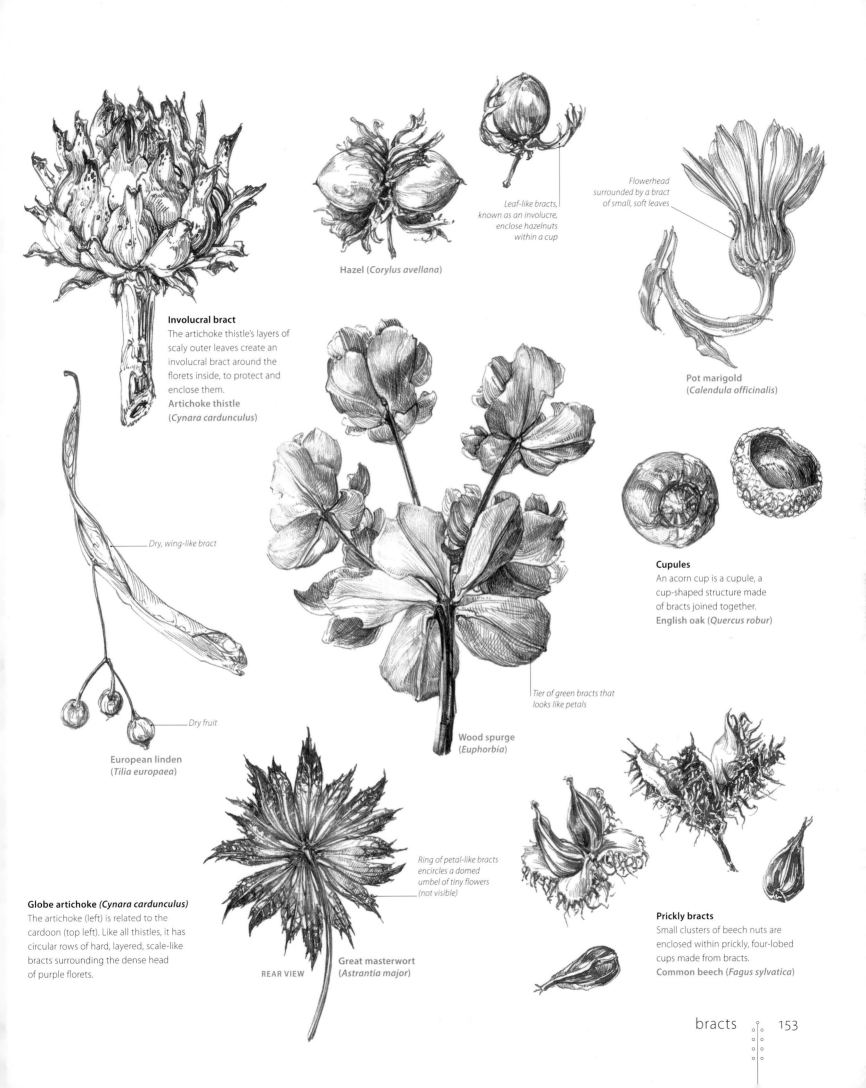

Involucral bract
The artichoke thistle's layers of scaly outer leaves create an involucral bract around the florets inside, to protect and enclose them.
Artichoke thistle (*Cynara cardunculus*)

Dry, wing-like bract

Dry fruit

European linden (*Tilia europaea*)

Hazel (*Corylus avellana*)

Leaf-like bracts, known as an involucre, enclose hazelnuts within a cup

Flowerhead surrounded by a bract of small, soft leaves

Pot marigold (*Calendula officinalis*)

Cupules
An acorn cup is a cupule, a cup-shaped structure made of bracts joined together.
English oak (*Quercus robur*)

Tier of green bracts that looks like petals

Wood spurge (*Euphorbia*)

Globe artichoke (*Cynara cardunculus*)
The artichoke (left) is related to the cardoon (top left). Like all thistles, it has circular rows of hard, layered, scale-like bracts surrounding the dense head of purple florets.

REAR VIEW

Ring of petal-like bracts encircles a domed umbel of tiny flowers (not visible)

Great masterwort (*Astrantia major*)

Prickly bracts
Small clusters of beech nuts are enclosed within prickly, four-lobed cups made from bracts.
Common beech (*Fagus sylvatica*)

Ferdinand Bauer (1760-1826) was among the most sensitive of botanical painters, and is revered for his work. Originally from Vienna in Austria, Bauer spent much of his working life in England. He was employed by several leading botanists, with whom he traveled on important expeditions, including one to Australia, and he assisted in the discovery and documentation of thousands of new plant and animal species. In the field Bauer made folders full of beautiful, rapid line drawings using the equivalent of an HB pencil on thin letter writing paper. Jostling together, these plants are described in clear, unshaded detail, then covered in numbers. For every set of plants Bauer studied in the wild, he made a numbered color chart. Once he returned to his studio, he matched his numbered field drawings to his colored charts and accurately created life-size portraits, sometimes up to eight years after seeing the plants. This extraordinary method of working appears to be unique to Ferdinand Bauer.

Bauer collected this arum around 1787 in Cyprus, while traveling with the botanist John Sibthorp. It is one of the 966 plants that he recorded for Sibthorp's *Flora Graeca*, one of the most important, ambitious, and beautiful of all published Floras. Bauer painted with gouache, a type of watercolor that contains a little chalk to make it opaque and that can be applied thickly and built up in layers. Many of Bauer's original paintings have a beautiful and characteristic pale chalky bloom to them. This is an unusual work, in which Bauer has glazed the darkest parts of the plant with a solution of gum arabic to make them shine on the page. Plant forms have been modeled in a very broad range of tones. At one end of the scale, strokes of the most dilute pink and green paint describe a new fleshy tuber, its fibrous roots, and central shoot, the white of the paper shining through. In contrast, the rich green leaves are painted in several opaque layers, from light green hues to successively darker green hues, and finished with strokes of pale green to describe the midrib and branched veins. The purple spathe (a modified leaf) surrounding the spadix (the flowering structure), was created in broad washes of pale pink, overlaid with deepening hues of purple, until reaching black last of all, and being glossed in gum arabic.

Arum dioscoridis
1787, pencil sketch on paper, 9 x 13⅝in (23 x 35cm), University of Oxford, UK

Closer look

Modelled form
Painting light shining from one direction only, here from the left, always heightens form. The roundness and striped veining of this bulbous, modified leaf have been defined by using varying strengths of color and tone.

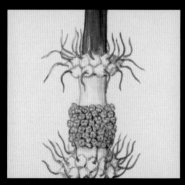

Male and female flowers
The tiny details of these flowers, clustered around the base of the spadix, were painted by following a pencil underdrawing, which was then erased. The pink hairs are made to appear three-dimensional by combinations of two or more tones of pink.

Arum dioscoridis
Early 19th century, original watercolor, 18½ x 13in (47 x 33cm), University of Oxford, UK

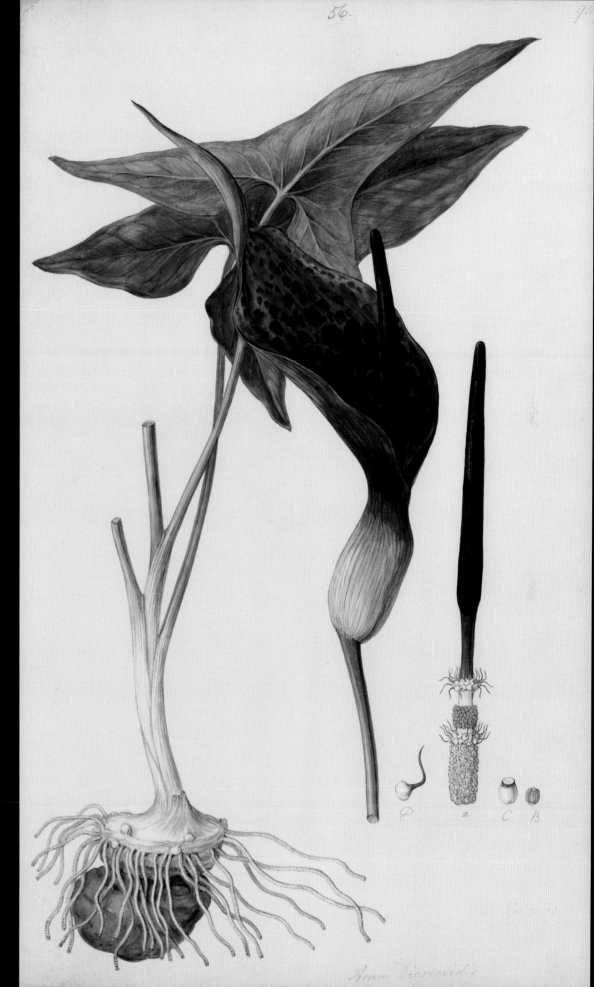

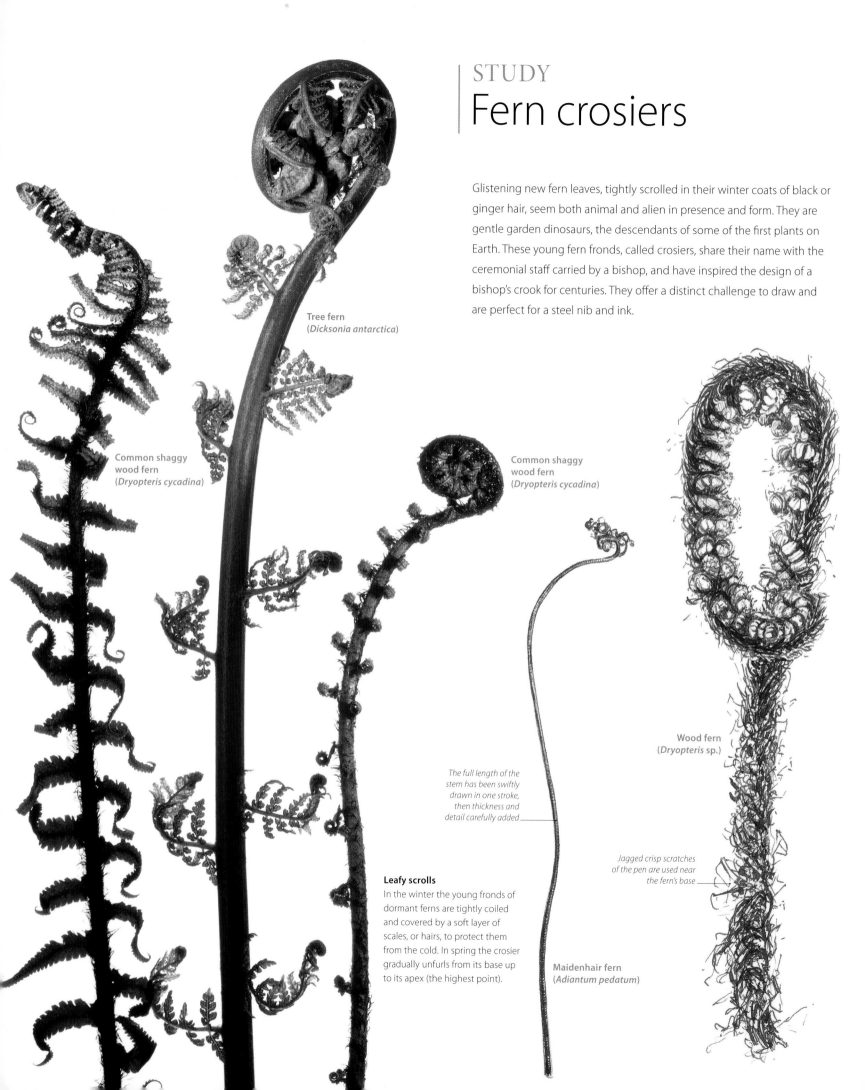

Fern crosiers

Glistening new fern leaves, tightly scrolled in their winter coats of black or ginger hair, seem both animal and alien in presence and form. They are gentle garden dinosaurs, the descendants of some of the first plants on Earth. These young fern fronds, called crosiers, share their name with the ceremonial staff carried by a bishop, and have inspired the design of a bishop's crook for centuries. They offer a distinct challenge to draw and are perfect for a steel nib and ink.

Tree fern
(*Dicksonia antarctica*)

Common shaggy
wood fern
(*Dryopteris cycadina*)

Common shaggy
wood fern
(*Dryopteris cycadina*)

Wood fern
(*Dryopteris* sp.)

*The full length of the
stem has been swiftly
drawn in one stroke,
then thickness and
detail carefully added*

*Jagged crisp scratches
of the pen are used near
the fern's base*

Leafy scrolls
In the winter the young fronds of
dormant ferns are tightly coiled
and covered by a soft layer of
scales, or hairs, to protect them
from the cold. In spring the crosier
gradually unfurls from its base up
to its apex (the highest point).

Maidenhair fern
(*Adiantum pedatum*)

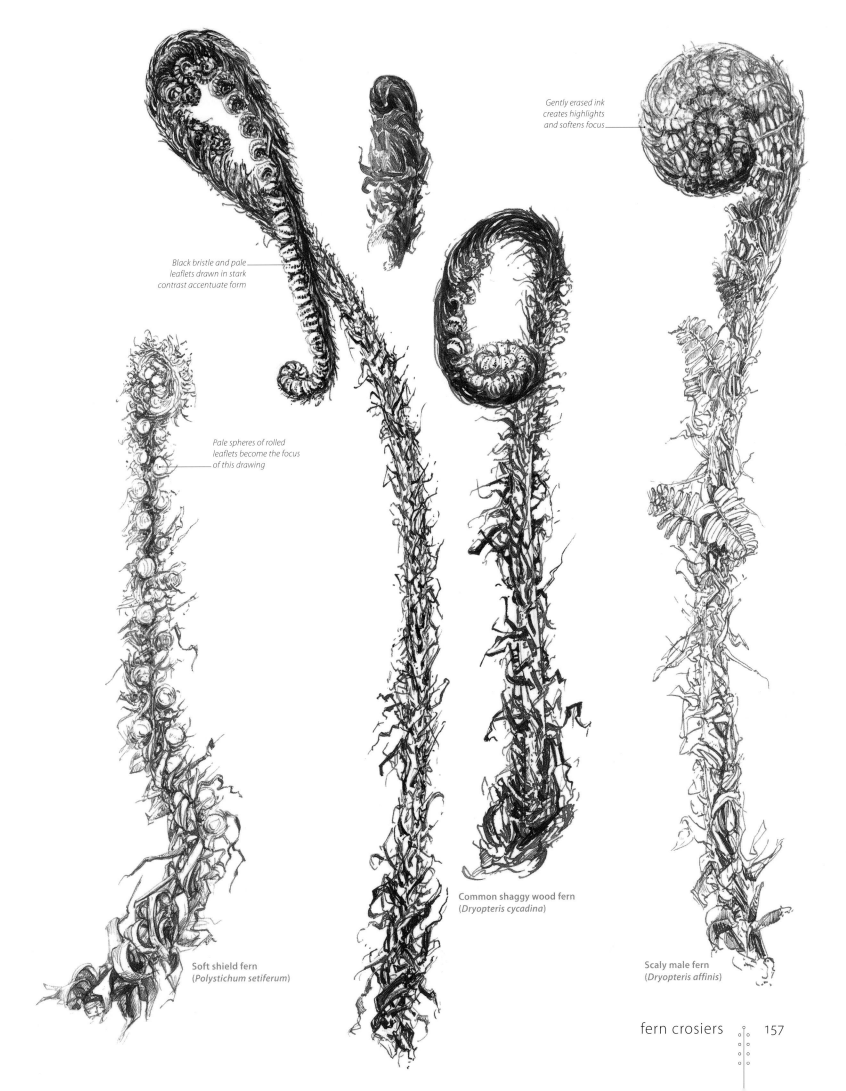

Gently erased ink
creates highlights
and softens focus

Black bristle and pale
leaflets drawn in stark
contrast accentuate form

Pale spheres of rolled
leaflets become the focus
of this drawing

Common shaggy wood fern
(*Dryopteris cycadina*)

Soft shield fern
(*Polystichum setiferum*)

Scaly male fern
(*Dryopteris affinis*)

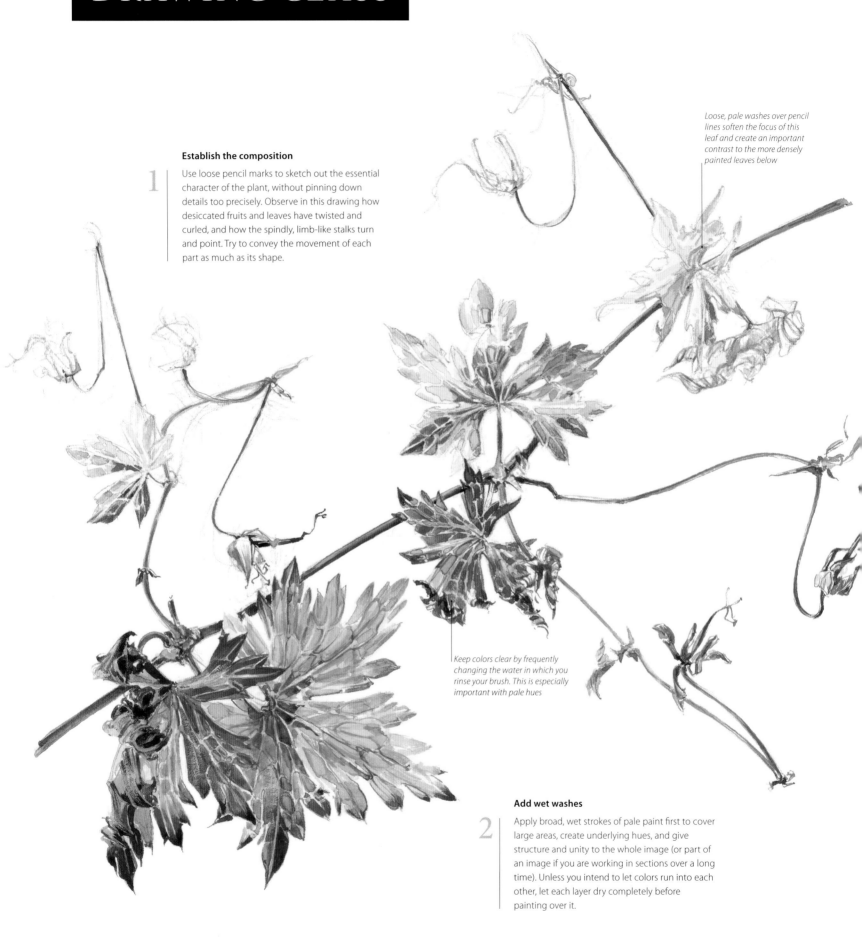

DRAWING CLASS

Establish the composition

1 | Use loose pencil marks to sketch out the essential character of the plant, without pinning down details too precisely. Observe in this drawing how desiccated fruits and leaves have twisted and curled, and how the spindly, limb-like stalks turn and point. Try to convey the movement of each part as much as its shape.

Loose, pale washes over pencil lines soften the focus of this leaf and create an important contrast to the more densely painted leaves below

Keep colors clear by frequently changing the water in which you rinse your brush. This is especially important with pale hues

Add wet washes

2 | Apply broad, wet strokes of pale paint first to cover large areas, create underlying hues, and give structure and unity to the whole image (or part of an image if you are working in sections over a long time). Unless you intend to let colors run into each other, let each layer dry completely before painting over it.

Autumn leaves

Autumn leaves turn fiery shades of red, orange, gold, and pink in response to falling temperatures and lower light levels. As plants prepare for winter dormancy, they stop producing their green pigment, chlorophyll, and in its absence other pigments normally hidden by the dominant green hue are revealed. Waste products (toxins) deposited inside leaves during the growing season are also revealed, and contribute to spectacular autumn leaf color.

I cut this sprightly length of blue-flowered geranium from my garden in October and plunged it into water to stay fresh. When I was ready to start drawing, I gently dried the plant so it would not leave watermarks, and laid it onto a sheet of cartridge paper. Holding the geranium still against the paper, I pushed the tip of a sharp HB pencil underneath it to mark the position of the whole length of the stem, each node, and the outlines of every leaf and fruit. Then I lifted the geranium away and checked its placement on the page. At this stage the whole composition was visible, but it could also be erased easily and redrawn if something was not in the right place. Next I used more energetic pencil lines to lightly develop the character and articulations of the plant before painting it. I mixed small amounts of three watercolors (transparent yellow, permanent rose, and ultramarine) on a white glazed plate and applied them using a wet wash and dry brush technique. Most botanical watercolors are made in this way. The essential principle to remember is to work from wet to dry, broad to fine, and pale to dark, while also keeping your palette, brush, and water clean and unmuddied.

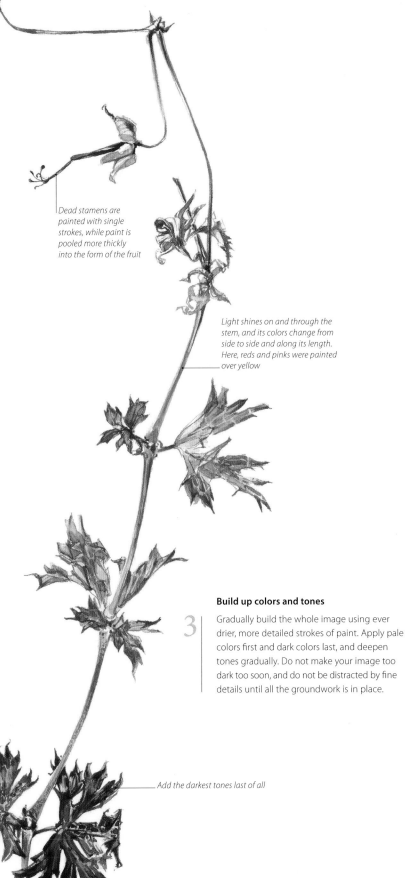

Dead stamens are painted with single strokes, while paint is pooled more thickly into the form of the fruit

Light shines on and through the stem, and its colors change from side to side and along its length. Here, reds and pinks were painted over yellow

Build up colors and tones

3 Gradually build the whole image using ever drier, more detailed strokes of paint. Apply pale colors first and dark colors last, and deepen tones gradually. Do not make your image too dark too soon, and do not be distracted by fine details until all the groundwork is in place.

Add the darkest tones last of all

Final details

4 I painted all of these leaves with pale washes of yellow, then developed them with reds and browns. See how the yellow shines through in the veins of the leaves, which I carefully avoided painting over. Pencil marks can be entirely erased from beneath dry watercolor, or can be left in place as part of the final image, or removed at any stage when they are no longer needed as a guide.

Hybrid cranesbill (*Geranium* x "Rozanne")

The slender stems of this hybrid cranesbill can scramble up to 5–6 ft (1.5–2 m) in length, and flower profusely from early summer until the first frosts.

Flowers

Flowers fill our lives. They are used to celebrate our beginnings, unions, and achievements and to mark our sympathies and our ends. In fact, flowers contain the reproductive parts of the most successful and diverse group of plants on earth. Their brilliant colors, shapes, and sweet perfume have evolved in myriad ways to ensure that they are pollinated and can thus produce fruits and seed

Introduction

Abundant and astonishingly varied, flowers have delighted and amazed people for thousands of years. We go exploring for new species, collect, grow, and display them, press, name, and catalog them, and then create images of them, be they photographed, embroidered, painted, or drawn.

Flowers are far from purely decorative, however. Their fascinating shapes, brilliant colors, intricate patterns, and intriguing perfumes have evolved over millions of years to ensure that pollen is carried from one flower to another, and that enough flowers are pollinated for plants to set fruit and produce seed. Flowers are sometimes pollinated by gusts of wind, as all grasses are, or they may have a relationship with a specific animal that pollinates them, be it an insect, a bird, or even a mammal, such as a bat or possum. Behind the dazzling array of forms, all flowers follow a basic plan when it comes to structure. This chapter looks at their anatomy and explains how it has evolved to aid pollination. It shows how flowers are arranged on single or branched stems, and reveals that some tiny flowers are clustered together so closely on one stem, that hundreds of them are commonly mistaken for a single flower.

1	2	3
4	5	6

1 Mock orange flowers are pollinated by moths. They are pale, heavily scented, and grouped together, so that their pollinators can easily find them at night.
Mock orange (*Philadelphus coronarius*)

2 This cup-shaped flower displays five lines of radial symmetry, one passing through the center of each petal. Black markings called nectar guides lead insects to the nectar inside the flower.
Potentilla (*Potentilla atrosanguinea*)

3 The dark, bulbous lower petal of the slipper orchid is shaped like the body of a bee, to attract a pollinating mate. Before forming a bud, an orchid flower twists through 180°, so it develops upside down.
Slipper orchid (*Paphiopedilum* sp.)

4 Hundreds of tiny, tubular flowers are gathered inside the head of a protea, so as to be more visible. Leaf-like structures called bracts encircle the flowerhead.
Protea (*Protea* sp.)

5 The scented, cupped flowers of this climbing cactus open at night. It is pollinated by bats and the flowers are just large enough for a bat's head to fit inside.
Walter Hood Fitch, c.mid-1800s
Night-flowering cactus (*Selenicereus grandiflorus*)

6 The flame-colored "petals" of this heliconia are in fact leafy bracts enclosing the plant's true flowers. Heliconia can have either upright or pendent flowerheads.
Heliconia (*Heliconia stricta*)

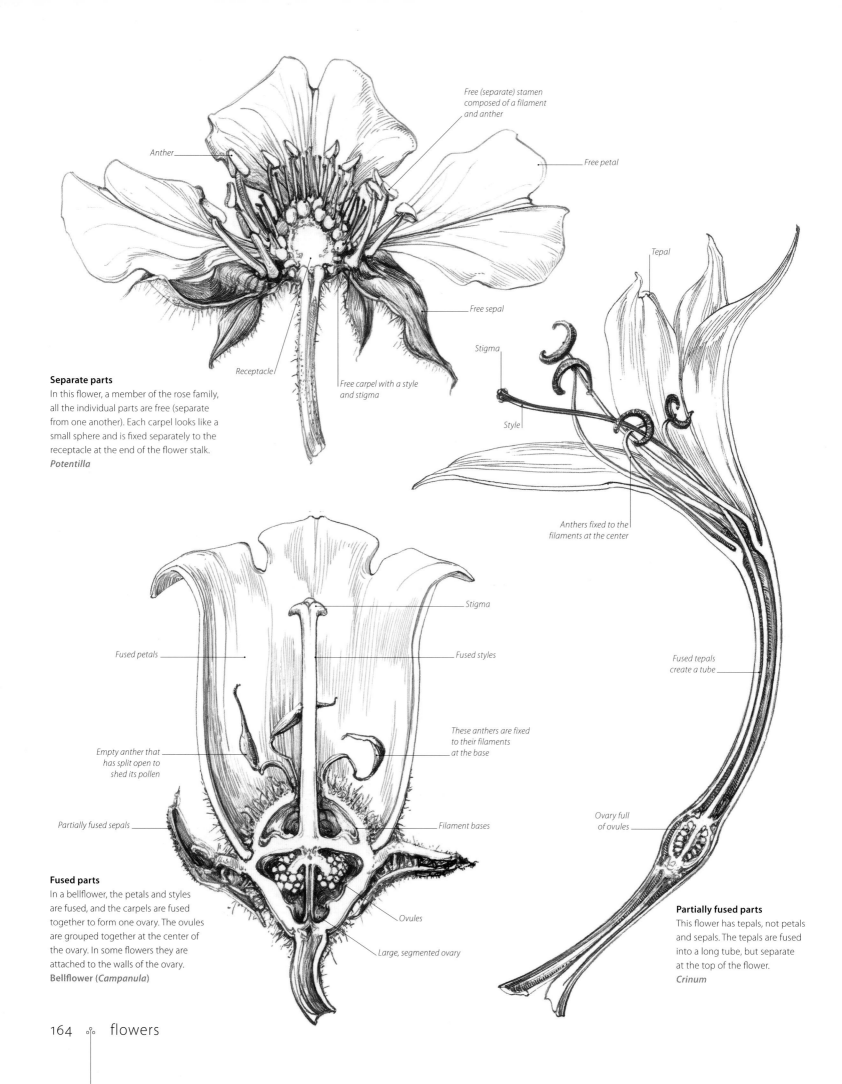

Anther

Free (separate) stamen composed of a filament and anther

Free petal

Tepal

Stigma

Style

Free sepal

Receptacle

Free carpel with a style and stigma

Anthers fixed to the filaments at the center

Separate parts

In this flower, a member of the rose family, all the individual parts are free (separate from one another). Each carpel looks like a small sphere and is fixed separately to the receptacle at the end of the flower stalk.
Potentilla

Stigma

Fused petals

Fused styles

Empty anther that has split open to shed its pollen

These anthers are fixed to their filaments at the base

Partially fused sepals

Filament bases

Fused tepals create a tube

Ovary full of ovules

Ovules

Large, segmented ovary

Fused parts

In a bellflower, the petals and styles are fused, and the carpels are fused together to form one ovary. The ovules are grouped together at the center of the ovary. In some flowers they are attached to the walls of the ovary.
Bellflower (*Campanula*)

Partially fused parts

This flower has tepals, not petals and sepals. The tepals are fused into a long tube, but separate at the top of the flower.
Crinum

Anatomy of a flower

A basic flower has four parts, which are all arranged around the receptacle, the swollen end of the flower stalk. At the center are the carpels, the female parts of the flower. These produce ovules, which become seeds once they are fertilized. The carpels are surrounded by stamens, the male parts of the flower, which produce pollen. Brightly colored petals (collectively known as a corolla) surround the male and female parts of the flower and these are encircled by sepals (collectively known as a calyx), which are usually dull and green. The petals and sepals vary in number and may be completely separate from each other, as in the potentilla (top left); partly fused, as in the crinum (left); or completely fused together, as in the angel's trumpet (right). When the petals and sepals of a flower look the same as each other they are called tepals. These are characteristic of monocots (see p.67) and can be seen on the crinum, as well as on snowdrops, bluebells, and crocosmia.

Each female carpel consists of an ovary filled with ovules, a stalk called a style, and a stigma on top of the style, which receives pollen during pollination. In some flowers, such as the potentilla, the carpels are all free or separate from each other, but in most flowers they are fused together and form one large, segmented ovary, fused styles, and one stigma, as you can see in the bellflower and crinum.

Stamens, the male parts of a flower, are each composed of an anther, which produces pollen, held on a slender stalk called a filament. Sometimes stamens are fused together into tubes. When the pollen inside an anther is ripe, the anther splits open. Anthers vary greatly in form and may be fixed to their filaments at one end, holding them still, as in the bellflower, or be attached at the center, as in the crinum, which leaves them free to tilt or tremble in the breeze.

Angel's trumpet (*Brugmansia*)
All the parts of the angel's trumpet, a member of the potato family, are fused. The fused petals form a graceful trumpet-shaped flower.

Inside a flower

The more closely you look into a flower, the more complex it becomes, and all the more fascinating. You can soon learn to distinguish each individual part and compare them. Flowers belonging to the same family have very similar forms, regardless of their species or cultivar. A fuchsia, for example, is always recognizable, regardless of whether it is dark red or pale pink, long and thin, or short and plump.

A nasturtium flower (opposite) is very robust because it has evolved to take the weight of a large bee. Five firm and deeply crinkled petals overlap at the front to cup and hide the flower's male and female parts, and the unusual fringe is thought to keep out smaller visitors. At the back of the flower a long nectary, called a spur, extends above the flower stalk. Only a bee with a long tongue can reach the nectar at the base of this spur.

The central drawing (opposite) shows a nasturtium gently pressed flat to reveal how its parts are arranged. The two top petals are markedly different in shape and detail from the three below. In the cross section (bottom left) four petals are removed to show the calyx and spur cut in half. Colored lines inside the spur guide bees to the nectar inside it. You can also see that a nasturtium has a superior ovary. In all flowers, ovaries situated above the base of the petals and sepals are called superior, and ovaries sited below are called inferior, as in the fuchsia (top left). Fuchsia flowers hang upside down. If you imagine the flower turned the other way around, it becomes clear that the small green ovary at the end of the stalk is actually below, or inferior to, the petals and sepals. The distinction between superior and inferior ovaries is important to observe when you are drawing.

The dissection of the nasturtium flower (bottom far right) shows the superior ovary of the flower, surrounded by stamens. The ovary, style, and stigma are collectively known as the pistil. Each anther, containing two pollen sacs, opens longitudinally and is fixed to a filament. Anthers shrivel after opening, so they can differ greatly in a single flower.

Fuchsia (*Fuchsia* sp.)
The stigmas and stamens of fuchsias all hang below the petals. The stigmas protrude the lowest and the stamens are grouped behind them. Insects brush against both female and male parts when coming in to land on the flowers.

Foxglove (*Digitalis purpurea*)
The stamens of a foxglove are curved and pressed against the sides and top of the tube of fused petals. The stigma pokes out from between the yellow anthers. Spots act as guides for insects, leading them to the nectar deep within the flower.

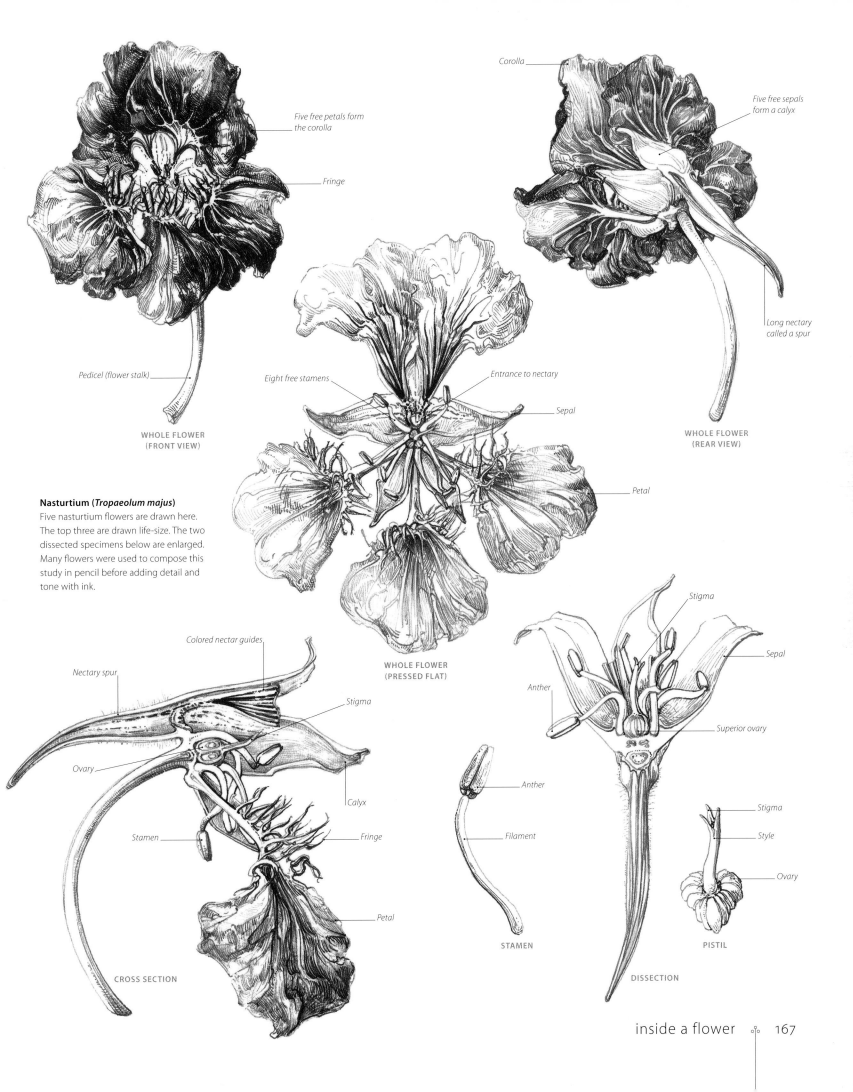

Corolla

Five free petals form
the corolla

Fringe

Five free sepals
form a calyx

Long nectary
called a spur

Pedicel (flower stalk)

**WHOLE FLOWER
(FRONT VIEW)**

Eight free stamens

Entrance to nectary

Sepal

Petal

**WHOLE FLOWER
(REAR VIEW)**

Nasturtium (*Tropaeolum majus*)
Five nasturtium flowers are drawn here.
The top three are drawn life-size. The two
dissected specimens below are enlarged.
Many flowers were used to compose this
study in pencil before adding detail and
tone with ink.

**WHOLE FLOWER
(PRESSED FLAT)**

Colored nectar guides

Stigma

Nectary spur

Anther

Stigma

Sepal

Ovary

Anther

Superior ovary

Stamen

Calyx

Fringe

Anther

Stigma

Filament

Style

Petal

Ovary

STAMEN

PISTIL

CROSS SECTION

DISSECTION

Pollination

To produce seed and the next generation of plants, most flowers must be pollinated. This means that tiny grains of pollen, from male anthers, are carried to a female stigma. After landing on the stigma, pollen grains germinate and grow a long tube through the style and into the ovary where the ovules are fertilized and mature into seeds. Most flowers have male and female parts and receive pollen from other flowers of the same species (cross-pollinate), but a few of them pollinate themselves (self-pollinate).

Flowers need a means to transport pollen. Some use wind, so their male and female parts hang out in the breeze. Most, however, use insects, birds, or mammals and have evolved myriad shapes, patterns, colors, scents, and most importantly, food in the form of nectar, a sweet liquid, to entice them.

The tree germander (below right) has a tongue-like platform, made from the deeply lobed petals, for bees to land on. Dark veins, called nectar guides, lead the bee toward the nectar deep inside the flower and overhead stamens curl, poised to brush pollen onto the bee's head and back. In the pea flower (opposite) a large, prominently veined petal, called the standard, attracts insects. Two curved, darker petals beneath, called the wings, enclose two more petals fused into a boat-shaped keel. This contains the ovary, style, and stigma, which are sheathed by pollen-laden stamens. The front of the keel is sensitive to the weight of an insect. When a bee lands, the anthers are exposed and spill their pollen, which the bee picks up and carries away to the next flower it visits. Meanwhile the stigma picks up pollen brought in by the bee from another flower.

Winged pea (*Lotus tetragonolobus*)
To an insect this flower looks black and white, not red, because its eyes are receptive to ultraviolet light. The striking contrasts in tone entice it to land.

Tree germander (*Teucrium fruticans*)
The stigma is held high to pick up pollen from visiting insects. Two rows of ball-shaped anthers act like airport landing lights, guiding insects into the flower.

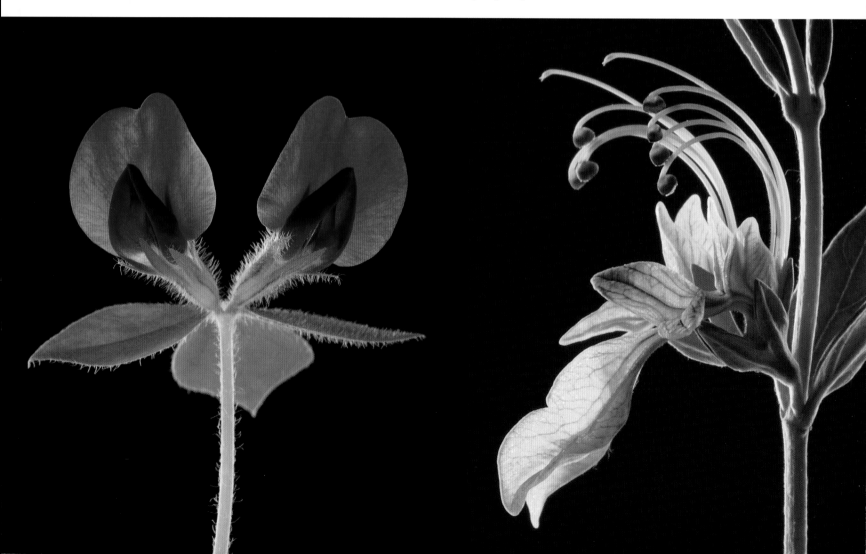

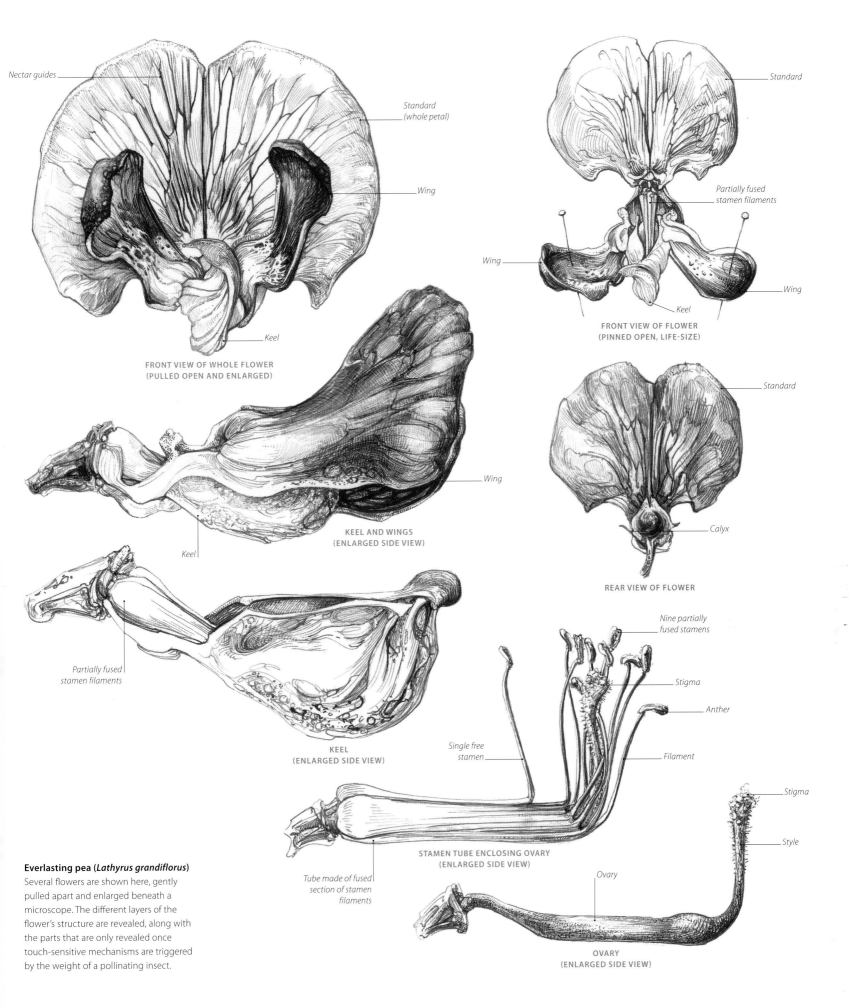

Nectar guides

Standard
(whole petal)

Wing

Keel

**FRONT VIEW OF WHOLE FLOWER
(PULLED OPEN AND ENLARGED)**

Standard

Partially fused
stamen filaments

Wing

Wing

Keel

**FRONT VIEW OF FLOWER
(PINNED OPEN, LIFE-SIZE)**

Wing

Keel

**KEEL AND WINGS
(ENLARGED SIDE VIEW)**

Standard

Calyx

REAR VIEW OF FLOWER

Partially fused
stamen filaments

**KEEL
(ENLARGED SIDE VIEW)**

Nine partially
fused stamens

Stigma

Anther

Single free
stamen

Filament

**STAMEN TUBE ENCLOSING OVARY
(ENLARGED SIDE VIEW)**

Tube made of fused
section of stamen
filaments

Stigma

Style

Ovary

**OVARY
(ENLARGED SIDE VIEW)**

Everlasting pea (*Lathyrus grandiflorus*)
Several flowers are shown here, gently
pulled apart and enlarged beneath a
microscope. The different layers of the
flower's structure are revealed, along with
the parts that are only revealed once
touch-sensitive mechanisms are triggered
by the weight of a pollinating insect.

STUDY
Cross sections

It is impossible to exaggerate the surprise and wonder you will experience at first seeing the parts of a flower enlarged beneath a microscope or hand lens. A new world is revealed. Enjoy choosing six flowers from your own garden, each big enough to handle, and use a new scalpel blade to gently cut them in half. Magnify them beneath a hand lens, and compare like parts, such as sepals, petals, stamens, and ovaries. Drawing each one will reveal further similarities and contrasts. Most flowers will last for a day if stored, cut-side down, on wet tissue paper in an airtight box at room temperature.

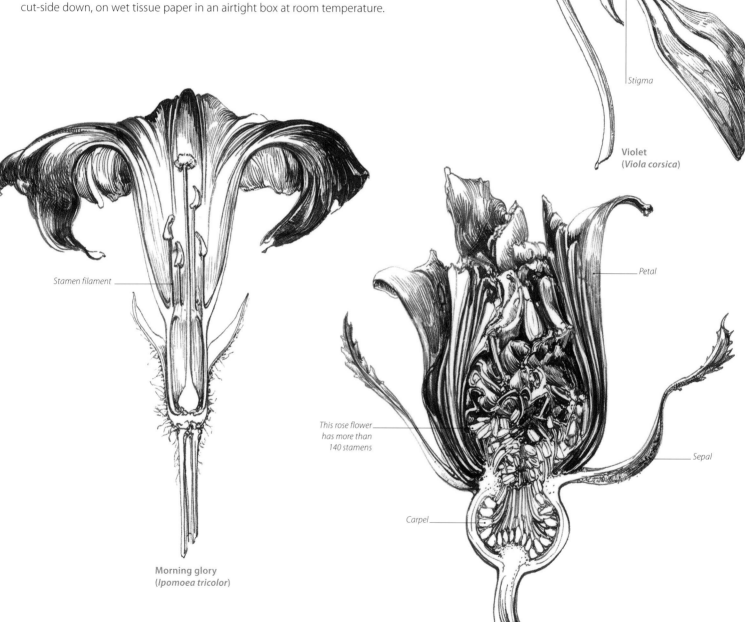

Spur (nectary)

Stigma

Violet
(*Viola corsica*)

Stamen filament

Morning glory
(*Ipomoea tricolor*)

Petal

This rose flower has more than 140 stamens

Sepal

Carpel

Rose
(*Rosa* "Roseraie de l'Haÿ")

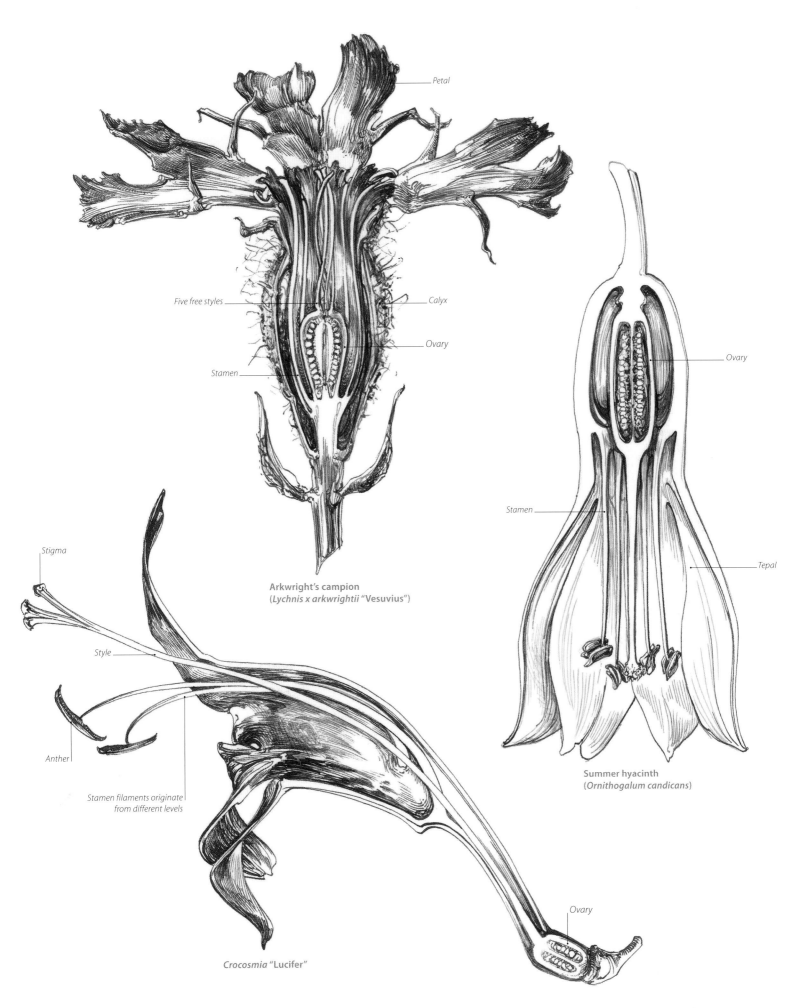

Petal

Five free styles

Calyx

Ovary

Stamen

Arkwright's campion
(*Lychnis x arkwrightii* "Vesuvius")

Ovary

Stamen

Tepal

Summer hyacinth
(*Ornithogalum candicans*)

Stigma

Style

Anther

*Stamen filaments originate
from different levels*

Crocosmia "Lucifer"

Ovary

cross sections ⚬⚬ 171

Geranium Phaeum
Arthur Harry Church

Many of the botanical artists featured in this book were great travelers, who risked their lives on ships and in strange lands, amid political turmoil and war, to discover and document the natural history of the world. Arthur Harry Church (1865–1937) was not a traveler. He remained focused on one place, The University of Oxford Botanic Garden, where he researched and taught botany and made exquisite paintings of magnified, dissected flowers. These paintings are celebrated today as being unique in the history of botanical art. It is often said that in his lifetime Church became the most knowledgeable and least traveled botanist in Britain, but at his desk, with his scalpel and microscope, he entered another world, one barely visible to the naked eye, one that surrounds us but that we rarely think of, an empire of lush color and sensuous texture, fragile sensitivity, and military precision: the microcosm of the anatomy of flowers.

This mourning widow geranium is an enlargement of a single, isolated flower, cut in half to show its reproductive parts. Church emphasized symmetry in all of his flowers, but he also saw and drew the subtle differences between their mirrored parts. He measured every part against a ruler and planned his compositions by gathering details from numerous specimens. Under a microscope, the smallest folds and connections of a dissected flower can appear blurred by broken membranes and spilt moisture, but Church clarified his subjects with long, clear, sweeping lines. He drew first in pencil, then painted with gouache, a water-based medium, which is coarser than watercolor and contains a small amount of chalk to make it naturally opaque. Gouache can be applied thickly, lending itself well to the velvet sheen of flowers. Here, the geranium petals were darkened and lightened using the same rich purple, mixed from red and blue with added white. Note how the deepest hues were built up and completed first, before paler hues were brushed over and blended into them. This is how Church achieved the luminosity so characteristic of this species.

Closer look

Striking contrasts
This curved filament was painted in white gouache, perhaps last of all, over the dark petal. In the whole drawing observe the balance and contrast between the white and pink filaments. They are not real changes in the plant's color, but indications of light and shade.

Glowing style
The lower part of the style (above right) is made luminous by letting the white of the paper glow though a thin green wash. The white filament is painted in solid gouache. Note the difference between these two whites.

phaeum (× 10) A.H.C

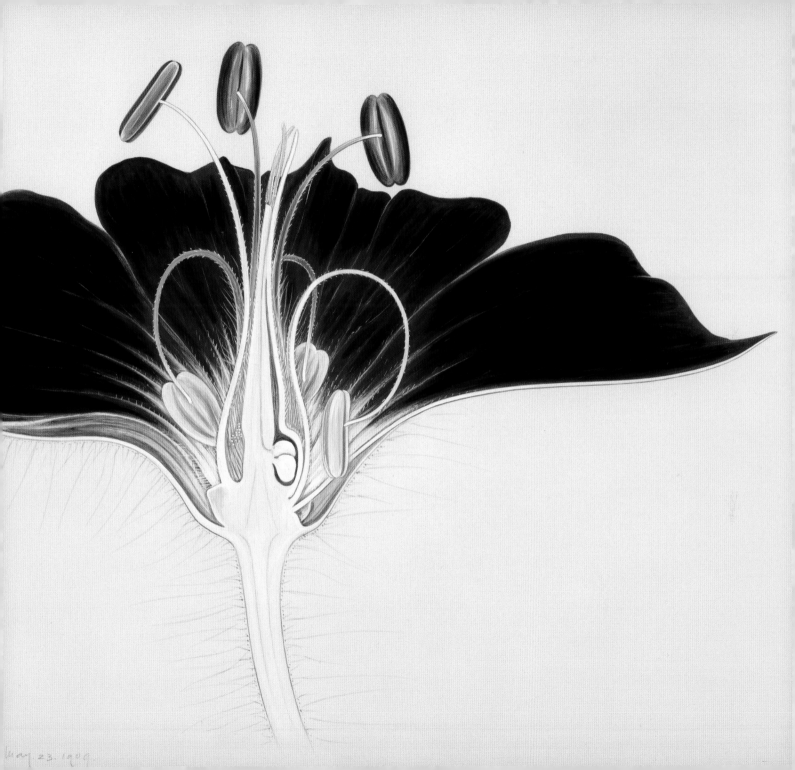

May 23. 1909.

Calyx

Developing bud

Style

Cape figwort
(*Phygelius capensis*)

STUDY
Opening buds

Every bud has a choice: it can produce a new stem and leaves, or a flower. Plants allocate their resources according to circumstance. If they are over-fed they produce a lot of leaves and very few flowers. A starved plant, however, senses a threat to its life and blooms swiftly in a bid to set seed. Flower buds vary greatly in shape, size, and the ways in which they arrange their immature sepals and petals before opening. Some fold their tubular parts like the limbs of an insect (barrenwort, below right). Others wrap their petals into a scroll, like the pink (bottom center). Catmint (below left) holds in the edges of its petals like the lips of an old toothless mouth, while the rock nettle (below center) has petals and sepals that simply touch at the edges and expand in a star form before popping open.

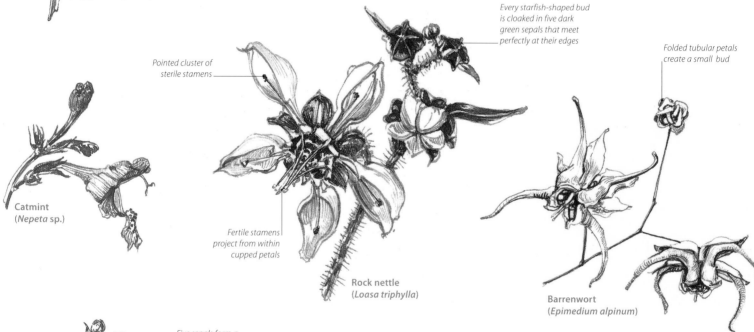

Every starfish-shaped bud is cloaked in five dark green sepals that meet perfectly at their edges

Folded tubular petals create a small bud

Pointed cluster of sterile stamens

Catmint
(*Nepeta* sp.)

Fertile stamens project from within cupped petals

Rock nettle
(*Loasa triphylla*)

Barrenwort
(*Epimedium alpinum*)

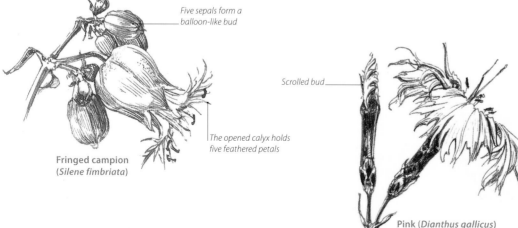

Five sepals form a balloon-like bud

Scrolled bud

Prairie gentian buds
These herbaceous annuals produce flowers on branched stems called cymes (see p.188). Each bud is formed like a scroll and individual blooms open over several weeks.
Prairie gentian (*Eustoma grandiflorum*)

The opened calyx holds five feathered petals

Fringed campion
(*Silene fimbriata*)

Agapanthus buds
Blue and white agapanthus produce their inflorescences on tall, tubular stems. Each large bud opens over a couple of days, releasing a large, rounded umbel of funnel-shaped flowers.
African lily (*Agapanthus*)

Pink (*Dianthus gallicus*)

174 ⁂ flowers

Symmetry in flowers

When drawing flowers and inflorescences, the first thing to look at is their overall geometric form and symmetry. Is your subject most like a sphere or hemisphere, a tube, a cone, or a mixture of several forms? This will help when drawing them. To understand a flower's symmetry, simply turn it to face you and see whether its complete form can be divided equally into two halves, like the slipper orchid, below left, or whether its parts all radiate from the center like the spokes of a wheel, as in the passionflower on the left. Almost all flowers show one of these two types of symmetry: radial, like the passionflower, or bilateral, like the orchid. More examples are shown (right).

Many radially symmetrical flowers have five lines of symmetry because their component parts, such as petals, stamens, and styles, are arranged in divisions of five, as seen in the Arkwright's campion (opposite, top left). The floral parts of monocots such as the Bulgarian onion (opposite, top right) are in multiples of three. Many "flowers" in the daisy family, such as chamomile, are radially symmetrical, but if you look at them closely, you will find that each tubular disk floret is radially symmetrical, while the ray florets are bilaterally symmetrical (see p.201).

When looked at head on, a bilateral flower can only be divided into two equal halves along a central vertical axis. Each half mirrors the other, although no two halves are ever identical. If, however, you look at a bilateral flower from the side or any other angle, it no longer looks symmetrical. Truly asymmetrical flowers are rare, but can be found, for example, at the outermost edges of hogweed (*Heracleum sphondylium*) flower heads.

Passionflower (*Passiflora caerulea*)
This flower (top left) is radially symmetrical: its parts radiate from the center of the flower and are evenly spaced. Five petals sit above and between five sepals, each of which has a small spike at its tip.

Slipper orchid (*Paphiopedilum* sp.)
This triangular-shaped flower (left) is bilaterally symmetrical: it can be divided into two equal halves if you imagine a vertical line drawn through the center of it from top to bottom.

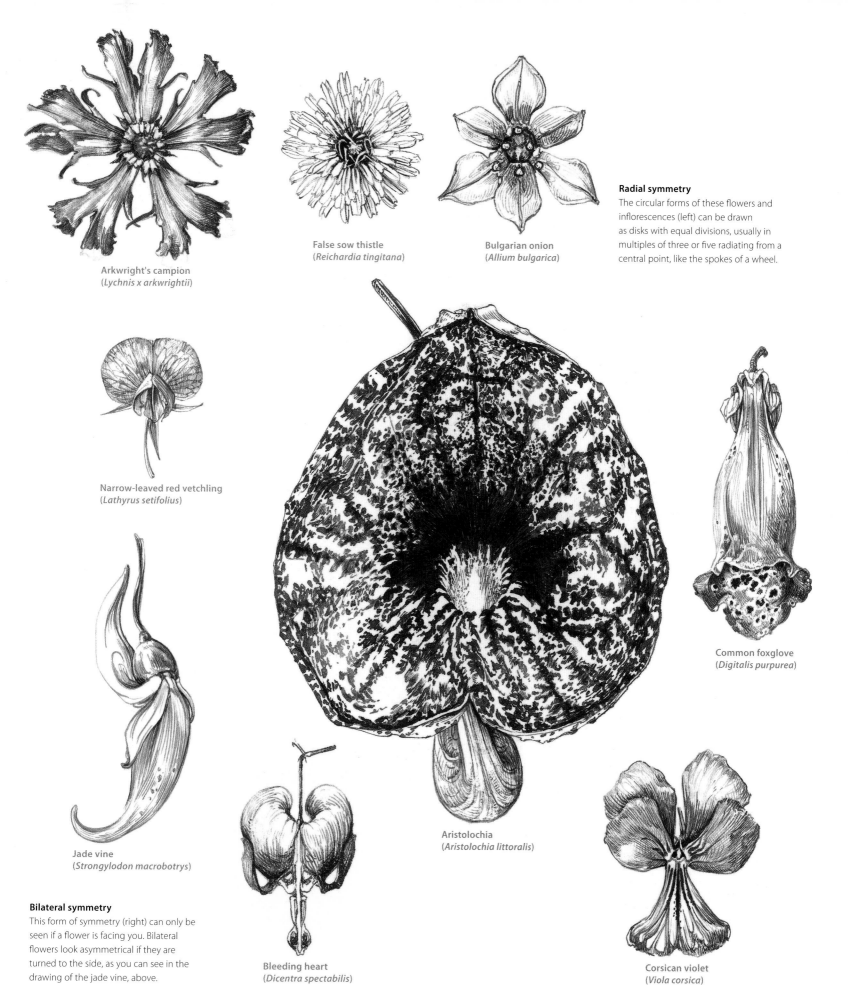

Arkwright's campion
(*Lychnis x arkwrightii*)

False sow thistle
(*Reichardia tingitana*)

Bulgarian onion
(*Allium bulgarica*)

Radial symmetry
The circular forms of these flowers and inflorescences (left) can be drawn as disks with equal divisions, usually in multiples of three or five radiating from a central point, like the spokes of a wheel.

Narrow-leaved red vetchling
(*Lathyrus setifolius*)

Common foxglove
(*Digitalis purpurea*)

Jade vine
(*Strongylodon macrobotrys*)

Bilateral symmetry
This form of symmetry (right) can only be seen if a flower is facing you. Bilateral flowers look asymmetrical if they are turned to the side, as you can see in the drawing of the jade vine, above.

Bleeding heart
(*Dicentra spectabilis*)

Aristolochia
(*Aristolochia littoralis*)

Corsican violet
(*Viola corsica*)

Aristolochia

Aristolochias are mostly vines, with simple leaves arranged alternately along twining stems. They are named pelican flowers, pipe weeds, Dutch pipes, and birthworts. Around 120 species grow in habitats ranging from tropical forests to the cool walls of old European monasteries and convents, where their presence suggests medicinal use. The flowers hang singly from leaf axils and are inflated near their base to create a delicate green globe extending into a curved pipe, then opening out into a soft skin-like lobe. They are pollinated by flies, so emulate the colors, odor, and texture of carrion. Fine hairs trap flies inside the flowers, and they buzz about in pollen until the hairs wither, releasing the flies to find another flower. Aristolochias are beautiful subjects for learning how to draw markings on undulating surfaces. They also highlight the importance of leaving areas of intense pattern less complete. Changes in pattern and tone direct the eye around the drawing and make it seem more three-dimensional.

Placing the image

1 Use an HB pencil and eraser to lightly and swiftly place the entire shape and form of the flower on the page. Keep all marks open to change and avoid irrelevant detail. Gently add and erase marks until you are happy with the proportional balance of all parts and how they fit in the picture space.

Controlling focus

2 Do not be tempted to fill in all of the pattern on the whole surface of the flower as this would look repetitive, and have an overwhelming, flattening, and dulling effect. Suggest light and fleeting focus by leaving a few different areas less highly worked. Less is more.

Creating contrast

3 This flower is bilaterally symmetrical, but it is not identical on both sides. Focus on the equalities and differences in each half. Here I lifted the skirt of the flower to glimpse the globe of the perianth tube, contrasting its pale convex form with the velvet black opening above.

Darkest tones last

4 Patiently build layers of tones, working from light to dark. Keep the darkest marks until last. Contrast areas of tiny and larger markings and see how they cluster and streak in different directions. Draw lines as if in contact with the undulating surface of the flower, so they actually seem to become the surface.

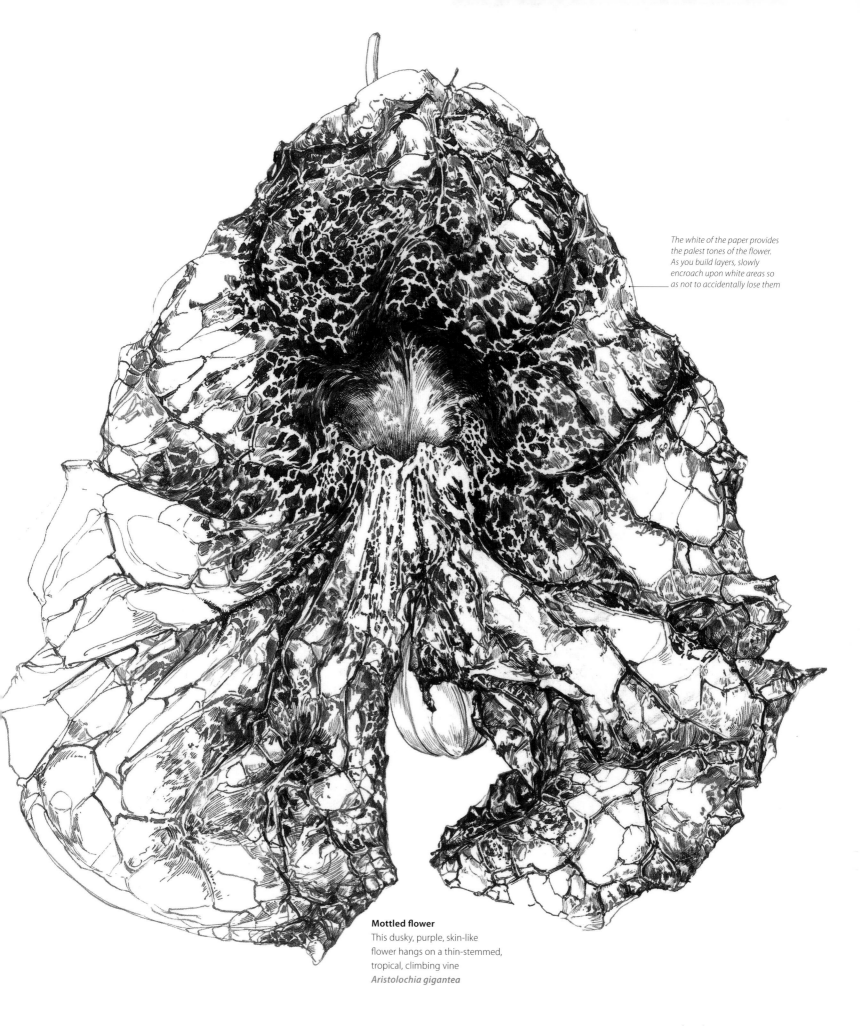

The white of the paper provides the palest tones of the flower. As you build layers, slowly encroach upon white areas so as not to accidentally lose them

Mottled flower
This dusky, purple, skin-like flower hangs on a thin-stemmed, tropical, climbing vine
Aristolochia gigantea

Flower forms

Flowers have evolved to attract pollinators, not humans—we just happen to enjoy them too. Every flower form has evolved to separate the male and female parts of the flower and to ensure that pollen is received and taken away efficiently. The spurs, cups, and folds of flowers pollinated by animals (including insects and birds), for example, are just the right size for the bodies and mouthparts of their pollinators. Tiny flowers attract creatures of a similar scale, while big flowers, such as the glory lily opposite, can take the impact of a bird. Flowers may be as tiny as a tenth of an inch across or as great as those produced by some rafflesias, measuring up to three feet across and weighing up to 22 pounds.

Botanists classify the forms and postures of flowers to aid identification and description. Forms may be described as tubular, cupped, or reflexed (turned backward), for example, and postures may be described as pendent, erect, or patent (held to the side). A flower's form, size, color, and scent reflect how it is pollinated. Birds like strong color contrasts and have no sense of smell, so bird-pollinated flowers are usually red and rarely scented, whereas flowers pollinated by moths can be highly scented and are often white so they are easier to locate in low light. Flowers that open at night may be pollinated by bats, so they are often brown or purplish, smell of mice, and are bucket-shaped, to accommodate a bat's head. Bee orchids look like female bees to attract male bees that will pollinate them.

Insects see differently from us because their eyes are receptive to ultraviolet light. If this is shone onto flowers in a laboratory a whole new world is revealed. We experience something resembling an insect's vision and witness not rich color, but stark contrasts between black and white, marked textures, and striking patterns not usually visible to us. In some ways, the monochrome ink drawings opposite, with their emphasis on tonal contrast, form, and pattern, echo what an insect sees.

Tubular flowers
Penstemons, like foxgloves, are pollinated by bees, which crawl inside and follow striped nectar guides down to the base of the flower. Bees also seem to rest inside tubular flowers, or use them to shelter from rain, hot sun, or passing birds.
Penstemon "Sour Grapes"

Form and posture
A wide range of different flower forms is shown here and overleaf. The shape of each flower has evolved over time to suit its pollinator. The first word beneath each flower describes its form, and the second word its posture.

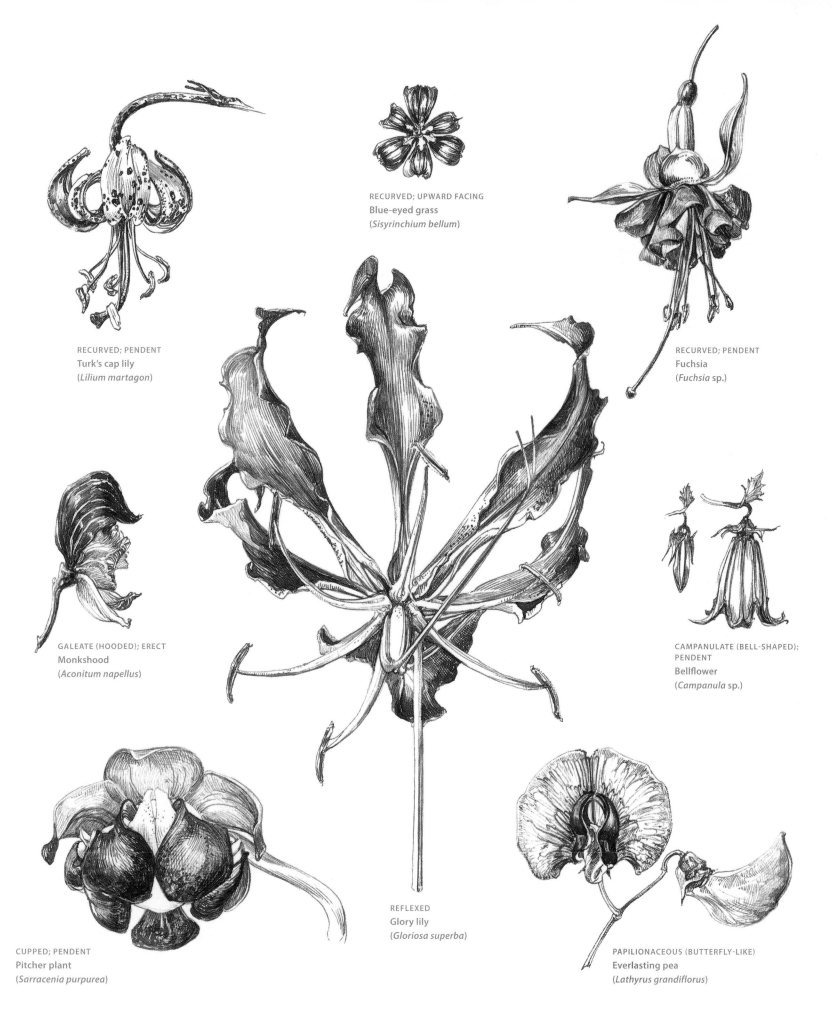

RECURVED; UPWARD FACING
Blue-eyed grass
(*Sisyrinchium bellum*)

RECURVED; PENDENT
Turk's cap lily
(*Lilium martagon*)

RECURVED; PENDENT
Fuchsia
(*Fuchsia* sp.)

GALEATE (HOODED); ERECT
Monkshood
(*Aconitum napellus*)

CAMPANULATE (BELL-SHAPED);
PENDENT
Bellflower
(*Campanula* sp.)

CUPPED; PENDENT
Pitcher plant
(*Sarracenia purpurea*)

REFLEXED
Glory lily
(*Gloriosa superba*)

PAPILIONACEOUS (BUTTERFLY-LIKE)
Everlasting pea
(*Lathyrus grandiflorus*)

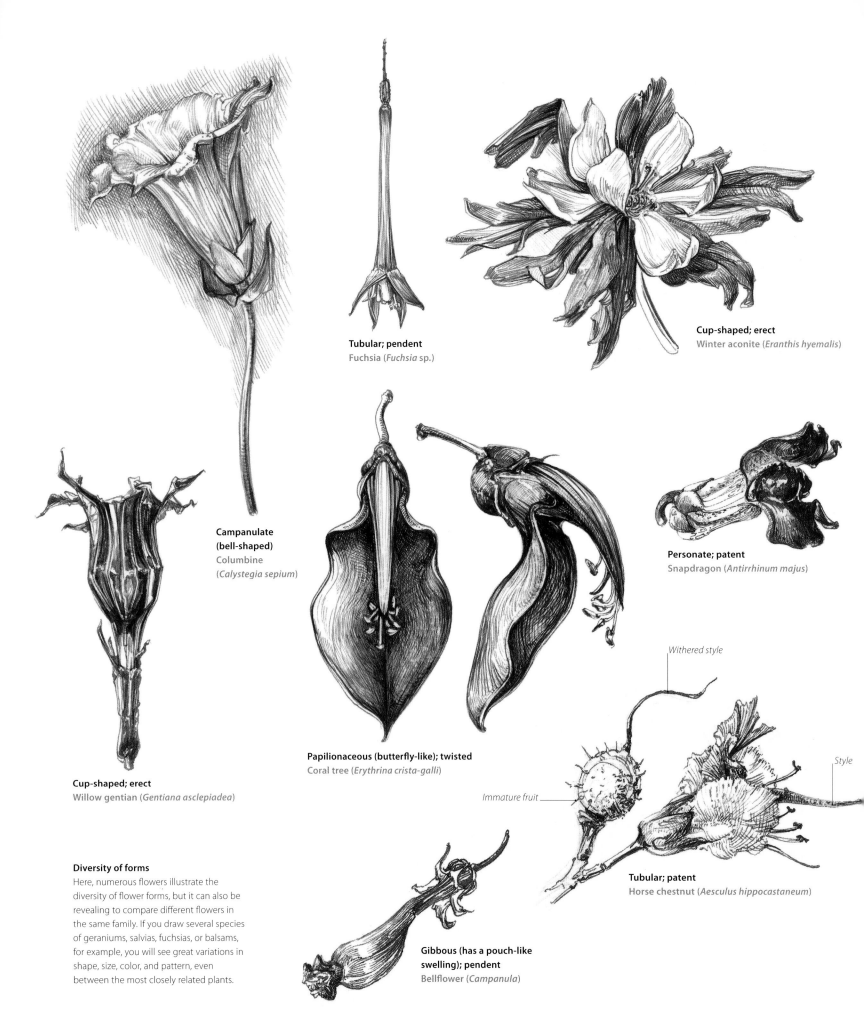

Tubular; pendent
Fuchsia (*Fuchsia* sp.)

Cup-shaped; erect
Winter aconite (*Eranthis hyemalis*)

**Campanulate
(bell-shaped)**
Columbine
(*Calystegia sepium*)

Personate; patent
Snapdragon (*Antirrhinum majus*)

Withered style

Style

Immature fruit

Cup-shaped; erect
Willow gentian (*Gentiana asclepiadea*)

Papilionaceous (butterfly-like); twisted
Coral tree (*Erythrina crista-galli*)

Tubular; patent
Horse chestnut (*Aesculus hippocastaneum*)

Diversity of forms
Here, numerous flowers illustrate the
diversity of flower forms, but it can also be
revealing to compare different flowers in
the same family. If you draw several species
of geraniums, salvias, fuchsias, or balsams,
for example, you will see great variations in
shape, size, color, and pattern, even
between the most closely related plants.

**Gibbous (has a pouch-like
swelling); pendent**
Bellflower (*Campanula*)

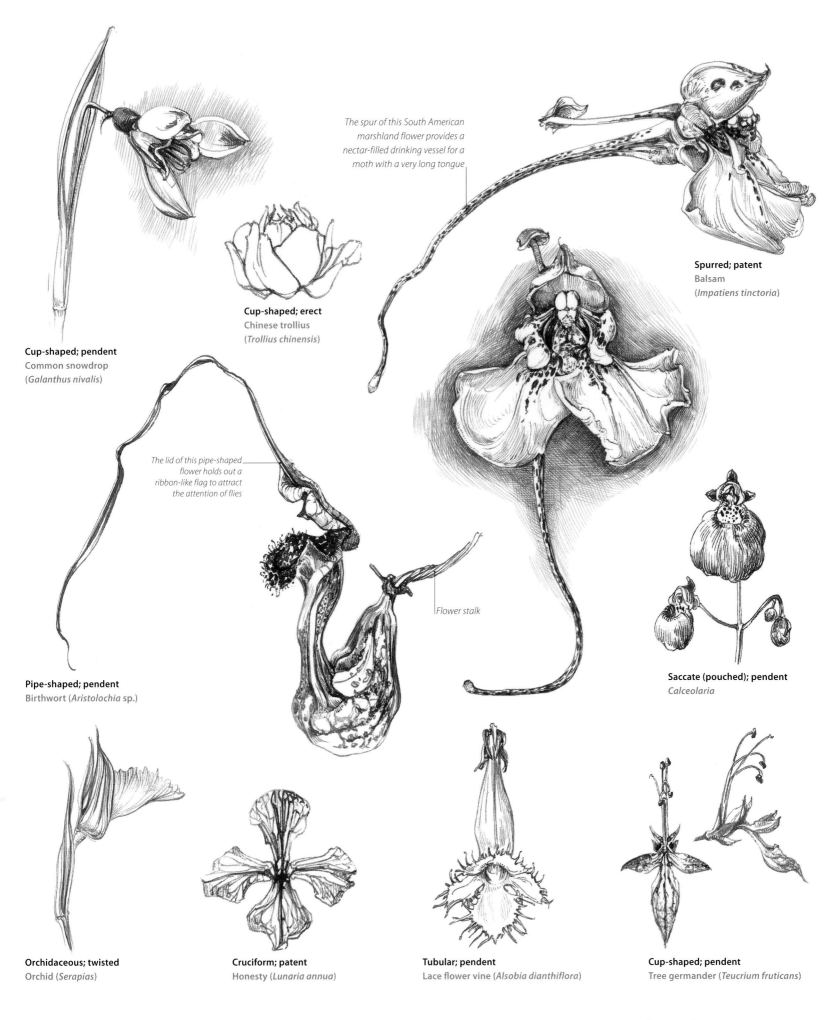

Cup-shaped; pendent
Common snowdrop
(*Galanthus nivalis*)

Cup-shaped; erect
Chinese trollius
(*Trollius chinensis*)

The spur of this South American marshland flower provides a nectar-filled drinking vessel for a moth with a very long tongue

Spurred; patent
Balsam
(*Impatiens tinctoria*)

The lid of this pipe-shaped flower holds out a ribbon-like flag to attract the attention of flies

Flower stalk

Pipe-shaped; pendent
Birthwort (*Aristolochia* sp.)

Saccate (pouched); pendent
Calceolaria

Orchidaceous; twisted
Orchid (*Serapias*)

Cruciform; patent
Honesty (*Lunaria annua*)

Tubular; pendent
Lace flower vine (*Alsobia dianthiflora*)

Cup-shaped; pendent
Tree germander (*Teucrium fruticans*)

flower forms ❀ 183

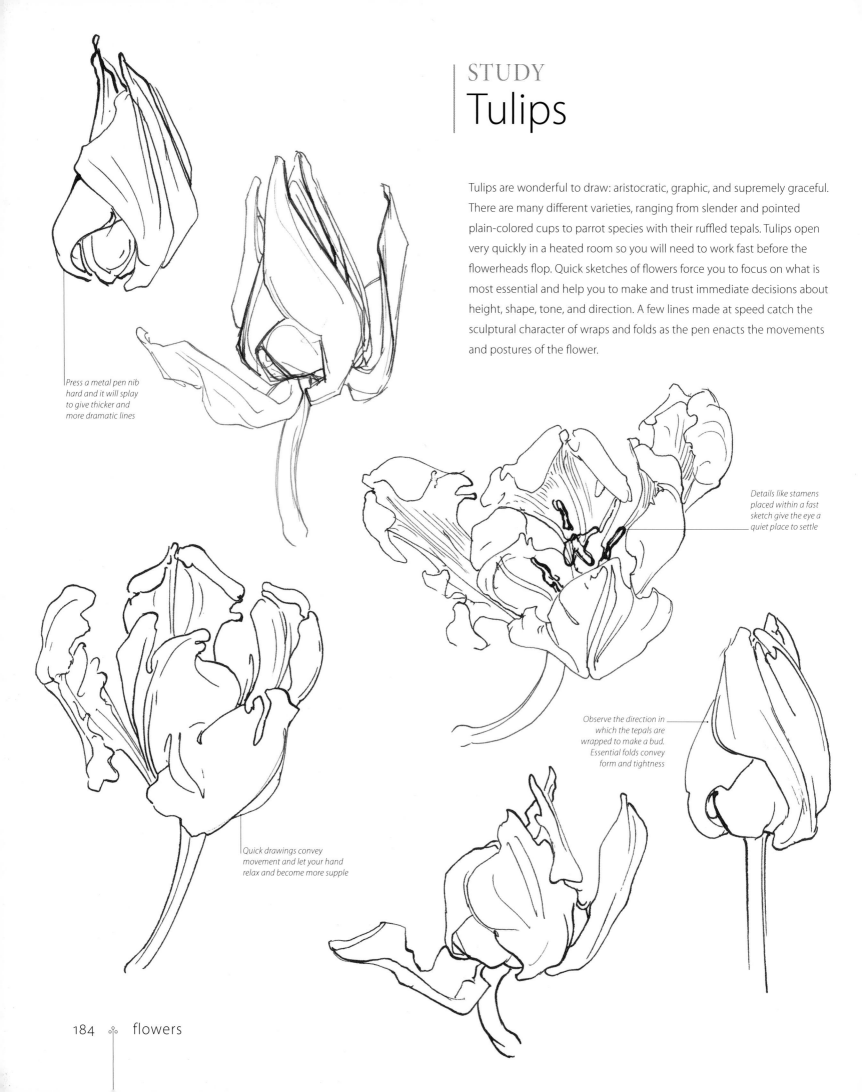

Tulips

Tulips are wonderful to draw: aristocratic, graphic, and supremely graceful. There are many different varieties, ranging from slender and pointed plain-colored cups to parrot species with their ruffled tepals. Tulips open very quickly in a heated room so you will need to work fast before the flowerheads flop. Quick sketches of flowers force you to focus on what is most essential and help you to make and trust immediate decisions about height, shape, tone, and direction. A few lines made at speed catch the sculptural character of wraps and folds as the pen enacts the movements and postures of the flower.

Press a metal pen nib hard and it will splay to give thicker and more dramatic lines

Details like stamens placed within a fast sketch give the eye a quiet place to settle

Quick drawings convey movement and let your hand relax and become more supple

Observe the direction in which the tepals are wrapped to make a bud. Essential folds convey form and tightness

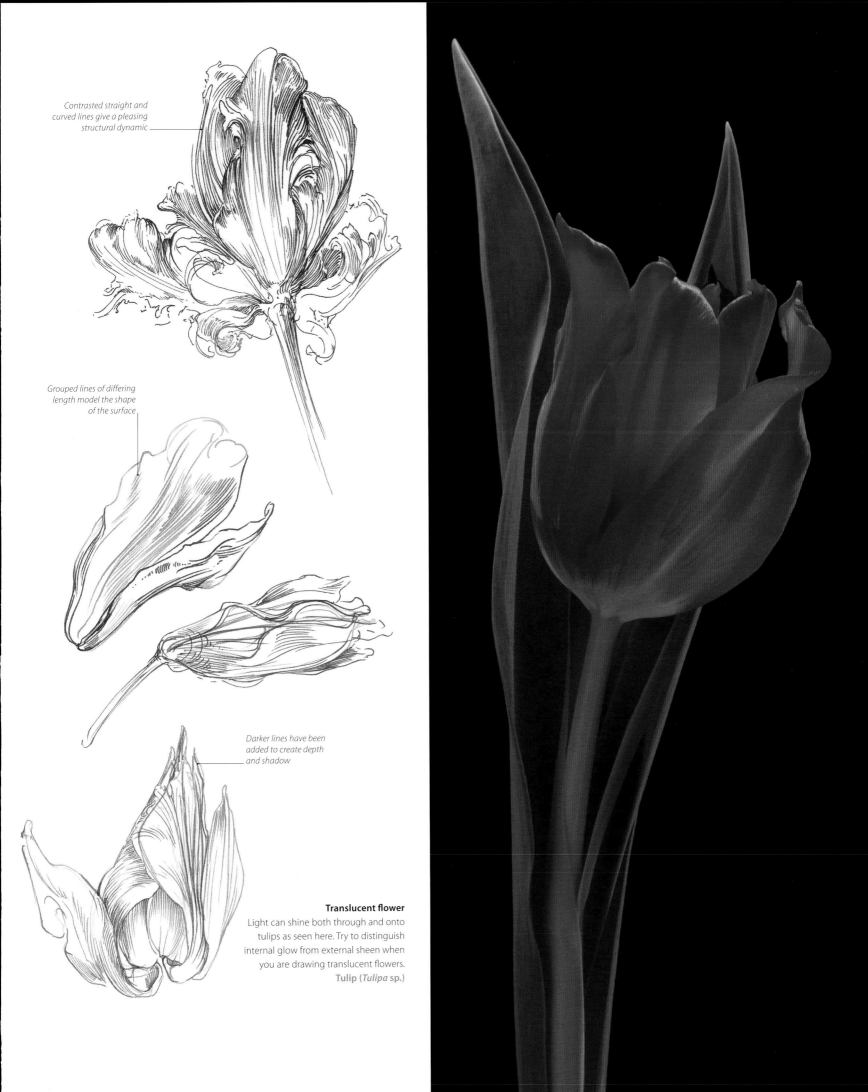

Contrasted straight and curved lines give a pleasing structural dynamic

Grouped lines of differing length model the shape of the surface

Darker lines have been added to create depth and shadow

Translucent flower
Light can shine both through and onto tulips as seen here. Try to distinguish internal glow from external sheen when you are drawing translucent flowers.
Tulip (*Tulipa* sp.)

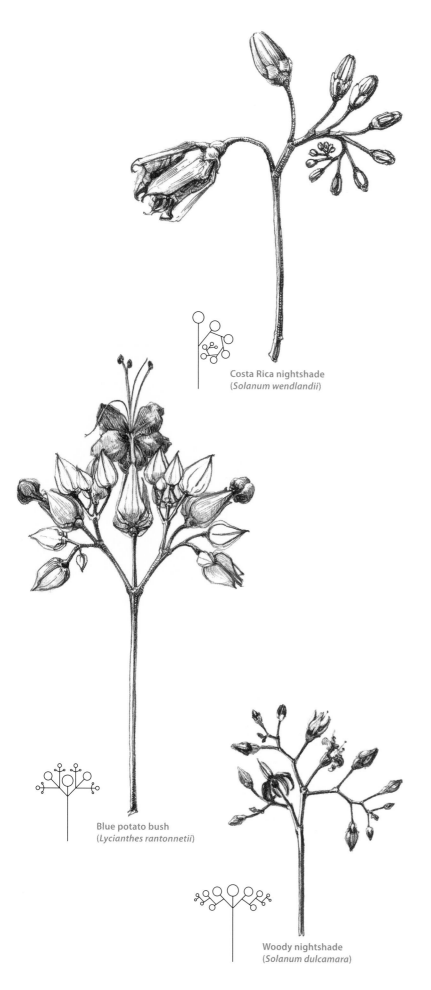

Branching

It is important to observe how flowers are arranged on their stems, how flowering stems branch, and the order in which flowers open and set fruit. The entire flowering shoot of a plant is called an inflorescence. This can take a solitary form, as in the case of many spring bulbs, such as crocuses and snowdrops (see p.90), in which single stems rise from the ground and each produce a single flower. Most inflorescences, however, are branched and bear many flowers. They usually fall into one of two groups: cymes and racemes, which are illustrated and explained on the following pages. The way in which a plant branches gives it its own unique character, so studying this is vital if you want to create accurate and evocative drawings.

Here three members of the potato family show how even closely related plants can branch differently from each other. The main stem of the Costa Rica nightshade (top left) ends in its first flower. A small branch produced to the right carries the second flower and further branches develop on the right, each terminated by a flower. This pattern is called helicoid because it gradually curls around into a helix. The blue potato bush (center left) produces its first flower in the center. Two identical new flowering branches develop on either side of it, then four more on each side of these and so on, creating an ever-widening fan. This is called dichasial branching. Woody nightshade (below left) produces new flowering shoots alternately to the right then left, creating a zig-zag pattern known as scorpioid branching.

Costa Rica nightshade
(*Solanum wendlandii*)

Blue potato bush
(*Lycianthes rantonnetii*)

Woody nightshade
(*Solanum dulcamara*)

Patterns of branching
These three members of the potato family each show a different type of branching: helicoid, dichasial, and scorpioid. A diagram next to each drawing shows the branching and the order in which flowers are produced. Drawing diagrams like this helps you to understand the structure of any inflorescence you are studying.

Inflorescences

Botanists use diagrams like those below to show how an inflorescence branches. They act as a simplified key. In each diagram the largest circle indicates the first flower to open, and the successively smaller circles show the sequence in which the following flowers open and then bear fruit.

It is worth noting that in real life plants never follow as rigid a pattern as the diagrams: any one plant can combine the features of different forms. When related to actual plants, the diagrams help to clarify what we see, but are rarely an exact match.

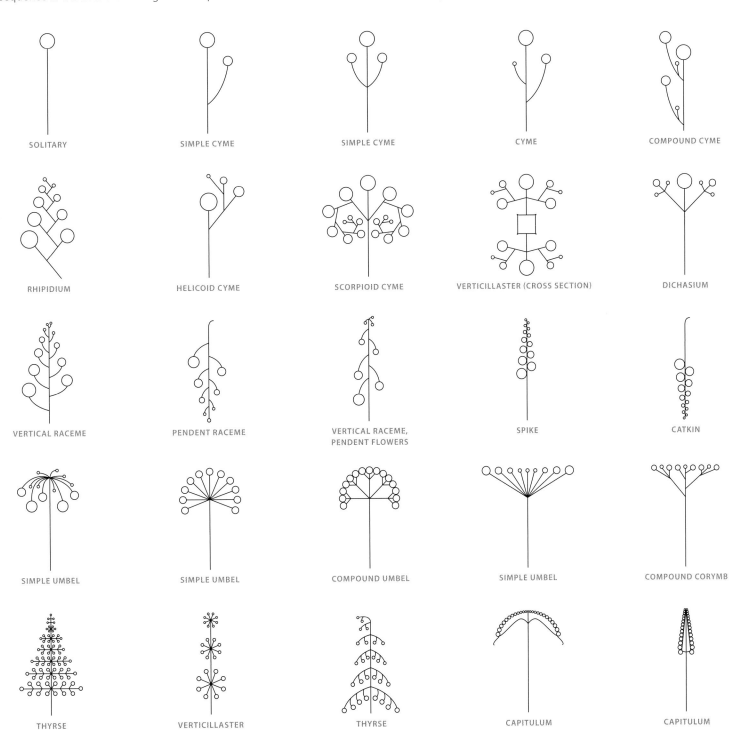

SOLITARY	SIMPLE CYME	SIMPLE CYME	CYME	COMPOUND CYME
RHIPIDIUM	HELICOID CYME	SCORPIOID CYME	VERTICILLASTER (CROSS SECTION)	DICHASIUM
VERTICAL RACEME	PENDENT RACEME	VERTICAL RACEME, PENDENT FLOWERS	SPIKE	CATKIN
SIMPLE UMBEL	SIMPLE UMBEL	COMPOUND UMBEL	SIMPLE UMBEL	COMPOUND CORYMB
THYRSE	VERTICILLASTER	THYRSE	CAPITULUM	CAPITULUM

Cymes

Cymes are a type of inflorescence in which the main flowering stem stops growing when the first flower develops. The first flower therefore appears at the top of the stem, with younger flowers beneath it or to the side of it. Cymes are the opposite of racemes (see overleaf) and four of them are illustrated here. The first inflorescence on the right is a dark blue and white beardless iris from Siberia and China. In the drawing we can see that the oldest flower has determined the height of the stem and has died. The stem then put out two side shoots. The second flower appears in full bloom at the top of the drawing, having branched out from below and behind the first flower. A third flower, still in bud, is held out on a lower branch, while the fourth and fifth flowers appear as tiny buds tucked in close to the main stem. Look at the diagram at the base of the drawing and follow the succession of circles from large (the first flower) to small (the last flower) to see the order in which the flowers open.

Soft yellow sow thistles, in the daisy family, grow in temperate regions worldwide and are often seen sprouting through the cracks of urban tarmac and colonizing roadsides. The sow thistle (second right) shows how an inflorescence can combine the characteristics of both cymes and racemes. It is clearly a cyme because the first inflorescence is opening at the top, with subsequent buds swelling in descending order below, but its overall structure is that of a corymb (see p.194). The Chinese trollius (third right) is a meadow plant with yellow flowers from China and northeast Russia. It belongs to the same family as buttercups and hellebores (see p.69), which, like the trollius, produce cymes. If you compare it with these, you will immediately see the similarities. The flowering stem of the white campion (far right) is a dichasium, like the blue potato bush on the previous page, and branches in an ever-widening fan.

Contrasting cymes
These flowering stems picked from a garden, a wild meadow, and a pavement are all different types of cyme and branch in contrasting ways. The diagrams next to the drawings show the order in which flowers develop and open.

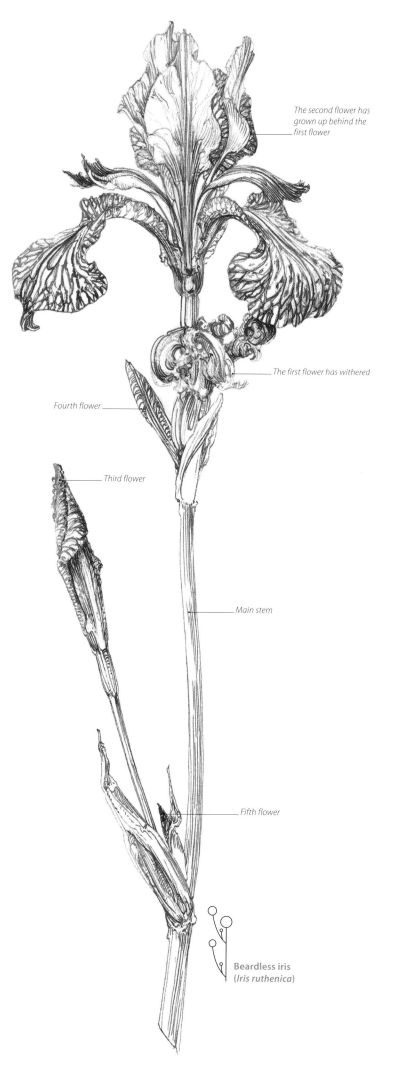

The second flower has grown up behind the first flower

The first flower has withered

Fourth flower

Third flower

Main stem

Fifth flower

Beardless iris
(*Iris ruthenica*)

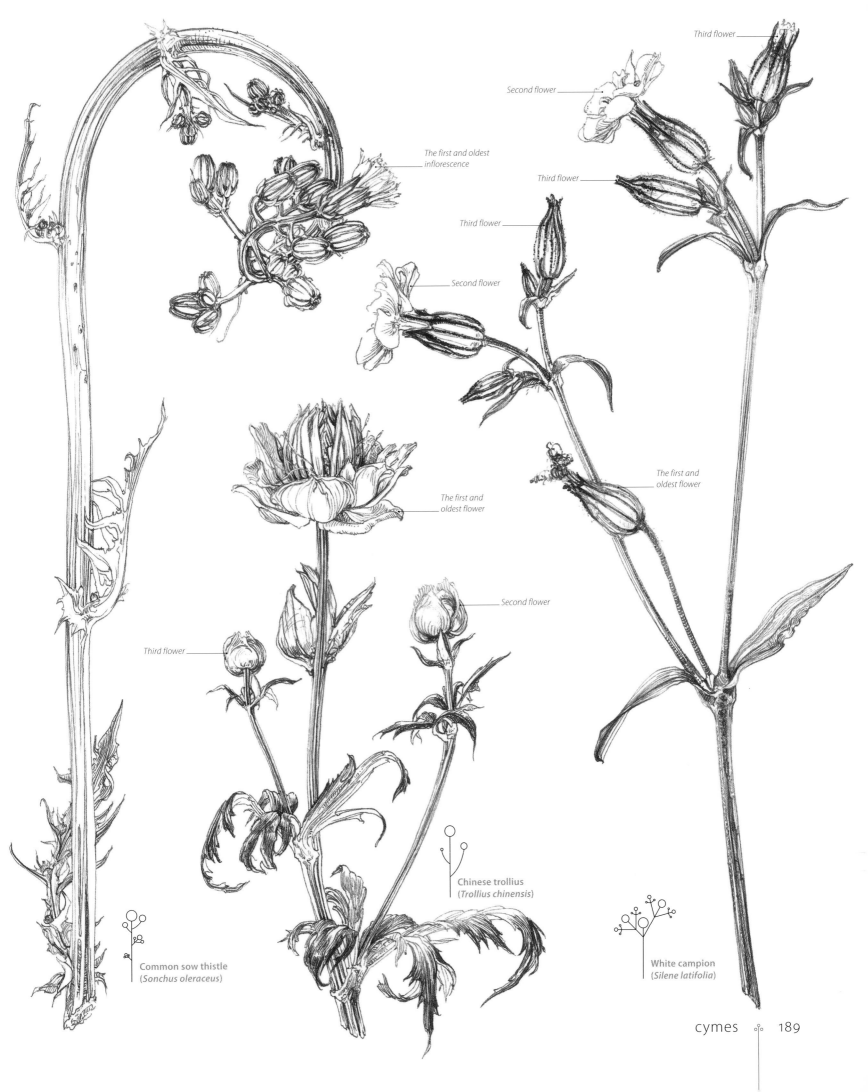

The first and oldest
inflorescence

Second flower

Third flower

Third flower

Third flower

Second flower

The first and
oldest flower

The first and
oldest flower

The first and
oldest flower

Third flower

Second flower

Common sow thistle
(*Sonchus oleraceus*)

Chinese trollius
(*Trollius chinensis*)

White campion
(*Silene latifolia*)

cymes ⚬ 189

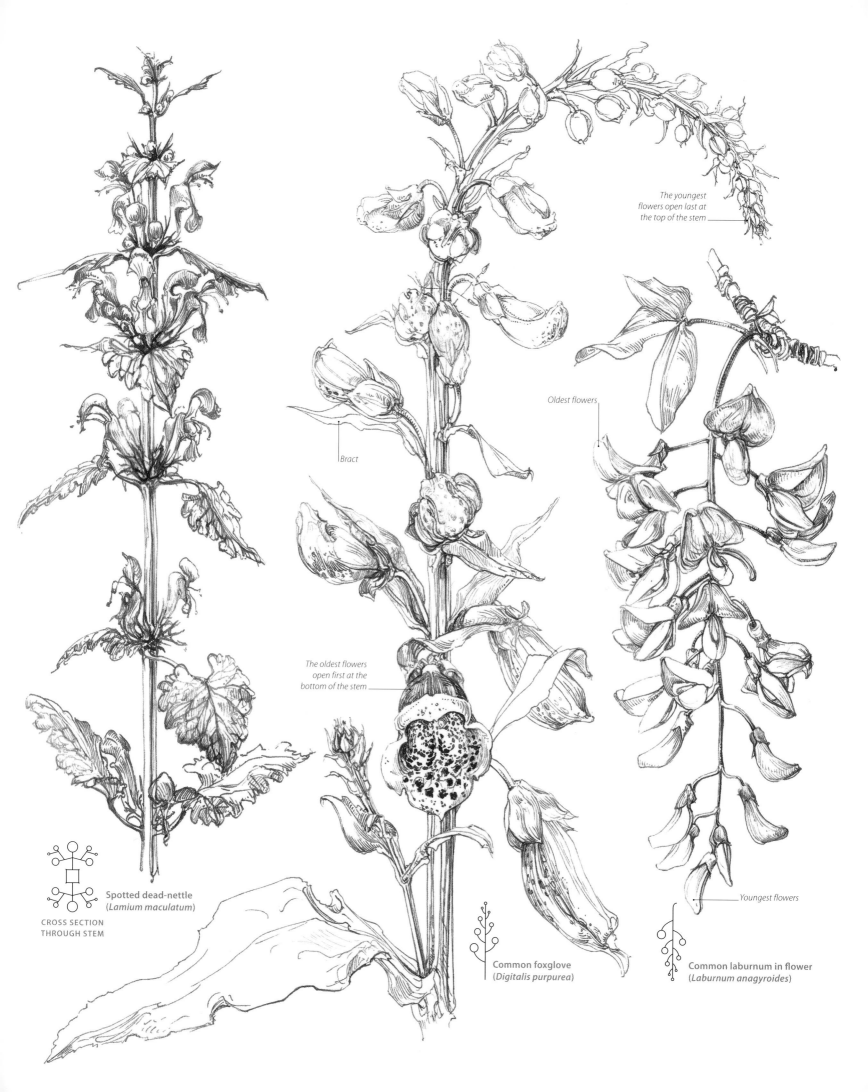

The youngest flowers open last at the top of the stem

Oldest flowers

Bract

The oldest flowers open first at the bottom of the stem

Youngest flowers

Spotted dead-nettle
(*Lamium maculatum*)

CROSS SECTION
THROUGH STEM

Common foxglove
(*Digitalis purpurea*)

Common laburnum in flower
(*Laburnum anagyroides*)

Racemes

The simplest raceme to understand is a foxglove (center left). This pale native of dappled woodland shade carries stout tubular flowers on short pedicels (stalks) along a rising vertical stem. The oldest flowers are at the base of the plant and the youngest at the top, and the stem carries on growing, regardless of developing flowers. Laburnum has the same structure but it flowers upside down and produces pendent racemes. The stem of the dead-nettle (far left) grows like a raceme, but flowers branch from the stem at regular intervals and each branch of flowers opens in the same order as a cyme. Stinging nettles (far right) are similar, but they bear panicles of flowers. A panicle is a raceme that branches into smaller and smaller racemes.

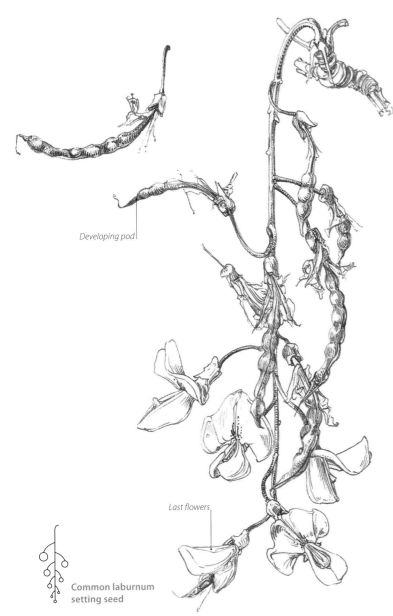

Developing pod

Last flowers

Common laburnum setting seed

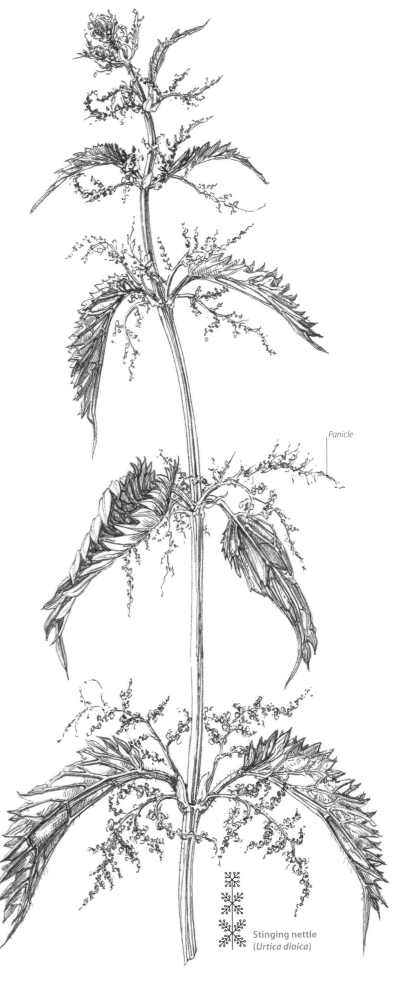

Panicle

Stinging nettle (*Urtica dioica*)

Wild flowers

Stiff and hairy little dark-leaved bushes of hedge woundwort, fragile stems of dove's-foot cranesbill, and heaps of brambles are just three of the many wild plants growing on common land near my studio; a very old city dump thickly overgrown with craggy, unkempt fruit trees that have sprouted from domestic waste. These small sketches made in pencil and watercolor took me straight back to the childhood pleasures of wild walks and discovering plants by copying their minute details into a pocket notebook.

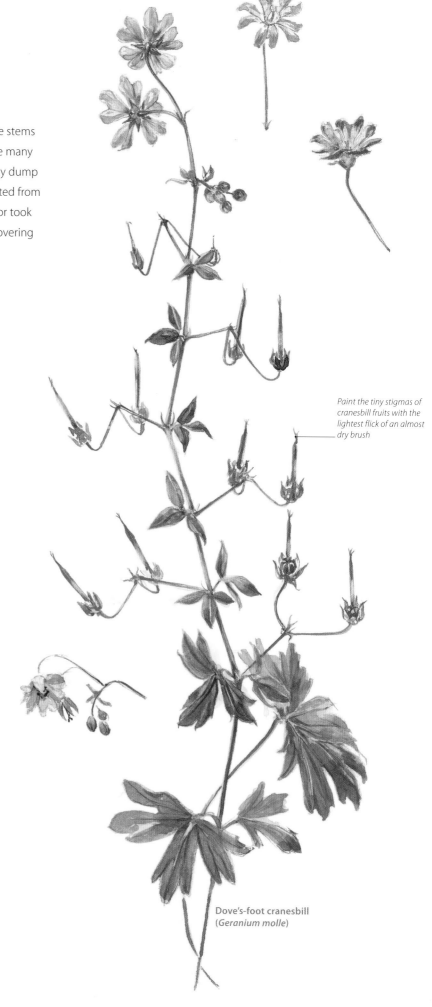

Paint the tiny stigmas of cranesbill fruits with the lightest flick of an almost dry brush

Accurate colors
I used three pigments to make these studies: transparent yellow, permanent rose, and ultramarine. Paint each color you mix on a scrap of paper, then hold your flower next to it to see how the hues compare. Gently adjust each color until perfect and keep your water clean so as not to muddy the hues.

Hedge woundwort
(*Stachys sylvatica*)

Dove's-foot cranesbill
(*Geranium molle*)

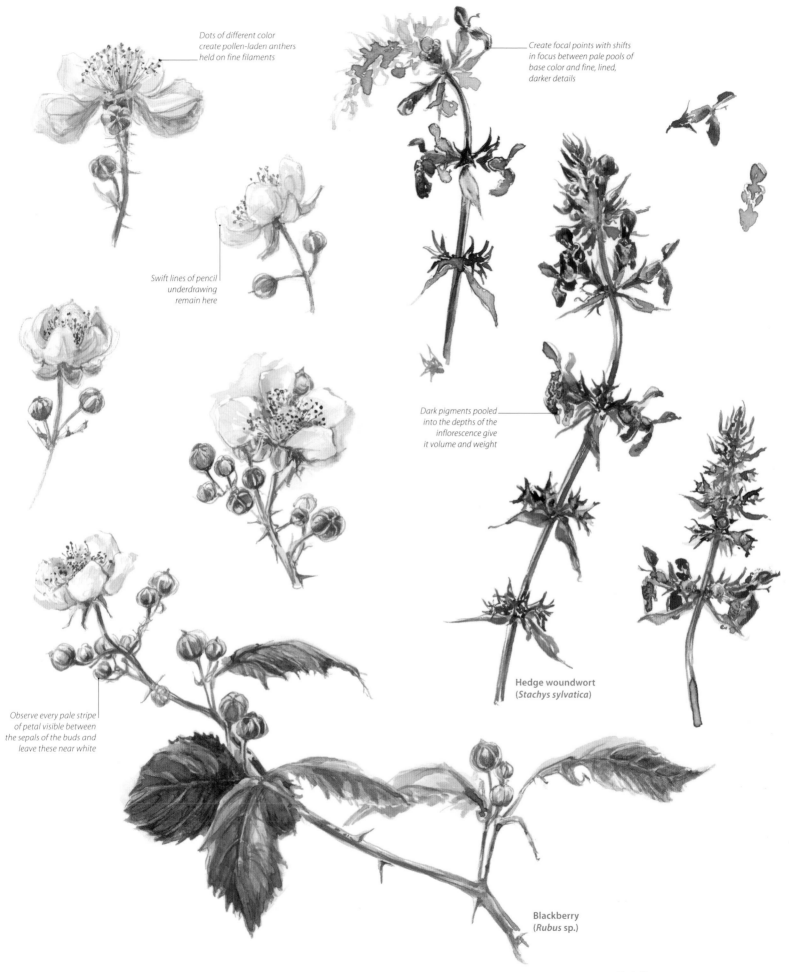

Dots of different color
create pollen-laden anthers
held on fine filaments

Create focal points with shifts
in focus between pale pools of
base color and fine, lined,
darker details

Swift lines of pencil
underdrawing
remain here

Dark pigments pooled
into the depths of the
inflorescence give
it volume and weight

Hedge woundwort
(*Stachys sylvatica*)

Observe every pale stripe
of petal visible between
the sepals of the buds and
leave these near white

Blackberry
(*Rubus* sp.)

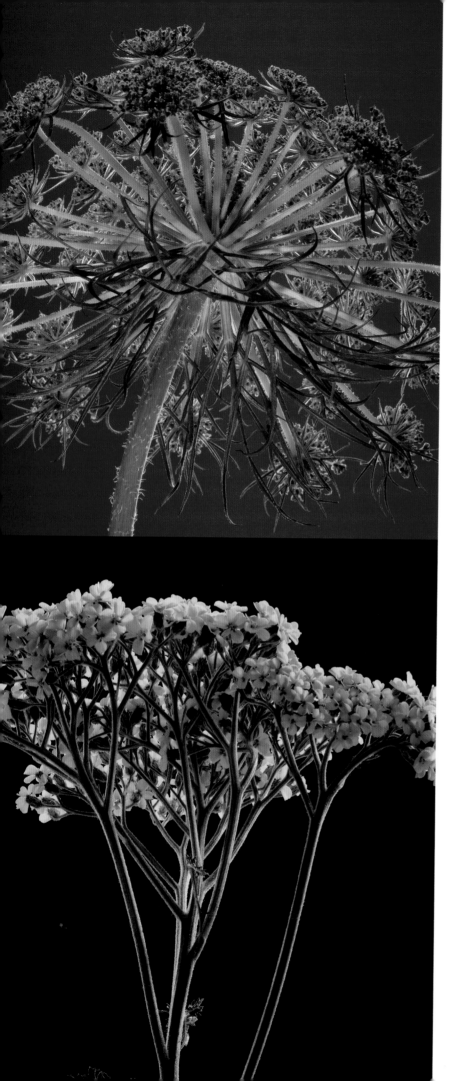

Flowerheads

In umbels and corymbs, large numbers of tiny flowers or inflorescences are gathered together into one flowerhead, making it easier for pollinating insects to find them. The inflorescences branch to create spheres and domes, familiar to us from many common plants. Umbels and corymbs are both a type of shortened raceme (see pp.190–191). They are described as simple if they only branch once before producing flowers and compound when they branch twice or more.

The flower stalks of an umbel grow from a single point at the top of a supporting stem. This point may be surrounded by a delicate whorl of green bracts called an involucre, which is particularly prominent in the wild carrot (left). Like many related plants, such as cow parsley, the wild carrot is an umbellifer, meaning that the inflorescence has stiff stalks and is shaped rather like an umbrella. Some umbels, such as the pitch trefoil, have very short stalks and look like a small domed cluster of flowers. Others, such as the honeysuckle, are looser and more open in structure, while yet others have pendent (drooping) stalks, like the *Tulbaghia* (top right center).

Corymbs have numerous flowering stalks that branch out from the upper part of the supporting stem. The lowest, outer stalks are longer than the inner stalks that form above them, so all the clusters of flowers are held at more or less the same height, like a flattened plateau. The cultivated yarrow, (below left), is a good example of this. Its stalks branch repeatedly to create a compound corymb, while the flowers are actually another form of inflorescence called a capitulum (see p.200). It is interesting to pull a yarrow apart to see how it really works. A thyrse is also made up of myriad small flowers, but unlike umbels and corymbs, it forms an elongated pyramidal shape. Lilac is a common example.

Compound umbel
In a compound umbel, each stalk that branches out from the supporting stem ends in an umbel of tiny flowers.
Wild carrot (*Daucus carota*)

Compound corymb
Here, each flowering stalk branches again several times, so it supports several clusters of capitula, creating a flat or gently rounded flowerhead. Simple corymbs, in which each stalk ends in a single flower, are less common than compound corymbs.
Yarrow (*Achillea* "Moonshine")

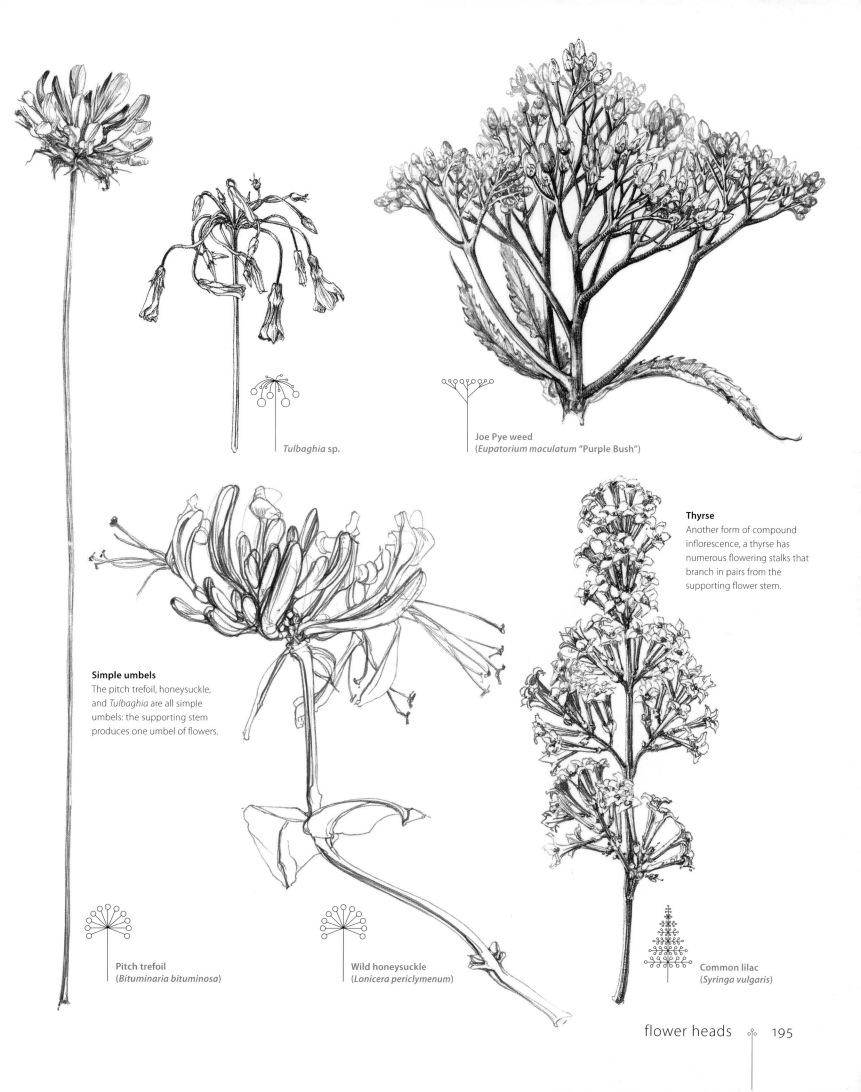

Tulbaghia sp.

Joe Pye weed
(*Eupatorium maculatum* "Purple Bush")

Thyrse
Another form of compound inflorescence, a thyrse has numerous flowering stalks that branch in pairs from the supporting flower stem.

Simple umbels
The pitch trefoil, honeysuckle, and *Tulbaghia* are all simple umbels: the supporting stem produces one umbel of flowers.

Pitch trefoil
(*Bituminaria bituminosa*)

Wild honeysuckle
(*Lonicera periclymenum*)

Common lilac
(*Syringa vulgaris*)

flower heads 195

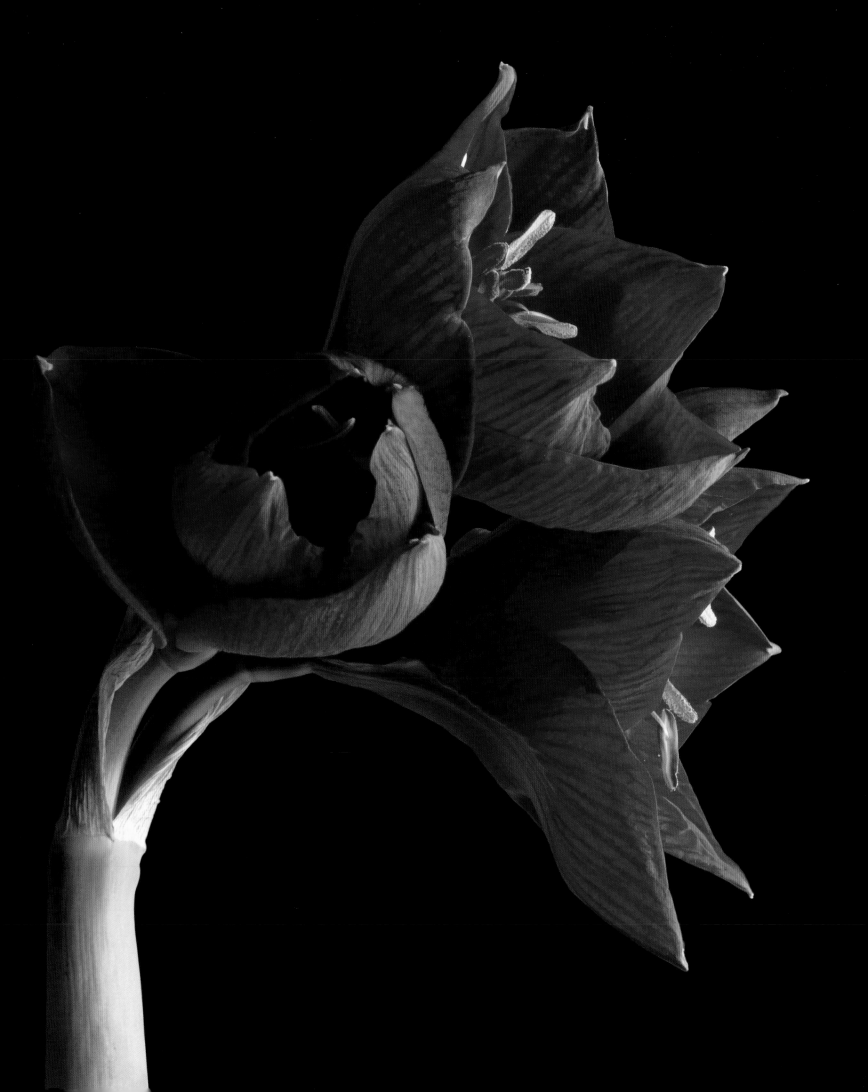

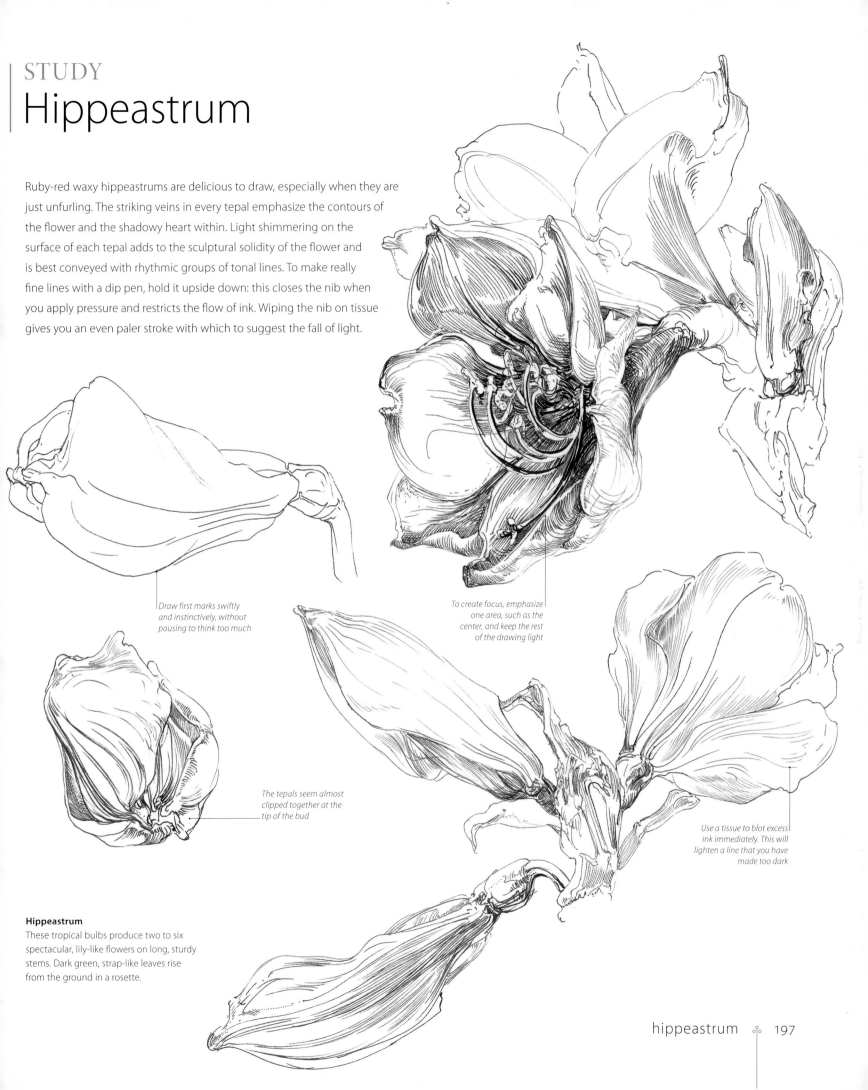

STUDY
Hippeastrum

Ruby-red waxy hippeastrums are delicious to draw, especially when they are just unfurling. The striking veins in every tepal emphasize the contours of the flower and the shadowy heart within. Light shimmering on the surface of each tepal adds to the sculptural solidity of the flower and is best conveyed with rhythmic groups of tonal lines. To make really fine lines with a dip pen, hold it upside down: this closes the nib when you apply pressure and restricts the flow of ink. Wiping the nib on tissue gives you an even paler stroke with which to suggest the fall of light.

Draw first marks swiftly and instinctively, without pausing to think too much

To create focus, emphasize one area, such as the center, and keep the rest of the drawing light

The tepals seem almost clipped together at the tip of the bud

Use a tissue to blot excess ink immediately. This will lighten a line that you have made too dark

Hippeastrum
These tropical bulbs produce two to six spectacular, lily-like flowers on long, sturdy stems. Dark green, strap-like leaves rise from the ground in a rosette.

Spikes, catkins, and spathes

Spikes are elongated inflorescences. Their flowers usually open from the bottom to the top and are stalkless. Catkins are pendulous spikes that mostly grow on trees. Some trees produce both male and female flowers and catkins are usually long clusters of male flowers, which open in winter or early spring before the leaves unfurl. Soft and pendulous, they dangle from branches, releasing clouds of pollen when the wind blows. Spathe is the botanical name for the colored bract surrounding the spadix, the fleshy flower spike of an arum. European arums flower in damp woods in spring, their pointed, mottled sheaths wrapped around silky rods, giving rise to a multitude of suggestive common names. Arums have an astonishing ability to heat their spadix, up to as much as 104°F (40°C), to attract flies that pollinate them. As an added attraction, they emulate the smell of rotting meat.

The previous year's female flowers have matured into woody, cone-like structures

Male and female flowers
The common alder produces male and female flowers close to each other on the same branch. Here you can see the male catkins next to buds that will become small, round female flowers. When the female flowers have been fertilized, the catkins wither and drop off the tree.

Buds of female flowers

Male catkins

Black or common alder (Alnus glutinosa)

Bract

Most grass flowers are wind-pollinated

Long anthers give the bottlebrush its characteristic shape

Spikes
Many grasses have tiny, fragile flowers that dangle over the sides of a column of shiny scale-like bracts. The plantain and bottlebrush drawings show how the flowers of spikes usually open from the bottom of the spike upward.

Wheat (Triticum aestivum)

Hoary plantain (Plantago media)

Willow bottlebrush (Callistemon salignus)

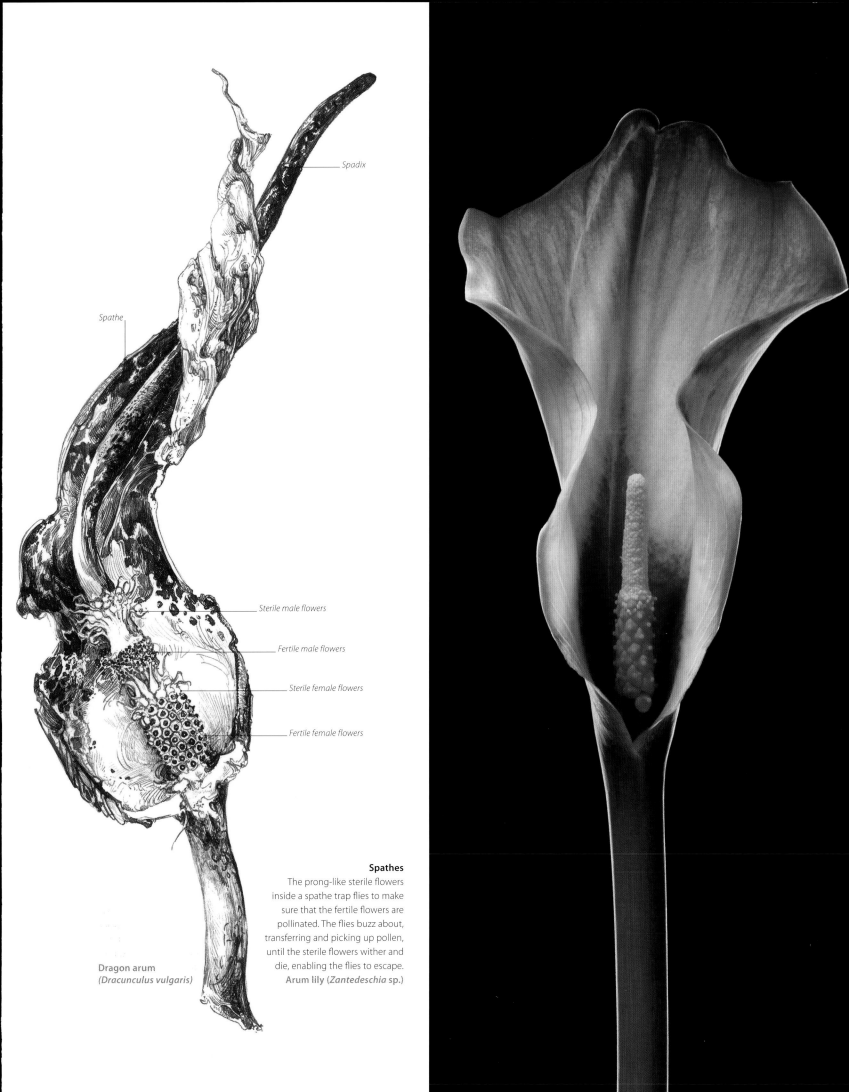

Spadix

Spathe

Sterile male flowers

Fertile male flowers

Sterile female flowers

Fertile female flowers

**Dragon arum
(*Dracunculus vulgaris*)**

Spathes
The prong-like sterile flowers
inside a spathe trap flies to make
sure that the fertile flowers are
pollinated. The flies buzz about,
transferring and picking up pollen,
until the sterile flowers wither and
die, enabling the flies to escape.
Arum lily (*Zantedeschia* sp.)

Capitula

Dandelions and daisies are evocative of long childhood summers spent playing outdoors, yet we may never realize that each "flower" is in fact a cluster of hundreds of flowers all packed together on the top of a stalk. Congregating in one place makes the tiny flowers far more visible to insects and means that plenty of them can then be pollinated at once. A capitulum (capitula in the plural) is the name for this type of compound inflorescence. It is a form of raceme (see p.191) in which the stem stops growing when a disk-like or globular receptacle develops at the top. Many tiny stalkless flowers called florets are embedded in the upper surface of the receptacle and they open in spiral formation from the outside of the receptacle inward, as can be seen in the photograph of the daisy on the left.

Daisy-type capitula are composed of two types of floret: short disk florets create the spongy yellow center of the flower, while delicate ray florets create a fragile ring of "petals" around the edge. Each so-called petal reveals itself, on close inspection, to be a whole flower in itself. Dandelion-type capitula only have one type of floret: soft, translucent ray florets, each with a forked style sticking out of its middle like a forked tongue.

Behind all capitula a layered whorl of green, scaly, leaf-like bracts creates an involucre, as can be seen in the drawing of the back of the sunflower opposite. The half sunflower drawn beneath shows the top of the stem flattened into a soft white pulpy receptacle holding many regimented rows of short disk florets and edged with a sweeping frill of longer ray florets.

Daisy-type capitulum
Tiny disk florets form the yellow center of the "flower" (above left). The white "petals" surrounding them are really a second type of floret, called ray florets.
Daisy (*Bellis perennis*)

Dandelion-type capitulum
This type of capitulum only has one type of floret. Each "petal" is a small flower called a ray floret. Here (left) you can clearly see the forked styles rising from the florets.
Dandelion (*Taraxacum* sp.)

Structure of a capitulum
The drawing at the top of the page (right) shows the leafy green involucre at the back of a sunflower. The drawing below shows a cross section of a sunflower, with one disk floret lifted out to display the composition of the minuscule flower.
Sunflower (*Helianthus annuus*)

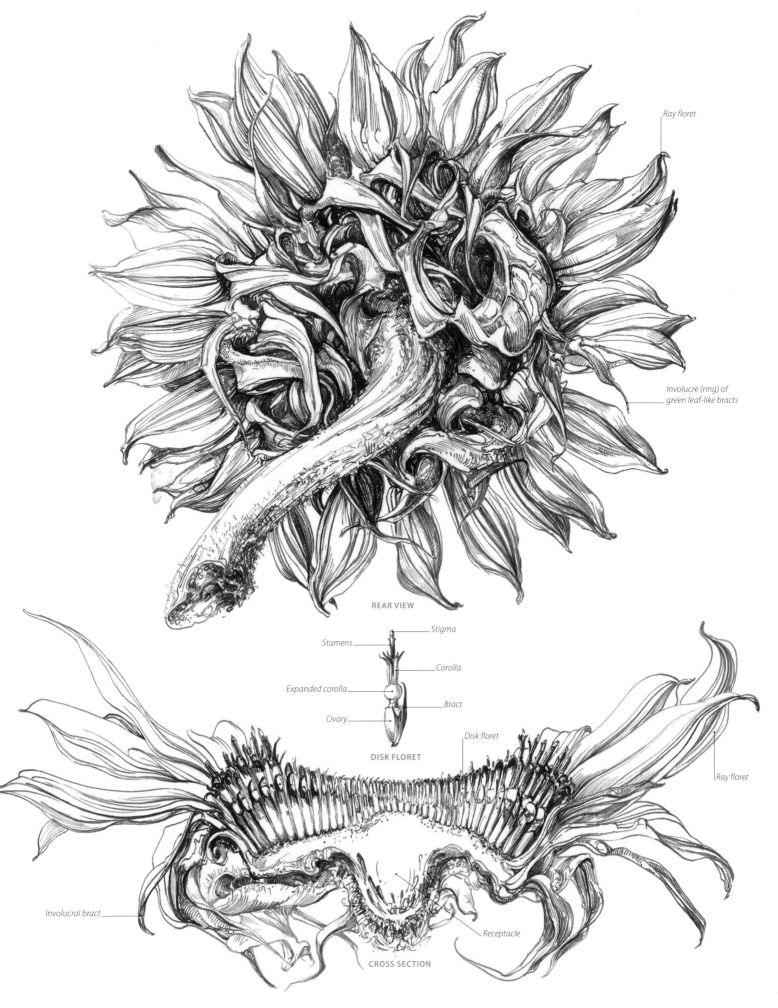

Ray floret

Involucre (ring) of
green leaf-like bracts

REAR VIEW

Stigma

Stamens

Corolla

Expanded corolla

Bract

Ovary

DISK FLORET

Disk floret

Ray floret

Involucral bract

Receptacle

CROSS SECTION

capitula ⚬ 201

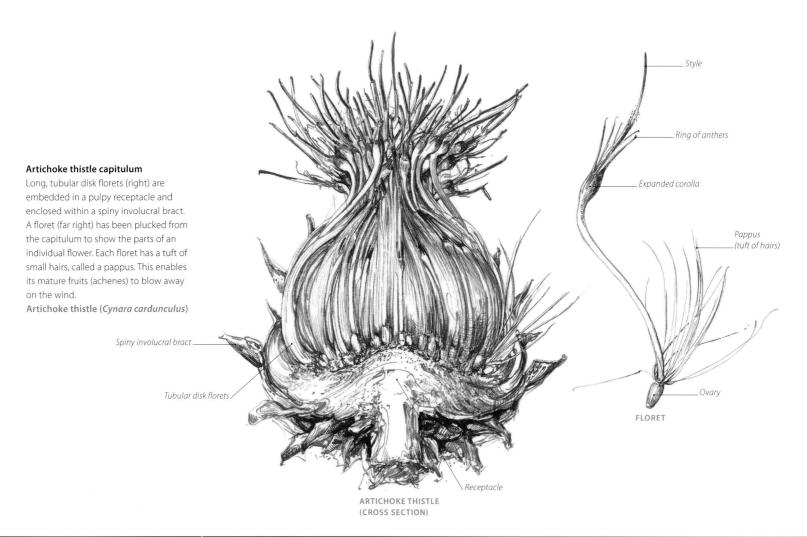

Artichoke thistle capitulum
Long, tubular disk florets (right) are embedded in a pulpy receptacle and enclosed within a spiny involucral bract. A floret (far right) has been plucked from the capitulum to show the parts of an individual flower. Each floret has a tuft of small hairs, called a pappus. This enables its mature fruits (achenes) to blow away on the wind.
Artichoke thistle (*Cynara cardunculus*)

Style

Ring of anthers

Expanded corolla

Pappus (tuft of hairs)

Spiny involucral bract

Tubular disk florets

Ovary

FLORET

Receptacle

ARTICHOKE THISTLE (CROSS SECTION)

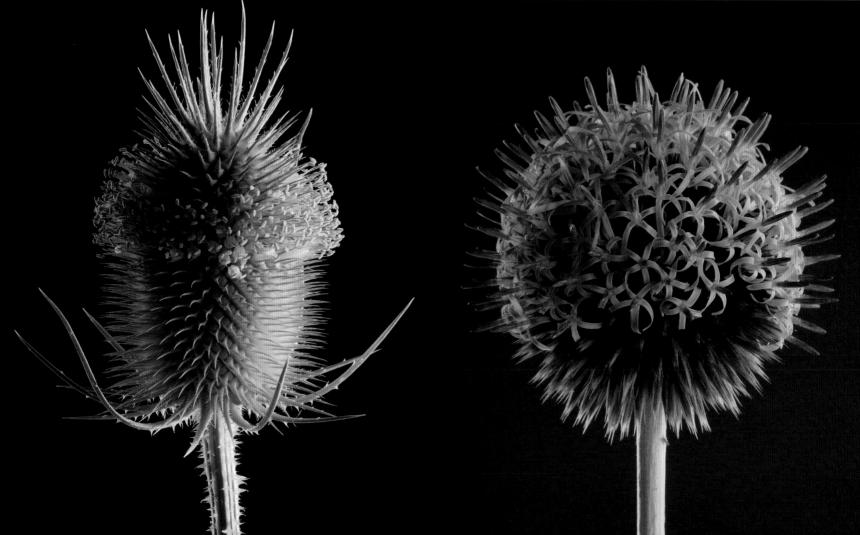

Capitula variations

All capitula are surrounded by an involucre (ring) of leaf-like bracts that protect their flowers and fruits as they develop. Most capitula have many flowers within the involucre, but some, such as globe thistles—also known as cardoons—are compound capitula, which means that each flower is in fact a single-flowered inflorescence with its own involucre. Capitula bracts can be soft and leafy, as is the case with daisies; hard and heavily armored with needle-like spines, as with thistles; or hooked, as on burdocks (see p.224). It is interesting to compare the artichoke thistle floret (left) with thistle achenes (see p.224) to see how one structure matures into the other.

Capitula-producing plants are found on every continent except for Antarctica, and are familiar to us as garden plants and weeds. Many are also cultivated for food and medicine. Single sunflowers give small children enormous pleasure when they rocket above the garden fence in the height of summer, but they also fill thousands of acres of fields in southern Europe, where they are grown for oil and seed. Jerusalem artichokes, named after a corruption of the Italian word *girasole* meaning "turn with the sun," are relatives of the sunflower that are grown for their edible tubers. The unopened buds of the globe artichoke, a member of the thistle family, is another Mediterranean gourmet crop. If allowed to bolt, salad lettuce and chicory will produce capitula. Chamomile and echinacea flowers are gathered to make herbal teas and remedies, and teasels were traditionally used by weavers as combs, to raise the nap of woollen fabric.

Capitulum of capitula
Every globe thistle (left) is a compound capitulum, sometimes known as a capitulum of capitula. Each tiny floret has its own involucral bract, making it a single-flowered inflorescence.
Globe thistle (*Echinops ritro*)

Staggered flowering
Teasel florets (far left) open in bands from the top of the inflorescence downward, so pollinating insects can feast on many florets at a time over a period of days.
Common teasel (*Dipsacus fullonum*)

Varied florets
The florets of the yellow scabious (top right) are not all the same shape. The lower lips of individual florets become larger toward the outer edge of the flower head.
Yellow scabious (*Cephalaria alpina*)

Floret arrangements
There are 14 forms of chrysanthemum (right), defined by how the ray and disk florets are arranged. In quill chrysanthemums the ray florets are tubular. The disk florets are concealed.
Chrysanthemum cultivar

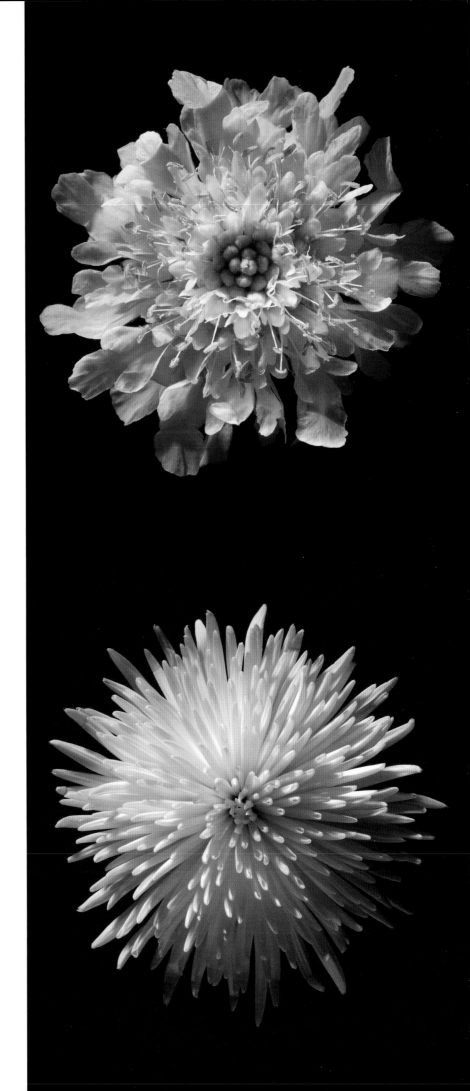

*Draw cups and dishes from
the outer rim inward*

Windflower

To draw any flower, first look at its simplest geometric form and decide whether it looks like a cup or dish, a tube, or a ring. Practice drawing these forms and cover a whole page with them, as I have with these windflowers (*Anemone blanda*). Then tilt them at different angles to see how they change in perspective. When you are ready, add petals to some of the shapes to see how they also change height and width when wrapped around a curved surface. Simple forms give us a framework to use as a guide and can help us to see. Once you are able to place rings of petals around differently shaped forms, practice raising and lowering single petals to make each flower look more natural. In time, try picturing simple geometric forms in your mind's eye, so that you can use them to see perspective without actually needing to draw them on the page.

Single flower

Spinning ellipses

1 It is best to draw ellipses quickly in one bold, but gentle, stroke. Spin your pencil in the air before bringing it down onto the page. The finished form will be transparent and this helps you to place petals around the center of the base correctly.

*Draw rings from the
center of the ellipse
outward*

Elliptical cup

2 This quick pencil sketch of an anemone (left) shows how visualizing an ellipse, or cup shape, can help you to draw a ring of petals in perspective. Note how anemone petals are often unevenly spaced, and held at different heights. Some of them will not touch the ellipse.

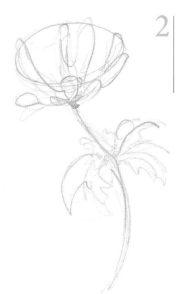

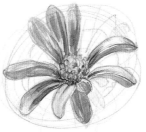

*Draw lightly, using
a sharp HB pencil*

Using a framework

3 The four anemone heads (left) show you can draw petals that curve backward by laying them against a framework that looks like a doughnut ring. Not all the petals will sit on the surface of the ring: some rise above and some fall beneath it. Use the ring to help capture the character of each flower.

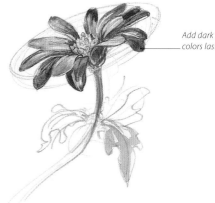

*Add dark
colors last*

Spring flower

Windflowers are small, delicate bulbs from the Mediterranean that flower in spring. All anemones belong to the buttercup family (*Ranunculaceae*) and their name comes from the Greek word for "wind."
Windflower (*Anemone blanda*)

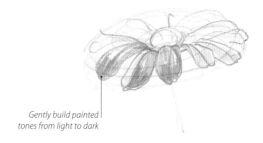

*Gently build painted
tones from light to dark*

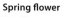

A vertical line drawn through the center of each shape defines the position of the stalk

Focus on expressing character rather than shape

Whole plant

Active character

1 When drawing a group of flowers, first look at how they relate. Study the posture of the stems and the angles at which the flowers are held. Use swift lines and simple shapes to encapsulate their essential postures and suggest active character.

Maintain energy

Next draw the leaves. See how they are attached to the stems and held around the flowers. Keep your lines swift to maintain the energy of the drawing and try to express the character of the plant. Do not worry about pinning down details. 2

Keep your pencil lines light, so that you can erase them completely after painting

Draw buds as flattened spheres. A line through the center of each bud locates the stalk and the apex of the folded petals

Lighting, color, and texture

Once you are happy with your underdrawing, enjoy adding washes of color. Observe how the plant is lit. Flowers in sunlight might look paler and more translucent than those in the shade. Flowers also change color and texture with age. 3

Spear lily
Mali Moir

The giant spear lily (*Doryanthes palmeri*) is a native of eastern Australia. Huge rosettes of gray-green leaves surround heavy flower spikes that arch like bridges under their own immense weight. Some grow up to 12 ft (4 m) long. The very tip of a flower spike has been painted here by one of Australia's foremost contemporary botanical artists, Mali Moir. This lily grew in the Royal Botanic Gardens, Melbourne, where Mali made rough sketches on semi-transparent drafting film, standing beside the plant, balancing her drawing board on her hip. She took photographs to record light reflections and, when ready, had the stem cut with a saw. Several people helped lift and transport it to her studio, where it was carefully positioned to match the light in the Botanic Gardens, using ropes to hang it from a small crane above and planks of wood to support it from below.

Mali only had one specimen of the plant, so she needed to plan her order of work carefully. She painted all of the buds first and then the open flowers, followed by spent flowers, fruits, stems, and finally the bracts. Her finished work is a precisely timed collage of observations made over several months of a lily that was continually moving. Buds swelled, burst, and bloomed, then withered as fruits grew and the stem twisted and decayed. This is both the unseen magic and the greatest challenge of botanical art.

Mali compares her process to fresco painting, where each section has to be completed before the next one can be begun. She said of this painting, "I worked blind across the page in a jigsaw pattern, starting with buds (the first to disintegrate), and finishing with stems and bracts (the last to disintegrate)." Mali refined her original sketch one section at a time, using a 2H pencil, then traced and transferred each piece to the final painting with HB and 6H pencils. She used Kolinsky sable brushes and tubes of watercolor to apply a dry brush technique to the flowers, to give control, create crisp detail, and to capture the effect of shiny surfaces. The fruits, stems, and bracts were painted with wet washes mixed on a palette, then finished with dry brush strokes, to create tough, dry textures.

Closer look

Stem and bracts
The underlying greens and browns in the stem and bracts were mixed as wet washes on a palette. Mali then applied them with a sable brush, following fine pencil outlines drawn on the hot pressed (smooth) watercolor paper.

Red petals
To paint the flowers, Mali applied five hues of red straight from the tube and blended them on the paper. She used a dry brush technique, in which the brush is almost dry and tiny amounts of paint are gently stroked on to the paper.

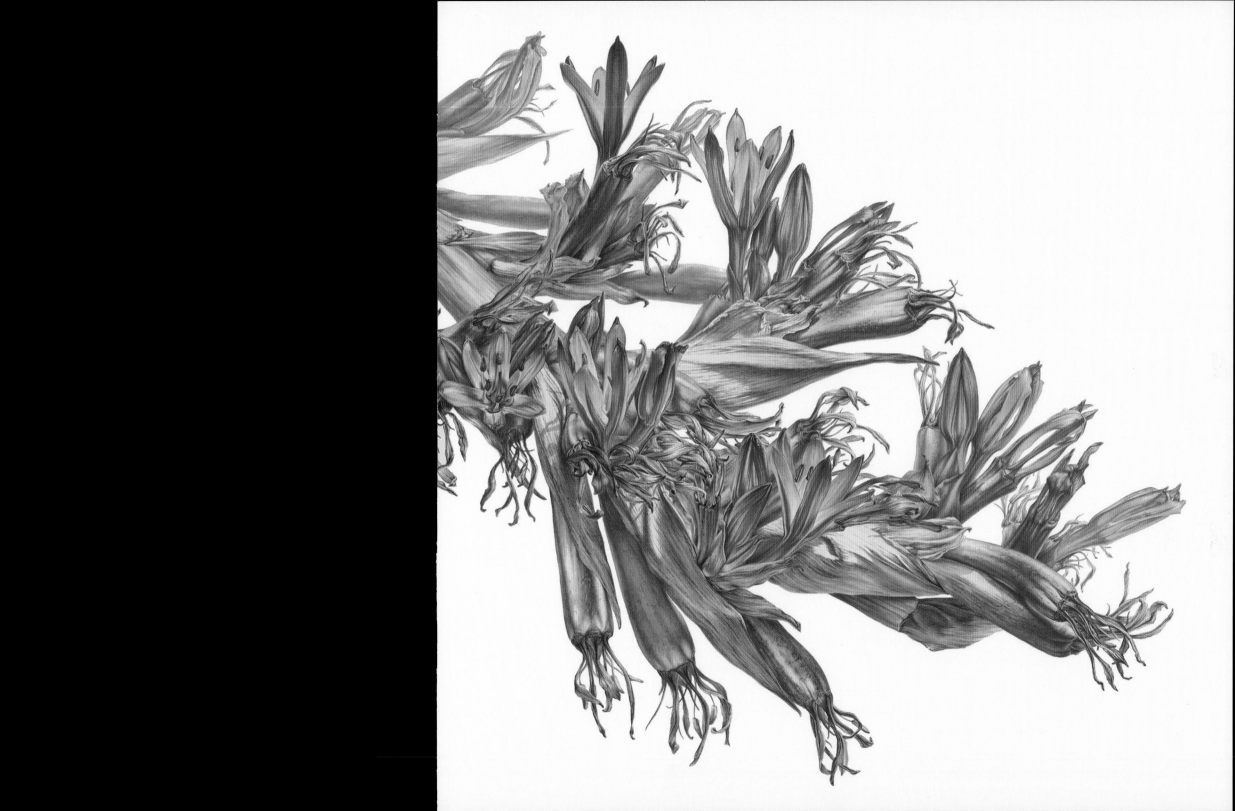

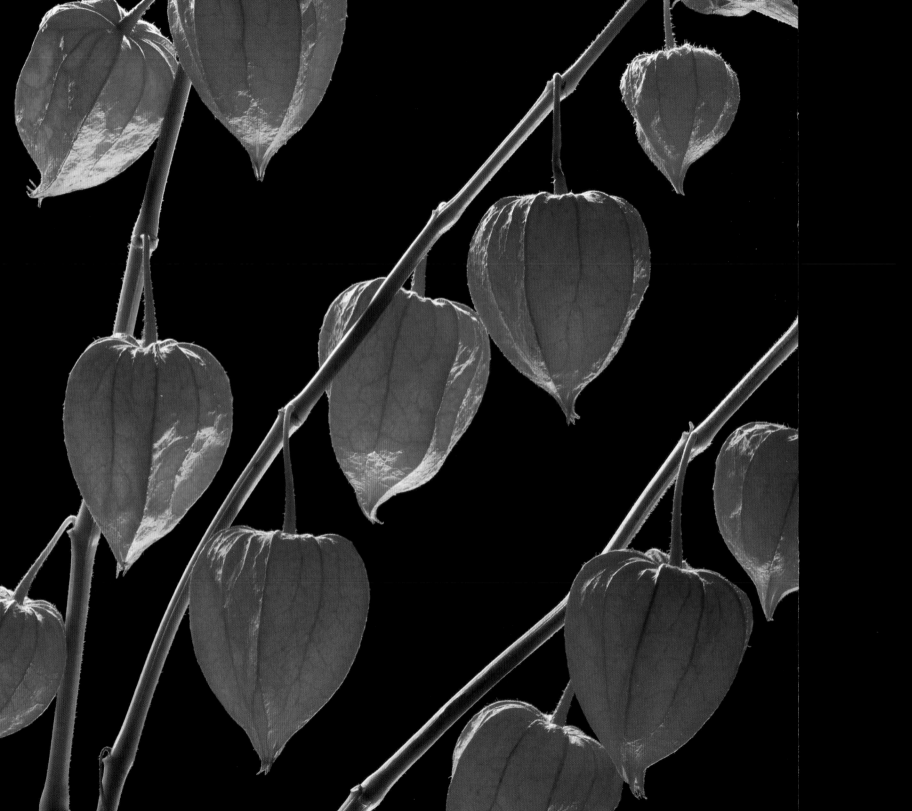

Fruits, cones, and seeds

Infinitely sculptural and diverse, fruits, cones, and seeds offer the artist a wealth of inspiration. Fruits are the mature ovaries of flowers and contain seeds, which are mature ovules. Cones, unexpectedly, are not fruits at all, but the reproductive structures of ancient trees, such as pines, that predate the evolution of flowers. Cones contain seeds that disperse on the wind as the scales of the cone open.

ntroduction

Ve see an amazing diversity of fleshy fruits for sale when we shop for food,
et these are only a fraction of the range produced by plants. Most fruits are
iny, dry, and inedible to humans, so we tend to overlook them, or mistake
hem for seeds, calling clusters of what we find seed heads. A poppy
apsule, for example, is a single, dry fruit filled with many loose seeds, while
dandelion clock (see p.225) is a cluster of numerous individual fruits, each
f which has a fine plume so it can separate from the others and float away
n the breeze.

or centuries common names have confused fruits, seeds, nuts, and, in
articular, vegetables, most of which are not formed from mature flower
varies, but from the roots, stems, and leaves of plants. These
nisconceptions will be unraveled in this chapter, as we look at the basic
natomy of a fruit and compare similar parts in different species. The most
mportant function of all fruit is to transport seed away from the parent
lant so it can grow in a new place with an independent food supply. This
rocess is called dispersal. Botanists classify all fruits according to several
ets of characteristics, including dispersal method and form. A fruit may be
escribed as wind- or animal-dispersed, and as simple, aggregate, or, most
ntriguingly, "false" in form. These terms are explained as they arise and
hey help us to understand exactly what fruits are.

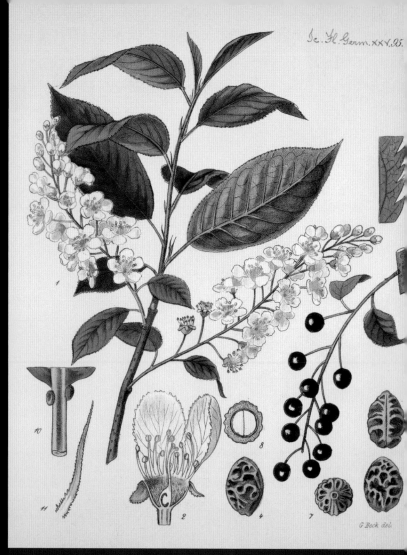

1	2	3
4	5	6

The fragrant, white spring blossoms of the
ird cherry tree flower on pendent racemes,
hen produce edible fruits in the summer.
Gunther Ritter Beck von Mannageta und
erchenau, 1913
ird cherry (*Prunus padus*)

The round, strawberry-like fruits of the
mall, gnarled, evergreen strawberry tree
re edible. They ripen after urn-shaped,
endent white flowers have appeared.
trawberry tree (*Arbutus unedo*)

This dry fruit is from a tree native to West
frica. As the capsule opens, hairy seeds
nside are released and dispersed into the air.
ochlospermum tinctorium

4 Poppies produce abundant seed. After a
poppy has bloomed, its ovary wall (pericarp)
forms a rattle-like chamber full of audibly
loose seeds, and its stigma forms the lid.
Poppy (*Papaver*)

5 Pine cones vary in hardness, thickness,
and size, and can take several years to
mature. The seeds inside the cones have
"wings" for wind dispersal.
Pine tree (*Pinus maximartinezii*)

6 The lotus is a water plant with ripe purple
seeds held inside the top of a flattened
swollen stem. When ripe, the seeds fall out
and are carried away by water.
Lotus (*Nelumbo nucifera*)

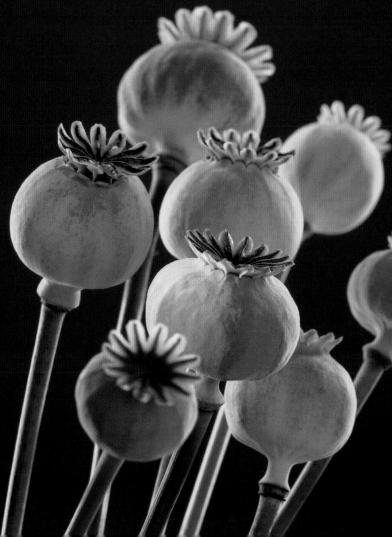

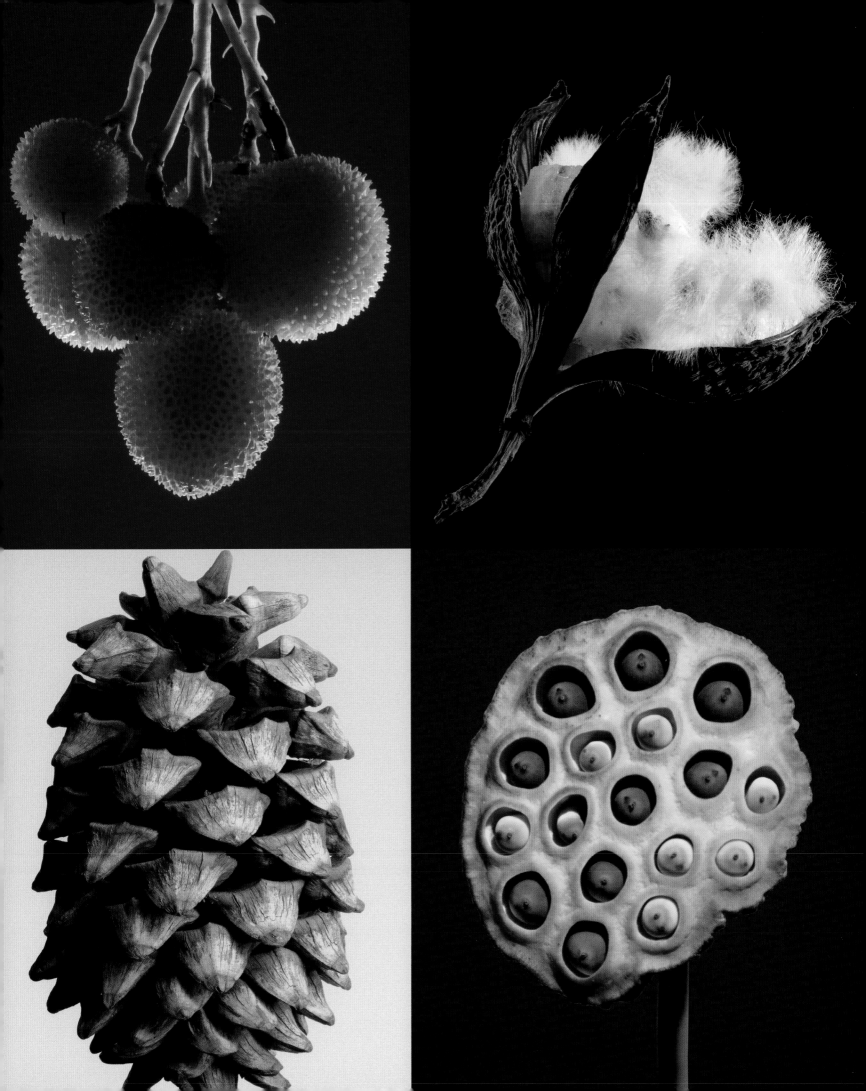

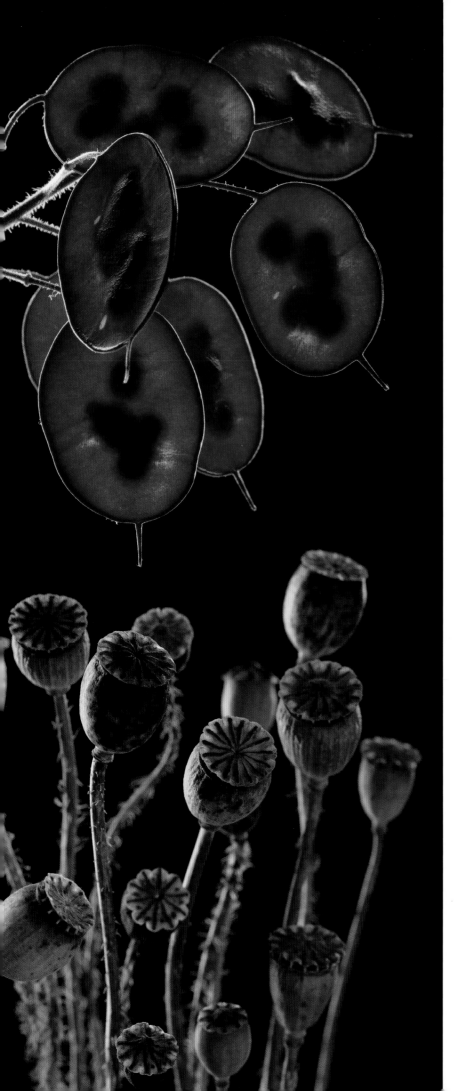

Dispersal

Fruits are classified first by their succulence as fleshy or dry, then by the way in which they disperse their seed as dehiscent (opens) or indehiscent (remains closed). Mature, dry fruits are literally dry to the touch, while fleshy fruits, such as berries, have juicy pulp. Dry fruits are far more prevalent and more diverse in form than fleshy fruits.

Dehiscent fruits (both dry and fleshy) can burst, sometimes violently, to disperse their seed. Walking through ripe gorse in late summer triggers a cacophany of popping pods, while in the fall, acanthus plants launch their big brown shiny seeds with a force that can sting. In the tropics, the sound of exploding ripe rubber fruits is indistinguishable from gunfire. Quieter dehiscent fruits simply split and wait to be shaken. The papery fruits of honesty (left), for example, peel into three translucent disks, enabling the seeds to simply drop away, while a poppy capsule (below left) has a circle of tiny holes beneath its flat lid, out of which seeds scatter when the plant moves. The capsules of the century plant (right) split lengthwise into three segments called locules, releasing papery seeds that are carried away on the wind or else germinate in situ, so that small plantlets later fall to the ground from the enormously tall flowering stem.

Indehiscent fruits do not open, so they have different ways of dispersing. They may have wings to carry them through the air, hooks to catch in fur, juicy pulp to be eaten, or they may use water to travel downstream or overseas. It is important to realize that different parts of plants disperse, for example: only the seeds, the entire fruit, collections of fruits, and, rarely, the whole dead plant can travel by rolling away on the wind.

Honesty (*Lunaria annua*)
A flat, dry, dehiscent fruit called a silicula (top left) is formed of three thin sheets attached to a circular frame. The two outer sheets peel away to reveal seeds attached to the central membrane.

Poppy (*Papaver rhoeas*)
The "pepper pots" of poppies (left) are goblet-shaped, dry, dehiscent fruits. Their rattle-like chambers are full of audibly loose seeds that are shaken out of the capsules when the wind blows.

Century plant (*Agave americana*)
Agaves (right) only flower once and then die. It can take up to 20 years for the century plant to flower, although people once thought it took 100 years, hence its name. From the center of a whorl of succulent leaves, a huge woody flower head grows up to 22 ft (7 m) tall, bearing hundreds of dry, dehiscent capsules. Each capsule opens in three segments, spilling out copious amounts of seed. This very small piece of a flower head is drawn life-size.

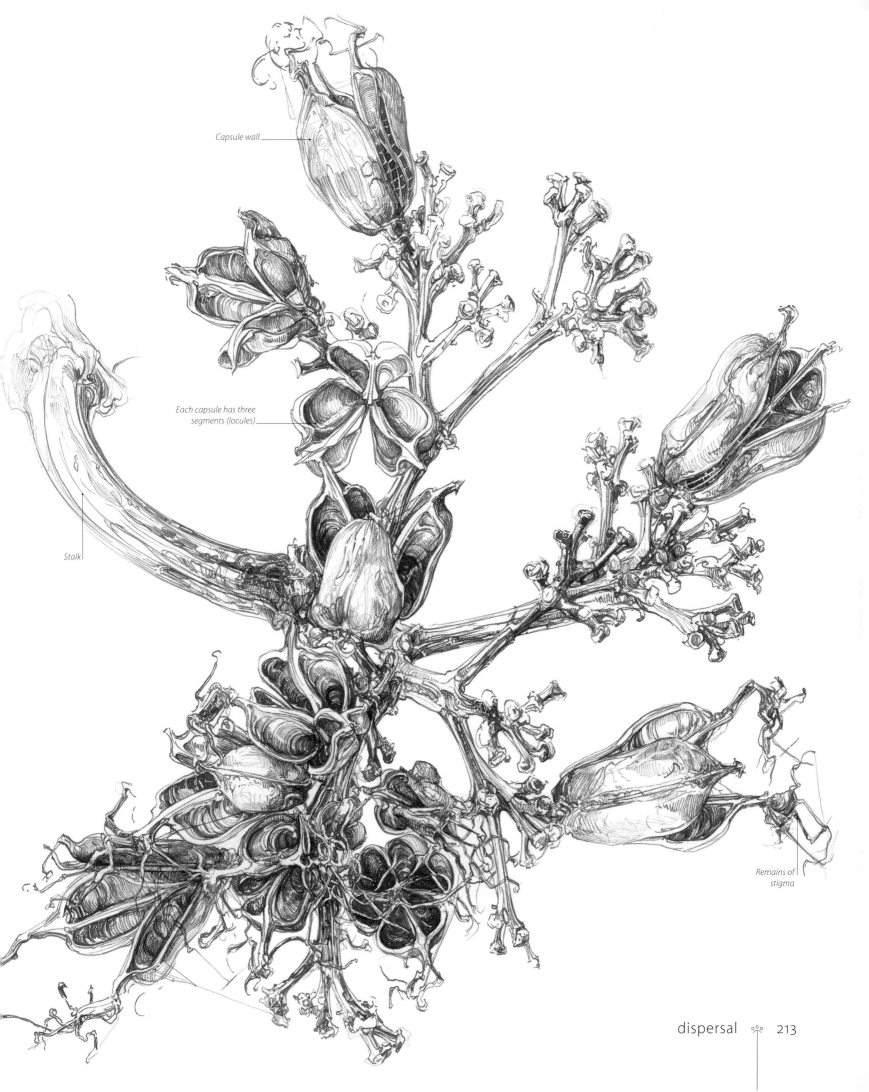

Capsule wall

Each capsule has three
segments (locules)

Stalk

Remains of
stigma

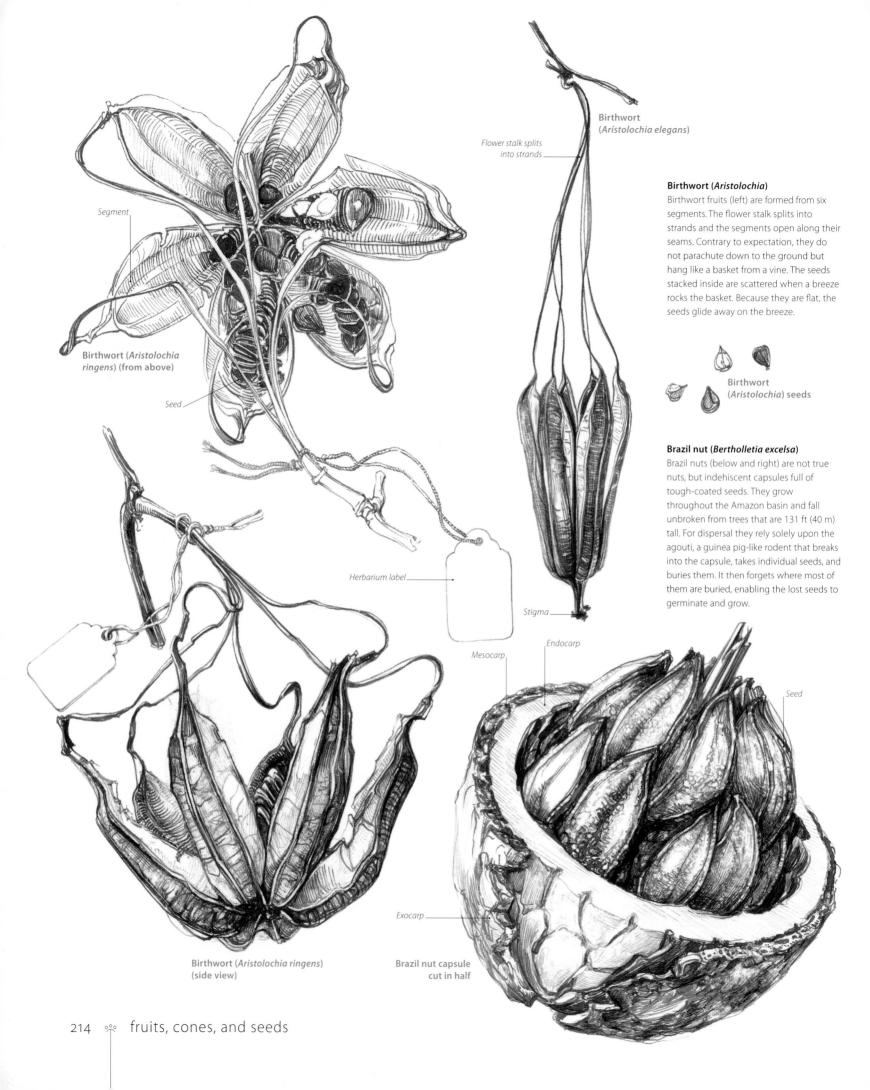

Segment

Birthwort (*Aristolochia ringens*) (from above)

Seed

Birthwort (*Aristolochia elegans*)

Flower stalk splits into strands

Birthwort (*Aristolochia*)

Birthwort fruits (left) are formed from six segments. The flower stalk splits into strands and the segments open along their seams. Contrary to expectation, they do not parachute down to the ground but hang like a basket from a vine. The seeds stacked inside are scattered when a breeze rocks the basket. Because they are flat, the seeds glide away on the breeze.

Birthwort (*Aristolochia*) seeds

Brazil nut (*Bertholletia excelsa*)

Brazil nuts (below and right) are not true nuts, but indehiscent capsules full of tough-coated seeds. They grow throughout the Amazon basin and fall unbroken from trees that are 131 ft (40 m) tall. For dispersal they rely solely upon the agouti, a guinea pig-like rodent that breaks into the capsule, takes individual seeds, and buries them. It then forgets where most of them are buried, enabling the lost seeds to germinate and grow.

Stigma

Herbarium label

Mesocarp

Endocarp

Seed

Exocarp

Birthwort (*Aristolochia ringens*) (side view)

Brazil nut capsule cut in half

Capsules

A capsule is a dry fruit containing many seeds that has developed from an ovary formed of two or more carpels (see p.165). Here, three contrasting capsules show the basic anatomy of all fruit. A fruit is simply a maturing ovary wall made of two or three layers: an outer layer, the exocarp; a middle layer, the mesocarp (this is sometimes absent); and an innermost layer, the endocarp. All three layers together are known as the pericarp, and they constitute the whole fruit. Seeds cannot develop without a fruit (or cone) to hold them, but they remain a separate entity within it. Some capsules form in segments that are joined at the seams, as seen here in the birthwort and giant lily. The pericarp of a Brazil nut is more unusual as it is very tough and does not open.

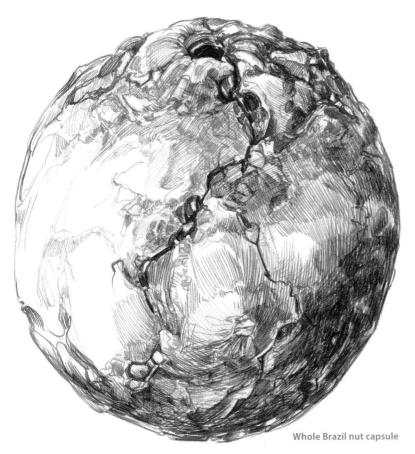

Whole Brazil nut capsule

Seed

Seed coat

Brazil nut seed

Giant lily (*Cardiocrinum giganteum*)
This regal native of Himalayan forests (right) bears spectacular heads of white tubular flowers 12 in (30 cm) long, on 12 ft (4 m) stems. Seeds develop inside immature green capsules, which slowly dry, turn brown, and split open when ripe to release the seeds.

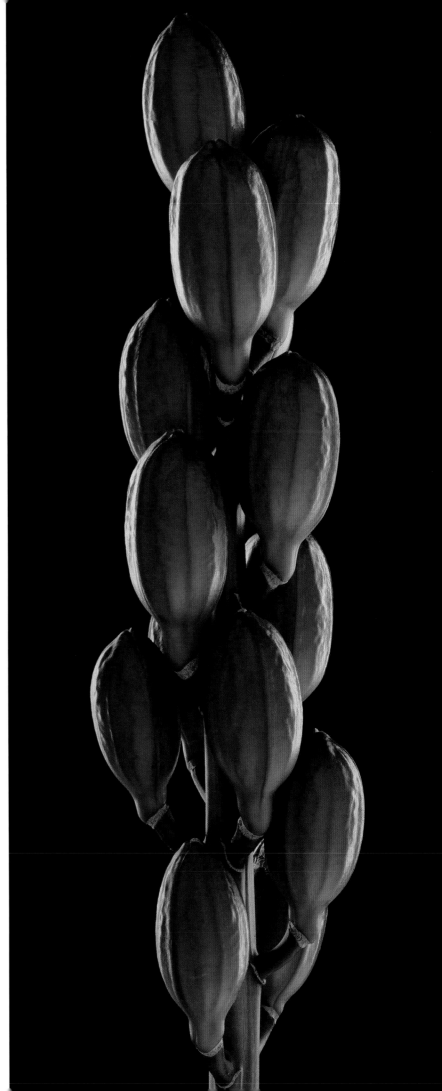

Conkers

A conker is the big, brown, silky seed of a European horse chestnut tree. In Britain, conkers are emblematic of childhood games and the early discovery of the wonder of nature. Children triumphantly hoard pocketfuls of them every fall. The coveted conkers pop out of spiky green capsules and when fresh have a white circular base, which gives them their American nickname "Buckeyes." The handful of conkers drawn here was collected from a tree I played under as a child. I chose them as simple subjects for practicing

adding color to a pencil drawing and learning how to make a curved surface look shiny. I used HB pencil for the preliminary drawing because it is easy to erase without leaving stains. I mixed all the colors from a simple palette of transparent yellow, ultramarine, and permanent rose, and used a firm but soft synthetic brush with a fine tip. This is good for working from light to dark tones, from broad to small areas, from wide to fine strokes, and from wet marks to drier ones, the best order in which to paint.

Establish highlights and pale tones

2 The white of the paper will provide highlights in the finished drawing, so it is important at all stages not to cover every area with paint. Build pale tones first, leaving greater patches of light than you will ultimately need in the finished picture. Establish the contrast between the pale capsules and the dark seeds and keep checking the unity of the whole drawing.

Preliminary drawing

1 Observe the three segments of the capsules, how they change shape in perspective, and split apart to reveal white flesh around dark seeds. Place lines as if in direct contact with the contours of the fruits, beginning loosely and then honing details. Add gentle tones so that the drawings feel three-dimensional before you begin painting.

Create a shiny surface

3 Paint the darkest tones of the seeds swiftly with curved strokes of paint. Flow plenty of paint into an area, then dry your brush on some tissue and touch the pool of applied paint so the bristles immediately absorb some of it, lightening the tone of one point to emphasize roundness. Keep the other main highlights white. Don't encroach on these too quickly.

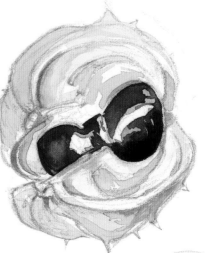

The fruit opens into three segments, making it look like a valve.

The white circular base connected this seed to its capsule during growth

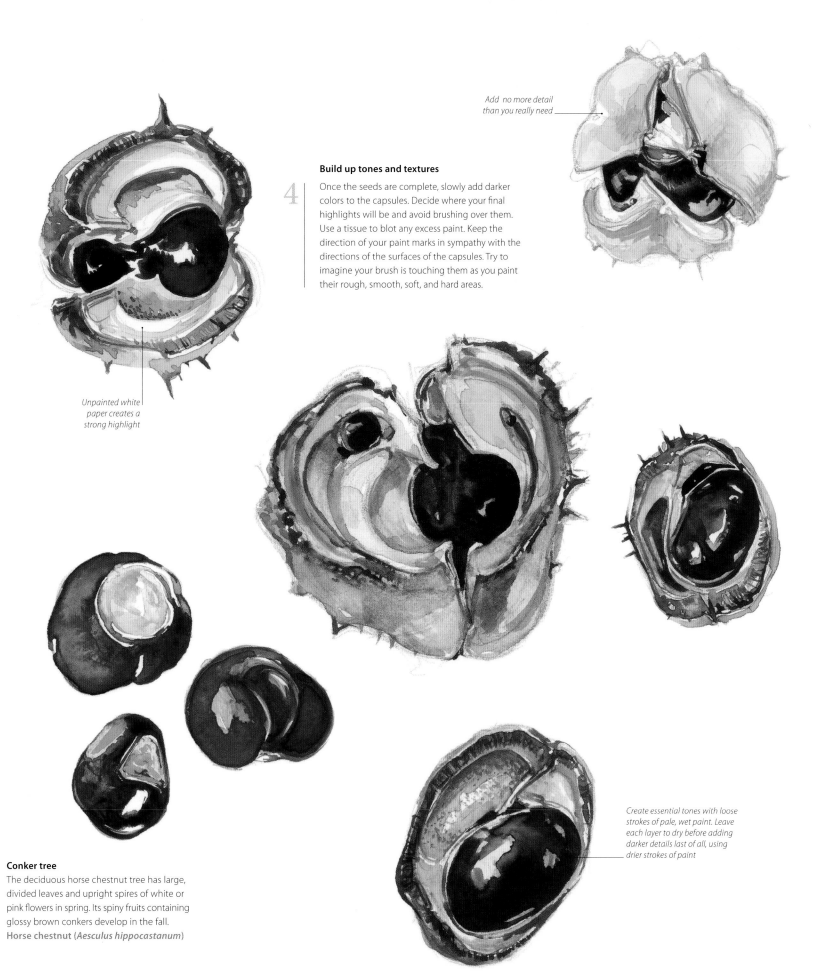

Add no more detail than you really need

Build up tones and textures

4 Once the seeds are complete, slowly add darker colors to the capsules. Decide where your final highlights will be and avoid brushing over them. Use a tissue to blot any excess paint. Keep the direction of your paint marks in sympathy with the directions of the surfaces of the capsules. Try to imagine your brush is touching them as you paint their rough, smooth, soft, and hard areas.

Unpainted white paper creates a strong highlight

Create essential tones with loose strokes of pale, wet paint. Leave each layer to dry before adding darker details last of all, using drier strokes of paint

Conker tree

The deciduous horse chestnut tree has large, divided leaves and upright spires of white or pink flowers in spring. Its spiny fruits containing glossy brown conkers develop in the fall.
Horse chestnut (*Aesculus hippocastanum*)

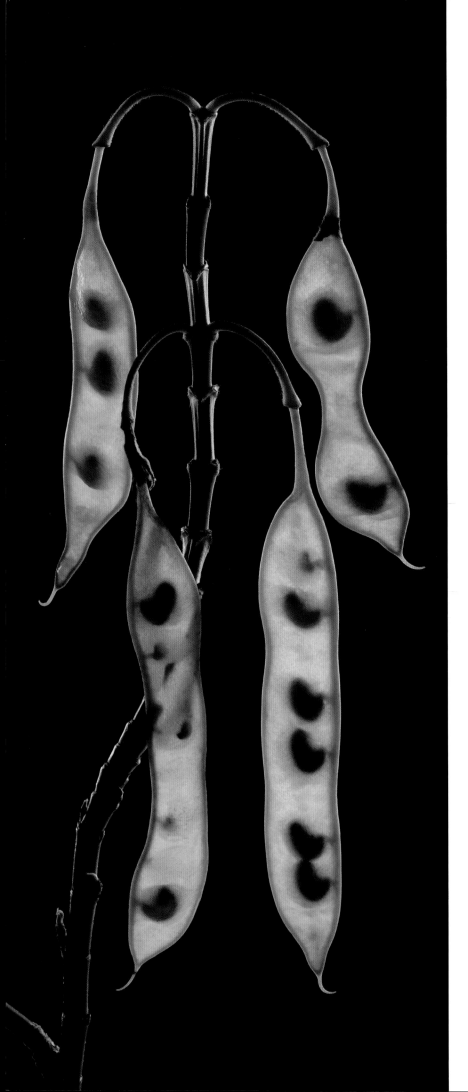

Pods

The peas and beans we eat are all types of pods, and they belong to a big family of flowering plants known as legumes (*Leguminosae*). We eat the pods while they are still green and succulent, and therefore immature. If the pods are left to ripen fully, they dry out and become hard and brown before splitting open.

A pod is a flattened, dry fruit, developed from a single, one-chambered ovary. It is also known as a "simple fruit," meaning that it is formed in one piece. Most, but not all, pods split open along both edges (seams). The two halves peel apart and twist open to expose a row of seeds hanging from tiny stalks, called funicles. The legumes and other varieties of pod illustrated here originate from Africa, North America, Asia, and Europe. They show immense differences in shape, form, texture, and method of dispersal.

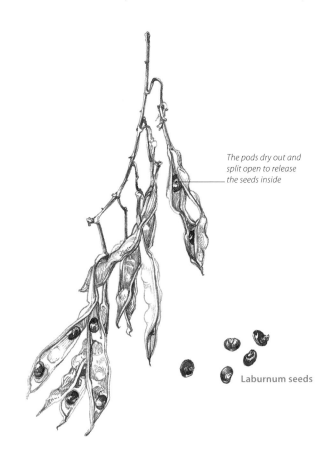

The pods dry out and split open to release the seeds inside

Laburnum seeds

Developing seeds
These unripe pods (left) look translucent against bright light. The developing seeds can be clearly seen inside, attached to the pod by small stems called funicles.
Gliricidia sp.

Splitting pods
When they are ripe, laburnum pods (above) split along both edges and twist back to shed tiny, hard, highly toxic black seeds. The empty pods remain on the tree.
Laburnum (*Laburnum* sp.)

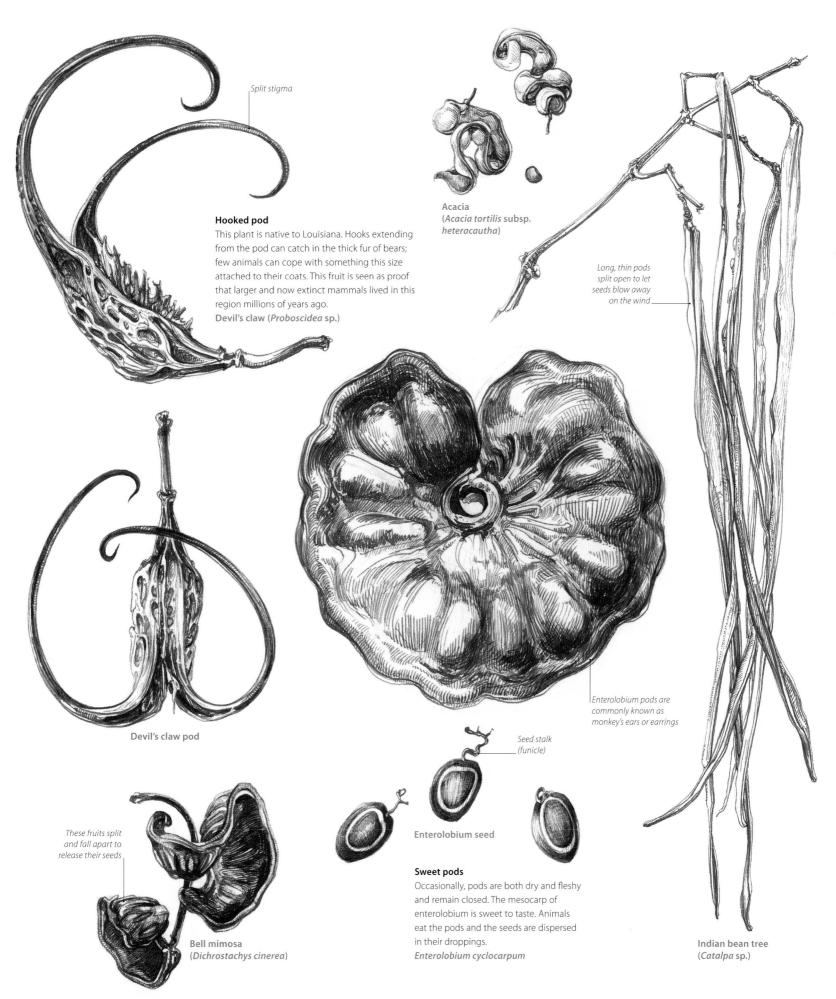

Split stigma

Hooked pod
This plant is native to Louisiana. Hooks extending from the pod can catch in the thick fur of bears; few animals can cope with something this size attached to their coats. This fruit is seen as proof that larger and now extinct mammals lived in this region millions of years ago.
Devil's claw (*Proboscidea* sp.)

**Acacia
(*Acacia tortilis* subsp. *heteracautha*)**

Long, thin pods split open to let seeds blow away on the wind

Devil's claw pod

Enterolobium pods are commonly known as monkey's ears or earrings

These fruits split and fall apart to release their seeds

Seed stalk (funicle)

Enterolobium seed

Sweet pods
Occasionally, pods are both dry and fleshy and remain closed. The mesocarp of enterolobium is sweet to taste. Animals eat the pods and the seeds are dispersed in their droppings.
Enterolobium cyclocarpum

**Bell mimosa
(*Dichrostachys cinerea*)**

**Indian bean tree
(*Catalpa* sp.)**

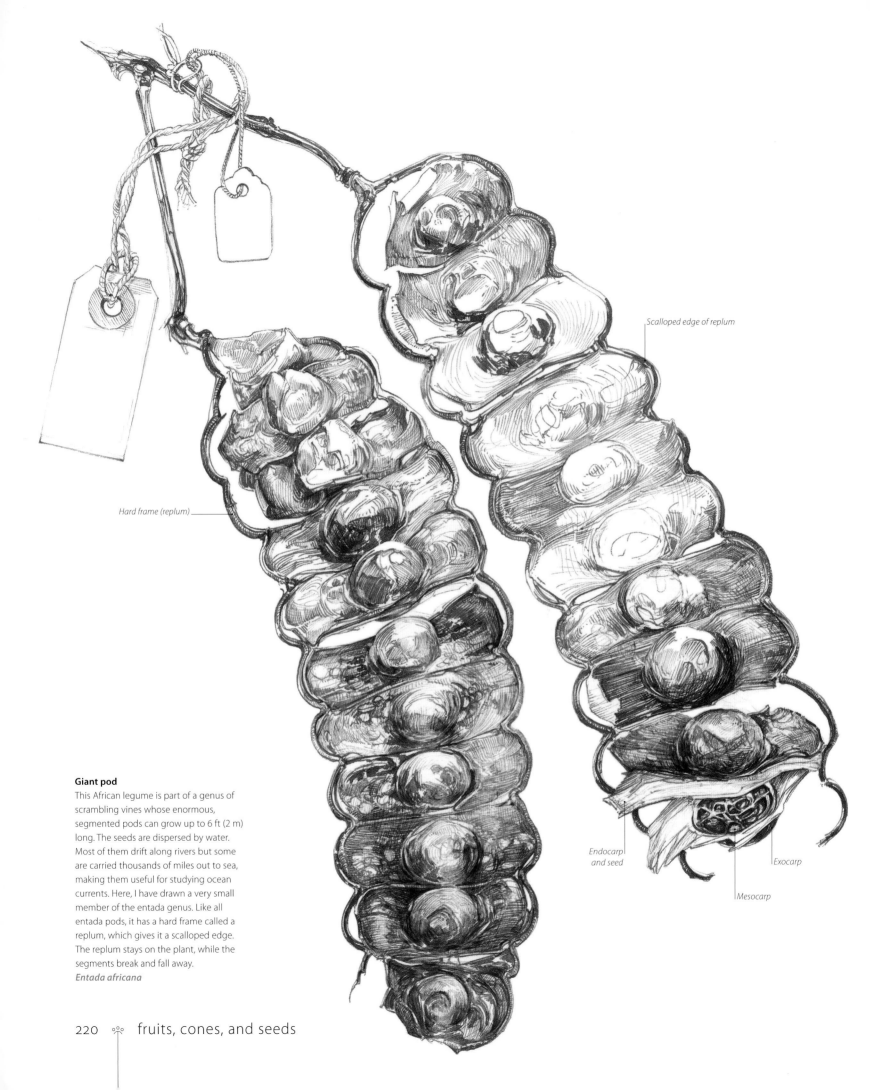

Scalloped edge of replum

Hard frame (replum)

Giant pod
This African legume is part of a genus of scrambling vines whose enormous, segmented pods can grow up to 6 ft (2 m) long. The seeds are dispersed by water. Most of them drift along rivers but some are carried thousands of miles out to sea, making them useful for studying ocean currents. Here, I have drawn a very small member of the entada genus. Like all entada pods, it has a hard frame called a replum, which gives it a scalloped edge. The replum stays on the plant, while the segments break and fall away.
Entada africana

Endocarp
and seed

Mesocarp

Exocarp

Herbarium fruits

These extraordinary dry fruits—a giant pod and aggregate follicle—belong to Oxford University Herbaria. I drew them life-size using a steel pen dipped in Chinese calligraphy ink diluted to mid-gray. I built up textures slowly by alternately adding and erasing ink, and the marks I made emulate the experience of touching the real objects. I also tried to find a balance between textures perceived as characteristic of the species, and those gained with time and use as collected objects. The labels are an important part of the exhibits.

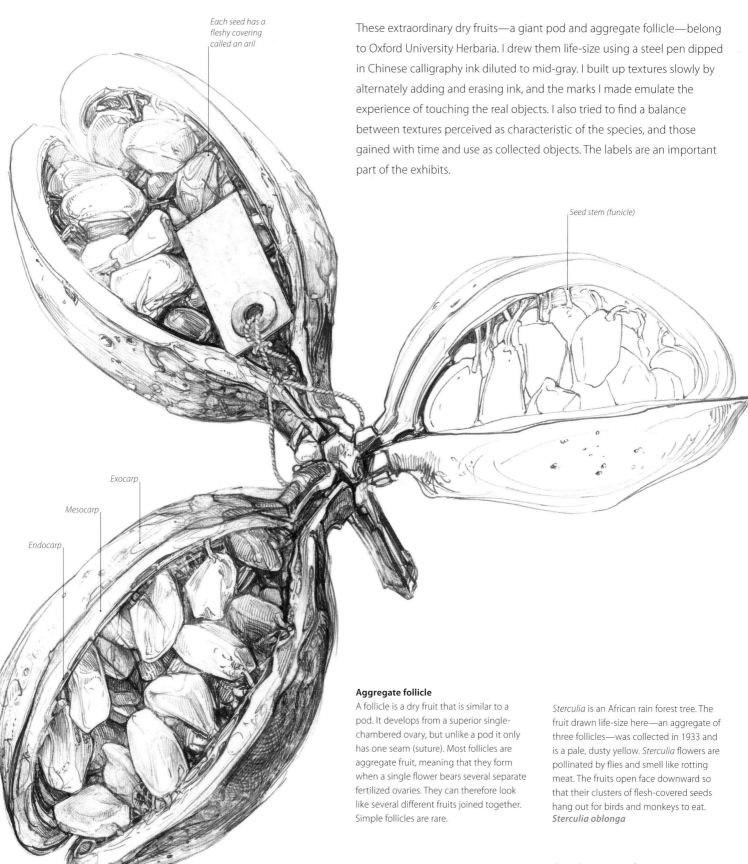

Each seed has a fleshy covering called an aril

Seed stem (funicle)

Exocarp

Mesocarp

Endocarp

Aggregate follicle

A follicle is a dry fruit that is similar to a pod. It develops from a superior single-chambered ovary, but unlike a pod it only has one seam (suture). Most follicles are aggregate fruit, meaning that they form when a single flower bears several separate fertilized ovaries. They can therefore look like several different fruits joined together. Simple follicles are rare.

Sterculia is an African rain forest tree. The fruit drawn life-size here—an aggregate of three follicles—was collected in 1933 and is a pale, dusty yellow. *Sterculia* flowers are pollinated by flies and smell like rotting meat. The fruits open face downward so that their clusters of flesh-covered seeds hang out for birds and monkeys to eat. ***Sterculia oblonga***

Bowl of broad beans
Giovanna Garzoni

Still lifes are often an artist's first introduction to plants. Paintings of fruit and flowers grace the walls of many palaces and homes—celebrations of abundance, often loaded with visual symbols we no longer understand. This is a different kind of still life, one that rejoices in simple, everyday food: a sturdy bowl of plump and luminous broad beans. One of 20 miniatures created for Duke Ferdinand II of Tuscany, it was painted in gouache on vellum by the Italian artist Giovanna Garzoni in 1650. Garzoni specialized in portraits of fruit and every painting in her series shows a single variety of fruit, together with an insect, bird, or garden flower. Popular and successful during her lifetime, Garzoni was commissioned, among others, by the powerful Medici family.

In the 17th century most miniaturists prepared their own gouache. Plants, insects, metals, minerals, and natural earths were ground into a fine powder, then bound with gum arabic and water or egg yolk to make a smooth paste. Artists applied this to their paintings using the tiniest brushstrokes. The brushes were made from squirrel hair, set in birds' quills mounted on wooden handles. Mussel shells often served as paint pots.

True vellum, from the Latin word *vitellus*, meaning calf, is made from the finely prepared skin of a still-born calf. Other prepared skins are called parchment, after the city of Pergamum, whose King Eumenes is said to have invented it in response to a trade block on papyrus. Skins have long been treasured by botanical painters for their natural warmth and vivid luminosity and they are still widely used today. Natural oils in the skin melt slightly with the touch of a damp brush, making the skin more absorbent. Vellum cannot be made too wet or it will buckle and spoil. Garzoni dipped her brush into tiny amounts of gouache, which she gently stippled onto the vellum and built up, layer upon layer. She probably sketched out her composition first, drawing a metal stylus over the vellum to leave fine gray lines similar to pencil marks. The same materials and techniques were used for the detailed work of illuminating manuscripts.

Closer look

Underdrawing
Traces of Garzoni's underdrawing can be seen in the upper part of the image. This carnation is outlined in ink and flushed with simple touches of color, to help connect the solid beans to the plain background.

Brushstrokes
Vellum is so luminous, it seems to glow. Here Garzoni has created highlights on the bean pods simply by letting the surface of the vellum show through. Using white paint to make highlights would have had a dulling effect.

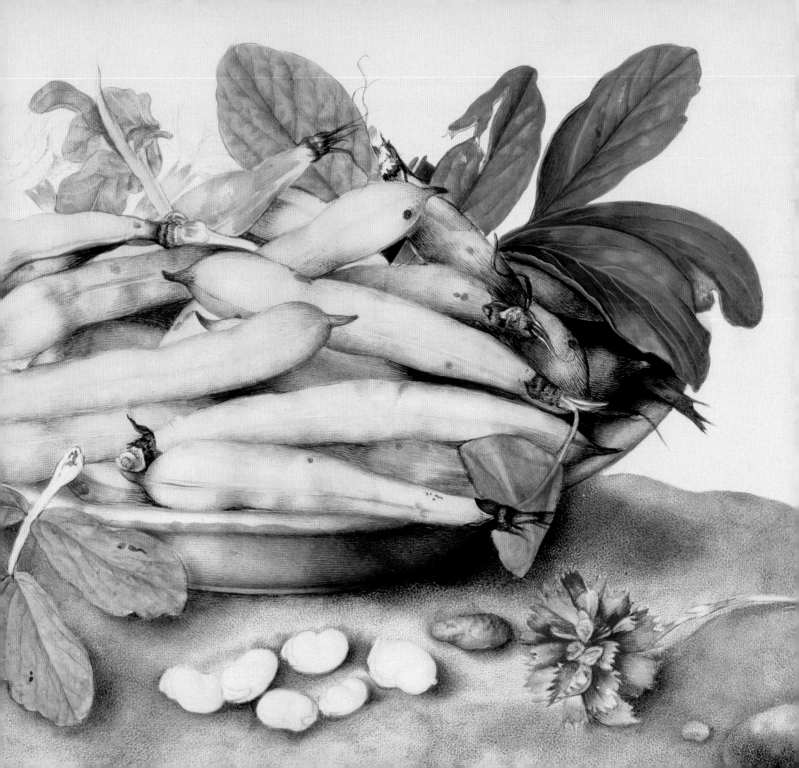

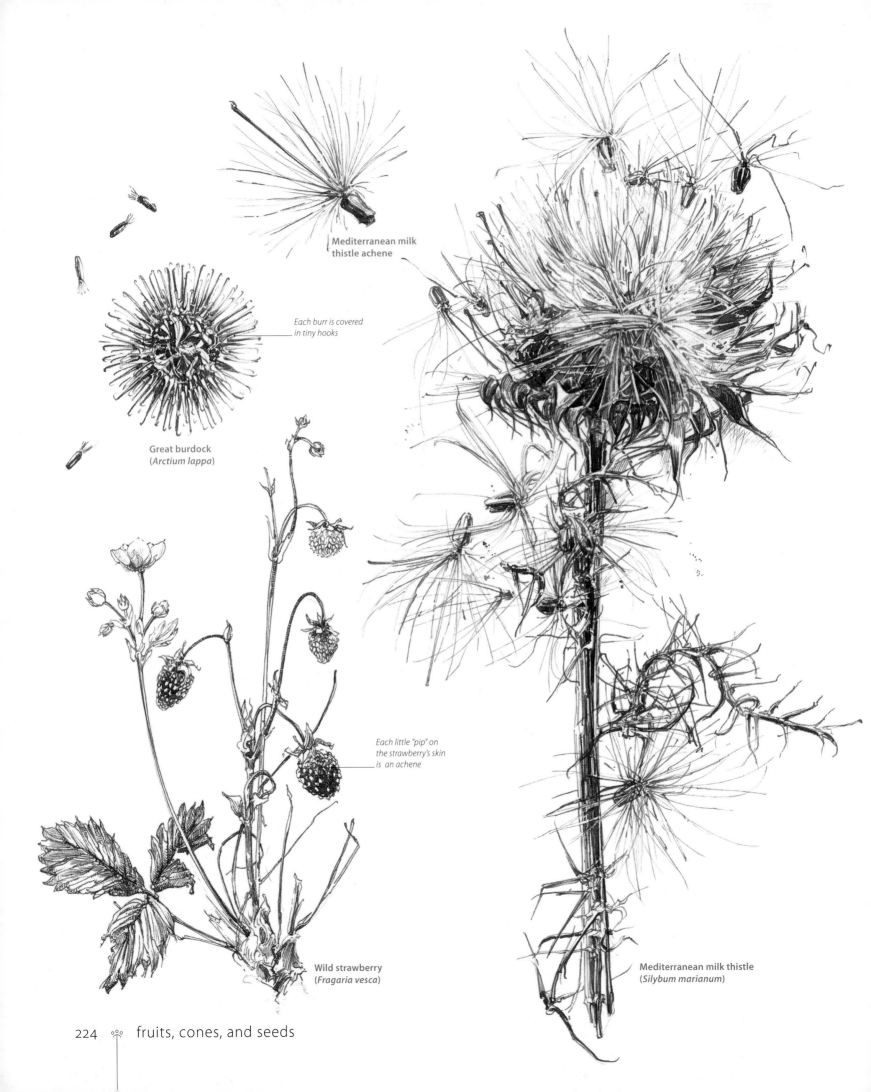

Mediterranean milk
thistle achene

Each burr is covered
in tiny hooks

Great burdock
(*Arctium lappa*)

Each little "pip" on
the strawberry's skin
is an achene

Wild strawberry
(*Fragaria vesca*)

Mediterranean milk thistle
(*Silybum marianum*)

Achenes

It is fascinating to discover that many completely unrelated plants have the same type of fruit. An achene is a small, dry fruit that develops from a single carpel (see p.165) and contains a single seed. Achenes are characteristic of all members of the aster family, including thistles, dandelions, and daisies. Many of them have long hairs enabling them to float in the breeze. The burdock produces round burrs, which disperse by catching in animal fur. Every burr forms from the involucre (ring of bracts) of a capitulum. It is covered in tiny hooks and opens from the tip to shed achenes.

Strawberries are classified as false fruits because every juicy morsel we pop into our mouth is not a flower's mature ovary but the swollen end of a stalk, which has grown into a dome-shaped receptacle encrusted with tiny green spheres. Each sphere is a separate ovary, and when each ovary is pollinated, the receptacle beneath it swells. If some ovaries are not pollinated, the receptacle beneath them does not swell, leaving the false fruit looking a little lopsided. Contrary to our expectations, every seed, or pip, on a strawberry's skin is a whole fruit in its own right: an achene.

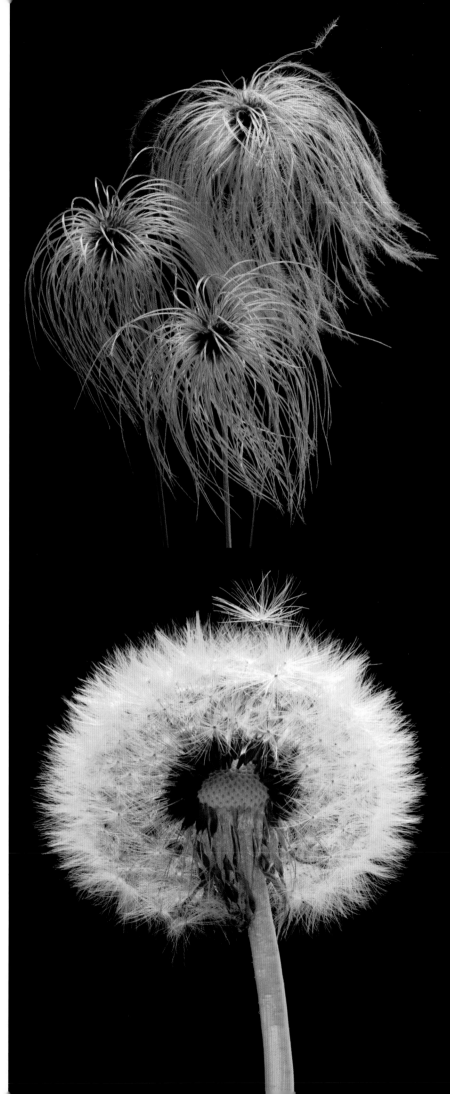

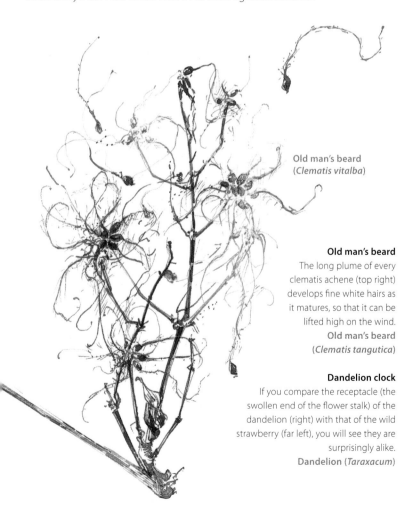

Old man's beard
(*Clematis vitalba*)

Old man's beard
The long plume of every clematis achene (top right) develops fine white hairs as it matures, so that it can be lifted high on the wind.
Old man's beard
(*Clematis tangutica*)

Dandelion clock
If you compare the receptacle (the swollen end of the flower stalk) of the dandelion (right) with that of the wild strawberry (far left), you will see they are surprisingly alike.
Dandelion (*Taraxacum*)

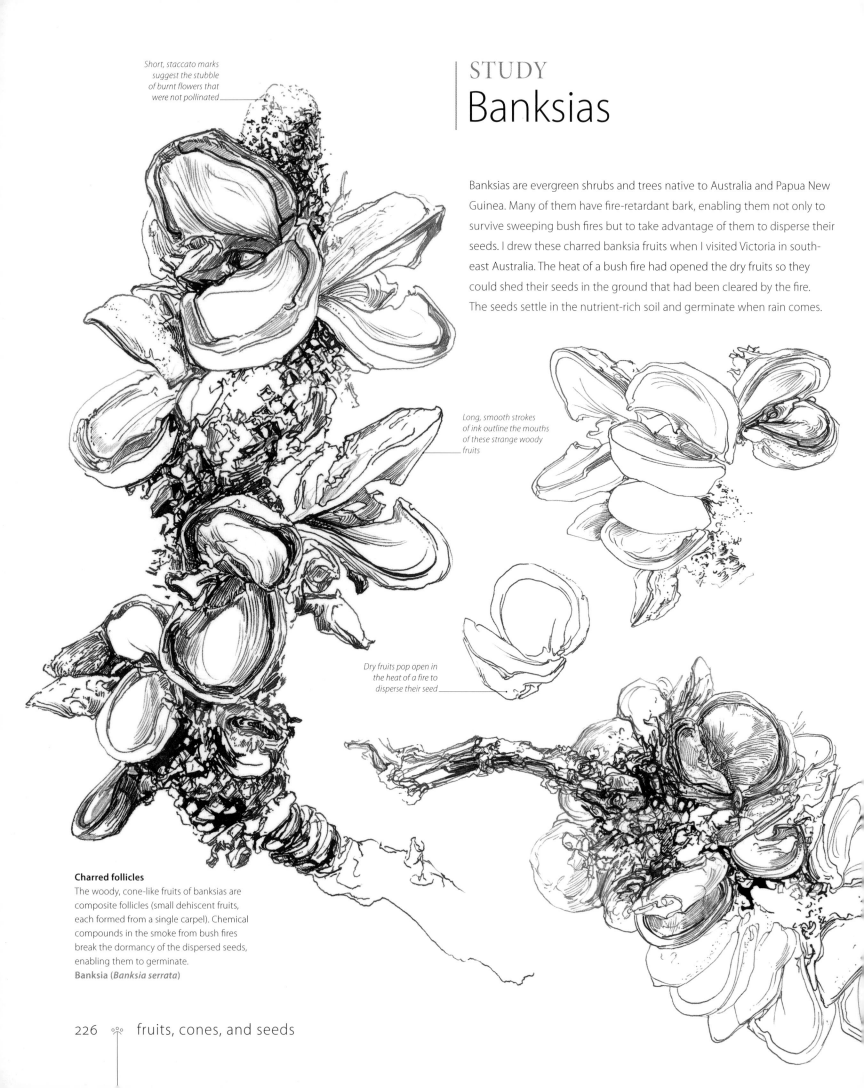

Short, staccato marks suggest the stubble of burnt flowers that were not pollinated

STUDY
Banksias

Banksias are evergreen shrubs and trees native to Australia and Papua New Guinea. Many of them have fire-retardant bark, enabling them not only to survive sweeping bush fires but to take advantage of them to disperse their seeds. I drew these charred banksia fruits when I visited Victoria in south-east Australia. The heat of a bush fire had opened the dry fruits so they could shed their seeds in the ground that had been cleared by the fire. The seeds settle in the nutrient-rich soil and germinate when rain comes.

Long, smooth strokes of ink outline the mouths of these strange woody fruits

Dry fruits pop open in the heat of a fire to disperse their seed

Charred follicles
The woody, cone-like fruits of banksias are composite follicles (small dehiscent fruits, each formed from a single carpel). Chemical compounds in the smoke from bush fires break the dormancy of the dispersed seeds, enabling them to germinate.
Banksia (*Banksia serrata*)

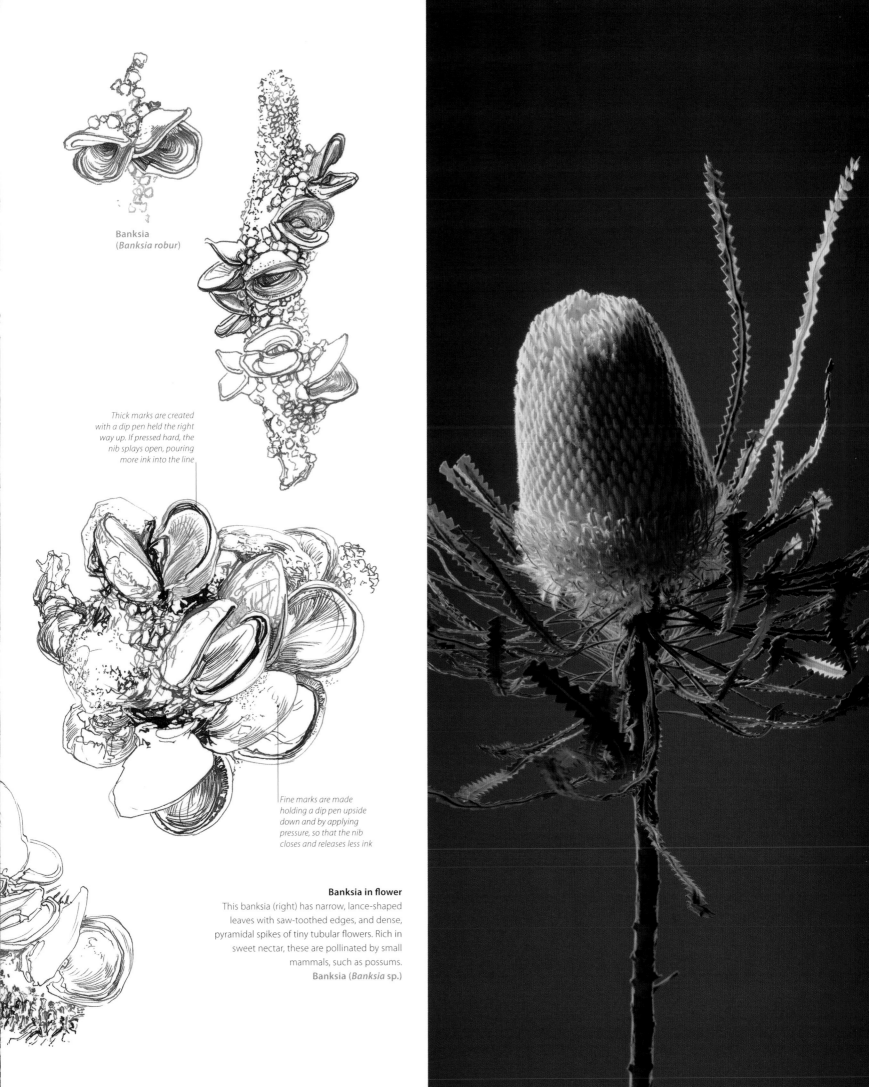

Banksia
(*Banksia robur*)

Thick marks are created with a dip pen held the right way up. If pressed hard, the nib splays open, pouring more ink into the line

Fine marks are made holding a dip pen upside down and by applying pressure, so that the nib closes and releases less ink

Banksia in flower
This banksia (right) has narrow, lance-shaped leaves with saw-toothed edges, and dense, pyramidal spikes of tiny tubular flowers. Rich in sweet nectar, these are pollinated by small mammals, such as possums.
Banksia (*Banksia* sp.)

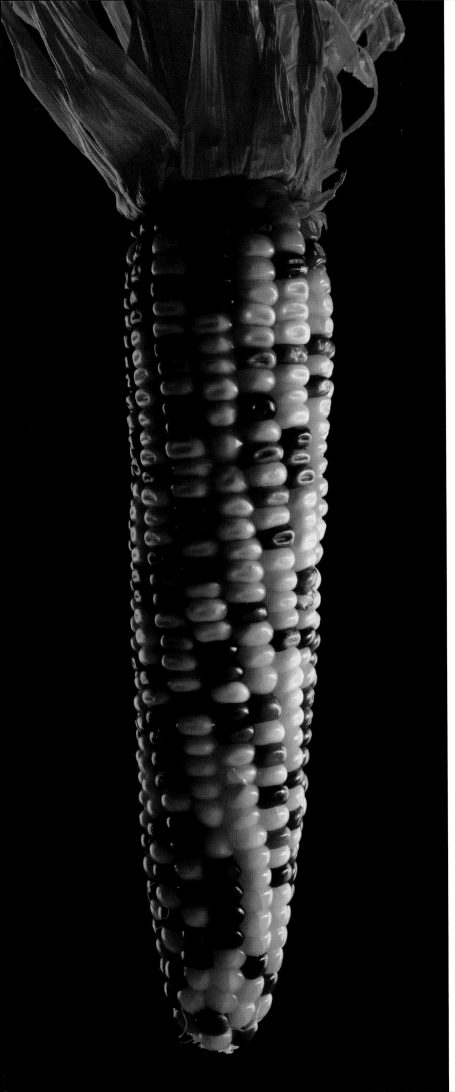

Small dry fruits

Out in the countryside you can pick up and compare an enormous range of small dry fruits. Some of these provide more than half of the food we eat. Cereal crops, such as rice, wheat, barley, oats, and corn, are all grass fruits and each individual grain or kernel is a dry, single-seeded fruit called a caryopsis. The umbrella-shaped flower heads of the carrot family, which includes cow parsley and hogweed, produce small dry fruits called cremocarps that form in two flattened halves, each containing one seed. Culinary spices, such as cumin, aniseed, and fennel, are all seeds from cremocarps. Mallows produce schizocarps, small rings of papery, single-seeded fruits held inside dry calyces, whereas geraniums have sharply pointed, explosive fruits, called regmata. A nut is a single-seeded fruit with a tough pericarp and bracts at its base. Sweet chestnuts, acorns, hazelnuts, and beechnuts are all nuts.

Cremocarps
The two flattened halves of a cremocarp (right and below) split apart when ripe and fall from two fine hairs that suspend them at the end of a flowering stalk.

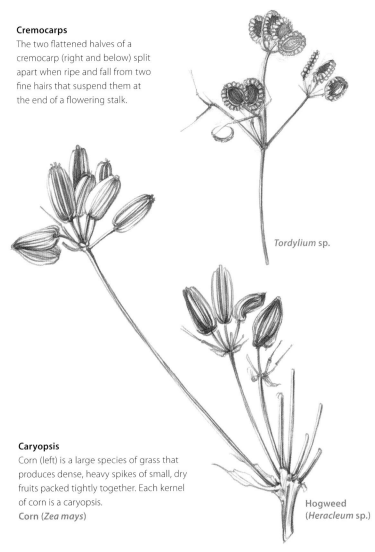

Tordylium sp.

Caryopsis
Corn (left) is a large species of grass that produces dense, heavy spikes of small, dry fruits packed tightly together. Each kernel of corn is a caryopsis.
Corn (*Zea mays*)

Hogweed
(*Heracleum* sp.)

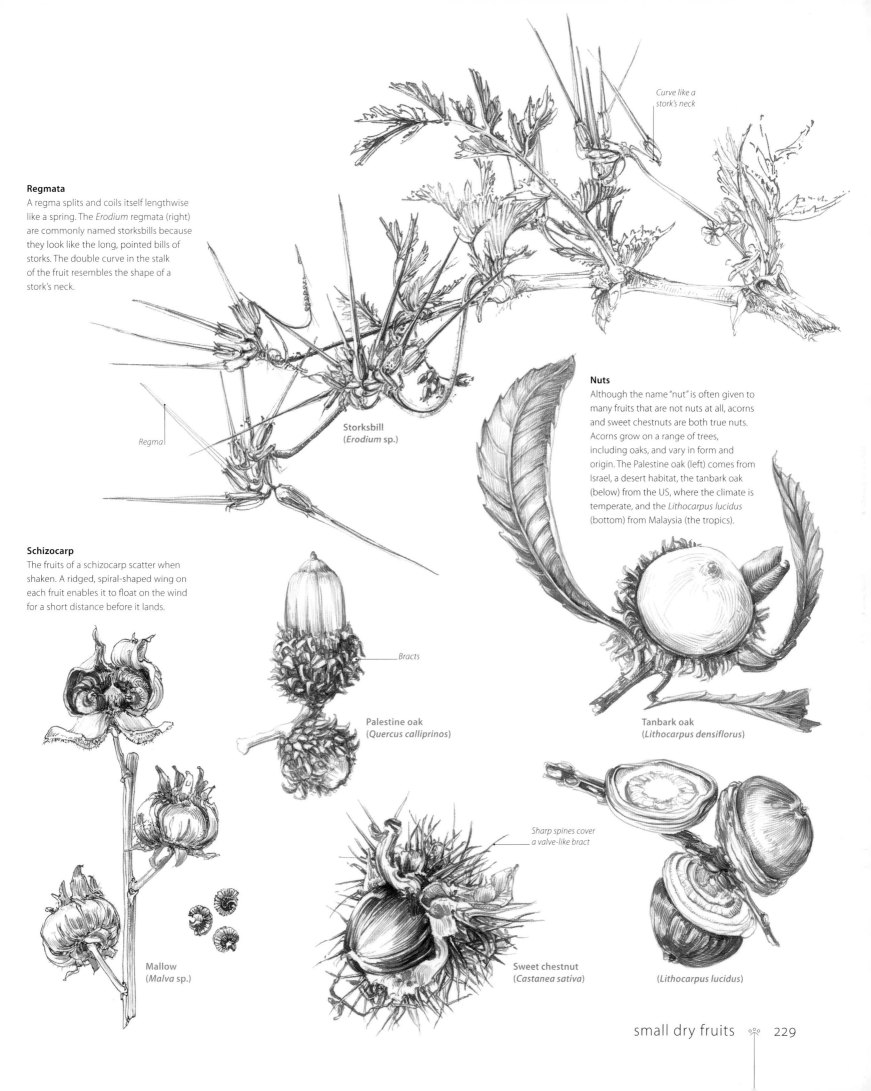

Regmata

A regma splits and coils itself lengthwise like a spring. The *Erodium* regmata (right) are commonly named storksbills because they look like the long, pointed bills of storks. The double curve in the stalk of the fruit resembles the shape of a stork's neck.

Curve like a stork's neck

Regma

Storksbill
(*Erodium* sp.)

Nuts

Although the name "nut" is often given to many fruits that are not nuts at all, acorns and sweet chestnuts are both true nuts. Acorns grow on a range of trees, including oaks, and vary in form and origin. The Palestine oak (left) comes from Israel, a desert habitat, the tanbark oak (below) from the US, where the climate is temperate, and the *Lithocarpus lucidus* (bottom) from Malaysia (the tropics).

Schizocarp

The fruits of a schizocarp scatter when shaken. A ridged, spiral-shaped wing on each fruit enables it to float on the wind for a short distance before it lands.

Bracts

Palestine oak
(*Quercus calliprinos*)

Tanbark oak
(*Lithocarpus densiflorus*)

Mallow
(*Malva* sp.)

Sharp spines cover a valve-like bract

Sweet chestnut
(*Castanea sativa*)

(*Lithocarpus lucidus*)

Winged fruits

Winged fruits are found on many completely unrelated plants, which have all evolved the same method of dispersing seed. Wings are fine, papery structures shaped to carry fruits or seeds through the air, helping them to glide, spin, flutter, or float as far as possible from the parent plant. Some wings grow out directly from the skin of a fruit, while others are modified leaves or floral parts.

Dipterocarps (right) have long pairs of wings made from the sepals of their flowers, while the glider-like wing of a linden tree (see p.153) is actually a modified leaf. Maple trees produce pairs of winged fruits called double samaras. Small fruits such as these, scattered in huge numbers, can create seed banks and lie dormant for many years before germinating. By contrast, dipterocarps germinate immediately, which is unusual. They develop extensive root systems, but remain as saplings until a gap opens in the rain forest canopy. Fully prepared, they then quickly grow tall.

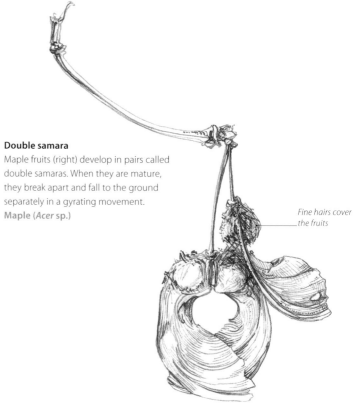

Double samara
Maple fruits (right) develop in pairs called double samaras. When they are mature, they break apart and fall to the ground separately in a gyrating movement.
Maple (*Acer* sp.)

Fine hairs cover the fruits

Veined wings
This winged fruit (left) only measures 2 x 1 in (5 x 3 cm). It is produced by a small African tree, and is enlarged here to show its prominent veining.
Montes africanus

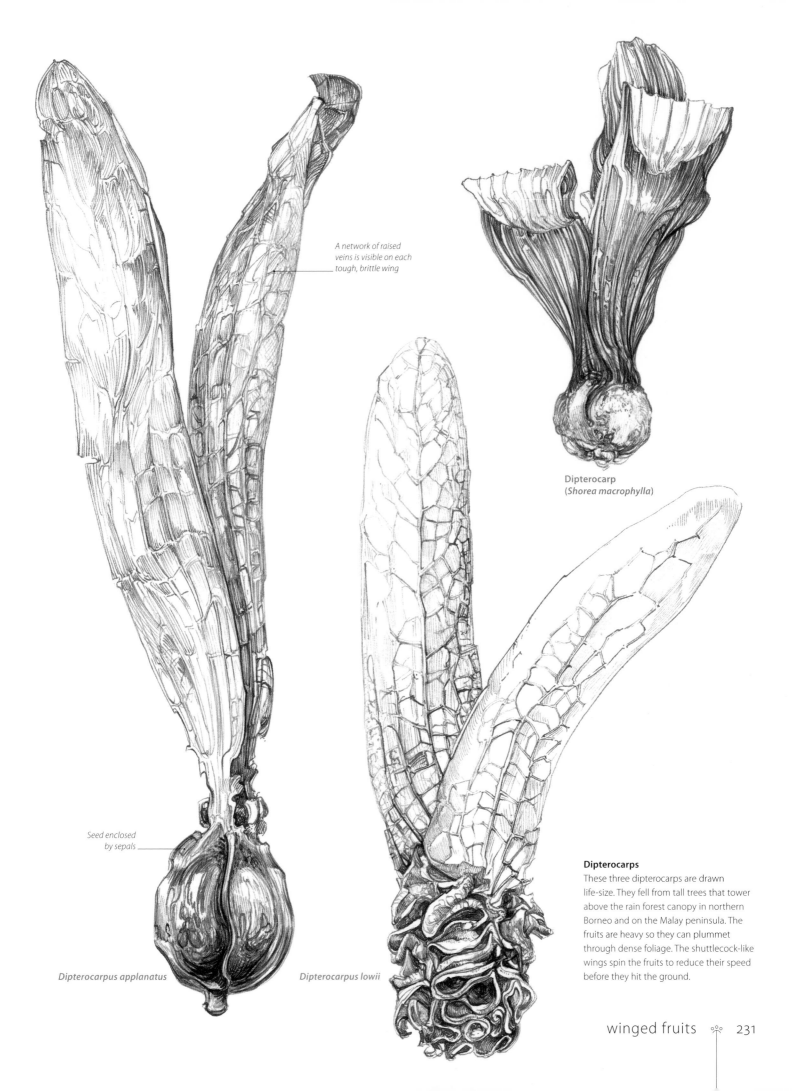

A network of raised
veins is visible on each
tough, brittle wing

Dipterocarp
(*Shorea macrophylla*)

Seed enclosed
by sepals

Dipterocarpus applanatus

Dipterocarpus lowii

Dipterocarps

These three dipterocarps are drawn
life-size. They fell from tall trees that tower
above the rain forest canopy in northern
Borneo and on the Malay peninsula. The
fruits are heavy so they can plummet
through dense foliage. The shuttlecock-like
wings spin the fruits to reduce their speed
before they hit the ground.

Yellow-throated warbler, pine warbler, and red maple

Mark Catesby

Mark Catesby (c.1682–1749) was born in Suffolk, England, and dedicated his life to recording the plants and animals of Britain's colonies in pre-revolutionary America. From the high blue mists of the Appalachian Mountains to the tidewater plantations of Virginia, and south through the Bahamas, Catesby hunted, studied, and drew the first Western images of native buffalo, bears, panthers, birds, reptiles, plants, and fish. With the guidance, support, and friendship of Native Americans, Catesby made two epic journeys through the Americas, the first lasting from 1710 to 1719, and the second from 1722 to 1726. On his final return to England, Catesby wrote his *Natural History of Carolina, Florida, and the Bahama Islands*, the first comprehensive survey of the flora and fauna of southeastern North America. Published in parts over 18 years, the book holds 220 engravings made by Catesby himself based upon his own original watercolors, of which this is one.

In this sensitively painted fanfare, two long-clawed warblers search for insects among fluttering umbels of late summer acer fruits. (This type of paired winged fruit is called a double samara.) Here, Catesby has used a fine brush and gouache paint to describe these fruits and birds. Gouache is a water-based pigment containing a little chalk, and this makes it opaque and luminous. Gouache can be applied thickly or in thin washes and, unlike watercolor, it can also be used to hide layers beneath. Pale tones can be laid over darker tones, as seen here in the surfaces of some of the fruits.

Catesby was a pioneer in depicting creatures among plants rather than separately, and sometimes he created delightfully odd contrasts in scale: another painting features a minutely drawn bison leaping through a giant sprig of Robinia leaves. Catesby once said, "As I was not bred a Painter I hope some faults in Perspective and other Niceties may be more readily [understood], for I humbly conceive Plants and other Things done in a Flat, tho exact manner, [and this] may serve the Purpose of Natural History better in some Measure than [if done] in a more bold and Painter like Way."

Closer look

Acer fruits
First, a pale pink wash was laid over each whole fruit and allowed to dry. Next, fine dark red lines were used to shape the enclosed seeds and rims of the wings. Flecks of ocher and off-white paint were added last to create surface texture.

Seasonal additions
The flowers of this tree were observed and added in the spring, while the fruits were painted the autumn before. Botanical artists often have to wait for seasons to pass to collect every detail they need for one image.

Yellow-throated Warbler, Pine Warbler, and Red Maple
c.1722–1726, watercolor and gouache over pen and ink, 14½ x 10½in (37 x 27cm), The Royal Collection, London, UK

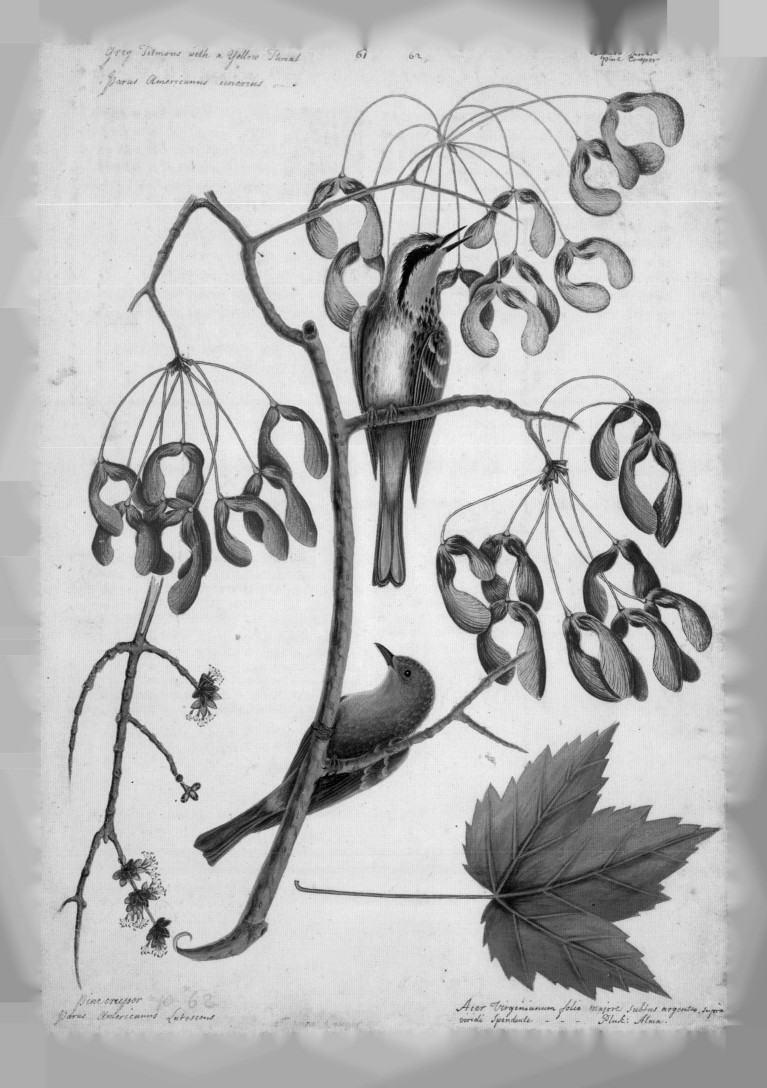

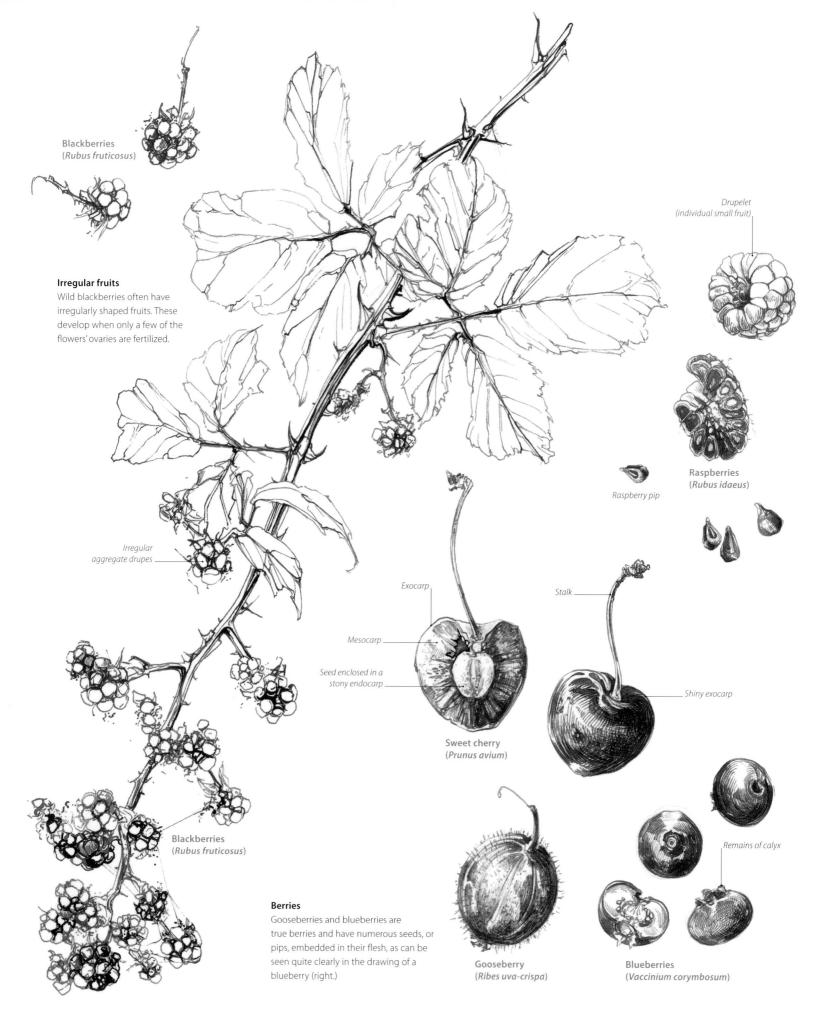

Blackberries
(*Rubus fruticosus*)

Irregular fruits
Wild blackberries often have
irregularly shaped fruits. These
develop when only a few of the
flowers' ovaries are fertilized.

*Irregular
aggregate drupes*

Blackberries
(*Rubus fruticosus*)

Berries
Gooseberries and blueberries are
true berries and have numerous seeds, or
pips, embedded in their flesh, as can be
seen quite clearly in the drawing of a
blueberry (right.)

*Drupelet
(individual small fruit)*

Raspberries
(*Rubus idaeus*)

Raspberry pip

Exocarp

Mesocarp

*Seed enclosed in a
stony endocarp*

Sweet cherry
(*Prunus avium*)

Stalk

Shiny exocarp

Remains of calyx

Gooseberry
(*Ribes uva-crispa*)

Blueberries
(*Vaccinium corymbosum*)

Fleshy fruits

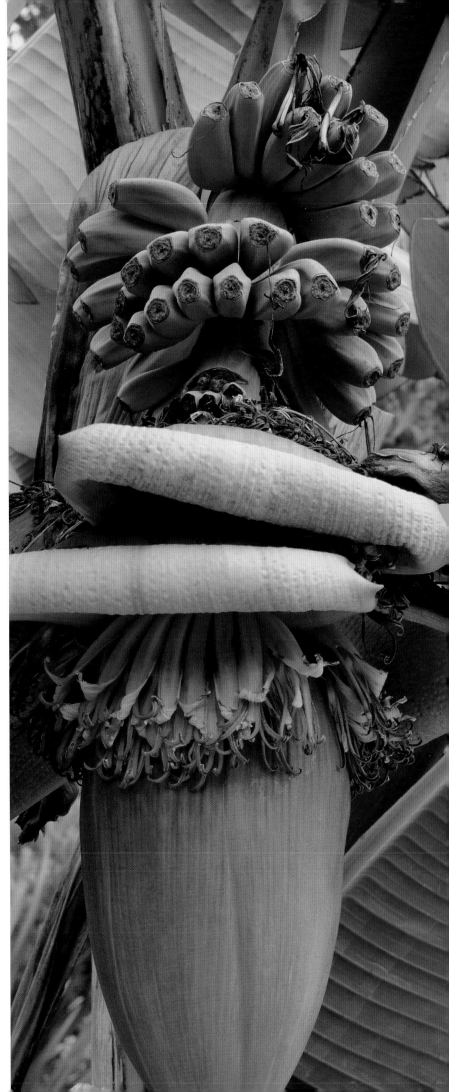

Fleshy fruits are all succulent and juicy, sometimes scented, and have evolved to be eaten. Plants grow edible fruits to attract and reward animals, which consume them, then carry away the seeds and deposit them in piles of nutritious manure away from the parent plant.

Simple stone fruits, such as peaches, plums, almonds, and coconuts (which we normally see stripped of their flesh) are all drupes. They have a thin exocarp (skin), a layer of juicy mesocarp (flesh)—although, in the case of coconut, this layer is fibrous—and a stony endocarp (inner skin) surrounding a seed, as seen clearly in the drawing of the sweet cherry (left). Aggregate stone fruits are produced when a flower with many ovaries grows numerous fruits joined together on a swollen receptacle (end of a stem). Raspberries and blackberries, for example, are aggregate stone fruits, not berries. True berries are usually simple in form and have many seeds (pips) loosely embedded in their flesh. Gooseberries, blueberries, pawpaw, physalis, tomatoes, and grapes are all berries. At first the seeds are attached to a placenta, but in some fruits they become detached and sit free in the flesh. A pepo is a type of berry in which the seeds remain attached to the placenta, as in melons, cucumbers, and sweet peppers. Bananas are also berries. Although cultivated varieties are seedless, bananas that grow in the wild are full of very hard seeds. A date is a single-seeded berry.

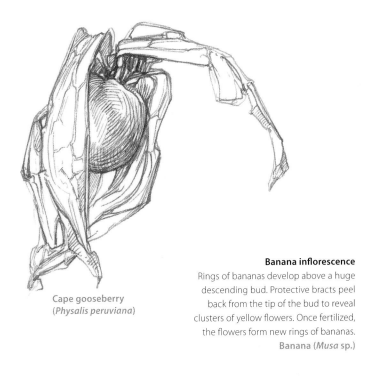

Cape gooseberry
(*Physalis peruviana*)

Banana inflorescence
Rings of bananas develop above a huge descending bud. Protective bracts peel back from the tip of the bud to reveal clusters of yellow flowers. Once fertilized, the flowers form new rings of bananas.
Banana (*Musa* sp.)

Watermelon

A watermelon is a huge and heavy berry, with thick, smooth skin that appears to have translucent liquid depth in its dark and marbled streaks running over paler shades of green. Looking closely at this solid fruit while I painted it, it was transformed (in my imagination) into a fascinating planet with a complex surface of lagoons, craters, and meteor scars. I used an HB pencil to gently mark a globe on the page—a life-size sphere tilted slightly to the right (pale pencil rubs out completely from beneath dry watercolor). I then sketched in segments to provide a center line for each strand of complex markings. I used a soft brush to lay a wash of pale green over the pencil sketch and allowed it to dry before adding richer color.

My basic palette was mixed from transparent yellow, ultramarine, and permanent rose. It is important to leave each layer of paint to dry before adding the next, unless you want colors to run into each other. I angled my lamp to cast light onto the top right of the fruit, and I stepped back frequently to check on the unified development of the whole painting.

Draw guidelines

1 Quickly and boldly draw a loose circle on the page with a pencil. Mark the stalk scar and from that point draw a series of curved lines to turn your circle into a sphere. Space your curved lines like segments to see where to place more detailed markings. Imagine the pencil is in contact with the surface of the fruit to help you maintain control.

Pale marks first

2 Paint the palest and most softly focused shapes first. Gradually darken the colors, sharpen the focus, and allow each layer to dry. The contrast of dark, sharp-edged marks laid over paler, soft-edged marks creates an illusion of depth, and light appears to shine out from within the melon skin.

Blotting out to bring back light

3 Always work with a generous quantity of tissue for blotting sudden errors, and to create light effects. Here clean water was rubbed over an area of dry paint with a soft brush, then swiftly blotted to lift away particles of pigment. This reveals the texture of the paper, which becomes part of the texture of the fruit.

Darkest tones last

4 Work on the whole image at the same time to avoid mapping from side to side, and keep an eye on the balance of all the parts as they develop. Add the darkest tones last, in balance with each other; never get too dark, too soon. This helps to ensure that the finished image looks like a three-dimensional melon.

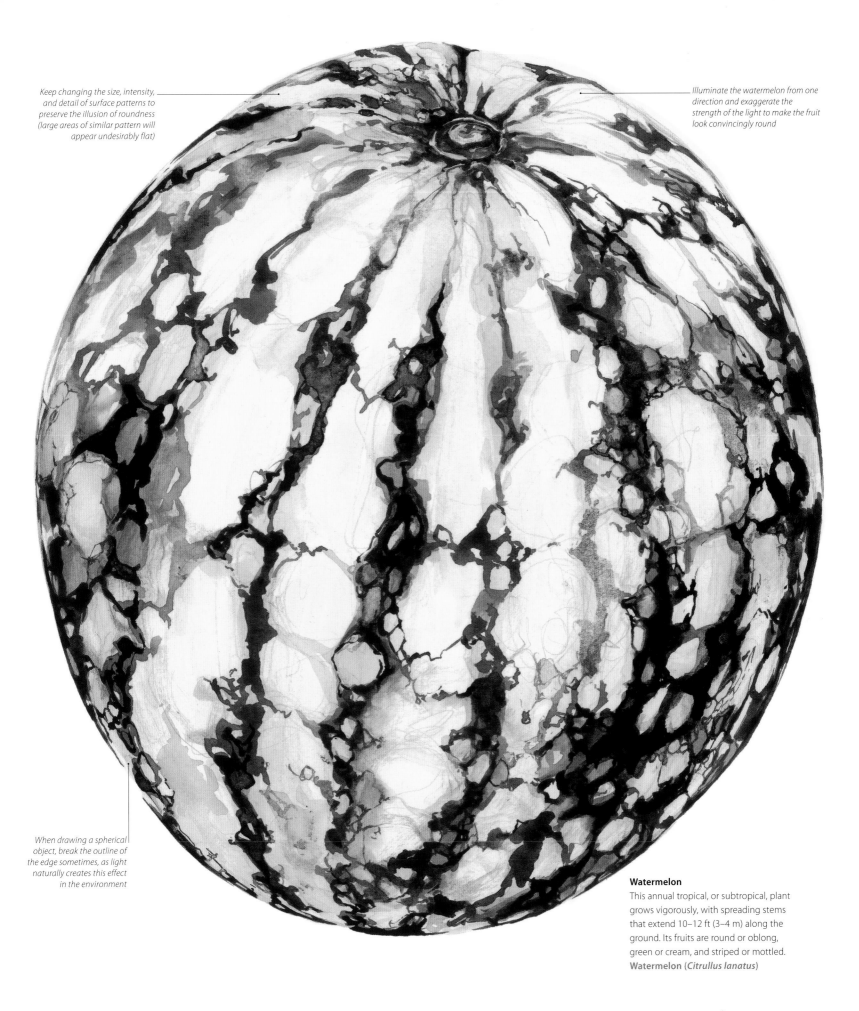

Keep changing the size, intensity, and detail of surface patterns to preserve the illusion of roundness (large areas of similar pattern will appear undesirably flat)

Illuminate the watermelon from one direction and exaggerate the strength of the light to make the fruit look convincingly round

When drawing a spherical object, break the outline of the edge sometimes, as light naturally creates this effect in the environment

Watermelon
This annual tropical, or subtropical, plant grows vigorously, with spreading stems that extend 10–12 ft (3–4 m) along the ground. Its fruits are round or oblong, green or cream, and striped or mottled.
Watermelon (*Citrullus lanatus*)

Fruit diversity

Many fleshy fruits are complex in structure and are not what they seem. Some common "fruits," such as apples, are not true fruits at all. They are classified as false fruits because their outer, edible flesh is not an ovary, but the swollen end of a flower stalk. In an apple, the true fruit is the core that we throw away. Rosehips are another example of a false fruit.

Contrary to appearances, a citrus fruit is really a berry with many cells, called a hesperidium. The pomegranate fruit is called a balausta, from which we get the words balustrade and banister. A balausta is a fruit with a tough skin (pericarp), and many cells, each containing a seed. A fig is really an enclosed urn-shaped inflorescence lined with tiny male and female flowers. Once the female flowers are fertilized, the soft receptacle holding them ripens and swells. A fig is not, therefore, one piece of fruit, but a composite of many tiny fruits.

The pericarp splits as the fruit ripens

Stamens

Stigma

**Pomegranate
(*Punica granatum*)**

Lemon cells
The light shining through the lemon (top left) reveals its many cells. The pale, circular chambers just touching the outermost edge of the skin (pericarp) are oil glands.
Lemon (*Citrus limon*)

Pomegranate fruit
Each pomegranate seed (left and above) is embedded in a fleshy red covering called an aril. Pomegranate fruits dry out, split open, and remain on the tree, where birds can feed from them.
Pomegranate (*Punica granatum*)

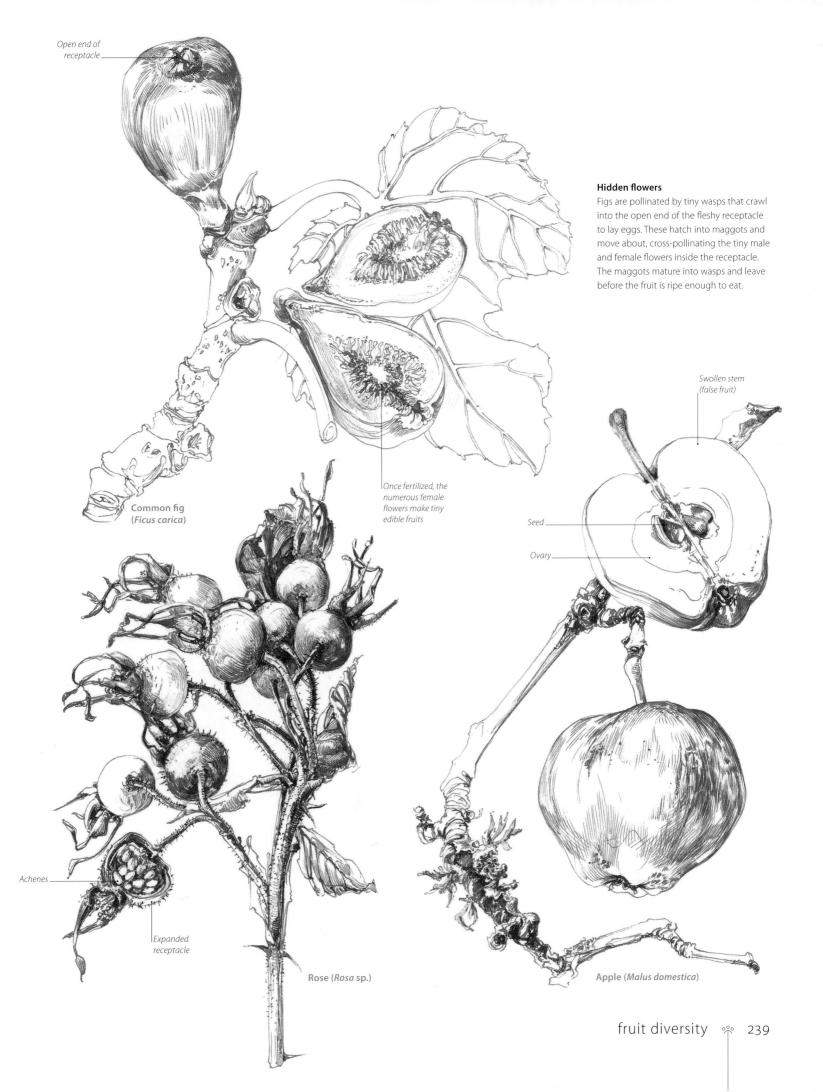

Open end of
receptacle

Hidden flowers
Figs are pollinated by tiny wasps that crawl
into the open end of the fleshy receptacle
to lay eggs. These hatch into maggots and
move about, cross-pollinating the tiny male
and female flowers inside the receptacle.
The maggots mature into wasps and leave
before the fruit is ripe enough to eat.

Swollen stem
(false fruit)

Seed

Ovary

Once fertilized, the
numerous female
flowers make tiny
edible fruits

Common fig
(*Ficus carica*)

Achenes

Expanded
receptacle

Rose (*Rosa* sp.)

Apple (*Malus domestica*)

fruit diversity ⚬⚬ 239

Pineapple with cockroaches
Maria Sibylla Merian

The Dutch artist Maria Sibylla Merian (1647–1717) was born into a dynasty of renowned engravers and influential publishers, and her passions for natural history and art were nurtured from early childhood. At the age of 52 she took her youngest teenage daughter to Surinam, South America, where they collected countless species of plants and insects that were then unknown in the West. Merian wrote and richly illustrated three scholarly books in her lifetime. Her most influential was *The Metamorphoses of the Insects of Surinam*, published in 1705.

Merian was a pioneer in the study of how caterpillars become butterflies and moths, which was still a mystery at the time. She made luminous illustrations painted with gouache in vivid colors on vellum, and translated these into copperplate engravings with the help of her daughter, who she trained as a printmaker and colorist. *Pineapple with Cockroaches* is one of the 60 original gouache on vellum paintings that Merian made for *The Metamorphoses*. In this, and all the other plates, she painted insects crawling over and flapping around the plants that they live on or are attracted to. Here, six different species are displayed on a gorgeous pink and yellow pineapple. Merian's paintings are characterized by her love of bright color, tentacle-like twists, curls, and flourishes. Her painted subjects rarely appear still. Here, for example, long red and yellow bracts ripple and wave from beneath the heavy fruit, like dragons' tongues at a carnival.

When a pollinated inflorescence (flowerhead) matures into one large fruit, it is called a composite fruit. Pineapples and figs are fascinating examples of this. The many flowers of a pineapple plant are packed tightly together to form a spike (see pp.198–199) and each delicate flower has a large, tough bract beneath it. Every rounded segment you see on the surface of Merian's pineapple grew from an individually pollinated ovary at the center of a long, slender, bright blue flower.

Closer look

Final touches
Merian painted the curved, parallel brown lines and trails of stippled spots on the surfaces of the fruits and bracts last of all. They were applied on top of pale pink and yellow washes, and strokes of deeper red.

Warm undertones
Light reflects through layers of paint on vellum to make the work glow. The red bracts were first painted yellow, then red was added on top. The underpainting gives the red an orange tint and helps to harmonize the two colors.

Pineapple (*Ananas comosus*) with Australian cockroaches (*Periplaneta australasiae*) and German cockroaches (*Blattella germanica*)
c.1701–1705, watercolor, gouache, and gum arabic on vellum,
19 x 13⅜ in (48.3 x 34.8cm),
The Royal Collection, London, UK

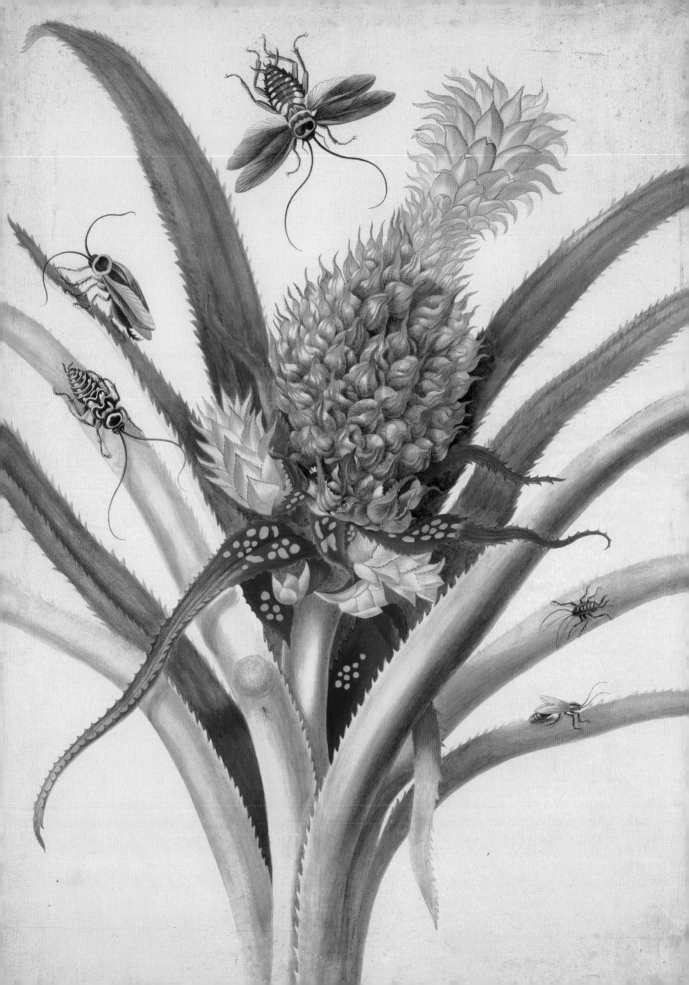

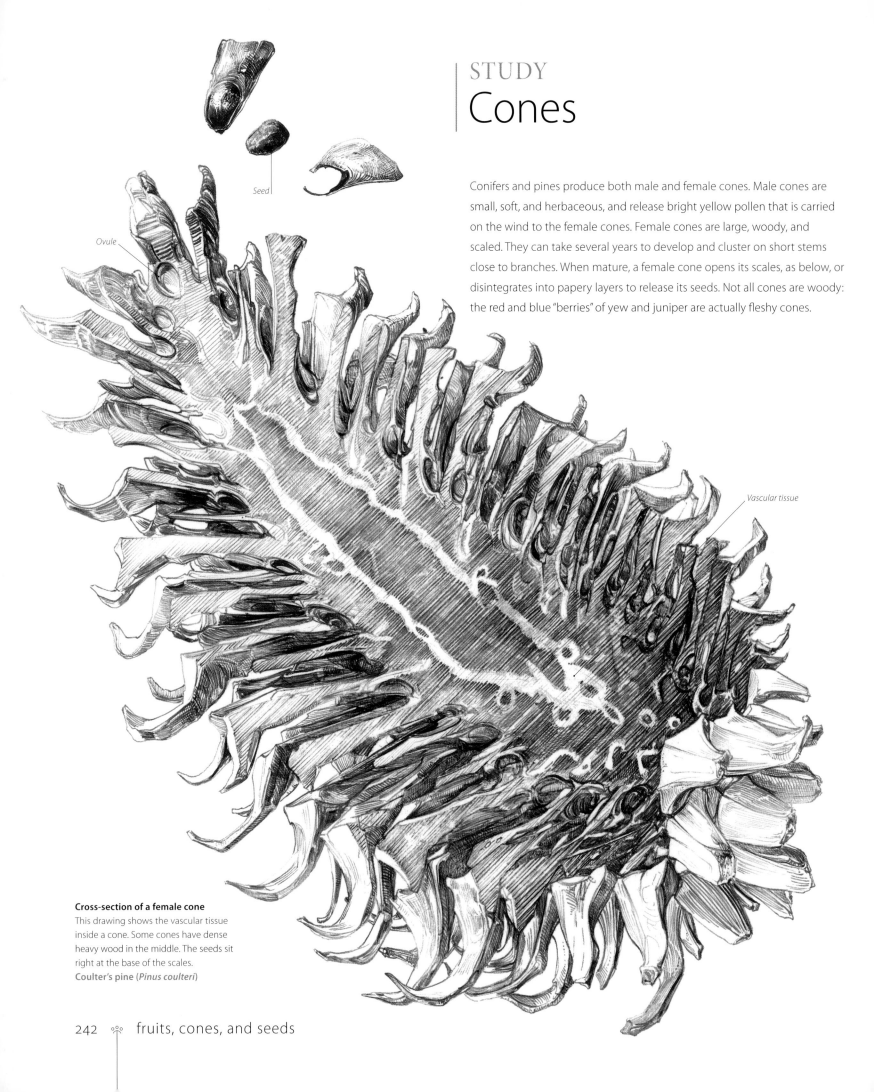

STUDY
Cones

Seed

Ovule

Vascular tissue

Conifers and pines produce both male and female cones. Male cones are small, soft, and herbaceous, and release bright yellow pollen that is carried on the wind to the female cones. Female cones are large, woody, and scaled. They can take several years to develop and cluster on short stems close to branches. When mature, a female cone opens its scales, as below, or disintegrates into papery layers to release its seeds. Not all cones are woody: the red and blue "berries" of yew and juniper are actually fleshy cones.

Cross-section of a female cone
This drawing shows the vascular tissue inside a cone. Some cones have dense heavy wood in the middle. The seeds sit right at the base of the scales.
Coulter's pine (*Pinus coulteri*)

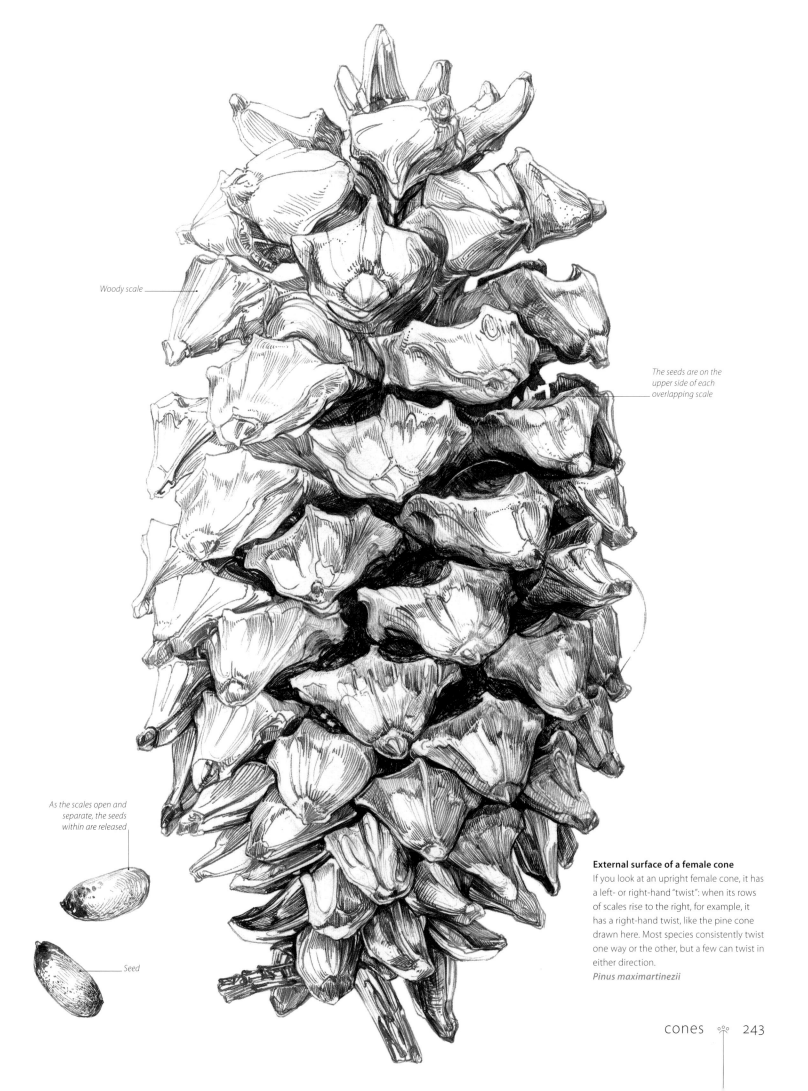

Woody scale

The seeds are on the upper side of each overlapping scale

As the scales open and separate, the seeds within are released

Seed

External surface of a female cone

If you look at an upright female cone, it has a left- or right-hand "twist": when its rows of scales rise to the right, for example, it has a right-hand twist, like the pine cone drawn here. Most species consistently twist one way or the other, but a few can twist in either direction.

Pinus maximartinezii

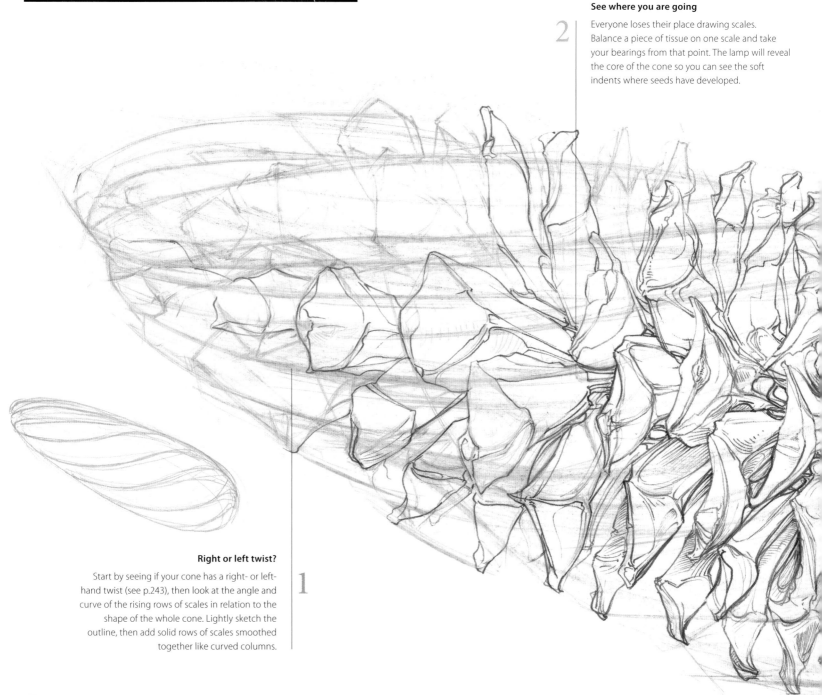

See where you are going

2 | Everyone loses their place drawing scales. Balance a piece of tissue on one scale and take your bearings from that point. The lamp will reveal the core of the cone so you can see the soft indents where seeds have developed.

Right or left twist?

Start by seeing if your cone has a right- or left-hand twist (see p.243), then look at the angle and curve of the rising rows of scales in relation to the shape of the whole cone. Lightly sketch the outline, then add solid rows of scales smoothed together like curved columns. | 1

Pine cone

In 1894, the conservationist John Muir wrote of the sugar pine, "This is the noblest pine yet discovered, surpassing all others not merely in size but also in kingly beauty and majesty". First described in 1826 by the Scottish botanist and explorer, David Douglas, who observed that native people chewed the sweet heartwood like a kind of gum, sugar pines grow on the moist western slopes of mountains that stretch along the west coast of the United States from Oregon right down to Mexico. They produce the biggest cones of all, which can grow up to 22 in (56 cm) long. The cones hang singly, or in twos and threes, from the ends of the branches. Apart from being attracted by its delightful size, I chose to draw this cone as an example of a left-hand twist (see p.243). As the cone is mature, the scales are open, so I positioned my lamp to shine into the scales and reveal the cone's inner structure. I used pencil for the preliminary sketch, then developed the drawing with pen and ink. You can achieve a similar result just using pencil.

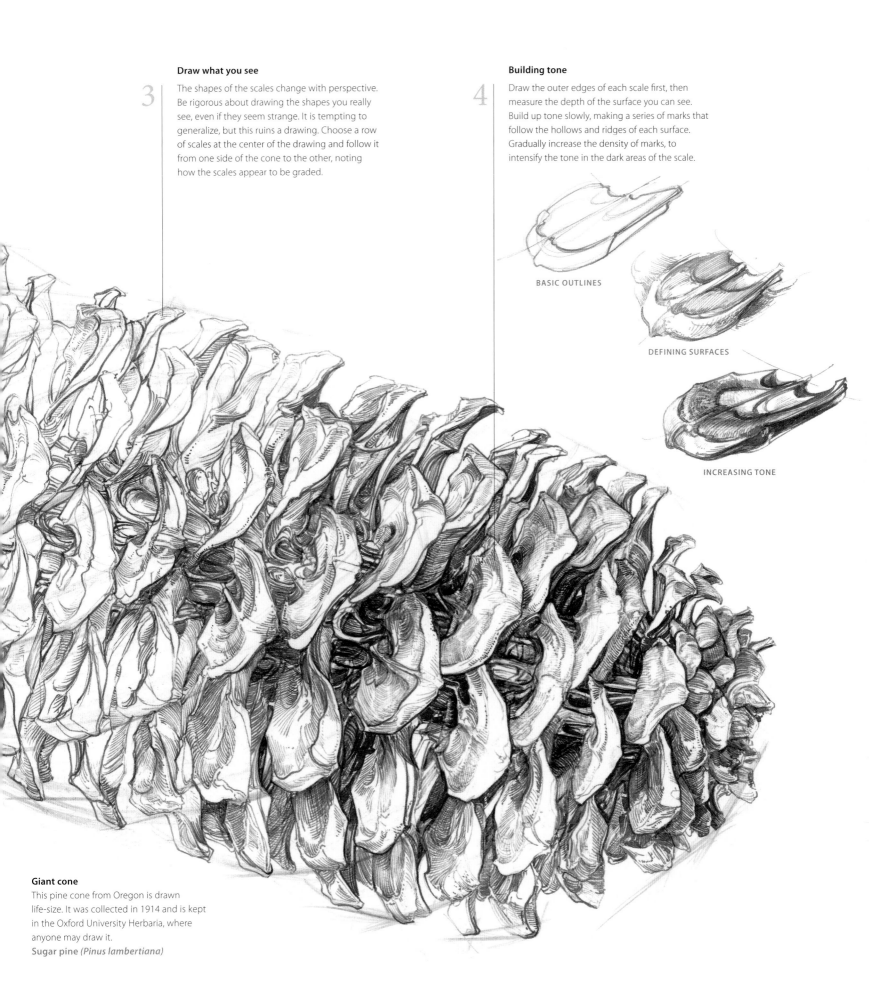

Draw what you see

3 | The shapes of the scales change with perspective. Be rigorous about drawing the shapes you really see, even if they seem strange. It is tempting to generalize, but this ruins a drawing. Choose a row of scales at the center of the drawing and follow it from one side of the cone to the other, noting how the scales appear to be graded.

Building tone

4 | Draw the outer edges of each scale first, then measure the depth of the surface you can see. Build up tone slowly, making a series of marks that follow the hollows and ridges of each surface. Gradually increase the density of marks, to intensify the tone in the dark areas of the scale.

BASIC OUTLINES

DEFINING SURFACES

INCREASING TONE

Giant cone
This pine cone from Oregon is drawn life-size. It was collected in 1914 and is kept in the Oxford University Herbaria, where anyone may draw it.
Sugar pine *(Pinus lambertiana)*

Germination

Seeds are packages, containing an embryo and food reserves. They are carried away from their parent plants, via wind, water, or animals, to new locations where they may lie dormant for so long that decades or centuries pass between two generations. Seeds remain dormant until they have just the right combination of air, light, warmth, and water to germinate. This explains the sudden blooming of deserts after rain, when dormant seeds grow, flower, set new seed, and die in only a few weeks. In 1941 incendiary bombs fell on the Natural History Museum Herbarium in London. Fire fighters drenched the collection with water to save it and, in the aftermath, hundreds of seeds began to grow. Scientists have recently also successfully germinated a date seed that was approximately 1,900 years old. Plants can travel across immense distances of time and space via their seeds.

Some seeds need to be damaged in order to germinate. Foraging animals might crack them and let in water that will trigger chemical changes leading to growth. Other types of seed have to pass through an animal's gut, where they are effectively bathed in hydrochloric acid while being transported to a new location where they will be deposited in a pile of nutritious manure. For other species of seed, fire is important. Some plants,

such as banksias (see pp.226–227), not only have defense mechanisms to help them survive fire, but actively take advantage of it. Many temperature-sensitive seeds need to be chilled or frozen before they are able to germinate, but a few seeds have no period of dormancy at all: winged dipterocarps (see p.231), for example, germinate as soon as they land.

There are two main forms of germination: epigeal, meaning "above earth," and hypogeal, meaning "below earth." Almost all seeds, including monocots (see p.67), eudicots (see p.68), and gymnosperms (see p.62), grow in one of these two ways. In both cases, water softens the seed coat (testa) so that the expanding embryo can break through it. Either the root (radicle) or the stem shoot (plumule) may be the first to emerge. Sensitivity to gravity determines which way a root or shoot grows—either upward toward sunlight, or downward in search of water.

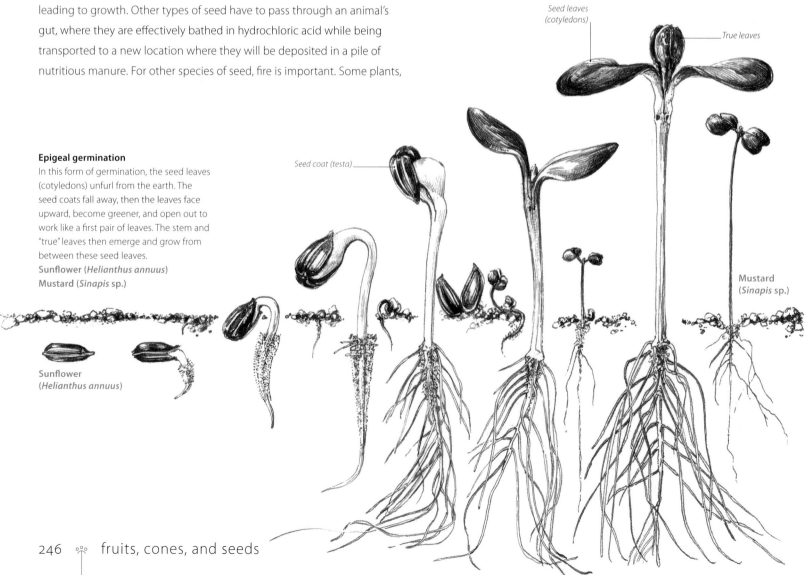

Seed leaves (cotyledons)

True leaves

Seed coat (testa)

Epigeal germination
In this form of germination, the seed leaves (cotyledons) unfurl from the earth. The seed coats fall away, then the leaves face upward, become greener, and open out to work like a first pair of leaves. The stem and "true" leaves then emerge and grow from between these seed leaves.
Sunflower (*Helianthus annuus*)
Mustard (*Sinapis* sp.)

Mustard (*Sinapis* sp.)

Sunflower (*Helianthus annuus*)

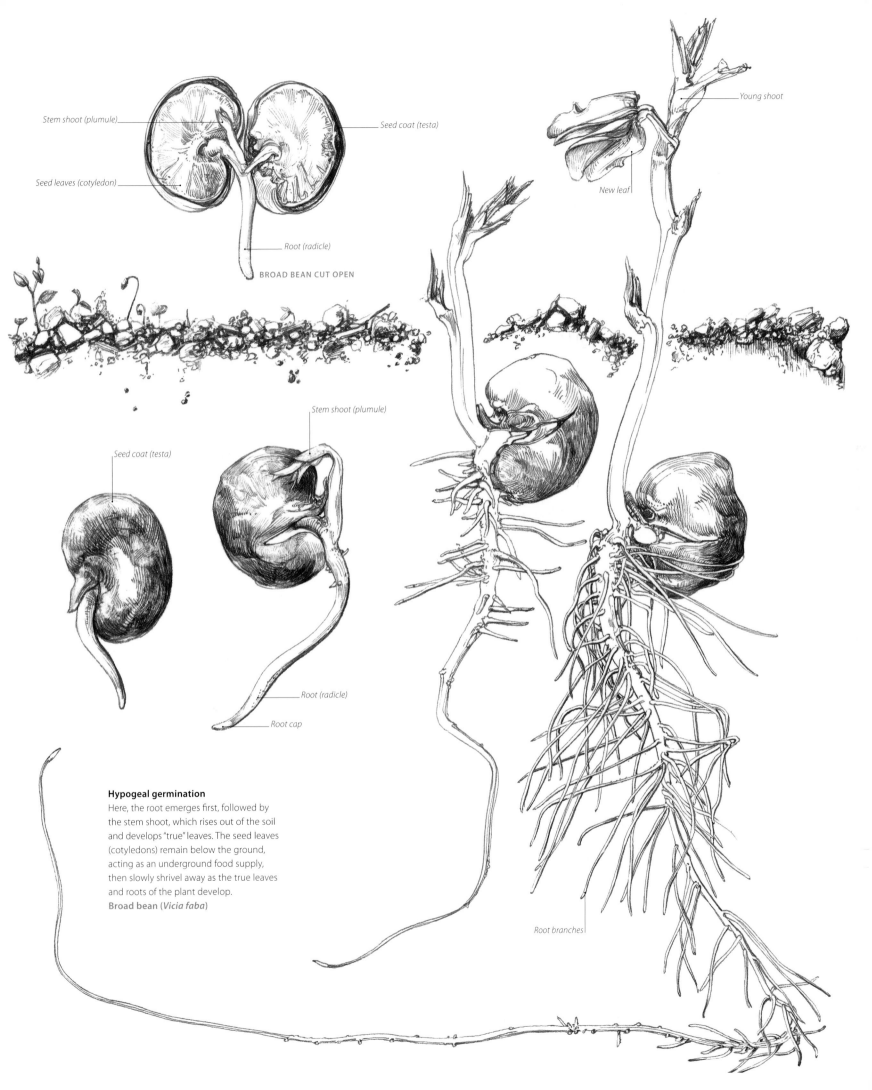

Stem shoot (plumule)

Seed coat (testa)

Seed leaves (cotyledon)

Root (radicle)

BROAD BEAN CUT OPEN

Young shoot

New leaf

Stem shoot (plumule)

Seed coat (testa)

Root (radicle)

Root cap

Hypogeal germination
Here, the root emerges first, followed by
the stem shoot, which rises out of the soil
and develops "true" leaves. The seed leaves
(cotyledons) remain below the ground,
acting as an underground food supply,
then slowly shrivel away as the true leaves
and roots of the plant develop.
Broad bean (*Vicia faba*)

Root branches

Glossary

Common laburnum in flower
(*Laburnum anagyroides*)

Achene A dry, one-seeded fruit that does not open.

Annual A plant that completes its life cycle—germination, flowering, seeding, and dying—in one growing season.

Adventitious Arising from places where growths do not normally occur, for example, adventitious roots may arise from stems.

Aerial root A root that grows from the stem of a plant that is located above ground.

Aggregate fruit A compound fruit that develops from several ovaries. The ovaries are all from the carpels of a single flower and the separate fruits are joined together. Examples are raspberries and blackberries.

Algae A group of simple, flowerless, mainly aquatic plant-like organisms that contain chlorophyll but do not have true stems, roots, leaves, and vascular tissue. An example is seaweed.

Angiosperm A flowering plant that bears ovules, later seeds, enclosed in ovaries. Angiosperms are divided into two main groups: monocots and eudicots.

Anther The part of a stamen that produces pollen; it is usually borne on a filament.

Apex The tip or growing point of a leaf, shoot, or root.

Aril The fleshy, hairy, or spongy layer around some seeds.

Axil (leaf axil) The upper angle between a stem and a leaf where an axillary bud develops.

Axillary bud A bud that develops in the axil of a leaf.

Balausta A fruit with a tough skin (pericarp) and many cells, each containing a seed. A pomegranate is a typical example of a balausta.

Bark The tough covering on woody roots, trunks, and branches.

Berry A fruit with soft, juicy flesh that has one or more seeds developed from a single ovary.

Bipinnate A compound leaf whose leaflets are divided into yet smaller leaflets, such as mimosa leaves.

Blade The whole part of a leaf except for its stalk (petiole). The shape of a leaf blade and its edges (margins) are important characteristics of a plant.

Bract A leaf modified into an attractive or protective structure (usually to protect buds) around the base of a flower or flower cluster. Some bracts are large, brightly colored, and look like petals to attract beneficial insects, while others resemble leaves, although these may may be smaller and shaped differently.

Bud An immature shoot covered with protective scales that contains immature leaves or flowers, which can be solitary, paired, or clustered. Buds can also modify into tendrils or thorns.

Bulb A modified underground bud acting as a storage organ. It consists of one or more buds and layers of swollen, colorless, fleshy scale leaves, packed with stored food, on a shortened, disk-like stem.

Bulbil A small bulb-like organ, often borne in a leaf axil, occasionally on a stem or flowerhead.

Burr A prickly or spiny dry fruit.

Calyx (plural: calyces) The outer part of a flower, formed from a ring of sepals, that is sometimes showy and brightly colored but usually small and green. The calyx forms a cover that encloses the petals while in bud.

Capitulum (plural: capitula) A group of flowers (inflorescence) on a stem that together look like a single flower head. An example is a sunflower.

Capsule A dry fruit containing many seeds that has developed from an ovary formed from two or more carpels. It splits open when ripe to release its seeds.

Carpel The female reproductive part of a flower that consists of an ovary, stigma, and style.

Caryopsis A dry, single-seeded fruit that is dehiscent (splits open). Grasses typically have rows or clusters of edible caryopses (grains).

Catkin A cluster of small, petalless flowers.

Chitin A tough protein in the cell walls of most fungi.

Chlorophyll The green plant pigment that is mainly responsible for light absorption and thus photosynthesis in plants.

Cladode A modified stem that resembles and performs the function of a leaf.

Compound leaf Composed of two or more similar parts.

Cone The densely clustered bracts of conifers and some flowering plants, often developing into a woody, seed-bearing structure, as in the familiar pine cone.

Conifers Mostly evergreen trees or shrubs, usually with needle-like leaves and seeds borne naked on the scales of cones.

Corm A bulb-like underground swollen stem or stem base, often surrounded by a papery tunic.

Corolla A ring of petals.

Corymb A broad, flat-topped, or domed inflorescence of stalked flowers or flowerheads arising at different levels on alternate sides of an axis.

Cotyledon A seed leaf that acts as a food store or unfurls shortly after germination to fuel a seed's growth.

Cremocarp A small, dry fruit that forms in two flattened halves, each containing one seed.

Cupule A cup-shaped structure made of bracts joined together.

Cyme A flat or round-topped, branched inflorescence with each axis ending in a flower, the oldest at the center and the youngest arising in succession from the axils of bracteoles (secondary bracts).

Dehiscent fruit A dry fruit that splits or bursts to release its seeds.

Dichasium *see* Inflorescence.

Drupe A fleshy fruit containing a seed with a hard coat (endocarp).

Emergent Strong-stemmed wetland plant that rises out of the water and stands unsupported.

Endocarp The innermost layer of the pericarp of a fruit.

Epiphyte A plant that grows on the surface of another plant without being parasitic; it obtains moisture and nutrients from the atmosphere without rooting into the soil.

Eudicotyledon A flowering plant with two seed leaves, or cotyledons. Most eudicots have leaves with branching veins and flowers usually divided into four parts.

Exocarp The outer layer of the pericarp of a fruit. The exocarp is often thin and hard, or like a skin.

False fruit The outer, edible flesh of a false fruit is not an ovary but the swollen end of a flower stalk.

Filament The stalk of a stamen that bears the anther.

Floret A small flower, usually one of many florets that make up a composite flower such as a daisy.

Flower The reproductive organ of a great many plant genera. Each flower consists of an axis which bears four types of reproductive organs: sepals, petals, stamens, and carpels.

Follicle A dry fruit, similar to a pod, that develops from a single-chambered ovary with one seam that splits open to release the seeds. Most follicles are aggregate fruits.

Frond 1. The leaf-like organ of a fern. Some ferns produce both barren and fertile fronds, the latter bearing spores. 2. Loosely applied to large, usually compound leaves such as those of palms.

Fruit The fertilized, ripe ovary of a plant containing one or more seeds, for example, berries, hips, capsules, and nuts. The term is also used of edible fruits.

Fungus A single-celled or multi-celled organism that is a member of the separate kingdom Fungi, for example, molds, yeasts, and mushrooms.

Funicle The tiny stalk inside a pod from which a seed hangs.

Genus (plural: genera) A category in plant classification ranked between family and species.

Germination The physical and chemical changes that take place when a seed starts to grow and develop into a plant.

Glabrous Smooth and hairless.

Gymnosperm A plant with seeds that develop without an ovary to enclose and protect them while they mature. Most gymnosperms are conifers, whose seeds form and mature within cones.

Haustoria Specialized parasitic roots that protrude into the tissues of a host plant.

Herbaceous A non-woody plant in which the upper parts die down to a rootstock at the end of the growing season. The term is chiefly applied to perennials, although botanically it also applies to annuals and biennials.

Hesperidium The fruit of a citrus plant with a thick, leathery rind, for example, a lemon or orange.

Heterophylly The presence of leaves of different shapes on one plant.

Indehiscent Describes a fruit that does not split open to release its seeds, such as a hazelnut.

Inflorescence A group of flowers borne on a single axis (stem), for example, a raceme, panicle, or cyme.

Involucre A ring of leaf-like bracts below a flower head.

Lamina A broad, flat structure, for example, the blade of a leaf.

Lateral A side growth that arises from a shoot or root.

Leaf Typically a thin, flat lamina (blade) growing out of a stem that is supported by a network of veins. Its main function is to collect the energy in sunlight to be used for photosynthesis.

Leaflet One of the subdivisions of a compound leaf.

Legume A dehiscent pod that splits along two sides to disperse ripe seed.

Lenticel A hole in the stem that allows gases to pass between the plant interior and the atmosphere.

Lignin A hard substance in all vascular plants that enables them to grow upright and remain standing.

Linear Very narrow leaves that have parallel sides.

Liverwort A simple, flowerless plant that lacks true roots. It has leaf-like stems or lobed leaves, reproduces by shedding spores, and is usually found in moist habitats.

Lobed Having curved or rounded parts.

Locule A compartment or chamber of an ovary or anther.

Margin The outer edge of a leaf.

Mesocarp The middle layer of the pericarp. In many fruits the mesocarp is the fleshy part of the fruit. In some pericarps the mesocarp is missing.

Midrib The primary, usually central, vein of a leaf.

Monocarpic Describes a plant that flowers and fruits only once before dying; such plants may take several years to reach flowering size.

Monocotyledon A flowering plant that has only one cotyledon, or seed leaf, in the seed; it is also characterized by narrow, parallel-veined leaves. Monocot examples include lilies, irises, and grasses.

Moss A small, green, flowerless plant that has no true roots and grows in damp habitats. It reproduces by shedding spores.

Mycorrhiza A symbiotic (mutually beneficial) relationship between a fungus and the roots of a plant.

Nectar A sweet, sugary liquid secreted by the nectary, it attracts insects and other pollinators to the flower.

Nectary A gland that secretes nectar. Nectaries are usually found in the flower of a plant, but are sometimes also found on the leaves or stems.

Node A point of a stem from which one or more leaves, shoots, branches, or flowers arise.

Nut A one-seeded, indehiscent fruit with a tough or woody coat, for example, an acorn. Less specifically, all fruits and seeds with woody or leathery coats.

Offset A small plant that develops from a shoot growing out of an axiliary bud on the parent plant.

Ovary The lower part of the carpel of a flower, containing one or more ovules; it may develop into a fruit after fertilization.

Ovule The part of the ovary that develops into the seed after pollination and fertilization.

Ovuliferous scales The scales of a female cone, which bear ovules that become seeds, once fertilized.

Bonnet cap
(Mycena capillaripes)

Passionflower
(*Passiflora* sp.)

Palmate A palmate leaf has lobed leaflets that arise from a single point.

Panicle A branched raceme.

Pedicel The stalk of a single flower in an inflorescence.

Pendent Hanging downward.

Pepo A many-seeded, hard-skinned berry that forms the fruit of *Cucurbita pepo*, for example, pumpkins, watermelons, and cucumbers.

Perennial A plant that lives for a number of years.

Perfoliate Stalkless leaves or bracts that grow opposite each other and extend at their bases to encircle the stem, so that the stem appears to pass through a single leaf blade.

Perianth The collective term for the calyx and corolla, particularly when they are very similar in form, as in many bulb flowers.

Pericarp The wall of a fruit that develops from the maturing ovary wall. In fleshy fruits the pericarp often has three distinct layers: exocarp, mesocarp, and endocarp. The pericarp of dry fruits is papery or feathery, but on fleshy fruits it is succulent and soft.

Petal A modified leaf, usually brightly colored and sometimes scented, that attracts pollinators. A ring of petals is called a corolla.

Petiole The stalk of a leaf.

Pinnate The arrangement of leaflets on opposite sides of the central stalk of a compound leaf.

Phloem The vascular tissue in plants that conducts sap containing nutrients (produced by photosynthesis) from the leaves to other parts of a plant.

Photosynthesis The process by which the energy in sunlight is trapped by green plants and used to carry out a chain of chemical reactions to create nutrients from carbon dioxide and water. A by-product is oxygen.

Pistil *See* carpel.

Plumule The first shoot that emerges from a seed on germination.

Pod A flattened dry fruit that develops from a single ovary with one chamber.

Pollen The small grains, formed in the anther of seed-bearing plants, which contain the male reproductive cells of the flower.

Pollination The transfer of pollen from anther to stigma of a flower.

Raceme A cluster of several or many separate flower heads borne singly on short stalks along a central stem, with the youngest flowers at the tip.

Radicle The root of a plant embryo. The radicle is normally the first organ to appear when a seed germinates.

Receptacle The enlarged or elongated tip of the stem from which all parts of a simple flower arise.

Recurved Arched backward.

Reflexed Bent completely backward.

Regma, (plural: regmata) A type of dry fruit consisting of three or more fused carpels that break apart explosively when mature.

Replum A partition in certain fruits.

Rhizome A creeping underground stem that acts as a storage organ and produces shoots at its apex and along its length.

Root The part of a plant, normally underground, that anchors it in the soil and through which water and nutrients are absorbed.

Root cap A hood-shaped cap at the root tip that continually produces new cells to protect the root from abrasion as it grows through the soil.

Root hair A thread-like growth that develops behind the root cap. Root hairs extend the surface area of a root and increase the amount of water and nutrients it can absorb.

Rosette A cluster of leaves radiating from approximately the same point, often at ground level at the base of a very short stem.

Runner A horizontally spreading, usually slender, stem that runs above ground and roots at the nodes to form new plants. Often confused with a stolon.

Sap The juice of a plant contained in the cells and vascular tissue.

Scale A reduced leaf, usually membranous, that covers and protects buds, bulbs, and catkins.

Schizocarp A papery, dry fruit, which breaks up into enclosed, single-seeded units that disperse separately when the seeds are ripe.

Seam (or suture) The edge of a pod where it breaks open.

Seed The ripened, fertilized ovule, containing a dormant embryo capable of developing into an adult plant.

Seedling A young plant that has developed from a seed.

Sepal The outer whorl of the perianth of a flower, usually small and green, but sometimes is colored and petal-like.

Septum A partition, such as a separating wall in a fruit.

Shoot A developed bud or young stem.

Simple fruit A fruit that forms from a single ovary. Examples are berries, drupes, and nuts.

Simple leaf A leaf that is formed in one piece.

Spadix A fleshy flower spike that bears numerous small flowers, usually sheathed by a spathe.

Spathe A bract that surrounds a single flower or a spadix.

Spike A long flower cluster with individual flowers borne on very short stalks or attached directly to the main stem.

Spore The minute, reproductive structure of flowerless plants, such as ferns, fungi, and mosses.

Spur 1. A hollow projection from a petal, which often produces nectar. 2. A short branch that bears a group of flower buds (such as those found on fruit trees).

Stamen The male reproductive part of a flower comprising the pollen-producing anther and usually its supporting filament or stalk.

Standard The upper petal in certain flowers in the pea family.

Stem The main axis of a plant, usually above ground, that supports structures such as branches, leaves, flowers, and fruit.

Stigma The female part of a flower that receives pollen before fertilization. The stigma is situated at the tip of the style.

Stipule A leafy outgrowth, often one of a pair.

Stolon A horizontally spreading or arching stem, usually above ground, that roots at its tip to produce a new plant. Often confused with a runner.

Stoma (plural: stomata) A microscopic pore in the surface of aerial parts of plants (leaves and stems), allowing transpiration to take place.

Style The stalk that connects the stigma to the ovary in flowers.

Submergent A plant that lives entirely underwater.

Succulent A drought-resistant plant with thick, fleshy leaves and/or stems adapted to store water. All cacti are succulents.

Sucker A new shoot that develops from the roots or the base of a plant and rises from below ground level.

Tap root The primary, downward-growing root of a plant.

Tendril A modified leaf, branch, or stem, usually filiform (long and slender) and capable of attaching itself to a support.

Tepal A single segment of a perianth that cannot be distinguished as either a sepal or a petal as in *Crocus* or *Lilium*.

Testa The hard, protective coating around a fertilized seed that prevents water from entering the seed until it is ready to germinate.

Thorn A modified stipule or simple outgrowth that forms a sharp, pointed-end.

Thyrse A compound inflorescence with numerous flowering stalks that branch in pairs from the main stem.

Trichome Any type of outgrowth from the surface tissue of a plant, such as a hair, scale, or prickle.

Trifolate Describes a compound leaf that has three leaflets growing from the same point.

Tuber A swollen, usually underground, organ derived from a stem or a root, used for food storage.

Umbel A flat or round-topped inflorescence in which the flower stalks grow from a single point at the top of a supporting stem.

Variegation Irregular arrangements of pigments, usually the result of either mutuation or disease, mainly in leaves.

Vascular bundle One of a number of strands of vascular tissue in the vein or stem of a leaf.

Vascular plant A plant containing food-conducting tissues (the phloem) and water-conducting tissues (the xylem).

Vein One of many lines—a vascular bundle—that can be seen on the surface of a leaf.

Velamen A water-absorbing tissue covering the aerial roots of certain plants, including many epiphytes.

Venation The arrangement of veins in a leaf.

Whorl An arrangement of three or more organs arising from the same point.

Winged fruit A fruit with fine, papery structures that are shaped like wings to help carry the fruits through the air.

Xylem The woody part of plants, consisting of supporting and water-conducting tissue.

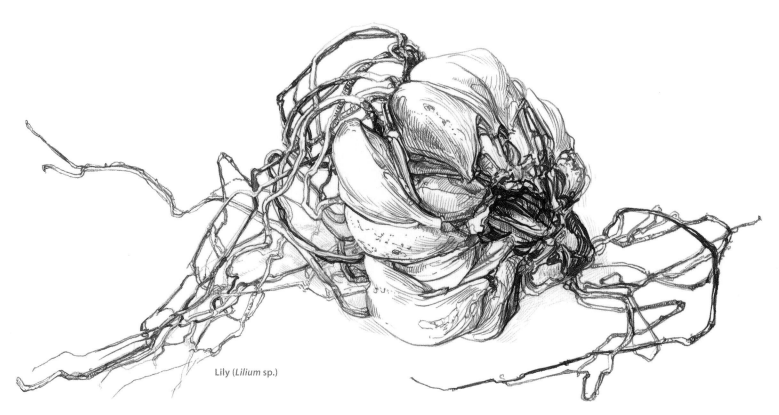

Lily (*Lilium* sp.)

Index

Page numbers in *italics* indicate a caption and its illustration; page numbers in roman indicate text only; page numbers in **bold** indicate a Study, Masterclass, or Drawing Class.

A

Abrus precatorius (jequirity seeds) *40*
Acacia (mimosa) 135
 A. nilotica (Nile acacia) *40*
 A. tortillis subsp. *heteracautha 219*
Acanthus 212
Acer (maple) 230, *230*
 A. palmatum (Japanese maple) *128*
 A. virginianum **232–3**
achenes 224–5
Achillea (yarrow) 133
 A. "Moonshine" *194*, 194
aconite, winter *see Eranthis hyemalis*
Aconitum napellus (monk's hood) *181*
acorns 150, 229
Adiantum pedatum (maidenhair fern) **156**
Aesculus hippocastanem (horse chestnut) *93, 182*, **216–17**
African lily *see Agapanthus*
Afzelia africana 40
Agapanthus (African lily) *174*
Agave 122
Agave americana (century plant) *212*, 212
Alchemilla mollis (lady's mantle) 133
alder *see Alnus glutinosa*
 Alexanders, perfoliate *see Smyrnium perfoliatum*
algae 44, 50–1, 57
 marine *114, 115*
 red *see Rhodophyta*
Alisma natans (floating water plantain) *114, 115*
Allium
 A. bulgarica (Bulgarian onion) 176, *177*
 A. sativum (garlic) *121*
almond, sweet *see Prunus dulcis*
Alnus glutinosa (black/common alder) *198*
Aloe vera 21
Alsobia dianthiflora (lace flower vine) *183*
Amanita muscaria (fly agaric) *52*
American smoke tree *see Cotinus obovatus*
amethyst deceiver *see Laccaria amethystea*
Amicia zygomeris 128
Ananas comosus (pineapple) **240–1**
Anemone
 A. blanda (windflower) **204–5**
 A. japonica 49
angel"s trumpet *see Brugmansia*

angiosperms 62, 64
Anisantha sterilis (barren brome) *94*
anther 165
Anthriscus sylvestris (cow parsley) *95*
Antirrhinum majus (snapdragon) *182*
apple *see Malus domesticus*
Arachis hypogaea (peanut) 135
Arbutus unedo (strawberry tree) *210*
Arctium lappa (great burdock) *224*
arils 150
Aristolochia (Dutchman's pipe) *183*
 A. gigantea **178–9**
 A. littoralis 177
 A. ringens 41, 214
 A. trilobata 137
Arkwright's campion *see Lychnis* x *arkrightii*
Arthropodium candidum (New Zealand rock lily) *136*
artichoke
 globe 203, *224*
 Jerusalem 203
arum, dragon *see Dracunculus vulgaris*
Arum dioscoridis **154–5**
ash, common *see Fraxinus excelsior*
Aspidosperma 40
Asplenium (spleenwort) *60, 61*
Astrantia major (great masterwort) 150, *153*
Athyrium niponicum (Japanes painted fern) *61*
Atlas cedar *see Cedrus atlantica*
avocado 70

B

balausta 238
 bald cypress *see Taxodium distichum*
balsam *see Impatiens tinctoria*
bamboo 67, 102, *102–3*
 ornamental *see* Phyllostachys viridi-glaucescens
banana *see Musa*
Banks, Joseph 22
Banksia **226–7**, 246
 B. serrata 48, 226
bark 98–9
barley, two-rowed *see Hordeum distichon*
barren brome *see Anisantha sterilis*
barrenwort *see Epimedium alpinum*
Bauer, Ferninand 154–5
beech, sea *see Delesseria sanguinea*
beet 74
bell mimosa *see Dichrostachys cinerea*
bellflower *see Campanula*
Bellis perennis (daisy) *200*, 200
berries 234
Bertholletia excelsa (brazil) *214, 215*
Besler, Basilius 17
Beta vulgaris see beetroot
Betula pendula (silver birch) *131*
birch *see Betula*
bird cherry *see Prunus padus*
birthwort *see Aristolochia*
Bituminaria bituminosa (pitch trefoil) 194, *195*
blackberry *see Rubus fruticosus*
bladderwrack *see Fucus vesiculosus*

bleeding heart *see Dicentra spectabilis*
bluchsing bracket *see Daedaleopsis confragosa*
bluebell 165
blueberry *see Vaccinium corymbosum*
Boletus edulis (porcini)) *52*
bonnet cap *see Mycena capillaripes*
Borago officinalis (borage) 122, *123*
botanic collections 17
bottlebrush *see Callistemon*
Brachystegia 40
bracket fungi 55
bracts 150–3
brake fern *see Pteris vittata*
bramble *see Rubus*
Brassica oleracea (kohlrabi) **118–19**
brazil nut *see Bertholletia excelsa*
Bremia lactucae (downy mildew) 25
bristlecone pine *see Pinus longaeva*
bristles 122
broad bean 77, **222–3**, *247*
Brugmansia (angel's trumpet) 165
Brunfels, Otto 15
brush strokes 102
brushes 33
bryony, black *see Tamus communis*
Buchan, Alexander 22
buck eyes *see Aesculus hippocastanum*
buds 130, 139
 opening **174–5**
 stem 92–3
 trees 30
bug on a stick *see Buxbaumia aphylla*
bulbils *121*, 121
bulbs 117
 roots 74
Bulgarian onion *see Allium bulgarica*
burdock, great *see Arctium lappa*
buttercup *see Ranunculus*
Buxbaumia aphylla (bug on a stick) *59*

C

cactus 123
 night-flowering *see Selenicereus grandiflorus*
Calceolaria 183
Calendula officinalis (pot marigold) 150, *153*
calfskin *12*
Calystegia sepium (columbine) *182*
calyx 165
cambium 98
Campanula (bellflower) *164*, 165, *181*, 182
campion
 Arkright"s *see Lychnis* x arkrightii
 fringed *see Silene fimbriata*
 white *see Silene latifolia*
candle-snuff fungus *see Xylaria hypoxylon*
cape figwort *see Phygelius capensis*
Cape gooseberry *see Physalis peruviana*
capitula 194, 200–1

capsules 215
Cardiocrinum giganteum (giant lily) *78, 79*, 215
cardoon *see Cynara cardunculus*
carnivorous plants 146–7
carpel 165
Carpinus betulus (hornbeam) *137*, 150, 150
Carrara Herbal *12*, 13
carrot family 228
caryopsis 228
Castanea sativa (sweet chestnut) *229*
Catalina ironwood *see Lyonothamnus floribundus*
Catalpa (Indian bean tree) *219*
Catesby, Mark 232–3
catkins 198
catmint *see Nepeta* sp.
cat's whiskers *see Tacca chantrieri*
cedro espina *see Pachira quinata*
Cedrus
 C. atlantica (Atlas cedar) *44*
 C. libani (cedar of Lebanon) *62, 63, 101*
century plant *see Agave americana*
Cephalaria alpina (yellow scabious) *203*
cereal crops 228
chain fern, giant *see Woodwardia fimbriata*
chalk 124
Chamaerops humilis (palm) *136*
chamomile 176, 203
cheese plant *see Monstera*
cherry *see Prunus*
 sweet *see Prunus avium*
 Tibetan *see Prunus serrula*
chestnut
 horse *see Aesculus hippocastanum*
 sweet *see Castanea sativa*
 water *see Trapa natans*
chicken-of-the-woods *see Laetiporus sulphureus*
Chinese trollius *see Trollius chinensis*
chitin 53
Chlorophytum comosum (spider plant) *108*
Chondrostereum (leather basket) 55
Chrysanthemum 102, *203*
Church, Arthur Harry 172–3
Citrullus lanatus (watermelon) **236–7**
Citrus limon (lemon) *238*
cladodes 121
classification of plants 48–9
Clematis 134
 C. tangutica (old man's beard) *225*
climbers 110–11
Clitocybe (funnel cap) *52*
clover *see Trifolium*
Cochlospermum 40
 C. tinctorium 210
cocksfoot *see Dactylis glomerata*
Codium tomentosus (velvet horn) *51*
Colletia paradoxa 120, 121
color
 building up *159*
 mixing 35, *35*
 preparation 119
 wheel *35*
columbine *see Calystegia sepium*
composition of pictures **104–5, 158–9**
cones 62, 150, *210*, **242–3**

conifers 62–3, 242
conker *see Aesculus hippocastanum*
Conocybe lactaea (milky cone-cap) *52*
contour lines *83*
contrast, creating *178*
Cook, James 22
copperplate engraving 16, 17
coral tree *see Erythrina crista-galli*
cork cells *18*, 18
cork oak *see Quercus suber*
corms 117
corn *see Zea mays*
corolla 165
Corona imperialis polyanthos see crown imperial
Corsican violet *see Viola corsica*
Corylus avellana (hazel) *131*
 nuts 150, *153*
corymbs *187*
Costa Rica nightshade *see Solanum wendlandii*
Cotinus obovatus (smoke bush) *128*
cotton thistle *see Onopordium acanthium*
cotyledon 67
Coulter's pine *see Pinus coulteri*
cow parsley *see Anthriscus sylvestris*
cranesbill *see Geranium*
Crassula (stonecrop) *131*
Crataegus monogyna (hawthorn) **82–3**
cremocarps 228
Crinum 164, 165
Crocosmia (montbretia) *116*, 165
 C. "Lucifer" *171*
Crocus 31, 84
crosiers, fern **156–7**
cross-pollination 168
cross sections **170–1**
crown imperial 16
cucumber 235
Cucurbita pepo (ornamental gourd) *137*
cupules 150, *153*
cycads 62
Cyclamen 130, *131*
cylinders, drawing **82–3**
cymes *187*, 188–9
Cynara cardunculus (cardoon) 150, *153, 202*, 203
cypress, bald *see Taxodium distichum*

D

da Vinci, Leonardo 124–5
Dactylis glomerata (cocksfoot) *94*
Daedaleopsis confragosa (blushing bracket) *54*
daffodil *see Narcissus*
Dahlia 116
daisy *see Bellis perennis*
dandelion *see Taraxacum*
Darwin, Charles 64
date *235, 246*
Daucus carota (wild carrot) 74, *194*, 194
De Historia Stirpium Commentarii Insignes 15
dead man's fingers *see Xylaria polymorpha*

dead-nettle, spotted *see Lamium maculatum*
Delesseria sanguinea (sea beech) *44*
Detarium senegalense (tallow tree) *41*
devil's claw *see Harpagophytum procumbens; Proboscidea*
Dianthus (pink) 174, *174*
Dicentra spectabilis (bleeding heart) *177*
Dichrostachys cinerea (bell mimosa) *219*
Dicksonia antarctica (tree fern) *44*, **156**
dicot *68*
digital art 27, *27*
Digitalis (foxglove) *166*
 D. purpurea (common foxglove) *177*, *190*, 191
Dillenius, Johann Jakob 57
Dionaea muscipula (Venus flytrap) *128*, 146
Dioscorea elephantipes (elephant's foot) *142–3*
Dipsacus fullonum (common teasel) *202*, 203
dipterocarps 230, *231*, 246
Dipterocarpus
 D. applanatus 231
 D. lowii 231
dispersal 210, 212–13
distance and space *104*
diversity 44–71
dock, broad-leaved *see Rumex obtusifolius*
Doryanthes palmeri (spear lily) **206–7**
Douglas, David 244
Douglas fir *see Pseudotsuga menziesii*
dove's foot cranesbill *see Geranium molle*
Dracunculus vulgaris (dragon arum) 198, *199*
dragon arum *see Dracunculus vulgaris*
drawing advice 28–43
drawing boards 32
Drosera (sundew) 146
 D. rotundifolia (round-leaved sundew) 122, *123*
drupes 235
Dryopteris (wood fern) *60*
 D. affinis (scaly male fern) *61*, **157**
 D. cycadina (common shaggy wood fern) **156–7**
Dürer, Albrecht 15, 70
Dutchman's pipe *see Aristolochia*

E

earthballs, common *see Scleroderma citrinum*
Echinacea 203
Echinops ritro (globe thistle) *202*, 203
Ehret, Georg Dionysius 20, *20*, 128
elephant's foot *see Dioscorea elephantipes*
elf cup *see Sarcoscypha austriaca*
ellipses, drawing *36*, *204*
emergents 114
endocarp 215
Entada africana 220

Entandrophragma (sapele) *41*
Enterolobium cyclocarpum 219
epigeal germination 246, *246*
Epimedium alpinum (barrenwort) *174*, 174
epiphytes 80
Equisetum telmateia (great horsetail) *61*
Eranthis hyemalis (winter aconite) *182*
erasers *32*
Erodium 229
Eryngium 44, 88
Erythrina crista-galli (coral tree) *182*
Eucalyptus 131
eudicot 68–9, 136, 246
euglena 50
Eupatorium maculatum "Purple Bush" (Joe Pye weed) 194, *195*
Euphorbia (wood spurge) 150, *153*
Eurhychnium 59
Eustona grandiflorum (prairie gentian) 174
everlasting pea *see Lathyrus*
exercise drawings 82
exocarp 215

F

Fagus sylvatica (beech) *93*, 150, *153*
false sow thistle *see Reichardia tingitana*
family names 48
feathers *33*
fern 60–1
 brake *see Pteris vittata*
 common shaggy wood *see Dryopteris cycadina*
 crosiers **156–7**
 giant chain *see Woodwardia fimbriata*
 Japanese painted *see Athyrium niponicum*
 scaly male *see Dryopteris affinis*
 wood *see Dryopteris*
Ficus carica (strangler fig) 74, 238, *239*, 240
figwort, cape *see Phygelius capensis*
filament 165
fins 120
fir, Douglas *see Pseudotsuga menziesii*
fir apple potato *see Solanum tuberosum*
flame tree *see Spathodea campanulata*
florilegia 17
flowers 160–207
 anatomy 164–9
 branching 186–7
 capitula 200–3
 cross sections **170–1**
 cymes 188–9
 form 180–3
 heads 194–5
 opening buds **174–5**
 parts *64*
 racemes 190–1
 spikes, catkins and spathes 198–9
 symmetry 176–7
 wild **192–3**
fly agaric *see Amanita muscaria*
focus, controlling *97*, *178*

follicles 221
fossil plants *10*, 10
foxglove *see Digitalis*
Fragaria 109
 F. vesca (wild strawberry) *224*
Fraxinus excelsior (common ash) *92*
fresh plants, keeping 30
fridge storage of plants 30
fringed campion *see Silene fimbriata*
Fritillaria thunbergii (fritillary) **106–7**
fronds 60, *61*
fruits 208–47
 capsules 215
 classification 212
 composite 240
 diversity 238–9
 fleshy 234–7
 herbarium **220–1**
 irregular 234
 simple 218
 small dry 228–9
 stone 235
 winged 230–3
fruits, keeping fresh 30
Fuchs, Leonard 15
Fuchsia 166, *166*, *181*, 182
Fucus 50
 F. vesiculosus (bladderwrack) 50, *51*
Funaria hygrometrica 44
fungi 52–5, 57 *see also* mushroom; toadstool
funicles 218
funnel cap *see Clitocybe*
Furneaux, Sera 27

G

Galanthus nivalis (snowdrop) 66, *90*, *138*, 165, *183*
Galium aparine (sticky weed) *138*
garlic 121
Garzoni, Giovanna 222
genera names 48
gentian *20*
 prairie *see Eustona grandiflorum*
 willow *see Gentiana asclepiadea*
Gentiana asclepiadea (willow gentian) *182*
Geranium 228
 G. molle (dove's foot cranesbill) 192, *192*
 G. phaeum (mourning widow geranium) **172–3**
 G. pyrenaicum 64
 G. x "Rozanne" (hybrid cranesbill) **158–9**
germander, tree *see Teucrium fruticans*
germination 246–7
Ginkgo biloba 62, *130*, 136, *137*
Gladiolus 116
glass models 25
Glaucium flavum (yellow-horned poppy) *133*
Glechoma hederacea (ground ivy) 131
Gleditsia triacanthos (honey locust) *120*, 121
Gliricidia 218
globe artichoke 203
globe thistle *see Echinops ritro*
Gloriosa superba (glory lily) *181*
glory lily *see Gloriosa superba*

gnetophytes 62
gooseberry, Cape *see Physalis peruviana*
gorse 212
gouache *12*, 154, 172, 232
gourd *see Cucurbita pepo*
grape 235
 summer *see Vitis aestivalis*
grasses 67, **70**
 blue-eyed *see Sisyrinchium bellum*
 wild 94
"ground" 70
ground ivy *see Glechoma hederacea*
gymnosperms 62, 64, 246

H

hairs 122–3
Handkea excipuliformis (pestle-shaped puffball) *see Handkea excipuliformis*
Harpagophytum procumbens (devil's claw) *41*
haustoria 80
hawthorn *see Crataegus monogyna*
hazel *see Corylus avellana*
Hedera helix (ivy) 111, *138*
hedge woundwort *see Stachys sylvatica*
Helianthus annuus (sunflower) *19*, 200, 200–1, 203, 246
Heliconia stricta 162
Helleborus
 H. foetidus (stinking hellebore) *135*
 H. x *hybrida* 68, *69*
 H. orientalis 74
Heracleum sphondylium (hogweed) *95*, 176, 228
herbaceous plants 90
herbals 10, 13
herbarium 41
herbarium fruits **220–1**
Herbarium Vivae Elcones 15
hesperidium 238
heterophylly 148–9
highlights 216
Hippeastrum **196–7**
Historia Muscorum 57
HMS Endeavour 22, *22*
hogweed *see Heracleum sphondylium*
holly *see Ilex aquifolium*
honesty *see Lunaria annua*
honey locust *see Gleditsia triacanthos*
honeysuckle *see Lonicera*
Hooke, Robert 18
hooks 111
Hordeum distichon (two-rowed barley) 67
hornbeam *see Carpinus betulus*
horse chestnut *see Aesculus hippocastanum*
horsetail 60–1
 great *see Equisetum telmateia*
Hortus Eystettensis 17
houseleek *see Sempervivum tectorum*
Hungarian clover *see Trifolium pannonicum*
hyacinth, summer *see Ornithogalum candicans*
Hyacinthus 78, 79

hyphae 53
Hypnum triquetrum (feather moss) 59
hypogeal germination 246, *247*

I

Iceland poppy *see Papaver naudicaule*
Ilex aquifolium (holly) *133*
Impatiens tinctoria (balsam) *183*
Indian bean tree *see Catalpa*
Indigofera 134, *135*
inflorescences *187*
ink 33, 38
 layers 34
inspiration sources 40–1
Ipomoea tricolor 170
Iris 24–5, 117
 I. reticulata 66
 I. ruthenica (beardless iris) *188*, 188
ironwood, Catalina *see Lyonothamnus floribundus*
Italian ryegrass *see Lolium multiflorum*
ivy, ground *see Glechoma hederacea*

J

jade vine *see Strongylodon macrobotrys*
Japanese art 24–5
Japanese maple *see Acer palmatum*
Japanese painted fern *see Athyrium niponicum*
Japanese weigela *see Weigela japonica*
jelly bracket *see Phlebia tremellosia*
jequirity seeds *see Abrus precatorius*
Jerusalem artichoke 203
Joe Pye weed *see Eupatorium maculatum*
Johnson Papyrus *11*, 13
Juncus effusus (soft rush) 95
juniper 62, 242

K

keel 168
keeping cut plants fresh 30
kohlrabi **118–19**
Korin, Ogata 24

L

Laburnum 88, 218
Laburnum anagyroides 190, 191, *191*
Laccaria amethystea (amethyst deceiver) 52, *53*
lace flower vine *see Alsobia dianthiflora*
lady's mantle *see Alchemilla mollis*
Laetiporus sulphureus (chicken-of-the-woods) 55
Lamium maculatum (spotted dead-nettle) *190*, 191
lancewood *see Pseudopanax crassifolius*
landscape framing *104*
larch *see Larix*

Larix (larch) *138*
 L. decidua (European larch)
 62, 62
Lathyrus
 L. grandiflorus (everlasting pea)
 168, *169, 181*
 L. latifolius (everlasting pea) *134*
 L. setifolius (narrow-leaved red
 vetchling) *110, 111, 177*
leader 92
leaf axil 92, 130
leaflets 134
 leather basket *see*
 Chondrostereum
leaves 126–59
 arrangements *138–9*
 autumn *42–3*, **158–9**
 compound 134–5
 in perspective *142–3*
 prayers on *26, 26*
 simple 130–1
 tendrils 111
 variety *128–9*
 veins 128, *136–7*
legumes 218–23
lemon *see Citrus limon*
lenticels 98
lettuce
 sea *see Ulva lactuca*
 water *see Pistia stratiotes*
liana vine *see Oncinotis pontyi* ;
 Sabia paniculata
lichens 56–7
light effects *105*, 124
lignin 60
lilac *see Syringa*
Lilium **42–3**, *117*
 L. martagon (Turk's cap lily) *181*
lily
 African *see Agapanthus*
 giant *see Cardiocrinum*
 giganteum
 glory *see Gloriosa superba*
 New Zealand rock *see*
 Arthropodium candidum
 spear *see Doryanthes palmeri*
 Turk's cap *see Lilium martago*
linden, *see Tilia europaea*
lines, drawing *34, 34*, 38, *38–9*
Linnaeus, Carl 20, 48
Liriodendron tulipifera (tulip tree)
 68, *131*
Lithocarpus
 L. densiflorus (tanbark oak) *229*
 L. lucidus 229
liverwort 58–9
 thalloid *see Marchantia*
 polymorpha
Loasa triphylla (rock nettle) *174, 174*
Lolium multiflorum (Italian
 ryegrass) *94*
London plane *see Platanus* x
 hispanica
Lonicera (honeysuckle) *37*
 L. periclymenum 68, 194, *195*
lotus *see Nelumbo nucifera*
Lotus tetragonolobus (winged
 pea) *168*
Lunaria annua (honesty) *183*,
 212, *212*
Lychnis x *arkrightii* "Vesuvius"
 (Arkright's campion) *171, 176, 177*
Lycianthes rantonnetii (blue potato
 bush) *186, 186*

Lycoperdon perlatum (common
 puffball) *see Lycoperdon perlatum*
Lyonothamnus floribundus (Catalina
 ironwood) *99*

M

magnolids 68
mahogany *see Swetenia*
 macrophylla
maidenhair fern *see Adiantum*
 pedatum
male fern, scaly *see Dryopteris affinis*
Malus domesticus (apple) 238, *239*
Malva 228, *229*
mangrove, red *see Rhizophora*
 mangle
maple, red *see Acer virginianum*
Marchantia polymorpha (thalloid
 liverwort) *58*
marigold, pot *see Calendula*
 officinalis
marks, making *34, 34*, 38, *38–9*
Marshall, Alexander 18
Martinez, Felix 44
masterwort, great *see Astrantia*
 major
materials needed 32–3
Mediterranean milk thistle *see*
 Silybum marianum
melic, Siberian *see Melica altissima*
Melica altissima "Atropurpurea"
 (Siberian melic) *67*
melon 235 *see also Citrullus*
Mentha (mint) *138*
Merian, Maria Sibylla 240–1
Merremia umbellata (morning
 glory) *88*
mesocarp 215, 235
Meyer, Albrecht 15
Micrographia 18
mildew, downy *25*
milkcap toadstool *31*
milky cone-cap *see Conocybe*
 lactaea
Miller, John 112–13
mimosa, bell *see Dichrostachys*
 cinerea
mint *see Mentha*
mistletoe *see Viscum album*
Mnium spinosum (calcareous
 moss) *59*
mock orange *see Philadelphus*
 coronarius
Moir, Mali 206–7
monkey cup *see N. maxima* x *mixta*
monk's hood *see Aconitum napellus*
monocot 66–7, *68*, 136, *142–3*,
 165, 246
Monstera (cheese plant) *79, 79*, 111
Montes africanus 230
morning glory *see Ipomoea tricolor;*
 Merremia umbellata
moss 44, 58–9
 calcareous *see Mnium spinosum*
 feather *see Hypnum triquetrum*
 hair *see Polytrichum commune*
mourning widow geranium *see*
 Geranium phaeum
Muelenbeckia astonii (shrubby
 tororaro) *131*
Musa (banana) 235, *235*
mushrooms *31*

mustard *see Sinapis*
Mycena capillaripes (bonnet cap) *52*

N

naiad, holly-leaved *see Najas*
 marina
Najas marina (holly-leaved naiad)
 115
Narcissus (daffodil) *31*
nasturtium *see Tropaeolum*
nectar 168
nectar guides 168
nectary 166
needles 128, *140–1*
negative space *82, 97*
Nelumbo nucifera (lotus) *210*
Nepenthes 146, *146*
 N. ampullaria 147
 N. khasiana 147
 N. maxima x *mixta* (monkey cup)
 147
 N. spectabilis 147
Nepeta sp. (catmint) *174*
nettle 123
 rock *see Loasa triphylla*
 stinging *see Urtica dioica*
New Zealand rock lily *see*
 Arthropodium candidum
nightshade
 Costa Rica *see Solanum*
 wendlandii
 woody *see Solanum dulcamara*
Nile acacia *see Acacia nilotica*
nutmeg 68
nuts *214, 215*, 228, *229*
Nymphaea (water lily) 130 *see*
 Liriodendron tulipifera

O

oak
 cork *see Quercus suber*
 tanbark *see Lithocarpus densiflorus*
offsets 108, *109*
oil paint 84
old man's beard *see Clematis*
 tangutica
olive *144–5*
Oncinotis pontyi (liana vine) *98*
onion, Bulgarian *see Allium*
 bulgarica
Onopordium acanthium (cotton
 thistle) *120*
orchid 80, 102
 moth *see Phalaenopsis*
 slipper *see Paphiopedium* sp.
Oryza sativa (rice) *67*
ovary 165
ovule 165
Oxalis (wood sorrel) 134, *134*
 O. acetosella 109

P

Pachira quinata (cedro espina) *41*
Palestine oak *see Quercus*
 calliprinos
palm 67 *see also Chamaerops*
 humilis
Papaver (poppy) *210*

P. dubium (long-headed poppy) *95*
P. naudicaule (Iceland poppy) *88*
P. rhoeas (common/corn poppy)
 94, 212, *212*
Paphiopedium sp. (slipper orchid)
 162, 176, *176*
papyrus *11*
parasitic plants 80
Parkinson, Sydney 22
Passiflora caerulea (passionflower)
 112–13, *121, 133*, 148, *176*
passionflower *see Passiflora*
 caerulea
pawpaw 235
pea
 everlasting *see Lathyrus*
 grandiflorus
 winged *see Lotus tetragonolobus*
peanut *see Arachis hypogaea*
pelican flower *see Aristolochia*
pencils *32, 33*, 38
pens *33*
Penstemon, *P.* "Sour Grapes" *180*
pepo 235
perennials 90
perspective. changing *142*
petal 165
petiole 130
Phalaenopsis (moth orchid) 80
Philadelphus microphyllus (mock
 orange) *162*
Phlebia tremellosia (jelly bracket) *55*
Phleum pratense (Timothy grass)
 94, 95
phloem 98
photosynthesis 77, 80, 128, 136
Phygelius capensis (cape figwort) *174*
Phyllostachys viridi-glaucescens
 (ornamental bamboo) *88*
Physalis peruviana (Cape
 gooseberry) *235, 235*
pigments 84
Pilosocereus royenii (Royen's tree
 cactus) *88*
pine
 bristlecone *see Pinus longaeva*
 European black *see Pinus nigra*
 long leaf *see Pinus palustris Miller*
pineapple *see Ananas comosus*
Pini, Gerolamo **84–5**
pink *see Dianthus*
Pinus (pine) *49*, **140–1**, 242
 cones 150, *210*, **242–3**
 needles *140–1*
 P. coulteri (Coulter's pine) **242**
 P. lambertiana (sugar pine) **244–5**
 P. longaeva (bristlecone pine) 62
 P. maximartinezii 210, **243**
 P. nigra (European black pine) *88*
 P. palustris Miller (long leaf
 pine) *128*
 P. sylvestris (Scots pine) **96–7**
pipe weed *see Aristolochia*
Pisanello, Antonio *13*, 13
Pistia stratiotes (water lettuce) *109*
pistil 166
pitch trefoil *see Bituminaria*
 bituminosa
pitcher plants 146–7
 see also Sarracenia
plane, London *see Platanus* x
 hispanica
plant classification 48–9
plant diversity 44

plant evolution 44
Plantago media (hoary plantain) *198*
plantain
 floating water *see Alisma natans*
 hoary *see Plantago media*
plastic bags/boxes, keeping plants
 in 30, *31*
Platanus x *hispanica* (London
 plane) *99*
plates 112
plum blossom 102, *102–3*
pods 218–23
pollen 165
pollination 168, 180–1
Polygonatum latifolium (Solomon's
 seal) *15*
Polytrichum commune (hair moss) *59*
pomegranate *see Punica granatum*
poppy
 common/corn *see Papaver rhoeas*
 long-headed *see Papaver dubium*
 yellow-horned *see Glaucium*
 flavum
Populus latior 10
porcini (cep) *see Boletus edulis*
positioning yourself *96*
potato, fir apple *116*
potato bush, blue *see Lycianthes*
 rantonnetii
Potentilla 164, 165
 P. atrosanguinea 162
 Leaf 134, *135*
prairie gentian *see Eustona*
 grandiflorum
prayer leaves *26, 26*
preparatory drawings 36–7
prickles 121, *122*
Proboscidea (devil's claw) *219*
proportions *96*
Protea sp. *162*
Prunus
 P. avium (sweet cherry) *234, 235*
 P. dulcis (sweet almond) *69*
 P. padus (bird cherry) *210*
 P. serrula (Tibetan cherry) *99*
pseudobulbs 80
Pseudopanax crassifolius
 (lancewood) *133*
Pseudotsuga menziesii (Douglas fir)
 150, 150
Pteris vittata (brake fern) *137*
puffball
 common *see Lycoperdon perlatum*
 pestle-shaped *see Handkea*
 excipuliformis
Pulsatilla 14
Punica granatum (pomegranate)
 238, 238

Q

Quercus (oak) *101, 133*
 acorns 150
 buds *30*
 Q. calliprinos (Palestine oak) *229*
 Q. robur 93, 153
 Q. suber (cork oak) *99*

R

racemes *187*, 190–1
Ranunculus

R. aquatilis (water buttercup) *148*
R. bulbosus (bulbous buttercup) *6*
R. flammula (lesser spearwort) *114*
raspberry *see Rubus idaeus*
Ray, John 68
receptacle 165
regmata 228, 229
Reichardia tingitana (false sow thistle) *177*
replum 220
Rhipsalis crispata (cactus) *78, 79*
rhizoids 58
rhizomes 60, 117
Rhizophora mangle (red mangrove) *74*
Rhodophyta (red algae) *115*
rhubarb 88
rhythm and form *97*
rice *see Oryza sativa*
ringworm senna *see Senna alata*
rock nettle *see Loasa triphylla*
roots 72–85
 aerial 80
 climbers 111
 how they work 76–7
 keeping moist 31
 parasitic 80–1
 spreading 78–9
 trees **82–3**
Rosa (rose) 121, 122, *122*
 hips *36–7,* 238, *239*
 R. "Roseraie de l"Haÿ" *170*
rosettes *139*
Rosmarinus officanalis (rosemary) *131*
rough drawings 82
Roxburgh, William 81
Royen's tree cactus *see Pilosocereus royenii*
Rubus
 R. fruticosus (blackberry) **124–5**, 192, *193,* 234, 235
 R. idaeus (raspberry) 234, 235
 R. uva-crispa (gooseberry) 234, 235
Rumex obtusifolius (broad-leaved dock) *95*
runners 108–9
rush, soft *see Juncus effusus*
Ruskin, John 144–5

S

Sabia paniculata (liana vine) *98*
sage *see Salvia*
Salvia officinalis (sage) *31*
samaras, double 230, 232
sanguine 124
sapele *see Entandrophragma*
Sarcoscypha austriaca (elf cup) *54*
Sarracenia 146
 S. purpurea (pitcher plant) *181*
 S. rubra (sweet pitcher plant) *146*
 scabious, yellow *see Cephalaria alpina*
scalpel *32*
schizocarps 228, 229
Scleroderma citrinum (common earthballs) *55*
Scots pine *see Pinus sylvestris*
sea beech *see Delesseria sanguinea*
sea lettuce *see Ulva lactuca*
seaweed 50
seeds 208–47
 development 215

dispersal 210, 212
 germination 246–7
Selenicereus grandiflorus (night-flowering cactus) *162*
self-pollination 168
Sempervivum tectorum (houseleek) *78, 139*
Senna alata (ringworm senna) *40*
sepal 165
Serapias (orchid) *183*
Serapion the Younger 13
sharpeners *32*
shininess 216
Shorea macrophylla 231
shrubs 90
Siberian melic *see Melica altissima*
Sibthorp, John 154
Silene
 S. fimbriata (fringed campion) *174*
 S. latifolia (white campion) 188,*189*
silver birch *see Betula pendula*
Silybum marianum (Mediterranean milk thistle) *224*
Sinapis (mustard) *77,* 246
Sisyrinchium bellum (blue-eyed grass) *181*
size contrasts *104*
sketch books 36
skin surfaces 122–3
slipper orchid *see Paphiopedium* sp.
smoke tree, American *see Cotinus obovatus*
Smyrnium perfoliatum (perfoliate Alexanders) *128, 131, 139*
snapdragon *see Antirrhinum majus*
snowdrop *see Galanthus nivalis*
Solander, Daniel 22
Solanum
 S. dulcamara (woody nightshade) *186,* 186
 S. lycopersicum (tomato) *134,* 134
 S. tuberosum (fir apple potato) *116*
 S. wendlandii (Costa Rica nightshade) *186,* 186
Solomon's seal *see Polygonatum latifolium*
Sonchus oleraceus (common sow thistle) *133,* 188, *189*
 sorrel, wood *see Oxalis*
sow thistle
 common *see Sonchus oleraceus*
 false *see Reichardia tingitana*
spathes 198
Spathodea campanulata (flame tree) *40*
spear lily *see Doryanthes palmeri*
spearwort, lesser *see Ranunculus flammula*
species names 48
spider plant *see Chlorophytum comosum*
spikes 198
spines 122
spleenwort *see Asplenium*
sporangia *60,* 60
spores 58
spur 166
Stachys
 S. byzantina 122–3, *123*
 S. sylvatica (hedge woundwort) 192, *192, 193*
stamen 165
standard 168
stem buds 92–3

stems 86–125
 modified 120–1
 runners 108–9
 strong 90–1
 tendrils 111, 112
 underground storage 116–17
 wild **94–5**
Stercula oblonga 221
sticky weed *see Galium aparine*
stigma 165
stinging nettle *see Urtica dioica*
stinking hellebore, see *Helleborus foetidus 135*
stolons 108, *109*
stomata 128
stonecrop *see Crassula*
storksbill *see Erodium*
strawberry 225
 wild *see Fragaria vesca*
strawberry tree *see Arbutus unedo*
Strongylodon macrobotrys (jade vine) *177*
style 165
stylus 70
submergents 114
succulents 136
suckers 108
sugar pine *see Pinus lambertiana*
sundew *see Drosera*
sunflower *see Helianthus annuus*
sweet chestnut *see Castanea sativa*
sweet peppers 235
Swetenia macrophylla (mahogany) *38–9*
symmetry in flowers 176–7
Syringa vulgaris (lilac) 194, *195*

T

Tacca chantrieri (cat's whiskers) 150, *150*
Tales of Ise 24
tallow tree *see Detarium senegalense*
Tamus communis (black bryony) *111, 136, 137*
tanbark oak *see Lithocarpus densiflorus*
tap roots 74, *76,* 77
Taraxacum (dandelion) *76,* 200, *200,* 210, *225*
Taxodium distichum (bald cypress) *74*
Taxus (yew) 62
teasel, common *see Dipsacus fullonum*
tempera 84
tendrils 111, *112–13, 121*
tepal 67, 165
Teucrium fruticans (tree germander) 168, *168, 183*
texture, creating *97, 205, 217*
thistle 123, 225
 common sow *see Sonchus oleraceus*
 cotton *see Onopordium acanthium*
 false sow *see Reichardia tingitana*
 globe *see Echinops ritro*
 Mediterranean milk *see Silybum marianum*
thorns *120,* 121
thyrse 195

Tibetan cherry *see Prunus serrula*
Tilia europaea (European linden) *90, 93, 148, 153*
Timothy grass *see Phleum pratense*
toadstool 53
 milkcap 31
tomatoes *134,* 134, 235
tomoraro, shrubby *see Muelenbeckia astonii*
tones, adding *97, 143, 159, 217, 236, 245*
Tordylium 228
Trapa natans (water chestnut) 80, *81*
tree fern 60
 see also Dicksonia
tree germander *see Teucrium fruticans*
trees **82–3, 100–1**
 bark 98–9
 buds 30
 composition of pictures *104–5*
 roots **82–3**
trefoil, pitch *see Bituminaria bituminosa*
Trifolium (clover; four-leaf clover) *135*
 T. pannonicum (Hungarian clover) *135*
Triticum aestivum (wheat) *198*
Trollius chinensis (Chinese trollius) *183,* 188, *189*
Tropaeolum majus (nasturtium) *166, 167*
tubers 117
Tulbaghia 194, 195
tulip mania 17
tulip tree *see Liriodendron tulipifera*
Tulipa (tulip) **184–5**
Turk's cap lily *see Lilium martagon*
Turpin, Pierre Jean François 65
tweezers *32*

U

Ulva lactuca (sea lettuce) *51*
umbels *187,* 194–5
Urtica dioica (stinging nettle) *191,* 191

V

Vaccinium corymbosum (blueberry) *234,* 235
Vanda (orchid) *74*
veins 60, 128, 136–7
velamen 80
vellum *12,* 222
velvet horn *see Codium tomentosus*
Venus flytrap *see Dionaea muscipula*
vetch, common *see Vicia sativa*
vetchling, narrow-leaved red *see Lathyrus setifolius*
Vicia
 V. faba see broad bean
 V. sativa (common vetch) *110*
vine
 jade *see Strongylodon macrobotrys*
 lace flower *see Alsobia dianthiflora*
 liana *98 see Vitis*
Viola corsica (Corsican violet) *170, 177*
Viscum album (mistletoe) 80, *131*

Vitis aestivalis (summer grape) *133*
volume creation *83*
von Goethe, Johann 65
von Jacquin, Nikolaus 42–3

W

warblers **232–3**
washes 70, *158*
water buttercup *see Ranunculus aquatilis*
water chestnut *see Trapa natans*
water lettuce *see Pistia stratiotes*
water lily 44 *see also Nymphaea*
watercolors *33,* 70, 144, *158*
watermelon *see Citrullus lanatus*
Weiditz, Hans *14,* 15
Weigela japonica (Japanese weigela) 130
welwitschia 62
Weston, Dr. Dillon 25
wetland plants 114–15
wheat 198
wild flowers **192–3**
willow bottlebrush *see Callistemon salignus*
willow gentian *see Gentiana asclepiadea*
windflower *see Anemone blanda*
winged pea *see Lotus tetragonolobus*
wings 168
winter aconite *see Eranthis hyemalis*
wood sorrel *see Oxalis acetosella*
wood spurge *see Euphorbia*
Woodwardia fimbriata (giant chain fern) *61*
woody nightshade *see Solanum dulcamara*
woundwort, hedge *see Stachys sylvatica*
wrack *see Fucus*

X

Xylaria
 X. hypoxylon (candle-snuff fungus) *54*
 X. polymorpha (dead man's fingers) *54*
xylem 98

Y

yams 142–3
yarrow *see Achillea*
yellow-horned poppy *see Glaucium flavum*
yew 150, 242
Yukinobu, Kano **102–3**

Z

Zea mays (corn) 44, 228

Acknowledgments

Author's acknowledgments

Many people have helped to create this book by freely giving their time and knowledge, expertise and practical help, criticism and unfailing support, and not least countless cuttings from their precious plants. I would especially like to thank:

Mamoru and Ruriko Abe, Hiroshi Abe and Miho Tanaka, Madi Acharya-Baskerville, Amanda Ahmed, Louise Allen, Ken Arnold, Pete Atkinson, Ann Baggaley, Dionne Barber, Lucy Baxandall, Malcolm Beasley, Diana Bell, Roddy Bell, Aliki Braine, Caroline Broadhurst, Paul Bonaventura, Audrey Butler, Vahni Capildeo, Oscar Carbonell Royol, Brian, Jack, Finn and Flossie Catling, Mark Cavanagh, Dorothy and Jog Chahal, Michele Clarke, Ralph and Sue Cobham, Nicola and Jason Connelly, Louie Crooks, Louise Dick, Alice Doi, Jackie Douglas, Helen Dudley, Caroline Durre, Richard East, Martha Evatt, Michael Fisher, Alison Foster, Juliet Franks, Tamsin Fraser, Lili Friend, Sera Furneaux, Oona Grimes and Tony Grisoni, Donna and Tom Han, Stephen Harris, Ken and Claire-Louise Hatton, Megan Hill, Rebecca Hind, Rob Hotchen, Karen Hosack, John Hunnex, Kurt Johannessen and Torill Nost, Christine Keilty, Clare Kelly, Nick Kent, James Kilvington, Simon Lewis, Edith Lombard, Serena Marner, Jonathan Metcalf, Mali Moir, Eka Morgan, Janet Nelson and Graham Halls, Liz Neville, Henry Noltie, Kirsten Norrie, Gary Ombler, Ria Osborne, Julie Oughton, Victoria Papworth, Valerie Parslow, Tess Perrin, Clare Pollard, Matthew Potter, Tom Price, Kate Pritchard, Ali Quantrell, James Rees, Matthew Reynolds, Matthew Robbins, John Roome, Sam Scott-Hunter, Rosemary Scoular, Chris Simblet and Mom, Luke Skiffington, the Slingsby family, Kenneth Smith, Sarah Smithies, Silke Spingies, Jo Stannard, Helen Statham, Susannah Steel, James Thompson, Sophie Torrance, Anne Marie Townsend, Timothy Walker, Bryn Walls, John Walter, Fiona Wild, Angela Wilkes, Kathryn Wilkinson, Sarah-Louise Wilkinson, Kit Wise, Matthew Wood, and Lorna Woolhouse.

I also wish to acknowledge the immense support that I have received from:
The Ruskin School of Drawing and Fine Art, University of Oxford
The University of Oxford Botanic Garden
Oxford University Herbaria, Department of Plant Sciences
The Gardens of New College, Oxford
Magdalen Road Studios, Oxford
The General Herbarium of the Natural History Museum, London
The Department of Fine Arts, Faculty of Art and Design,
 Monash University, Melbourne

Publisher's acknowledgments

Dorling Kindersley would like to thank Kathryn Wilkinson, Martha Evatt, and Megan Hill for editorial assistance, Matthew Robbins and Mark Cavanagh for design assistance, Fiona Wild for proofreading, Michele Clarke for compiling the index, and Insektenfang plants—Carnivorous Plant Nursery, website: www.insektenfang.com, email: enquiries@insektenfang.com crb.

Mediterranean milk thistle achene

Picture credits